THE ART
HISTORIAN

CLARK
STUDIES
IN THE
VISUAL
ARTS

THE ART HISTORIAN

National Traditions and Institutional Practices

Edited by Michael F. Zimmermann

Sterling and Francine Clark Art Institute
Williamstown, Massachusetts

Distributed by Yale University Press, New Haven and London

This publication is based on the proceedings of the Clark Conference "The Art Historian: National Traditions and Institutional Practices," held 3–4 May 2002, at the Sterling and Francine Clark Art Institute, Williamstown, Massachusetts. For information on programs and publications at the Clark, visit *www.clarkart.edu.*

© 2003 Sterling and Francine Clark Art Institute
All rights reserved. No part of this book may be reproduced without the written permission of the Sterling and Francine Clark Art Institute, 225 South Street, Williamstown, MA 01267

Curtis R. Scott, *Senior Manager of Publications*
David Edge, *Graphic Design and Production Manager*
Diane Gottardi, *Layout*
Mary Christian, *Copy Editor*

Printed by the Studley Press, Dalton, Massachusetts
Distributed by Yale University Press, New Haven and London

ISBN (Clark) 0-931102-54-5
ISBN (Yale) 0-300-09791-3

Printed and bound in the United States of America
10 9 8 7 6 5 4 3 2 1

Title page and divider page illustration: Albrecht Dürer, detail of the Apocalyptic Beast from *The Apocalypse: The Beast with Two Horns Like a Lamb,* 1496–97. Woodcut. Sterling and Francine Clark Art Institute, Williamstown, Massachusetts

Library of Congress Cataloging-in-Publication Data

The art historian : national traditions and institutional practices / edited by Michael F. Zimmermann
 p. cm. — (Clark studies in the visual arts)
 Based on the proceedings of the Clark conference "The art historian: national traditions and institutional practices" held 3–4 May 2002 at the Sterling and Francine Clark Art Institute, Williamstown, Mass.
 Includes bibliographical references.
 ISBN 0-931102-54-5 (pbk. : alk. paper)
 1. Art historians. 2. Art criticism. I. Zimmermann, Michael F. II. Sterling and Francine Clark Art Institute. III. Series.

N7475.A783 2003
701'.18—-dc21

 2003045593

Contents

Part Three: What Art History Is, or What It Does

Part Four: Legacies, Practices, Reflections

Introduction

Michael F. Zimmermann

Why Art History within Its Limits?

There is a deeply rooted cliché of the art historian as one who talks instead of produces, surrounding innocent artworks with nebulous over-interpretations.[1] Art historians talking about themselves—that sounds like excuse or narcissism. Even more so, if, as in this book, the topic is not the freedom, but the limits of exploring visual products—the institutional frameworks of art historians' practices, the national traditions behind their education, the discipline's origins in Europe and the United States—in general, in what was once "Occidental" or "Western" culture!

The participants in the conference, organized by Michael Ann Holly and Mariët Westermann and held in May 2002 at the Sterling and Francine Clark Art Institute in Williamstown, Massachusetts, consciously accepted these limits. Academic curricula or career structures, museum budgets and sponsorship, and state offices for the protection of monuments are all formed by the institutional traditions of the nations. However, national voices struggle to organize themselves into a whole—as do the museum and the academic world, studied in 1999 in the Clark Conference "The Two Art Histories," organized by Charles W. Haxthausen.[2]

Only in the nineteenth and twentieth centuries has art history been established as a professional discipline corresponding to public interest. Succeeding methods and paradigms flourished in institutions: artistic biography within art academies; connoisseurship and oeuvre-cataloguing in museums, in the conservation of monuments, and the art market; interpretations of historical epochs according to style or iconography in the academic field; scientific inquiry into artworks in departments and studios of restoration; inventories of iconographic subject matter or of collections and provenances in research institutes or departments. All this forms a network whose name is art history. As museums became ever more all-encompassing institutions, the field was even extended beyond "art": from painting to drawing, from sculpture to reproductive casts, from architecture to design, from decoration to graphic art, from reproduction to photography, from popular broadcasts to newspaper illustrations, from scientific illustrations to the Internet, from advertisement to propaganda.[3] Art history always comprised many art histories.[4]

The very era that invented national artistic patrimony also invented the idea of a unique, global "art," distant from religion or philosophy, politics or science.[5] Romanticism rediscovered folk as well as medieval traditions and made the nation the subject of history. During the nineteenth century, the various national schools, whether historic or contemporary, joined in museums and world fairs, where the spectator could admire Nordic light along with Spanish mysticism, American panoramas along with Italian rhythms, French classicism along with German fantasy. Art history took a long time to emancipate itself from the national paradigm, once artistic development was understood as depending less on national character than on such inner necessities as style or *Kunstwollen*, studied by Heinrich Wölfflin and Alois Riegl.[6]

In the wake of colonialism artists, critics, anthropologists, and finally also art historians, fascinated with Oriental or African art, struggled for the acceptance of a fetish as a work of art, before museums arranged departments of Oriental, Oceanic, Pre-Columbian, or African art side by side with the corridors for European and American works. Ever since the publication of book series such as the Pelican History of Art or L'Univers des Formes, the idea of world art swept away the limits of a classical definition of art.[7] Soon the very notion of "our" culture was questionable. Already in 1895 the art historian Aby Warburg, born into a Jewish family in Hamburg, studied the culture of the Hopi Indians in Arizona, especially the Moki snake dance, even before he discovered forms as related to desires deeply anchored in Renaissance belief systems and visual traditions.[8] If post-colonial art appropriates suppressive European traditions, this is still an attempt at renegotiating the content, form, and public of a global imaginary museum.[9]

Art history, while it formed national elites and constructed national publics, paradoxically established an idea not less universal than human rights. Nowadays, the idea of art as a collective public heritage, full of promises and deceptions, excluding one and elevating the other, still is institutionally flourishing, even if it may be materially empty except of its dignity, or has come to an end, and only goes on playing with its shadow.[10] "Art" still imposes itself as responsibility: it *has* to be preserved, it *has* to be shown, it *has* to be explained.[11] For art history, for its public, and for its private or state sponsors, that purpose or even duty is constantly more tangible than what "art" may *be* in general, or at the moment. That responsibility came up, together with the very idea of art, in certain places, and in concrete historical situations.[12]

"You," and Games Where the Loser Is the Winner

In the essays assembled in this volume, art historians, discussing how to deal with their heritage within global professionalism, address their colleagues and their public. They address "you," invited to reflect about what you want to do as art historian, or what you want art historians to do, even without affecting the radical narrative perspective Michel Butor had chosen for his novel *La Modification*, published in 1957, which starts:

> You have put your left foot on the copper groove, and with your right shoulder you try in vain to push the sliding panel a little further. . . . You ease your way through the narrow opening, rubbing against both sides, then you take your suitcase, covered in dark, pebbled leather the color of a thick bottle, the rather small suitcase of a man accustomed to long trips, you pull it by its sticky handle with your fingers which have heated up, as light as it is, just from carrying it this far, you pick it up and you feel your muscles and tendons stand out not only in your fingers, in your palm, your fist and your arm, but in your shoulder too, in the whole half of your back and in your verte-brae from your neck to your waist. . . . No, it is not just the hour, scarcely daylight, which is responsible for this unaccustomed weak-ness, it is already age, trying to convince you of its domination over your body.[13]

The hero, Léon Delmont, is an alter ego for the reader who will, of course, stay himself, even if he feels emphatically with the director of the Parisian branch of an Italian typewriter-producer, who regularly travels to Rome, where he flees from the hostile indifference of his family into a love affaire with Cécile, a French woman living in the eternal city. When she wants to return to Paris, he again travels to Rome, this time in order to propose her to share lives. But on the train he recognizes that all her spell, for him, is Rome. The *modification* of *his* wishes is *yours,* the reader's, who finally realizes that the novel "has not only allowed for communication between you and the author, but what is more, con-tains a lesson," and the game reveals itself "a game of loser takes all."[14]

If art history, in this volume, reflects about the suitcases it wears and that make it aware of its age, this is similarly "a game of loser takes all." Art his-tory, losing herself to forgotten or suppressed traditions, losing her identity in

the oceans of the non-artistic, even the industrialized image, or simply going on doing what she feels she *has* to do, might end finding herself where she already is, or where she already once had been—and not elsewhere.

The Belgian art historian and critic Thierry de Duve, in the first chapter of his book *Kant after Duchamp* (1996), explicitly addresses "you," in order to introduce you into the possible approaches of art history.[15] For de Duve, the art historian is neither "I," "he," nor part of a "we," but "you," looking for what you want to do and don't want to do with "art."[16] However, as in a work by Lorenzo Lotto, or by Giulio Paolini, it is not certain who it is who addresses "you," or who "you" are, being addressed that way (fig. 1). With de Duve, "you and I" (to quote T. S. Eliot, who constructed a "we" that is not a collective singular)—we—now may follow the argument of the introduction of his book.[17]

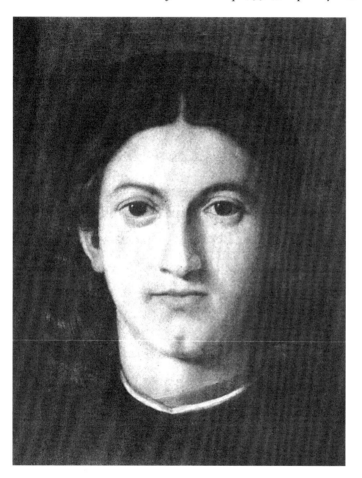

Fig. 1. Giulio Paolini (Italian, b. 1941), *Young Man Looking at Lorenzo Lotto*, 1967. Photo-reproduction on canvas, 11 13/16 × 9 1/2 in. (30 × 24 cm). Laupheim, Germany; F.E.R. collection. Based on a portrait (possibly a self-portrait) by Lorenzo Lotto in the Uffizi, Florence

De Duve invites you first into the role of an ethnologist or anthropologist, arriving from outer space on the earth. Art, for you, in most societies you know about is "an activity either integrative or compensatory, lying midway between their myths and their sciences."[18] As a structuralist extra-terrestian influenced by Claude Lévi-Strauss, you accept this place of art as a human activity inaugurating the possibility of symbolic exchange.[19]

But you are not satisfied with that tautological attitude of accepting everything as art—what *humans* might call such. You want to see it from the inside, from a humanistic perspective within a culture you are part of. Whether it originates in Greece or in Mesopotamia, you tell its evolution as a history completing the (however underlying) idea of art. Historians such as Henry Focillon or André Malraux told *La Vie des formes* or *Les Voix du silence* not as a history of change, but of metamorphosis.[20] As for a theory of "art as art" (Ad Reinhardt), you are, however, not more advanced than the anthropologist you just ceased to be: art itself negotiates and renegotiates what it is, whether imitation or expression, whether styled object or monument as opposed to document.[21]

Unsatisfied with that relativism, you become a logician and look for a paradigm. And you find it at the very limits of art: "you pull—indeed, yes—a urinal."[22] Of course the urinal shown at the first and juryless exhibition of the newborn Society of Independent Artists, in New York in 1917, was signed "R. Mutt." One of the founders of the society, Marcel Duchamp, was behind that provocation of the "juryless" notion of art. You realize that art as a human activity, here, still is reduced to a tautology: it is whatever an *artist* calls art. And you realize: "The detachment of the observer—the ethnologist's outsideness, the historian's overview, the logician's neutrality—are unsuitable when the meaning of art, not just its recognition, is at stake. You will have to start all over again."[23]

You will finally accept the loss of a real or possible omniscience. First, you become a sociologist, studying not society in general but your society, studying not human consensus as such, but a consensus you are a part of. Like the French sociologist Pierre Bourdieu, you realize that there is class privilege behind what seems to be a general consensus.[24] You see that art is more a matter of historical conflict than of human identity. If you still believe in art, and do not decide to leave it behind as an illusion—such as the German critic Carl Einstein when he fought, in 1937, in the Spanish civil war[25]—it becomes for you a purpose, not an accomplishment, and you realize that it always had been a goal, confronting man not with what he was but with what he could or should become. "The word 'art' exists, certainly, but when it signals accord, it is already past."[26] Art, by now, is more in its practices than in the work. Of course, de Duve now leads you in the midst of the "new" or "social" art history of the 1970s and 1980s that studied not only art but also hostility toward it, whether the refusal to accept Courbet's neither humanistic nor romantic representation of provincial society as art, or the destruction of artworks in

churches—from Byzantium, to the followers of Jan Hus, to the Reformation.[27]

De Duve does not mention the radical historicizing of the concept of "art" by Hans Belting that was possible only on the basis of social art history.[28] After having described the artistic practice of the Middle Ages as fundamentally linked to sacral or pagan cult, Hans Belting analyzed the very origins of the concept of art and art history: once the visual objects ceased merely to be functional within a religious or social ritual and started in turn to become the focus of an ever more aesthetic ritual, the idea of "art" only came into being.[29] Already Walter Benjamin had described that shift from art as *subservient within* ritual to art as focus of a ritual as a shift of the aura from the Divine to the artistic.[30] Belting's radical analysis is a decisive step: with him, you historicize not only, as with de Duve, the consensus within art, but the very phenomenon (and not just the notion) of art. You do not only realize that art was not always what it is for you, or, to place you within a broader historical context, in societies that had *Kunstkammern,* picture galleries, or even museums and exhibitions.[31] You do not only realize that art was something else in the Middle Ages, or in those African cultures Carl Einstein had analyzed in his 1917 groundbreaking book *Negerplastik*—a book that obviously influenced Benjamin for his much-disputed idea of the "aura."[32] With Belting, you become aware that only you go on giving the status of "art" to the artifacts of the Middle Ages or to ritual objects of the so-called "primitive" cultures.

In German art history during the 1980s, the analysis of the "functions" of the artwork seemed to be a unifying paradigm.[33] The "function" *as* art was seen as only one of the possible roles *of* artworks and artifacts within all sorts of symbolic exchange. "Art *as* art" is art for "us," as a value. It goes beyond any function *of* art, analyzed by de Duve's extra-terrestians.

The excursion from the "you" of Thierry de Duve to the epic "we" Belting favors more and more in his books, has taught you that art was not always, and will maybe not always, exist. The same is true for that "we"—that collective singular for whom it is "art as art."[34] So, after that extra lesson, you might like to return to being you, instead of "we," because "you" will remain what you are, as long as you can speak up for yourself, even if it is in "a game of loser takes all." But you are aware now that art, once reduced, through an urinal, to a proper name, can also be reduced to nothing, or to an empty shadow of what it was, for instance to a new branch of higher entertainment, or to new ways of marketing strategy by means of museums and exhibitions.[35]

You might follow de Duve when he transforms you back to an amateur, for whom art is charged with a multitude of emotional values, values that cannot be reduced to the simplistic, Kantian alternative of pleasure or pain, but allow for all the light and shadow of desire, and of the unconscious. And you might consider the inventory of art simply as a sediment of amateur's tastes shared by others for their subtlety, for human values once lived and stocked in a repository of life-as-linked-to-visual-artifacts. You cannot but be charmed by this act of modest renunciation to *possess* art, whether in a philosophic definition or in a well-constructed narrative of its history.

You discovered the fragile history and status of art. But you also see that the old-fashioned idea of art is still interesting enough for visual trash culture, for ideology interested in "naturalizing," to use Roland Barthes's term, its key prejudices, for commercial culture that already has started the assault.[36] You might still feel compelled to defend it, and to insist that it reveals more than just taste, that it tells of possible freedom and real humiliation, that it gives access not only to life but to something you defend as a fundamental human truth. You might still feel that it is *good,* even a *duty,* to conserve works of art, whether you like what you think is their ideological message or not. Also, you might decide to stay, somehow, the sociologist involved in a struggle for a consensus even if it is unrealistic, for a utopia in the sense of the avant-garde, even if it has lost the totalitarian inclinations of the historical avant-gardes and of modernism, even if it is a very modest utopia.[37] But once you do so, you leave the community of the "you" with the one who is speaking, with de Duve, whom you now envy for his optimism and savoir-vivre, or with anyone who speaks to you only in order to speak for you. You have learned your own lesson. Art history for you, is also what it *happens* to be for you: your tradition, your education, your institutional practice. And it is what you feel you *must* do with and within it.

Art history, thus, is thrown back to its own history, to an identity it can only maintain in its self-reflexive practice. If art history looks back at its own history, it accepts its task as cultural environmentalism, not only enjoying but defending the fragile values it stands for and is part of.

More or Other Histories of Art History

How did classical antiquity remember its own antiquity; how did Egypt do so? Alain Schnapp, the specialist of archaeology's history,[38] now inquires into the construction of cultural memory, into the prehistory of archaeology, arguing

that all historical cultures establish a relationship to the past and its visible remnants. In the thirteenth century B.C. an Egyptian prided himself for having excavated and restored a monument of a priest that dated from around 2700 B.C.. With reference to the research of Jan Assmann, Schnapp insists on the Egyptians' attempts at anchoring historic time in non-historic eternity.[39] Preserving and collecting the remnants of the past—not for the present, but for eternity—was an antiquarian activity even then. Ruins from Mesopotamia to China already illuminated their own culture with her previous ambitions and her fate. If the monument erases time, time in turn erases everything. Writing took a long time to encode time into history—and ruins, into material memory.

Art history has told its own origin as rooted in romanticism, its love for the culture of the sane people, understood in a proto-nationalistic sense, its idealization of the corporative society of the Middle Ages, its self-expression in the total artwork of the cathedral.[40] Instead of reasserting that mythic origin of art history, two of the essays focus on other traditions equally fundamental: one is on the place of art history within the French academic system, and another on the rediscovery of Giorgio Vasari's *Lives* (1550 and 1568) in France, Italy, and Germany—both too-often forgotten sources of an art history keen on erasing its past within the institutional system of absolutism.[41]

In 1841 Paul Delaroche had finished his pantheon of the artists of all the times gathered, on a wall painting, behind the teachers and students in the Parisian École des Beaux-Arts.[42] The work illustrates what Stephen Bann now calls a forgotten "ego-nucleus"—a term by Melanie Klein—of art history's prehistory. In the early nineteenth century, art history in France was present in a great variety of institutions. Even today, teaching in the École des Beaux-Arts, the École du Louvre, the Collège de France, the universities and the École Normale Supérieure is institutionally much less integrated than in other countries.[43] For Delaroche, who previously had proposed a reform of the academy, art history still had its place in the context of training artists. However, an illuminated, historically informed bourgeois public needed historically informed art. If Delaroche used the illustrations of Vasari's *Lives* as a model for some of the artist's portraits, for others, such as Arnolfo, Giotto, and Orcagna, he took his models from the chapterhouse in Santa Maria Novella, in order to avoid anachronism.[44] In the Napoleonic Louvre art had already been arranged according to the evolution of different "schools," thus historically.[45] In Delaroche's assembly of masters of all the times, however, diachronic art history is still synchronically present. The

paradigm of history took a long time to emancipate itself from the paradigm of progress toward its standstill in perfection.

Carlo Ginzburg accentuates the continuity from the art history that was invented in 1550 by Giorgio Vasari, who over twenty years later also founded an academy, and the new discipline shaped during the nineteenth century in the wake of historicism. Recent studies by Gabriele Bickendorf and Elisabeth Décultot reject the image of Johann Joachim Winckelmann as an isolated founder of art history in favor of continuity from humanistic antiquarianism and its methods of linking paleography to connoisseurship to art history.[46] Ginzburg compares revisionists readings of Vasari after Winckelmann in Germany, Italy, and France. Johann Dominicus Fiorillo, a pupil of the painter Pompeo Batoni and after 1883 a teacher of art history in Göttingen, based his *Geschichte der zeichnenden Künste* (1798–1808) still on Vasari's *Lives*. In the early nineteenth century, Carl Friedrich von Rumohr or Johann David Passavant replaced the role of Michelangelo as the epiphany of art in Vasari through the early Raphael, thereby pleasing the Nazarenes, for whom Michelangelo already meant decadence. Friedrich Overbeck's painting *Italia und Germania* (1828), translating romantic friendship into the longed-for renaissance of two nations, accentuated the reactionary character of that reading. In Italy, the Purists shared the Nazarenes' dreams of catholic unity. But there the rediscovery of Giotto and the medieval tradition, instead of praising the past glory of the Holy Roman Empire, worked for the *risorgimento* of a supposed Italian cultural primacy in a nation-state. Until 1848, such Italians as Vincenzo Gioberti invited the pope to lead Italy toward freedom from Austrian domination. Gaetano Milanesi's two editions of Vasari's *Lives* (1846–55, 1878–85) are still rooted in a catholic reading linked to cultural patriotism. The principal figure of the Vasari renaissance for Ginzburg is Philippe-Auguste Jeanron, painter, director of the Louvre in 1848–49, and writer who commented a translation of Vasari between 1839 and 1842. Even before the avant-garde and its rhetoric, the republican Jeanron, revolutionary of 1830, described art in political terms: he saw artists such as Giotto as having gained individual freedom against Byzantine dogmas. Ironizing the German readings of Vasari, Jeanron argues against final perfection, whether in Raphael or in Michelangelo. He accentuates an element in Vasari that Ginzburg calls historical "perspectivism," not to be confused with relativism. The share Vasari admitted for the historical conditions of art, when he explains why Giotto could not reach the perfection of a Michelangelo, for Jeanron becomes the core of the argument. He links artistic progress, an idea Vasari had

inherited from Pliny, to social conditions and political progress. Thus, Jeanron's truly historic reading is the opposite of Delaroche's. Also his artistic endeavor, focused on the losers of progress, or of the revolution of July 1830, was at the opposite of Delaroche's historicism. For Ginzburg, Jeanron "who identified with the defeated, ended up a winner." And for the conference, Ginzburg's work-in-progress-paper was the model of another art history's history, or, to say it with Michel Butor, of "a game of loser takes all."

The conference did not pass over the exodus of the best of German art history after 1933. The discussions focused also on the destiny of those Jewish art historians in Nazi Germany who were killed or had to give up their careers.[47] Karen Michels deals with the more practical aspect of the academic (and culinary) experience of Jewish art historians urged into emigration from Germany to the United States. She confronts the American tradition of pedagogic mission with the German university system built on the ideals of Wilhelm von Humboldt, who wanted teaching narrowly linked to research. Nowadays, the situation somehow seems to have turned around: whereas at the time of Erwin Panofsky's arrival in New York, the European approach, presented in "Problems in" seminars, was perceived as over-specialized and technical, now, in many fields European art history would be provincial without the dialogue with American specialists. Students in European mass universities are still required to learn a general (if often superficial) overview of Western art history. Specialization is often allowed only in master's or post-graduate programs. Almost all the German Jewish emigrants welcomed the pragmatic clarity of the English language and felt freed from the fogs of German idealistic philosophy. However, the pragmatic turn of this generation and of their pupils, a change that transformed many radical questions of art history into institutionalized techniques such as an iconography that is all too dictionary-related, is today criticized as a narrowing of the discipline.[48]

Françoise Forster-Hahn defends the disciplinary pragmatism of that generation. Reflecting on her own academic career between "the Old and New Worlds," she regrets that the practices of art history are actually moving further apart. After her dissertation about caricature in Bonn,[49] she studied at the Warburg Institute in London. She compares the anti-Hegelian tradition of Anton Springer and other German art historians of the nineteenth century with the empiricist spirit of international art history after 1945, when structural analysis of form and style in the wake of the Vienna school joined with iconography in a transatlantic methodological consensus. Even social history of the 1970s shared

aims on both sides of the Atlantic. However, the reception of French theory in the United States has reintroduced difference in academic cultures and mentalities, the belief in "historical continuity and aesthetic coherence" being questioned more on the American than on the European side of the Atlantic.

Questioning Myths and Master Narratives of Art History

However, also in Europe, the postwar consensus so convincingly analyzed by Forster-Hahn is under discussion. How did art historians construct the figure of an artist? Ernst Kris and Otto Kurz had taught *topoi* of artistic biography from Vasari to the present, such as the myth of nature revealing herself to an innocent genius who then is discovered (and introduced into the culture of representation) by a teacher whom he will surpass (Giotto drawing sheep, discovered by Cimabue).[50] The circularity of nature and culture is repeated in the circularity of work explained through life, and vice versa, in monographs and in connoisseurship—narratives Mieke Bal had already questioned in her book *Reading "Rembrandt"* (1991).[51] Now, she analyses myths that govern even the practices of positivist or scientific analysis. Even if Bal's attacks against Dutch cultural nationalism may seem a bit vitriolic, her questioning of concepts such as mastery, originality, and authenticity is all the more challenging. Is Rembrandt's "hand"—a synthesis of all that—just an anthropomorphic fiction implying the possibility of the spectator's encounter with the painter's true intentions through his work? Can art history, through its own mastery, grant that encounter with the master, present for example in his self-portraits?[52] The individualism underlying connoisseurship from Bernard Berenson to Max Friedländer shares the circularity of the artist-and-his-work explanations. Arguing against a paradigm that has structured art history, Bal insists that the artist cannot possibly speak through the mouth of the art historian.[53]

Vermeer, for H. Perry Chapman, is an artist whose work, so rich in facts, hides a life so poor in them. Research as positivistic as Vermeer's studio practice has gained evidence about his circle; the trade and prices of paintings as compared to, for example, coats; the artist's dependence on a patron, Pieter Claesz van Ruijven; his house that could be reconstructed from his paintings; and his use of strings in establishing perspective—or of a camera obscura. A realist who hides everything in showing so much is compelling for postmodern fiction. Chapman takes sides with Tracy Chevalier's novel *Girl with a Pearl Earring* (1999) that tells Vermeer's distance from humanity, and from his female sitter, the maid Griet, in a fictional story based on careful observations of his works.[54]

Georges Didi-Huberman inquires into the notion of time that art history implies, just as the artwork cuts into time. If artworks are explained from origins, time is established as a continuous chain of related phenomena encompassing the spectator here and now. Referring to Michel Foucault and his reading of Friedrich Nietzsche, Didi-Huberman argues against origin and continuity.[55] An African sculpture in a collection of European art was an anachronism, revealing any powerful image as such. Like a symptom, the image arises, interrupting the chain of representation, according to a logic anchored in the unconscious. In *Devant le temps* (2000), Didi-Huberman focused on the anachronism of the artwork, a term he had borrowed from Carl Einstein.[56] Later, he insisted on the move of art historians such as Aby Warburg of "folding" the past into the present.[57] He now inquires into the French Annales-School's historical time, whether fast or slow, on the intersecting rhythms of historical time and time as related to life.[58] The image, emerging from the "porosity" of history, becomes a paradigm of multifold time. Art history, folding onto its own past, discovers a theory of the image as symptom (linking representation to the unconscious) already developed by Aby Warburg, Walter Benjamin, Carl Einstein, and German Jewish intellectualism before 1933. In contrast to Françoise Forster-Hahn, who prizes the generation of the emigrants and of postwar art history, Didi-Huberman regrets that they suppressed the critical energy of their predecessors in the moves toward philological, technical pragmatism. He invites art history to re-read Warburg, Einstein, Benjamin, similar to how Jacques Lacan re-read Freud, thereby rethinking paradigms such as origin, the haptic, survival, or modernity.

What Art History Is, or What It Does

Horst Bredekamp tries to reconstruct a tradition of *Bildwissenschaften* (inquiry into images, or the image). Focusing on art history and *its* media as well as on art history and *the* media, he demonstrates that the limitations of art history's field, imposed by idealistic aesthetics, had already been questioned by Austrian and German art historians, who between 1900 and 1933 studied illustrations, figures, and other popular imagery as seriously as works of art. After 1970 social art history regained that breadth, focusing on advertisement, video art, or political iconography.[59] Only recently, visual studies are established more and more beside art history. Contradicting Belting, for whom iconology could have developed into a general science of the image had it not again limited art history to art, for Bredekamp, it is not the generation of Panofsky who is to blame for the

narrowing of the field, but a more recent loss of disciplinary memory.[60] The discipline, having used reproduction from photography to double slide-projection in a self-reflective way, also focused on the media outside art history. Warburg had been interested in the propaganda machine of the First World War before studying, in 1919, religious propagandistic prophecies in the woodcut images during the Reformation.[61] The last sheet of his Mnemosyne-picture-atlas is particularly revealing. Here, images referring to the Vatican contract between Pius IX and Mussolini—which in 1929 ended the confrontation of the Italian nation-state with the sovereign of the patrimonium Petri—are combined with illustrations alluding to golfing and other seemingly unrelated topics. Revealing a deeper psycho-iconography, all the images refer to the dadaistic mix of mundane triumph typical in the illustrated press. In his 1936 essay "On Movies," Panofsky would treat cinema as the most important successor of the iconographic tradition, more so than, it is understood, avant-garde art.[62] Bredekamp strongly argues in favor of the unity of *Bildwissenschaft* and against splitting the fields into interdisciplinary visual studies and traditional art that would, in one of these fields, lead to a lack of professionalism in description, and, in the other, reduce the history of art to its own archaeology.

Not arguing against ethnological or post-colonial approaches, my essay tries to warn against versions of totalizing anthropology, of art history envisioning itself as arrived at its end(s). André Malraux and Belting both radically question art as linked to the imaginary museum, present in books, or as originating in late medieval and early absolutist courts.[63] Also, both have contributed toward opening art to global culture.[64] That opening of the perspective becomes the prelude for a more radical closure if "we" (the epic community of art history) believe to understand in art not men, but man. Urania's owl flies over the world at dawn, linking understanding to the death of what it understands. For Belting, the death of art is celebrated over and over again within recent art.[65] Against art history as negative theology, I favor radical contingency (in an admittedly generalizing, thus in itself not contingent, move).[66] It may be a poor project to focus onto the procedures through which art goes on reinventing itself, against the pressures of the ever more industrialized image. But instead of conflating non-artistic images with "art," it focuses on an accelerated change—and on artists' capacity and responsibility to confront societies with themselves, with the human condition they create and with what presents itself as their other side, their hidden self.

Schnapp started the reflective gaze of art history onto itself with the archaeology of archaeology. May it also end with archaeology, with memory, linked to objects. Eric Fernie demonstrates that whereas nowadays archaeology is based on a set of widely accepted methods and techniques, art history's identity is weak. The field of art history, vaguely defined, seems to be ever more restricted. Recent exclusions are architecture, design, photography, film, and digital media. Archaeology, on the contrary, as a scientific approach, is all-inclusive as to the cultural material found in a given site. Art history, belonging to the *humanities,* should less define itself on the ground of what it is, than of what it does: analysis, and behind it, questions. Fernie exemplifies this through an erroneous analysis, mislead by evolutionism, of differently decorated arches of the arcades at St. Mary at Hemel Hempstead in Hertfordshire. The paradigm linking variations to changes in the mind of the builders, deeply rooted in art history, was wrong. But the question was not. Thus, even not analysis, but questions are in the center of that insecure discipline which is art history. Fernie's plea for the primacy of questions over answers is one of the rare conclusions a majority of art historians would tend to accept.

Whenever possible, the notes refer to editions in the original language.

1. Willibald Sauerländer, "Kunsthistoriker: 'Alte Meister' oder die Kunsthistoriker in den Romanen," in *Kunstchronik* 39 (1986): 81–86.

2. *The Two Art Histories: The Museum and the University,* ed. Charles W. Haxthausen (Williamstown, Mass.: Sterling and Francine Clark Art Institute, 2002).

3. Heinrich Dilly, *Kunstgeschichte als Institution. Studien zur Geschichte einer Disziplin* (Frankfurt am Main: Suhrkamp, 1979); *Altmeister moderner Kunstgeschichte,* ed. Heinrich Dilly (Berlin: Reimer, 1990). The 1979 book is influenced by Thomas S. Kuhn's 1962 study, *The Structure of Scientific Revolutions* (reprinted Chicago: The University of Chicago Press, 1970). Kuhn insists that new paradigms are not introduced in order to solve old problems, but as attempts to restructure entire fields of knowledge, often introducing, at the beginning, more problems than they resolve. The fashionable use of the term *paradigm* goes back to Kuhn. It designates, in a Wittgensteinian sense, a new experiment and interpretation functioning more as a practical than as a theoretical model for further investigation according to similar schemes.

4. That history is always based on narrative structures has been shown by Hayden White—who, however, insists on the fundamental difference between history and fiction, on the paradoxical fact

that historians attempt, in their storytelling, at telling the truth. See Hayden White, *Metahistory: The Historiographic Imagination in Nineteenth-Century Europe* (Baltimore and London: Johns Hopkins University Press, 1973). For traditional art historical myths, see Ernst Kris and Otto Kurz, *Die Legende vom Künstler. Ein geschichtlicher Versuch,* preface by Ernst H. Gombrich (1934; reprinted Frankfurt am Main: Suhrkamp, 1980). From its beginnings, the narrative structure of national history—such as the history of the republic of Florence—has influenced the narrative of patriotic art history. See Michael Baxandall, *Giotto and the Orators: Humanist Observers of Painting in Italy and the Discovery of Pictorial Composition, 1350–1450* (Oxford: Oxford University Press, 1971). Not by chance, art history has been invented once absolutism, while eliminating the political influence of art, includes it into a separate, autonomous field of knowledge. See Georges Didi-Huberman, *Devant l'image. Question posée aux fins d'une histoire de l'art* (Paris: Minuit, 1990), chap. 2, 65–104: "L'Art comme renaissance et l'immortalité de l'homme idéal"; and Michael F. Zimmermann, "Le Jardin de Cosme Ier à Castello. Remarques sur le maniérisme et l'histoire de l'art," in *Ruptures. De la discontinuité dans la vie artistique,* ed. Jean Galard (Paris: Musée du Louvre/École Nationale Supérieure des Beaux-Arts, 2002), 72–99.

5. See Udo Kultermann, *Geschichte der Kunstgeschichte: der Weg einer Wissenschaft* (1966; Munich: Prestel, 1996). For an example of a national history of art history, see Wilhelm Waetzoldt, *Deutsche Kunsthistoriker,* 2 vols. (Leipzig 1921–24; reprinted Berlin: Spiess, 1986).

6. Thomas DaCosta Kaufman, "National Stereotypes, Prejudice, and Aesthetic Judgments in the Historiography of Art," in *Art History, Aesthetics, Visual Studies,* ed. Michael Ann Holly and Keith Moxey (Williamstown, Mass.: Sterling and Francine Clark Art Institute, 2002), 71–84; Michael Podro, *The Critical Historians of Art* (New Haven, Conn., and London: Yale University Press, 1982); Joan Goldhammer Hart, "Heinrich Wölfflin: An Intellectual Biography" (Ph.D. diss., University of California at Berkeley, 1981; Ann Arbor, Mich.: University Microfilms, 1988); Wolfgang Kemp, "Alois Riegl," in Dilly, *Kunstgeschichte,* 19–34, 37–60.

7. About the Pelican History of Art, founded by Niklaus Pevsner and published since the early 1950s, see François Souchal, "A Propos de la nouvelle Pelican History of Art," in *Gazette des Beaux-Arts,* ser. 6, 126, no. 1522 (1995): 1–2; Alban Cerisier, "l'Univers des formes (1955–1997): livres d'art et pratiques editorials," in *Bibliothèque de l'Ecole des Chartes* 158 (2000): 247–71.

8. See Kurt W. Forster, "Zu Aby Warburg. Die Hamburg-Amerika-Linie, oder: Warburgs Kulturwissenschaft zwischen den Kontinenten," in *Aby Warburg. Akten des internationalen Symposium Hamburg* 1990, ed. Horst Bredekamp, Michael Diers, and Charlotte Schoell-Glass (Weinheim: VCH-Acta Humaniora, 1991), 11–37. Warburg is by now ever more in the center of art historical discourse; see Aby Warburg, *Gesammelte Schriften. Die Erneuerung der heidnischen Antike. Kulturwissenschaftliche Beiträge zur Geschichte der europäischen Renaissance,* ed. Gertrud Bing with Fritz Rougemont, 2 vols. (Leipzig and Berlin: Teubner, 1932; new edition directed by Horst Bredekamp

and Michael Diers, 3 vols. [Berlin: Akademie-Verlag, 1998]); Edgar Wind; "Warburgs Begriff der Kulturwissenschaft und seine Bedeutung für die Aesthetik," in *Zeitschrift für Ästhetik und Allgemeine Kunstwissenschaft,* special issue 25 (1931): 63–179; Ernst H. Gombrich, *Aby Warburg: An Intellectual Biography,* 2d ed. (Oxford and Chicago: Phaidon, 1986); Werner Hofmann, Georg Syamken, and Martin Warnke, *Die Menschenrechte des Auges. Über Aby Warburg* (Frankfurt: Europäische Verlagsanstalt, 1980); Claude Imbert, "Warburg, de Kant à Boas," in *L'Homme. Revue Française d'Anthropologie* (special issue "Image et Anthropologie") 165 (Jan.–Mar. 2003): 11–40, see also the essays in this issue by Carlo Severi and Giovanni Careri.

9. For the post-colonial perspective, see *Global Conceptualism: Points of Origin, 1950s–1980s,* exh. cat. (New York: Queens Museum of Art, 1999); *Documenta 11 Platform 5: Ausstellung,* ed. Okwui Enwezor, exh. cat. (Ostfildern-Ruit: Hatje Cantz, 2002).

10. Pierre Bourdieu, *L'Amour de l'art* (Paris: Minuit, 1966). See, for the debate of last images and end(s) of art, most recently, *Iconclash,* ed. Bruno Latour and Peter Weibel, exh. cat. (Cambridge, Mass., and London: MIT Press, 2002).

11. Classical text: Max Dvořák, *Katechismus der Denkmalpflege* (Vienna: Bard, 1918). Valuable introductions: Gottfried Kiesow, *Einführung in die Denkmalpflege* (Darmstadt: Wissenschaftliche Buchgesellschaft, 1982); Georg Mörsch, *Aufgeklärter Widerstand. Das Denkmal als Frage und Aufgabe* (Basilea, Berlin et al.: Birkhäuser, 1989).

12. The American pragmaticist philosopher Richard Rorty was asked, after a conference in Munich in presence of the sociologist Ulrich Beck and the philosopher Jürgen Habermas, whether for him participation in political and civic debate was a moral obligation or merely a professional behavior. He replied: "It *happens to be* a moral obligation" [my italics conveying his emphasis]. See, for the context, Jürgen Habermas, *Strukturwandel der Öffentlichkeit* (Darmstadt and Neuwied: Luchterhand, 1962); Jürgen Habermas, *Theorie des kommunikativen Handelns,* 2 vols. (Frankfurt am Main: Suhrkamp, 1981); Jürgen Habermas, "Vorlesungen zu einer sprachtheoretischen Grundlegung der Soziologie," in his courses at Princeton in 1971, *Vorstudien und Ergänzungen zur Theorie des kommunikativen Handelns* (Frankfurt am Main: Suhrkamp, 1984); and Richard Rorty, *Contingency, Irony, and Solidarity* (Cambridge: Cambridge University Press, 1989).

13. "Vous avez mis le pied gauche sur la rainure de cuivre, et de votre épaule droite vous essayez en vain de pousser un peu plus le panneau coulissant. . . . Vous vous introduisez par l'étroite ouverture en vous frottant contre ses bords, puis, votre valise couverte de granuleux cuir sombre couleur d'épaisse bouteille, votre valise assez petite d'homme habitué aux longs voyages, vous l'arrachez par sa poignée collante, avec vos doigts qui se sont échauffés, si peu lourde qu'elle soit, de l'avoir portée jusqu'ici, vous la soulevez et vous sentez vos muscles et vos tendons se dessiner non seulement dans vos phalanges, dans votre paume, votre poignet et votre bras, mais dans votre épaule aussi, dans toute la moitié du dos et dans vos vertèbres depuis votre cou jusqu'aux reins. . . . Non,

ce n'est pas seulement l'heure, à peine matinale, qui est responsable de cette faiblesse inhabituelle, c'est déjà l'âge qui cherche à vous convaincre de sa domination sur votre corps." Michel Butor, *La Modification* (Paris: Éditions de Minuit, 1957), 7. My thanks to Sarah Lees for this translation. See Mieke Bal, "Second-Person Narrative," in *Painting and Narrative,* ed. Michael Worton (Edinburgh: Edinburgh University Press, 1996), 179–204.

14. "non seulement aura permis entre l'auteur et vous une communication mais contient, de surcroît, une leçon"; "un jeu de qui-perd-gagne." Butor, *La Modification,* 314.

15. Thierry de Duve, *Kant after Duchamp* (Cambridge, Mass., and London: MIT Press, 1996), 3–86.

16. In technical terms, "you" is an intra-diegetic narrator addressing an intra-diegetic reader. As in an epistolary novel, both are part of the narration. None of them is placed outside, in an objectifying distance. And none can focalize the entire field, outside of its exploration in the course of the narrative. See Gérard Genette, "Discours du récit," in his *Figures III* (Paris: Seuil, 1972), 67–282.

17. T. S. Eliot, *The Waste Land* (1922), with a translation into German by Ernst Robert Curtius (Wiesbaden: Insel, 1957), For the focus onto "you" and "we" see Genette, "Discours" and Mikhail M. Bakthin, "Discourse in the Novel" (1934–35), in *The Dialogic Imagination: Four Essays by M. M. Bakhtin,* ed. Michael Holquist, trans. Caryl Emerson and Michael Holquist (Austin: University of Texas Press, 1981), 259–422, especially on his notion of voice, 275–300.

18. De Duve, *Kant after Duchamp,* 3–4.

19. Claude Lévi-Strauss, *Anthropologie structurale* (Paris: Plon, 1958); Claude Lévi-Strauss, *La Pensée sauvage* (Paris: Plon, 1962); Claude Lévi-Strauss, *Mythologies,* 3 vols. (1964; reprinted Paris: Plon, 1968).

20. See Henri Focillon, *La Vie des formes* (Paris: Ernest Lroux, 1934); and the much more voluminous André Malraux, *Les Voix du silence* (Paris: Pléiade, 1952).

21. De Duve, *Kant after Duchamp,* 4–12. See Barbara Rose, *Art-as-Art: The Selected Writings of Ad Reinhardt* (New York: Viking Press, 1975); and *Ad Reinhardt: Schriften und Gespräche,* ed. Thomas Kellein (Munich: Silke Schreiber, 1984).

22. De Duve, *Kant after Duchamp,* 12.

23. Ibid., 14.

24. Bourdieu, *L'Amour de l'art;* Pierre Bourdieu, *La Distinction. Critique sociale du jugement* (Paris: Minuit, 1979); Pierre Bourdieu, *Les Règles de l'art. Genèse et structure du champ littéraire* (Paris: Libre examen/Seuil, 1992). See also the special issue about Bourdieu, mostly from a philosophical point of view, of *Critique* 579/580 (Aug.–Sept. 1995).

25. Carl Einstein, *Die Fabrikation der Fiktionen,* ed. Sibylle Penkert (Reinbek/Hamburg: Rowohlt, 1973).

26. De Duve, *Kant after Duchamp,* 19.

27. T. J. Clark, *Image of the People* (London: Thames & Hudson, 1973); T. J. Clark, *The Absolute Bourgeois* (London: Thames & Hudson, 1973); Horst Bredekamp, *Kunst als Medium sozialer Konflikte. Bilderkämpfe von der Spätantike bis zur Hussitenrevolution* (Frankfurt am Main: Suhrkamp, 1975).

28. Belting's book about Assisi was a cornerstone of the social historical paradigm of the 1970s. See Hans Belting, *Die Oberkirche von San Francesco in Assisi. Ihre Dekoration als Aufgabe und die Genese einer neuen Wandmalerei* (Berlin: Mann, 1977).

29. Hans Belting, *Das Bild und sein Publikum im Mittelalter. Form und Funktion früher Bildtafeln der Passion* (Berlin: Mann, 1981); Hans Belting, *Bild und Kult. Eine Geschichte des Bildes vor dem Zeitalter der Kunst* (Munich: Beck, 1990); Hans Belting, *Das Ende der Kunstgeschichte?* (Munich: Deutscher Kunstverlag, 1983), 63–91, chapter 2: "Vasari und die Folgen. Die Geschichte der Kunst als Prozeß?"; Hans Belting and Christiane Kruse, *Die Erfindung des Gemäldes: das erste Jahrhundert der niederländischen Malerei* (Munich: Hirmer, 1994). See also Umberto Eco, *Arte e bellezza nell'estetica medievale* (Milan: Bompiani, 1987), chapter 10.

30. Walter Benjamin, "Das Kunstwerk im Zeitalter seiner technischen Reproduzierbarkeit" (1935), in *Gesammelte Schriften,* ed. Rolf Tiedemann and Hermann Schweppenhäuser with Gershom Scholem and Theodor W. Adorno (Frankfurt am Main: Suhrkamp, 1974), vol. 1, no. 2, 430–508.

31. Julius von Schlosser, *Die Kunst- und Wunderkammern der Spätrenaissance. Ein Beitrag zur Geschichte des Sammelwesens,* 2d ed. (1923; rev. ed. Braunschweig: Klinkhardt & Biermann, 1985); Horst Bredekamp, *Antikensehnsucht und Maschinenglauben. Die Geschichte der Kunstkammer und die Zukunft der Kunstgeschichte* (Berlin: Wagenbach, 1993). Bredekamp insists on the fact that the status of the artwork was intensely negotiable in the polyphonic ensembles of the *Kunstkammer.* The increasingly differentiated literature on the history of the museum cannot be quoted here. The status of art in the sense of liberal societies with their characteristic public life, however, is reflected in a synthetic manner, in these publications: Georg Friedrich Koch, *Die Kunstausstellung. Ihre Geschichte von den Anfängen bis zum Ausgang des 18. Jahrhunderts* (Berlin: de Gruyter, 1967); Oskar Bätschmann, *Ausstellungskünstler. Kult und Karriere im modernen Kunstsystem* (Cologne: DuMont, 1997).

32. Carl Einstein, *Negerplastik* (Berlin: Die Weissen Bücher, 1915; reprinted Berlin: Fannei and Walz, 1992).

33. *Funkkolleg Kunst. Eine Geschichte der Kunst im Wandel ihrer Funktionen,* ed. Werner Busch with Tilman Buddensieg, Wolfgang Kemp, Jürgen Paul, et al., 2 vols., Deutsches Institut für Fernstudien an der Universität Tübingen, 1984–1987 (Munich: Piper, 1997).

34. Hans Belting, *Das Ende der Kunstgeschichte. Eine Revision nach zehn Jahren* (Munich: Beck, 1995).

35. An example of that expropriation of art in a marketing strategy was, with rare exceptions (notably the show in the pavilion of the Swiss National Bank about "Art and Value—The Last Taboo"

by Harald Szeemann with Thomas Zaunschirm), the Swiss National Exhibition of 2002 with its *Arteplages* around the lakes of Neuchâtel, Morat, and Bienne. See Nelly Wenger, *The Official Guide to Expo. 02. Arteplages, Exhibitions, Events, Maps, Etc.* (Zurich: Werd, 2002).

36. Roland Barthes, "Le message photographique" (1961) and "Rhétorique de l'image" (1964), in Roland Barthes, *L'Obvie et l'obtus. Essais critiques III* (Paris: Seuil, 1983), 9–42.

37. Boris Groys, *The Total Art of Stalinism: Avant-Garde, Aesthetic Dictatorship, and Beyond* (Princeton, N.J.: Princeton University Press, 1992).

38. Alain Schnapp, *La Conquête du passé. Aux origines de l'archéologie* (Paris: Carré, 1993).

39. Jan Assmann, *Das kulturelle Gedächtnis. Schrift, Erinnerung und politische Identität in frühen Hochkulturen,* 3d. ed. (Munich: Beck, 1997).

40. Waetzoldt, *Deutsche Kunsthistoriker,* 1:14–73.

41. Giorgio Vasari, *Le vite de' più eccellenti pittori scultori et architettori nelle redazioni del 1550 e 1568,* ed. Rosanna Bettarini and Paola Barocchi, 6 vols. (Florence: Sansoni; Studio per Edizioni Scelte, 1966–87).

42. See Stephen Bann, *Paul Delaroche: History Painted* (London: Reaktion, 1997), 200–27. In my critical review of the book in *Kunstchronik* (May 1999), 207–18, I did not mention a small but important complement: Stephen Bann: *After Delaroche: Art and Its Reproductions in Mid-Nineteenth-Century France,* exh. cat. (The Strag Print Room, London: University College, 1998).

43. For a history of art history and its institutions from a French perspective, see Roland Recht, *Penser le patrimoine: mise en scène et mise en ordre de l'art* (Paris: Hazan, 1998).

44. About the theory of historicism, see "Geschichte allein ist zeitgemäß," in *Historismus in Deutschland,* ed. Michael Brix and Monika Steinhauser (Gießen: Anabas, 1978).

45. Thomas W. Gaehtgens, "Le Musée Napoléon et son influence sur l'histoire de l'art," in *Histoire de l'histoire de l'art,* ed. Édouard Pommier, Conférences et colloques du Musée du Louvre (Paris: Klincksieck, 1995), 89–112.

46. Gabriele Bickendorf, *Die Historisierung der italienischen Kunstbetrachtung im 17. und 18. Jahrhundert* (Berlin: Gebr. Mann, 1998); Elisabeth Décultot, *Johann Joachim Winckelmann: Enquête sur la genèse de l'histoire de l'art* (Paris: Presses universitaires de France, 2000).

47. Ulrike Wendland, *Biographisches Handbuch deutschsprachiger Kunsthistoriker im Exil. Leben und Werk der unter dem Nationalsozialismus verfolgten und vertriebenen Wissenschaftler,* 2 vols. (Munich: Saur, 1999); Karen Michels, *Transplantierte Kunstwissenschaft: deutschsprachige Kunstgeschichte im amerikanischen Exil* (Berlin: Akademie-Verlag, 1999).

48. Michael Ann Holly, *Panofsky and the Foundations of Art History* (Ithaca: Cornell University Press, 1984).

49. F. Forster-Hahn, *Johann Heinrich Ramberg als Karikaturist und Satiriker* (Hannover: Schulze, 1963).

50. Kris and Kurz, *Die Legende vom Künstler.*

51. Mieke Bal, *Reading "Rembrandt": Beyond the Word-Image Opposition* (Cambridge: Cambridge University Press, 1991).

52. On the paradox of a technique of originality, see Richard Shiff, *Cézanne and the End of Impressionism: A Study of the Theory, Technique, and Critical Evaluation of Modern Art* (Chicago: University of Chicago Press, 1984).

53. Gary Schwartz, "Connoisseurship: The Penalty of Ahistoricism," *Artibus et Historeae* 18 (1988), 201–6.

54. Tracy Chevalier, *Girl with a Pearl Earring* (New York: Dutton, 1999).

55. Michel Foucault, "Nietzsche, la généalogie, l'histoire" (1971), in *Dits et Ecrits 1954–1988,* vol. 2 (Paris: Gallimard, 1994), 147–48.

56. Georges Didi-Huberman, *Devant le temps. Histoire de l'art et anachronisme des images* (Paris: Minuit, 2000), ch. 3, "L'image-combat. Inactualité, expérience critique, modernité," 159–232.

57. Georges Didi-Huberman, *L'image survivante. Histoire de l'art et temps des fantômes selon Aby Warburg* (Paris: Minuit, 2002).

58. See also, quoted by Didi-Huberman: Reinhard Koselleck, *Vergangene Zukunft. Zur Semantik geschichtlicher Zeiten* (Frankfurt am Main: Suhrkamp, 1979).

59. See, for example, Martin Warnke, "Zur Situation der Couchecke," in *Stichworte zur "geistigen Situation der Zeit,* ed. Jürgen Habermas, vol. 2, *Politik und Kultur* (Frankfurt am Main: Suhrkamp, 1979), 673–87.

60. See already Horst Bredekamp, "Words, Images, Ellipses," in *Meaning in the Visual Arts: Views from the Outside. A Centennial Commemoration of Erwin Panofsky (1892–1968),* ed. Irving Lavin (Princeton, N.J.: Institute for Advanced Study, 1995), 363–71.

61. Aby Warburg, *Heidnisch-antike Weissagung in Wort und Bild zu Luthers Zeiten,* Sitzungsberichte der Heidelberger Akademie der Wissenschaften. Philosophisch-historische Klasse, vol. 10 (1919), abh. 26 (Heidelberg: C. Winter, 1920).

62. The essay was later revised and published as Erwin Panofsky, "Style and Medium in the Motion Pictures," *Critique* 1, no. 3 (1947): 5–28.

63. André Malraux, *Psychologie de l'art. Le Musée imaginaire* (Geneva: Skira, 1947); Belting, *Das Ende der Kunstgeschichte?;* Belting, *Bild und Kult;* Belting and Kruse, *Die Erfindung des Gemäldes,* see n. 29, above. The renaissance of antique strategies to tell art history is analyzed in Baxandall, *Giotto and the Orators.*

64. Hans Belting, "Der Ort der Bilder," in *Das Erbe der Bilder. Kunst und moderne Medien in den Kulturen der Welt,* ed. Hans Belting and Lydia Haustein (Munich: Beck, 1998), 34–53, where Belting argues still in a perspectivist sense "dass wir selbst die Bilder mitbringen, die wir sehen wollen—und sehen (verstehen) können." (53).

65. Hans Belting, *Das unsichtbare Meisterwerk. Die modernen Mythen der Kunst* (Munich: Beck, 1998). My critical review was published in *Kunstchronik* 52, no. 1 (Jan. 1999): 47–51.

66. That move is all the more regrettable as there would have been the model for a more elegant argument opposing the humanly concrete against the humane in general: for Meyer Shapiro against Heidegger and about van Gogh's shoes, see Meyer Schapiro, "The Still Life as a Personal Object—A Note on Heidegger and van Gogh" (1968), "Further Notes on Heidegger and van Gogh" (1994), in Meyer Schapiro, *Theory and Philosophy of Art: Style, Artist, and Society: Selected Papers* (New York: George Braziller, 1994), 135–42, 143–51.

Main Library Hours

Monday	12 p.m. – 8 p.m.
Tuesday	10 a.m. – 8 p.m.
Wednesday	10 a.m. – 8 p.m.
Thursday	10 a.m. – 8 p.m.
Friday	12 p.m. – 5 p.m.
Saturday	10 a.m. – 5 p.m.
Sunday	Closed
Telephone : 946 – 8130	

THER HISTORIES
OF ART HISTORY

Vestiges, Monuments, and Ruins: The East Faces West

Alain Schnapp

In one of the most convincing books to explore the poetics of ruins, Roland Mortier explains the lack of sensitivity among the ancients: "The ruin—curiously non-existent for the Greeks—was interesting to the Romans only as the intangible image of Destiny; a ruin was not a presence but an *absence* or a *void,* the witness of a vanished presence, the negative mark of destroyed grandeur. For them, the ruin became identified with nothingness, so to speak; it was no longer a concrete thing which could be the object of fear, admiration or sorrow, but was like the indent left by a footprint, the mortal city razed to its foundations."[1]

This remark, even though it contains some truth, leaves the classical historian somewhat in the lurch. Naturally, Troy or Carthage invoked the idea of the decline and fall of empires, but was it not Thucydides, in his celebrated parable of Athens and Sparta, who emphasized that monuments played a role in the history of cities, and that assigning them too much importance was to risk historical misinterpretation? The ruin was not unknown to the Greeks and Romans. However, the image that they had of the ruin was different from that which predominated in Western literature since the Renaissance. The word *ereipion* (pl. *ereipia*) comes from a verb that means "to fell, to knock down," exactly like *ruo,* which gives us *ruina* in Latin: it stands for remains, the traces of ancient constructions. These *ereipia* were not the objects of reverie for poets and sensitive souls, but were instead marks of the past, which curious spirits such as Herodotus and Thucydides did not fail to decipher. Ancient cities were saturated with funerary monuments and ancient edifices for which names and explanations were sought. From Herodotus to Pausanias, urban spaces were stuffed with every sort of vestige that was attributed to the ancient heroes and the country's original inhabitants. The line of a country's borders and the legitimacy of this or that group's claims over a given territory could depend on the observation and interpretation of these monuments. They were indeed ruins, if we agree with Roland Mortier that "the ruin has value as a memorial, and as a reminder; it is a sign, an indicator which allows the spirit to momentarily forget the irreversibility of history and to allow itself to be carried away by time's flow."[2]

In the temple of Athena Alea, the Tegeans displayed the chains with which they had bound their Lacedaemonian prisoners. Similarly, the Lacedaemonians

sent for the remains of Orestes to be exhumed in Tegea and repatriated to Sparta in order to ensure revenge over the Tegeans.[3] In both these cases, these vestiges served as indicators and even as symbols. One could object that this is only a use of the past in an instrumental sense, and that it lacks a certain sensitivity which is the domain of the poetry of ruins. To see this at work, one need only reread this passage from the *Tusculan Disputations,* where Cicero describes the discovery of the tomb of Archimedes while he was *quaestor* at Syracuse, or even one of the poems of Ausonius:

> On the name, engraved in marble, of a certain Lucian.
> A single letter shines between two points and this simple .L.
> Marks the first name. Then comes an M, which I think is not complete:
> The point has disappeared, along with a bit of broken stone. Is it a
> Marius, a Marcius or a Metellus who sleeps here? No one can know
> for certain. The torn-away letters lie scattered, their lines mutilated, and
> all sense disappears in the jumble of characters. Why do we wonder
> that men die? Monuments crumble away; the end arrives even for
> stones and names.[4]

This text contains all the elements for a poetics of ruins: the idea of time passing, the fragility of memory, the wearing away of stone. There is no doubt that the spirit that moved the neo-Latin and Italian poets is present in this poem.

Certainly the ancients had a concept of ruins—a relationship to the past that should not be confused with that of the Western Renaissance—but the theme of the monument, of its splendor and its decline, are present in most of the traditions of antiquity. Depending on the type of object—whether temple or palace, statues or inscriptions, ancient texts or rare objects—from Egypt to Mesopotamia, from Greece to China and Tibet, the poetics of the past and the cult of monuments contributed to the development of a sort of antiquarian melancholy. This differs, certainly, from the poetics of Western ruins, but springs from a similar sensibility. By examining a wide range of examples and traditions, as well as texts of very diverse origins, I want to inquire into the relationship of people to their past. This necessary relationship is formed from a wide variety of elements, and uses knowledge and practices all aimed at evoking or representing the past.

"That antiquarians are so taken with the sight of old things, not at doting upon the bare form or matter (though both oftentimes might be very notable

in old things) but because these surviving evidences of Antiquity represent unto their minds former times, with as strong an impression, as if they were actually present, and in sight, as it were." [5] This very clear description of antiquarian curiosity given by Méric Casaubon seems to be universal in that it suggests that the antiquarian attitude or method consists of a certain way of reliving the past by the observation of the present. The type of object does not matter whether it fits in the hand or is the size of a building—or the genre—text, image, simple tool, or complex machine: the work of interpretation gives the object its significance. By nature this significance varies from one epoch to another and from one culture to another. The value of Casaubon's remark is due to the fact that it gives primacy to the method over the object. However diverse they may be, objects only make sense by the work of the antiquarian who must lift them out of daily life and out of the ground in order to create what Krzysztof Pomian calls *sémiophores*. Of course, the antiquarian does not employ methods that differ greatly from those of the philologist or the naturalist, but he applies his knowledge mainly to objects made by man, with priority given to their form and substance. This interpretive view is certainly not exclusive: one may be carried away more by the emotion invoked by a ruin than by its meaning. The poetics of ruins needs therefore a conscience, a definition of vestiges that presupposes a relation to the past as universal as the idea of antiquity itself.

Of Stone and Time

One of the oldest existing texts that may give us an idea of the conceptions of the past of the ancient Egyptians is on the base of a statue, an inscription to the priest Ka-Wab, son of Kheops (c. 2700 B.C.). The inscription is by a certain Khaemois/Khaemou—asset, priest, and keeper of the domain of Memphis, and also the son of a pharaoh, Ramses II (1290–1224 B.C.). Khaemois prided himself on having discovered, excavated, and restored the statue of his distant predecessor "after having restored all the cult of them in the temple and in the memory of the people, who had forgotten them" [6]

All the conditions posed by Méric Casaubon appear in this text: the precise identification of the object, its assignation to a period and even to a precise individual, the desire to establish a dynastic relationship with the past. Above all, there is the idea of a recovered continuity leading to a reinstatement of sacred rituals. Against the erosion of architecture and of statues, the observation of the soil is a tool of memory, a means of reestablishing the fragile but decisive continuity

between people of the present and the past. Of course, the excavation was the result of a chance discovery linked to the construction of a sanctuary, but even this reinforces the antiquarian dimension of the event. It is not a search for rare and precious objects—traditional in a society that reserved the finest products of its craftsmen for embellishing tombs—but the religious, cultural, and political affirmation of memory. The rediscovery, reestablishment, and identification of the traces of the past are the signs of a piety that is also a form of respect and emotion. This care for the past is not an isolated case, and the restorations of Khaemois are many.[7]

The adventure of Khaemois is particularly striking in that it illustrates the desire to recall the religious figures of ancient Egypt, and we will see that this particular sensibility is as common to the Egyptians as it is to the Mesopotamians and the Chinese. Nevertheless, another document illustrates a different sort of curiosity, of a private and more secular nature. It concerns a fossil discovered by Ernesto Schiaparelli at Heliopolis in an archaeological zone whose functions are not well defined. This fossil of a sea urchin *(echinolampas africanus)* from the Lutetian bears an inscription composed of a dozen hieroglyphs that E. Scamuzzi has translated as follows: "found south of the quarry of Sopdw by the 'divine father' (priest) Tcha-Nefer."[8] The quarry mentioned is well known from various sources, and the name of the priest is often attested to in Egyptian sources from the New Kingdom period onward. Between this inscription and the one by Khaemois there is a considerable distance. On the one hand there is an official document attesting to the piety and knowledge of its author, and on the other a private token of the curiosity of a scholar who picks up a strange object: a *sémiophore*. It is difficult to know the reasons that this priest kept and labeled this object, but it is enough for us to suppose that his interest reveals a curiosity that is the source of what we would call collecting: an act which involves extracting an object from its functional or natural environment and setting it apart, briefly describing it, identifying it—in short, the constitution of an object of significance. Halfway between antiquarian and naturalist, Tcha-Nefer deserves a place in the hall of fame of mankind's first collectors.

Scribes and scholars collected and deciphered ancient inscriptions for reasons beyond personal curiosity. This type of knowledge was a necessary tool for religious activities and out of respect for the gods; it established a link between curiosity and truth. The cult of monuments was for the Egyptians tantamount to an obsession: the Pharaohs sought to construct monuments for eternity. Jan Assmann defines the heart of Egyptian civilization: "For the Egyptians, stone was the medium of memory and the means of projecting the self into eter-

nity, and time was a dimension in which and against which this civilization of stone was built."⁹

Each Pharaoh sought the services of the best architects in order to leave behind an indelible reminder of his power and piety.¹⁰ Knowledge of the monuments of the past and how to imitate them were also part of the tasks of the architect, who surrounded himself with painters and sculptors whose mission was to ensure the glory of the Pharaoh. The rank which each occupied in society depended on their skills and the secrets of their art: "The king . . . has elevated me above the courtesans . . . and my master has shown himself to be satisfied with the solutions I have proposed . . . He has promoted me to direct the work . . . and I have been introduced into the Golden Palace to bring into being the cult statues and images of all of the gods. I have been admitted to the inaccessible, someone who sees Ra in his manifestations and Atum in his rebirth . . . I am the one to whom it has fallen to lay them to rest in their sanctuaries."¹¹

A mastery of the arts is one of the conditions of the glory of the ruler; it fulfills the hope for a longevity greater than that of the human life span, a sort of guarantee of memory which associated the monument and its patron. In the Egyptian vision of the creation and construction of a monument, the artisan was an inspired person, capable of communication with the gods—and this capacity was the means to escape the erosion that threatened objects as well as people. Knowledge of the secrets of the past was therefore one of the conditions for the success of a work: each Pharaoh was in competition with his predecessors and his successors. The recovery of *spolia* was a way of distinguishing and honoring the work. Thus Hordjedef, son of the Pharaoh Snofrou (Kheops's predecessor) collected ancient inscriptions, according to the *Book of the Dead:* "This phrase was found at Hermopolis, on a block of quartzite from Upper Egypt, beneath the feet of this god, in the time of his majesty Myderinus, the king of Upper and Lower Egypt, by the prince Hordjedef, who found it when he was inspector of temples, while a force accompanied him on this mission: he demanded it as an homage to himself, and brought it back as a object of wonder to the king when he saw that it was something very secret, which had never been seen or perceived."¹²

Antiquity was no longer simply an object of piety, like the discovery of Khaemois; it was a rarity, a collector's item, something which was accessible only to the king and his counselors. Another text from the same collection illuminates precisely this antiquarian dimension: "This text is transcribed in conformance with that which was found and written by the prince Hordjedef, who found it in a se-

cret box, in the hand of the god himself, in the temple of Ounou, mistress of Ounou, when he was traveling to inspect the temples, cities, countrysides, and mounds of the gods; that which is recited in secret in the Douat, a mystery of the Douat, a mystery of the kingdom of the dead."[13]

The discovery was not a chance one; it was linked to the prince's role as inspector and administrator. And the gods revealed to the emissary of the Pharaoh that which they had hidden from other men and other kings: the original text attributed to the gods themselves, a message too precious to be revealed to anyone other than a Pharaoh. The scribes themselves certified the authenticity of the message transcribed by the prince and carefully recopied. The status of the text, and the ways in which it was preserved and transmitted are part of the story which, in order to be received, must produce a real effect: antiquarian curiosity and its accompanying methods are there as witnesses.

But it was not enough to build monuments and to erect pyramids and tombs: these edifices must bear witness to the rank and renown of those who commissioned them. In response to the architects, sculptors, and painters, scribes—or certainly some of them—claimed the renown which was due them:

> Those writers, men of learning,
> who travel back to earlier times, to the arrival of the gods
> those true soothsayers of the future, they have become such
> that their names will be written in eternity
> even though they have gone to the other side, when their time of life
> is finished
> when their contemporaries will have all been forgotten
> They have not built for themselves pyramids of bronze
> Not steles of iron;
> They have not sought to leave heirs in the form of children,
> To keep their name alive.
> But they have created books as their heirs
> And the lessons which they have composed. . . .
> More precious than an inscribed funeral stone is a book
> more precious than a well-constructed funerary chamber
> Their books will serve as tomb and pyramid
> to keep their names alive.
> In the great beyond it is certain that it is important

that a name will be in the mouths of men.
A man departs this world, his body turns to dust
all of his contemporaries are laid in the earth.
Yet will his writing ensure that he is remembered
and that one mouth will tell of it to another.
More precious than a house of decorated walls is a book
more precious than a funerary chamber facing the west
more precious than a palace well fitted to its foundations
more precious than a votive stone in the temple.[14]

This text from the Ramesside era (end of the second millennium) expresses with surprising vigor the competition among the different types of artisans of memory. Rivaling stone, the text claims its autonomy and superiority—writing which is not mute but which needs the mouths of men to speak its contents. Picking up on Jan Assmann's conclusions, there are two ways to deal with the conflict between *Stein* and *Zeit*. One consists of mastering the construction of the tomb, of leaving a trace of oneself in stone to last until the end of time. The other is more of an immaterial approach, since it gives over to words the task of memory. Even engraved in the side of a monument, words are of a different order since "one mouth must say it to another." Verbal communication, made possible because the potential reader reads the text out loud, establishes a different order between the generations. Jesper Svenbro drew attention to the relation of writing to memory in ancient Greece, and he insisted on the strange relationship between the writer and the reader by the intermediary of reading out loud: one can see that this Greek idea was already in place among the Egyptians.[15] For the Greeks, immortality consisted of *kleos* (renown) and *genesis* (descent). The Egyptians thought along the same lines, but differed from the Greeks in the ways that *kleos* could be assured. Even if their poets proclaimed loud and long that their works ensured their immortality, the pharaohs—like the people—placed more faith in stone and in the tomb.

The monuments embodied a mute communication; they captivated, seduced, or awed those who saw them, and Greeks, starting with Hecateus Abderitus, were fascinated by the silenced message of the Egyptian tombs. "For the inhabitants of Egypt considered the span of a human life to be of no consequence and thought that the moment after death was of the greatest importance, since virtue would render it worthy of memory. The homes of the living are called guesthouses, since we inhabit them only for a brief moment; to those of the dead they have

given the name of houses of eternity, because the time that they spend in Hades has no end. This is why the Egyptians take little notice of their houses, but lavish every attention on their tombs."[16]

The Greeks therefore saw Egypt as a dwelling for eternity, as a civilization that valued the afterlife over the brevity of human existence. Assmann strongly emphasized that this particularity of the Egyptians was the fruit of an unparalleled dialectic between monument, writing, and memory. It was necessary to leave a trace of oneself, and to make sure this lasted a very long time, monument and writing worked together in the service of memory. But the Greeks understood only a part of this need for memory, since they did not have access to those texts that the decipherment of hieroglyphics has given to us. These reveal to us a sensitivity to the past, a poetics of ruins which is not without echo in the emotion which ran through the literature of the European Renaissance when it came into contact with the newly rediscovered Greco-Roman world.

The song of Antef gives an example:

The generations pass
others take their place, since the time of the ancients.
The gods who preceded them
lie in their pyramids
The Noble and the Great
are buried in their pyramids.
Those who built houses—their dwellings are gone—
where are they now?
I heard the words of Imhotep and of Hordjedef
their words are on every tongue
where now are their dwellings? Their walls have fallen down
they are no longer, as if they had never existed.[17]

The past is peopled with gods, with greats, and with poets: if the first two repose in their pyramids, the poets—who were also builders like Imhotep and Hordjedef—live through their works which are passed from mouth to mouth. The monuments of eternity are made up of stones and the words of those who constructed them. The sense of time which passes and the melancholy of the human condition are the ingredients of the type of poetry that draws its sustenance from the contemplation and the understanding of the past. Mortier's definition can be readily

discerned here: "Before being beautiful in its own right, the ruin has foremost an intermediary function: it allows for meditation, whether historical, philosophical, or moral."[18]

There is no doubt, therefore, that ancient Egypt laid the foundations for antiquarian practices and that it created a cultural universe in which the relationship of the past to the present, as well as the competition between verbal and monumental forms of remembrance, played a role in giving a historical and religious framework to the practice of a particular style of social memory. If everyone, from the noblest to the most humble, thought about projecting themselves into the time that succeeded their biological death, it was also necessary to turn back toward a past as distant as it was haunting, a past whose ruins dominated the current landscape. Each individual wanted to make his own contribution to the ruins of the past, adding new pyramids or new poems, meant to outlast erosion. One accepts the idea that memory must come to terms with the ruin. The infinitely large, the infinitely small, or the infinitely beautiful are the means to do battle with time, the tools to resist erosion: pharaoh-architect, scribe, or poet—each had recourse to a strategy that employed these means (sometimes in combination). The Egyptians were, in a manner of speaking, antiquarian arsonists, who anticipated the ruin in a monument's plans. In this way, their experience of ruins prefigures the "Ruin of Ruins" so dear to Benjamin Péret: "Pursued by a thousand phantoms, man runs screaming from a castle of unforgettable shadows which will haunt him all his life until, dead, he will be shut up in another castle, a ridiculous scarecrow built to the measure of the worm which will devour him. Behold man, a phantom to himself and a castle haunted by his own ghost. No matter how far back in history one looks, no matter how young in years he is, man's desire takes the form of a house: be it a cave fought over with a bear, or a tiny construction of which memory will preserve only a youthful image."[19] Péret does not cite the pyramid in his essay, but the cave is the counterpart of the pyramid: both tomb and text, sprawling architecture and scale model, futurist construction and ruin. Péret's text established an almost Egyptian relationship between the castle in which man lives and the tomb which marks his final end. Every castle is destined to become a tomb, and every tomb is forgotten.

The Future Is Behind Us

The rulers of the great empires experimented in various ways with techniques of preserving, conserving, and exalting memory. Next to Egyptians, the Mesopotamians

and Chinese are good examples, but their contribution is through those ways and means specifically for establishing links between their power and memory. "Oriental despotism" is thus a vast testing laboratory for memory, and a social regime which lends itself more than others to memorial strategies. Not that we should deny prehistoric peoples the concern for memory, but without resorting to the poetic, we have very poor means at our disposal to reconstruct the techniques they used.

The Mesopotamian rulers were thus no less antiquarians than the Egyptians; like them, they established an equation between the sovereign and the builder, but they replaced stone with brick. Like the Egyptians, they had recourse to writing as a means of communication between generations, and they encouraged the growth of a scholarly culture that required recourse to tradition, to earlier texts, even to the knowledge of the ancients. The Babylonian ruler was by definition a builder. Sylvie Lackenbacher has demonstrated that the relationship between the king and his constructions was necessary to deal with the rapid destruction of brick architecture: temples and palaces had to be periodically reconstructed, and this reconstruction was both a pious and a political act. The reverence of the rulers of the present toward the rulers of the past requires a cultural continuity, a capacity to decipher ancient writings down through centuries and even millennia. The process of construction is thus a process of reconstruction: traces of ancient temples and palaces must be found in order to build new ones that are both identical and different—identical in spirit, because neither the king nor his artisans cared for stylistic verisimilitude. It was the intent that counted, not the resemblance: "The memory of the monument became more important than the monument itself, whose existence was not linked to its concrete form: the idea gained ascendancy over a fleeting reality."[20]

The pharaohs responded to the challenge of erosion by the sheer mass and solidity of their constructions. The Mesopotamian sovereigns imagined another solution: that of organizing the memory of the refoundation of their monuments by means of the bricks of foundations, through dedicatory inscriptions systematically produced at the construction of their edifices. Of course, the pharaohs did not hesitate to glorify themselves through inscriptions about their works, but the Mesopotamians went much further by creating a formula for the ages that stressed their piety, their grandeur, and the continuity which they established between their predecessors and successors. The tale of the construction is a literary and poetic genre which Benjamin Péret does not spurn: "Nothing of our collective childhood is to be disowned, except for those societies which

have become unworthy, and glorify it in order to better disown it. Mussolini celebrated ancient Rome, even though his actions were in opposition to the progress that Rome had brought to the world. Stalin sought to make of Lenin a dead ruin in order to better betray him. It is the same everywhere. Ruins are disowned by those whose lives are already nothing more than ruins, of whom nothing will remain except the memory of some spit."[21]

The memory strategy of the Mesopotamian rulers raises an idea very close to that of Péret. It consists in domesticating the past but within the limits of continuity: the ruler may be conceited or a liar; he knows that the tablet or brick laid in the base of the foundation will, some day, be read by another, in the same way that he deciphered those of his predecessors. And he knows from experience that the piety of those that come after will in reality be the continuation of his own. Hence the grandiloquence of the formulaic style that contrasts with a certain sobriety and concern betrayed by the magic incantations. Whoever does not respect the work of his predecessors will find that the gods will avenge his impiety.

These foundation declarations consisted of a formula which each sovereign could freely adapt as long as he respected the rules. Sennacherib (704–681 B.C.) did not hesitate in naming his new palace at Ninevah the Palace Without Peer. The phrase neatly expresses the idea of continuity and competition which is at the heart of this type of action: a balance must be found between tradition and creation, and the Palace Without Peer—which invokes the names of its predecessors and at the same time boasts of the sumptuous achievements and innovations of Sennacherib—is the most perfect example of this.[22]

We should not therefore be surprised at the role of antiquarianism in Mesopotamian culture. It was not simply idle curiosity about the past, but one of the strongest components in an ideological system that established fairly specific rules between past and present. Elena Cassin has called attention to the fact that in Akkadian, the term used to designate the future is *warkatu,* which means "that which is found behind one's back."[23] Conversely, the term for "in the past" was formerly *pananu,* a root which means "facing" or "in front." Spatial concepts are employed to designate the past as much as the future. The future is that which is behind you, while the past is there before your eyes.

Kings and scribes kept their gaze turned toward the past. It is this contemplation that gave them leave to both build new cities and write, in appropriate terms, texts about the greatness of the present moment. Stefan Maul has emphasized this singular dimension of Mesopotamian thought that finds equal expression

in social attitudes, constructions, and inscriptions: kings were the issue of "eternal seed," "precious seed from before the flood."[24] The texts describing their deeds are written in an archaic language that imitates ancient inscriptions. Assurbanipal boasted of being able to decipher inscriptions "from before the time of the flood." The king and his scribes had to master the literary tradition, and the artisans had to be capable of identifying the traces of ancient temples in order to be able to re-build them. The antiquarianism of rulers was not, therefore, merely a question of style. It led them to uncover the temples and palaces of their predecessors, to lo-cate the ancient foundation tablets and to decipher them. Antiquarianism, as in fifteenth-century Rome, was an auxiliary to the art of building—more than a means, it was a necessity evident in numerous inscriptions, including the foundation brick of Ebbabar of Larsa, which gives us a glimpse of the extraordinary research into the original temple whose foundations go back to Hammurabi himself.[25] In addi-tion, one can see the development, particularly under the Assyrian empire in the first millennium, of various forms of historical and antiquarian curiosity. The kings had the ancient inscriptions assembled, they set up libraries in their palaces, in-cluding one that the excavators of Babylon somewhat hastily named a museum: a part of the palace where thirty-three objects of various epochs were found. These included a statue of Mari, a Hittite inscription, and a stele of Darius the First. Egipar, the great sanctuary of Ur, possessed a similar collection.[26] This royal cu-riosity goes hand in hand with the interest of the scribes, who displayed their interest in ancient inscriptions in various ways, whether by making impressions of them, recopying them or translating them into modern language.

Like the Egyptians, the Mesopotamians knew how to deal with the chal-lenge of time: they invented similar memorial practices by developing the art of the scribes and philological knowledge. However, when confronted with more fragile building techniques, they were innovative, using the same clay that was used to build their palaces and sanctuaries. Faced with immense walls and with raised zig-gurat, miniscule tablets and bricks were witnesses to the sovereigns' desire for eternity and to the humble and persistent curiosity of the scribes. Like small bottles thrown into the sea, the countless tablets sought a way to transform weakness into strength. The humble scribe could make himself heard at the same time as the king: "Man is a hermit crab, who sees in life only the ruin wherein he hides that animal nature which he tries to deny. But the animal transforms itself. From a tiger, he becomes a wolf, and from a wolf he changes to a dog. A dog born of a dog barely recognizes the ruins of the wolf, but those of the tiger are no more to him than a footprint in

the sand, that sand which has forgotten the ruins, their pitiful images which he fails to understand."[27] The long chain that connects men together is fragile and difficult to preserve. Each one attempts to do so according to his own aims and by his own means; each is part tiger, part wolf, and part dog, because nothing can guarantee the continuity of memory and the respect for memory.

Francis Ponge, like Péret, used the metaphor of the shell to explain the metaphor of ruins: "The monuments of men resemble parts of his skeleton, of any skeleton, of large bones stripped of flesh: they do not conjure up their former inhabitant. The biggest cathedrals release only a shapeless throng of ants, and even the most sumptuous villa or castle made for a single man can be compared more to a beehive or an anthill with its many compartments, than to a shell. When the lord leaves his dwelling, he makes less of an impression than when the hermit crab allows his claw to be glimpsed at the mouth of the magnificent cone which is its home."[28]

The monument is a precaution against forgetting, but its very excess has something of the ridiculous about it; it will be the home of someone different from those who designed and built it, and those who will dwell in it when it has become a ruin will not even have the smallest idea of the existence of its builders. Diderot displaced the poetics of ruins from the past to the future: Péret and Ponge go even further, and perceive in the monument the ruin that is to be. It is no longer the builder's desire for immortality that interests them, but the pathetic fragility of this ambition over the course of time. Shells are more modest, as they are content to offer shelter to small crustaceans.

The Great Wall, Books, and Bronze Vessels

Along with the Egyptians and the Mesopotamians, the Chinese made their contribution to the practices of social memory and antiquarian wisdom. This is because, like the others, they were ruled by emperors, and part of the emperor's role was to be a builder. The most beautiful contribution of the Chinese to this chapter of intellectual history is told to us by Sima Qian, a historian from the end of the second century B.C. It recounts the decision of Qin Shi Huangdi—the ruler who united China in the third century B.C. and named himself the first emperor—to construct a tomb for himself unlike any other: "a tomb without rival" like the palace of Sennacherib.[29] This tomb—an artificial mountain—consisted of a sort of giant map of the empire, complete with its flowers, forests, villas, and palaces: in short, the final dwelling place of the emperor was the microcosm of his own empire. Jorge Luis Borges, who was an admirer of Qin Shi Huangdi, never wrote about this monu-

ment, but he was interested in the activities of this sovereign who was both builder and founder. He wrote a short essay, "The Great Wall and the Books," about this personage who, according to tradition, ordered the construction of the Great Wall and had all the books burned. Borges expressed this parabola of destruction and conservation, this relationship between power and memory, and put these words in the emperor's mouth: "Men love the past, and against this love I can do nothing, neither I nor my executioners, but one day there will come a man who will feel as I do, and this man will destroy my wall as I destroyed the books, and he will erase my memory and he will be my shadow and my mirror and he will not know it."[30] In his commentary Borges elucidates the essential relationship that power has established between the book and the monument. Both occupy a strategic place in a learned and imperial society because they are, to various degrees, the guarantors of memory. In the interpretation of Borges, Qin Shi Huangdi's program is a coherent one: leaving a trace in the soil and burning the books are two sides of the same project—that of resistance to oblivion, of stopping time. At the time of Borges's essay, in 1950, archaeologists had not yet begun to excavate the great Xian tumulus that yielded, at the tomb's periphery, its extraordinary army of buried warriors. Their presence attests to the accuracy of the account of Sima Qian, but to a certain degree, in the "Universal History of Infamy," published in 1954, Borges had anticipated it. He imagined a group of cartographers of a vanished empire who draw up more and more precise maps of greater and greater scale until they create an expanded map the size of the empire itself. The map is abandoned and becomes a ruin inhabited by animals and beggars who, like the dogs of Péret, do not know where they are dwelling.[31] The first emperor, in his desperate search for time and space, discovered the substance of Borges's premonition. The map that covers the territory is the most complete expression of the control of the center over the periphery, of power over society, of desire for eternity over the fragility of memory. The Chinese were more sensitive to this contradiction than other societies: the empire needs memory, and it must tame it if it resists. This idea no doubt explains the determining role that antiquarian practices played in the ancient Chinese civilizations. The emperor, the princes, and the scribes had need of the past. The proto-historic bronze Chinese vessels known as *liqi* are important tools in the search for the past. These vessels not only possess the particularity of existing in several dozen well-known styles, they are also inscribed. Here again, the treatment and deciphering of the writing contributed to the political and religious efficiency of antiquarian knowledge. A story, again attributed to the first emperor, attests to the role of these objects in Chinese tradition.

In 219 B.C. Qin Shi Huangdi attempted to gain possession of the Nine Tripods[32] cast by the legendary first Xia dynasty (first quarter of the second millennium B.C.), which symbolized the alliance between gods and sovereigns. He was told that these *ding* vessels had been seen at the bottom of the river Si. An underwater archaeological expedition was mounted using, according to Sima Qian, a thousand men. When one of the tripods was found and was being hauled out of the water, a dragon rose up and cut the cord holding it—a bad omen for the king. The incident seemed so portentous that quotations from Sima Qian were reproduced in a series of funerary chambers from the second century A.D. For Chinese scholars, the search, unearthing, and identification of these vases was as much a matter of passion as a necessity. For if these bronze vessels were useful to the emperor to affirm his power, they were desired by princes, governors, and other powerful figures for the same reason. Jessica Rawson has shown how, over the course of Chinese history and the various dynasties, *ding* vessels remained objects of desire, distinction, and even legitimizations of power.[33] In order to find, authenticate, and interpret them, specialists were needed who could create typologies, draw up catalogues, and develop collections. Under the Song, this antiquarian curiosity reached its height with the writing and printing of the first catalogues of antiquities. This type of approach clearly profited from the expansion of historical research under the T'ang dynasty (seventh to tenth centuries A.D.), and the creation of records of the court and the first official historical offices.[34]

One might think that the Chinese science of antiquities was the result of a utilitarian vision of the past which was used as a tool for social order. One only needs to read, however, the marvelous essay by Stephen Owen to discover that the antiquarians and the poets did not neglect what we call the poetics of ruins.[35] Ruins in a Chinese context were not so much monuments as fortuitously discovered objects found during excavations or collection-oriented research. For the poets, invoking the past was an occasion for a dialogue with a personal dimension, but at the same time the ancient tombs are described in quasi-archaeological detail as in the poem by Xie Huilian, from the fifth century A.D.[36] "The Song of an Arrow Point from the Battlefield of Chang-Ping" by Li Ho (A.D. 791–817) reveals the same poetic curiosity for a past that is brought to life by a nearly anatomical attention to detail:[37]

> Lacquer ash, powder of bone,
> pebbles of cinnabar:
> In the cold shadows, the ancient blood

makes flowers bloom in the bronze.

white feathers and far-flung shafts

have disappeared in the rain,

and all that remains

is this wolf's jaw broken in three.

I came as a seeker to this peaceful plain

leading my pair of horses;

across the fields of stones east of the fortification

to the foot of a slope covered in wild grass;

the day's light begins to fade, the wind persists,

the stars hang shimmering,

banners of rain-soaked black clouds drape themselves

in the empty evening sky.

To my right and left their ghosts

sob, starving and thin.

I pour a jar of cream in libation,

I have brought a lamb to roast it;

The insects arrive, the wild geese take flight,

broken-hearted,

sprouts of reeds turn red once again,

spirals of wind push the traveler on his way

breathing their fiery shadows.

A seeker of the past, with tears streaming

I pick up this worn-out arrow,

whose broken point and its red-brown cracks

once drove straight into flesh.

In a small southern street in the eastern quarter of the capital

a boy on a horse

tries to persuade me to trade the metal

for an offering basket.[38]

Stephen Owen insisted on the poetic construction of this poem, which departs from the factual experience of the discovery of an arrowhead, on the site where the armies from the state of Zhao were defeated by Qin troops, in order to establish a poetic and emotional relationship between the present and the past. At the site, the visitor at first sees only fragments, decomposed and decayed. But the

material lives, the ancient bronze is swollen with blisters: "bronze flowers." Seen at closer range, these fragments make sense, the arrow is the sign of combat, the ruined symbol of a fatal object which pierced living flesh, destroying life. From the clinical presentation of an antiquarian context, the poet then passes to the description of the frozen scene of the discovery. It is nature itself which, in this sinister place, mourns the departed. The antiquarian poet is called by the ghosts to come to their aid. It is because he is a pious and compassionate man that he can "harvest the arrow," the "seeker of the past" being like the peasant who must harvest his wheat which grows on ancient sites. The lost object becomes an archaeological vestige: the young man who offers to trade for the arrowhead is the counterpart of the antiquarian and his double—the exchange is the final echo of forgetting, and objects of collection are no longer memories.

Li-Ho, like Diderot, tells us that memory is not the ruin, and the cult of memory is not archaeology. The ruin as archaeology (understood here as an antiquarian practice) requires psychological and intellectual systems, without which it is impossible to "bring the past to life," according to Casaubon. Egyptians, Mesopotamians, and Chinese each invented for themselves social means for resisting the erosion of memory. These systems can take the form of monuments, objects, or texts, but they all require a questioning and a distancing of the past. All men have memories, all societies have memories, but some men and some societies develop techniques of remembering that transform their memories into ruins—objects that allow exploration of the past because they agree to represent it. This is why the poetics of ruins is inseparable from their construction. Even if the poetic discourse is hidden beneath the austere learning of the antiquarian, it is always present from the moment the object or monument attracts our curiosity. They are—by the various methods of extraction, copy, and identification—detached and decontextualized to allow for interpretation. The antiquarian responds to the desire for eternity of the pharaoh, to the scribe's curiosity, and to the poet's hunger for fame. He opens the bottle thrown into the infinite sea of history, and when he pulls the cork it is not a genie who appears, but the fragrances of time past. Certainly the poetry of ruins is a rather refined genre which has had its ups and downs, but the poetics of ruins is present wherever there are ruins; that is, not only vestiges and traces, but infinitely large and infinitely small ensembles, which antiquarians of all persuasions transform into ruins.

Mesopotamians and Chinese see in the soil a means of communication between generations: the kings which restored the temples or built palaces, the

priests which look for the figures of the ancient gods, the scholars who stamp inscriptions or collect vases—all of them participate in the type of curiosity which transforms the soil into a history book. It is not a question of treasure hunting, but a quest for symbols. In the Tibetan medieval tradition, the "hidden teachings" and their discoverers play a fundamental role in the creation of theological learning. The Tibetans call treasures, gold or silver jewelry, and religious objects *gter*. By extension, the term *gter-ma* means a religious text that has been hidden by a master during the period when Buddhist missionaries penetrated Tibet, and which is found by a pious man who was predestined to discover it.[39] These texts, hidden in the floors of temples, were usually announced by prophesies. There are three types of *gter*: "the book concealed in the earth"; "the book twice hidden," a book was discovered a first time and then reburied to be found a second time; and finally "the concealed teachings perceived in meditation."[40] The transmission symbolism is clear. These texts contain a spiritual power that passes down through the generations, from master to master. But why resort to burial instead of depositing them in a religious library? Hiding texts in the soil seems to me a sort of magic ritual. The texts may become lost, or their meanings may become obscure to contemporaries. Burial is a call to the future, the surety of a choice that guarantees its discoverer will gain access to wisdom, but at the same time assures the book's author that it will fall into the hands of one equally learned and pious. Down through the generations an invisible group of pious, learned men is formed. The "books twice hidden" are the quintessential manifestation of this procedure; their discoverers, twice inspired, could only become more learned. The virtue of "the concealed teachings perceived in meditation" lies in the same fact of being hidden; they are wedded by their very nature to works hidden in the earth, but represent a more refined form of them. "In this vision the future discoverer of Concealed Books revives a mystic empowerment that enables him to study the tantric cycles."[41]

The Tibetans perceived a theological component to the burial of books in the earth: to prevent the erosion of time, they organized a series of cycles that combated it by symbolic as well as material means. The books of the third group did not need to be placed underground because they were the symbolic product of the previous burials. It is not a question of pure theological speculation: books that had been buried in temple floors were actually discovered. But the symbolic development of this cycle of burial and rediscovery reveals a very singular path—very much Tibetan—to the various strategies of memory: if everything is destined to end up in the earth, the best means to outstrip the contradiction between the work

and time is to turn even the tools of erosion against erosion itself. Time, which erases everything, is erased by the burial of books in the earth. These books, buried like the tablets of the Mesopotamian kings, are more resistant than the constructions and more protected than in the heart of the rarest libraries.

Antiquarians and History

The Greeks and Romans had their antiquarians, just like the ancient Eastern sovereigns. But all that remains of them, even the most renowned, Varro, is empty shells. The countless works that discussed manners and techniques "whether it was about the constructions of man, their sites, their location in the city, all of the elements of which human life and the cult of the gods is made,"[42] according to the definition given by Cicero, all that remains is titles or chapter headings. In a certain way, it is more difficult to reconstitute the world of the Greco-Roman antiquarians than that of the rulers of ancient Asia. We know the titles of some of their works, we understand the role which they assigned to descriptions of former edifices, to the interpretations of inscriptions and to the collecting of objects attributed to heroes or to peoples of former times. But no antiquarian treatise has, properly speaking, survived. There is a simple explanation: in the fifth century B.C. Herodotus invented a new method of presenting the past that freed itself from royal annals and genealogies—the *Histories.* This implies inquiry in the etymological sense of the word *Historia,* but it goes much further than the presentation of texts—ancient though they may be—and the gathering of moving and prestigious objects and monuments. It expounds a desire to examine behaviors, classify actions, and reflect on causes—a desire that breaks free from labored didactics and antiquarian curiosity. The invention of history did not signal the end of the antiquarians; on the contrary, it stimulated their curiosity and helped open new paths to knowledge about monuments and objects from the past. But in Greece as well as Rome, the historians took center stage; it was their works that were copied which elicited the admiration of scholars. The heavy catalogues of the antiquarians met the same fate as much of the literary production from antiquity: oblivion. They thus vindicated those in Egypt and Greece who challenged the ascendancy of stone over text. In terms much like those of the poets of Egypt, Pindar wrote: "I am not a sculptor; I do not carve figures that stand, unmoving, on their bases. No! Whether it be bark or merchantship, let the first vessel which sails from Egine take you, oh my sweet song."[43]

The poem, unlike the statue or monument, does not stand motionless on its pedestal but, carried by man, passes from hand to hand, in defiance of space

and time. Because the poem does not age like marble or stone, it speaks to men down through the generations.[44] This lesson is surely that of the bards from every corner of the earth and every epoch who freed themselves not only from stone and brick, but also from the servitude of the scribes and the poetry of ruins—since even their poems are, in the sense of Péret, ruins.

Translated from the French by Mark Carlson.

1. Roland Mortier, *La Poétique des ruines en France* (Geneva: Droz, 1974).

2. Ibid., 9.

3. Herodotus 1.68.

4. Ausonius, *Epitaphia Heroum,* book 32.

5. Méric Casaubon, *Treatise of Use and Customs* (London, 1638).

6. Alain Schnapp, *The Discovery of the Past* (New York: Abrams, 1997), 405.

7. For more about this personage, see the article by Sydney Aufrère, "Les Anciens Egyptiens et leur notion de l'antiquité, une quête archéologique et historiographique du passé" (forthcoming).

8. Ernesto Scamuzzi, "Fossile eocenico con iscrizione geroglifica rinvenuto in Eliopoli," in *Bolletino della società piemontese di archeologia e di belle arti,* n.s., 1 (1947): 11–14. I would like to thank S. Aufrère for bringing this document to my attention.

9. Jan Assmann, *Mensch und Gesellschaft im alten Ägypten* (Munich: Fink, 1995), 11.

10. Maya Müller, "Die Ägyptische Kunst aus Kunsthistorischer Sicht," in Marianne Eaton-Krauss and Ehrart Graefe, *Studien zur ägyptischen Kunstgeschichte* (Hildesheim: Gerstenberg Verlag, 1990).

11. P. Leiden 5.1, trans. Kruchten, 110–112 (18th Dynasty), in Jean Marie Kruchten, "Un Sculpteur des images divines ramessides," in *L'Atelier de l'orfèvre: Mélanges offerts à Ph. Derchain,* ed. M. Broze and Ph. Talon (Leuven: Peeters, 1992), 107–18; Philippe Derchain pointed out this text to me.

12. Pierre Barguet, *Le Livre des Morts des anciens Egyptiens* (Paris: Cerf, 1967), 1:104–5. On this text, see Aufrère, "Les Anciens Egyptiens et leur notion de l'antiquité."

13. Barguet, *Livre des Morts,* 56. See Aufrère, "Les Anciens Egyptiens et leur notion de l'antiquité."

14. P. Chester Beatty 4, verso 2, 5–3, 11, quoted in Assmann, *Stein und Zeit,* 173.

15. Jesper Svenbro, *Phrasikleia, anthropologie de la lecture en Grèce ancienne* (Paris: La Découverte, 1988), 53: "At the moment of reading, the reader finds before him a text in the absence of the writer. In the same way that he foresees his own absence, the writer foresees the presence, before the reader, of his writing. The reading is the meeting between reader and the written trace of one who is absent."

16. Diodorus of Sicily, 1.51–52.

17. London Pap. Harris 500, in Assmann, *Stein und Zeit,* 215.

18. Mortier, *La Poétique des ruines,* 9.

19. Benjamin Péret, "Ruines: Ruine des Ruines," *Minotaure* 12–13 (1939): 57–61B.

20. Sylvie Lackenbacher, *Le Palais sans rival* (Paris: La Découverte, 1990), 183.

21. Péret, "Ruines," 59.

22. Lackenbacher, *Le Palais sans rival,* 120.

23. Elena Cassin, "Cycles du temps et cadres de l'espace en Mésopotamie ancienne," *Revue de Synthèse* 55–56, no. 90 (1969): 242–43; see also *Chroniques mésopotamiennes,* ed. and trans. Jean-Jacques Glassner (Paris: Les Belles Lettres, 1993), 19–47: "L'Avenir du passé."

24. Stefan Maul, "Die Altorientalische Hauptstadt. Abbild und Nabel der Welt," in *Die Orientalische Stadt, Kontinuität, Wandel, Bruch,* ed. G. Wilhelm (Saarbrucken: Saarbrucker Druckerei und Verlag, 1997), 109–24.

25. Schnapp, *Discovery of the Past,* 18–22. For other versions of this text see S. Langdon, *Die Neubabylonische Königsinschriften* (Leipzig: Hinrichs, 1912).

26. Glassner, *Chroniques mésopotamiennes,* 31; Paul Alain Beaulieu, "Antiquarianism and the Concern for the Past," *Bulletin of the Canadian Society for Mesopotamian Studies* 28 (1994): 37–42.

27. Péret, "Ruines," 57.

28. Francis Ponge, "Notes pour un coquillage," in *Le Parti pris des choses* (Paris: Gallimard, 1967), 75. My thanks to Jesper Svenbro for having brought this text to my attention.

29. *Les Mémoires historiques de Sima Quian,* trans. Edouard Chavannes (Paris: Librairie d'Amèrique et d'Orient, 1967), 193–95.

30. Jorge Luis Borges, "Autres inquisitions," in *Oeuvres complètes* (Paris: Gallimard, 1993), 1:673.

31. Jorge Luis Borges, *Histoire universelle de l'infamie,* in *Oeuvres complètes* (Paris: Gallimard, 1993), 1:1509.

32. On the role of these tripods in Chinese tradition and the idea of the monumental in China, see Wu Hung, *Monumentality in Early Chinese Art and Architecture* (Palo Alto, Calif.: Stanford University Press, 1995), particularly the introduction, "The Nine Tripods and Traditional Chinese Concepts of Monumentality," 1–17.

33. Jessica Rawson, "The Ancestry of Chinese Bronze Vessels," in *History from Things, Essays on Material Culture,* ed. Steven Lubar and W. David Kingery (Washington, D.C.: Smithsonian Institution Press, 1993), 51–73.

34. Denis Twitchett, *The Writing of Official History under the T'ang* (Cambridge: Cambridge University Press, 1992).

35. Stephen Owen, *Remembrances: The Experience of the Past in Classical Chinese Literature* (Cambridge, Mass.: Harvard University Press, 1986).

36. Ibid., 38–41.

37. Ibid., 70.

38. Ibid.

39. Eva Dargyay, *The Rise of Esoteric Buddhism in Tibet* (Delhi: Motilal Banarsidass, 1977).

40. Ibid., 63.

41. Ibid., 65.

42. Cicero, *Academica*, 1, 3.

43. Pindar, *5th Nemean Ode*, verses 1–5.

44. Pindar, *6th Pythian Ode*, verses 1–17. See Svenbro's commentary in "La Parole et le Marbre, aux origines de la poètique grecque" (thesis, Lund University, 1967).

Pre-Histories of Art in Nineteenth-Century France:
Around Paul Delaroche's *Hémicycle des Beaux-Arts*

Stephen Bann

On 21 June 1843 Jacob Burckhardt wrote from Paris to Willibald Beyschlag: "If you visit Kugler, tell him that I have not yet been to Delaroche, but will be going along in the next few days."[1] Whether or not this implied calling on Delaroche personally or paying a visit to his most recent and celebrated work, the *Hémicycle des Beaux-Arts,* opened to the public at the École des Beaux-Arts just two years previously, I am not entirely sure. But I am quite certain that if a visit to the artist himself was being proposed this was largely because the fame of that work had so rapidly spread beyond the French borders (fig. 1). Franz Kugler himself took the opportunity of his fact-finding artistic missions throughout Europe in 1845 to see Delaroche's vast wall painting for himself, and gave more sustained attention to it than to any of the other major works that he observed in Paris. Taking as his comparison the

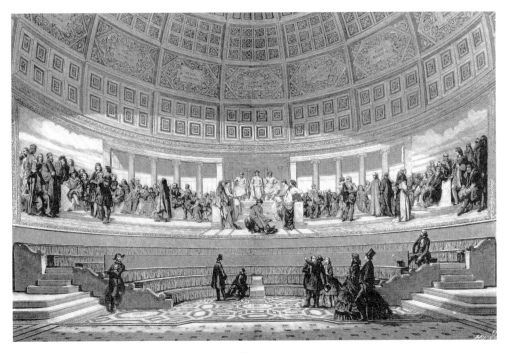

Fig. 1. Paul Delaroche (French, 1797–1859), *Hémicycle de l'École des Beaux-Arts,* 1837–41. Woodblock engraving after drawing by M. A. Marc

Fig. 2. Louis Pierre Henriquel-Dupont (French, 1797–1892), burin engraving, 1853, after Paul Delaroche, *Hémicycle.* Central print of three showing Ictinus, Apelles, and Phidias seated at rear

evident similarity to Ingres's *Apotheosis of Homer* (1827), he praised Delaroche's "wonderfully beautiful general effect" ("wunderbar schöner Gesammtwirkung").[2] Making a direct comparison with Ingres, he concluded: "in the truth, strength, beauty and largeness of life ("der Wahrheit, Kraft, Schönheit und Grösse des Lebens") here everything is achieved that is missing in the other."[3]

Despite his expressed intentions, Burckhardt evidently did not respond to Kugler's eager promptings by visiting the *Hémicycle* on his 1843 trip to Paris. Much later in his correspondence, we learn that he did in fact see it for the first time as late as 1860, when he would doubtless be familiar with its overall aspect from the widely diffused tripartite print by Louis Henriquel-Dupont, published in 1853. Burckhardt's first reaction, as he confessed later in a letter to Max Alioth, was to acknowledge Delaroche's immense superiority over the German historical wall paintings produced at least partly under his influence. Specifically referring to the *Reformation* painting of Wilhelm von Kaulbach, Burckhardt exclaimed:

"What an enormous *social* superiority the Delaroche has! In what an unaffectedly good and lifelike way ("welcher ungezwungenen guten Lebensart") the whole company sits and stands together."[4] Earlier in the same exchange of letters, Burckhardt had particularly praised the "supreme tact" with which Delaroche had negotiated the inclusion of the idealized figures of Ictinus, Apelles, and Phidias into the colorful array of "artists of all ages" (fig. 2): "if he had wanted to give only a little bit *more,* then it would have been *too much,* since the placing right in the background is only the middle of a frieze . . . a full Olympus, in which he would have wanted to bring others in, would have let the style down completely."[5]

I use these brief quotations spanning the middle years of the nineteenth century to indicate that two of the most crucial figures in the development of German art history were both openly admiring of—and one might say fascinated by—the effect of Delaroche's *Hémicycle*. Now it is not at all original to argue that Delaroche's historicizing spectacle was widely admired and copied throughout Europe in the later part of the century, spawning a large series of related projects that range from the frieze around the Albert Memorial to Nicaise de Keyser's works at Antwerp and Nice and Vojtech Hynais's in the opera house at Prague, let alone Wilhelm von Kaulbach's at Munich and Berlin.[6] But I intend to use this opportunity to begin a rather different argument. Given that the history of art was not at this stage an institution—given that it is precisely such figures as Kugler and Burckhardt who may be credited with helping it to become one—it is worth asking what such a project as Delaroche's may tell us about history of art's coming into being. There is clearly one important respect in which this question is justified from the start. As Michael Ann Holly has argued, there is ample evidence to suggest that the historians who engendered art history felt themselves obliged to prefigure the historical field in the form of a picture. I quote: "An historical text is like an historical painting executed in perspective. Certain subjects and figures should be highlighted; others should more properly retreat into the shadows."[7] We have already seen how Burckhardt's praise for Delaroche's "supreme tact" depended specifically on his judgment about the quantity and arrangement of figures at the focal point of a large composition. I am suggesting that there is a special significance in attributing such skill and discretion to a contemporary who was, after all, in an important sense also concerned with prefiguring a history of art. In other words, Burckhardt might well have devoted his time principally to the great masterpieces of the Renaissance, such as Raphael's *School of Athens*. But the fact that he, and indeed Kugler before him, detected comparable achievement in the visual

Gesamtwirkung of a work by a contemporary bearing precisely on the visualization of the "artists of all ages" is an indication of a different order if we are concerned with analyzing aspects of the pre-history of the history of art (fig. 3).

This reference to pre-history of the discipline leads me, however, to make a very brief explanation of what I imply by such a term, apart from mere temporal priority. In fact, my theoretical model here is borrowed very broadly from psychoanalysis, and from the concept adapted from Edward Glover by Melanie Klein that the ego being "at first but loosely organized, consists of a considerable number of ego-nuclei."[8] It takes no great stretch of the imagination to think of a discipline in terms of a collective ego, and no special pleading to assert that the ego of art history has been, very specifically, a German ego, surviving even now in an archaic and possibly persecutory form. What interests me here, however, is precisely the diverse typology of structures of authority vested in the different attitudes to the history of the visual arts before the discipline was finally organized. Before there was art history, there were, evidently, different claims to authority in representing the history of art. Not only do these bear a clear relevance to the situation that we face today when the authority of the discipline can no longer be seen as monolithic. But one might say that through the seemingly inevitable process of deconstruction to which it is subject, many of the original "nuclei" present before its formation come into focus once again.

Fig. 3. Louis Pierre Henriquel-Dupont, burin engraving, 1853, after Paul Delaroche, *Hémicycle.* Right print of three

I want to argue for giving the French tradition a special place in this type of investigation, precisely because of the sharp contrasts that it presents with the case of Germany. It is often said that Marxism was a German theory about French revolutions. I am not going to suggest for a moment that historians like Burckhardt and Kugler were fixated specially on France. But it is surely true that precisely because of the extreme breadth and diversity of French artistic culture, and the diverse institutions vested with authority over different aspects of it, the development of art history in France followed a path quite different from that in Germany. One has only to read Lyne Therrien's illuminating account of the history of art in France to recognize the extraordinary richness of the tradition, but at the same time its propensity to division and fragmentation, with such bodies as the École des Beaux-Arts, the École du Louvre, the Collège de France, and the Sorbonne all presenting distinct claims to intellectual authority.[9] The loss that resulted, in my view, was that during the very period when German art history was acquiring its disciplinary primacy, French art history was overtaken by a major reconceptualization of the relation of past to present that sacrificed crucial aspects of its own artistic tradition to the ideologies of modernism.

I think it may be possible even to pinpoint the stage at which this reorientation took place. In 1893 Henry Lemonnier, a former student of the École des Chartres and professor of history at the École des Beaux-Arts from 1874 to 1881, became the first historian to be entrusted with a course in the history of art at the Faculté des Lettres of the University of Paris.[10] Six years later, in 1899, he was appointed to the first chair of history of art to be created in France. Lemonnier was soon joined by Emile Mâle, who taught a course in the history of Christian art, and succeeded him in his chair when he retired in 1912. At this point, there was a dispute about who was to succeed Mâle, which brought into the limelight the brilliant young historian of modern art, Léon Rosenthal. Rosenthal was rejected, partly on the argument proffered by the philosopher Gabriel Séailles that "the teaching of the history of art should be something concrete" and that it should be integrated with both the study of museum objects and with the newly available image documentation through photography.[11] However Rosenthal became professor of history of art at the École normale supérieure in 1912, and two years later published the book that succeeded in entrenching an extraordinarily tenacious orthodoxy about the development of French art in the nineteenth century: *Du Romantisme au réalisme. Essai sur l'évolution de la peinture en France de 1830–1848.*

It is not my intention to fault the strategy of this highly persuasive text, which in effect eliminates from serious discussion virtually all the academic painting done in France in the second quarter of the nineteenth century, and favors only those artists admitted to the fold by the pungent but highly selective criticism of Baudelaire. Nor do I want to spend time on repeating the argument that has already been clearly rehearsed in Michael Marrinan's introduction to the reedition of Rosenthal's text in 1987: that it relies heavily on contemporary artistic statements of the primacy of *facture* such as Signac's *D'Eugène Delacroix au néo-impressionisme.*[12] What does concern me, however, is the effect of this retrospective reading of history on our understanding of the historical intuitions of the Romantic generation, which contrasts so strikingly with the engaged interest of the German art historians mentioned at the outset. Significantly, it was with regard to Delaroche's *Hémicycle* that Henry Lemonnier, by then in retirement, published an article in 1917 that openly stigmatized the adversarial approach developed by Rosenthal, and commended the work in terms that seem appropriately historicist. When reading this moderate plea for historical objectivity, one must also remember that it passed unheard, if we reckon that nothing of interest would be written on the *Hémicycle*, or any other work of Delaroche, for more than half a century:

> Let us not allow ourselves to be caught up in certain scornful tendencies of today. We are well aware that the work does not have certain qualities that we have a taste for, and which are extolled in an exclusive way by some people. But why not acknowledge its clever composition, the fine way in which it holds together, the harmony and happy equilibrium of the painting with the architecture of the room, and, above all else, I know not what atmosphere of calmness in which the scene is enveloped, what serene dignity which magnifies the personages and raises them from reality to the level of history.[13]

I would point out just in passing the interesting connection with what Kugler and Burckhardt saw in the work, and the fact that all three art historians view the pictorial achievement of Delaroche as, in some important sense, being measured by the degree to which history itself is prefigured and represented through the manifestation of aesthetic qualities that are described as if they also had an epistemological function. What I want to go on to show is that this is not simply an effect of Delaroche's painting, but an index of a program that was itself strictly historio-

graphic in its implications and relied on a principle of historical authority that was based in the historical traditions of the French Academy. What Kugler, Burckhardt, and Lemonnier all register in their comparable ways is the result of a dialectical synthesis between tradition and innovation that was highly specific to the development of French painting in the post-revolutionary period.

It is sometimes asserted that, for Hegel, the death of art was the precondition of the rise of the history of art. Nevertheless, for the indefatigable Franz Kugler, a period spent sitting literally at the feet of Hegel does not seem to have curbed his appetite for seeing and commenting on contemporary art production wherever he could find it. On the other hand, Paul Delaroche does seem to have believed quite firmly that the succession of great art, pioneered by the Greeks and resumed with the Renaissance, had in some important sense come to an end. His close friend and biographer Henri Delaborde reported his views in this way: "The great masters have exploited the field of poetic invention with such success, that there is hardly more to be gleaned in their traces than a few scraps. From now on the harvest is over" ("Désormais la moisson est faite").[14] Yet this realization did not, of course, prevent Delaroche from being a painter. It meant, quite simply, that the focus of the new genre of painting that he projected had to shift from "poetic invention" to historicism.

The implications of this strategy had to be negotiated, however, within the context of the Académie des Beaux-Arts, and it is within this precise context that the significance of Delaroche's historicism can be clarified and given more general reference. Much of the writing on the Academy over the nineteenth century subscribes, overtly or implicitly, to what I would call the champagne cork fallacy. This is the view that there is a mass of effervescent and creative activity going on, which the Academy valiantly tries to bottle up. What such foreshortened accounts as Patricia Mainardi's *The End of the Salon* fail to recognize is the fact the struggle between conservative and progressive forces in the second quarter of the century was in fact endemic to the Academy itself, though it was by no means confined to specific issues like the composition of the Salon jury.[15] It is a remarkably little-known aspect of the period that such members of the Academy as Delaroche and his future father-in-law, Horace Vernet, were agitating for reform throughout the early 1830s, and only gave up their struggle in 1836, when both resigned from the Salon jury. The draft of the paper which Delaroche presented to his academic colleagues on 30 January 1836 shows, however, how the reform of the Salon was bound up with far-reaching questions about the nature

of art history and the authority vested in academic painting, which form the ideological prelude to the achievement of the *Hémicycle*.

Delaroche begins his paper with a highly positive note: his wish is "to see the future of the arts in our country confided to our care . . . to assure their success and to fix the path that they should follow."[16] His first proposal is that the representatives of the different arts—painting, sculpture and so on—should scrutinize and make a preliminary selection from all the works entered before the resultant choices were presented to the full jury. (This I take to be a way of avoiding the notorious abuse of the system by the architects, some of them ex-members of David's studio, who succeeded in imposing on the more liberally minded painters criteria that the latter considered out of date.) Delaroche's second proposal, however, has a practical as well as an ideological justification, since he complains that the present system of hanging the Salon in the main galleries of the Louvre each year, over several months, obliges the administration "to cover the old paintings with works which are certainly not worthy to be presented to the eyes of the public." In consequence, as Delaroche summarizes: "The respect due to the masterpieces of the great masters which compete with the Vatican in gaining the admiration of foreigners [and] the interest of the art which does not admit that young students should be deprived for a large part of the year of works whose continual study is for them so precious a resource . . . oblige us to ask the King in the interests of national glory and the consideration enjoyed by France that in future the annual exhibitions should no longer take place in the Louvre."[17]

The notion that the Louvre is in competition with other locations—or at least one of them—has apparently been added as an afterthought. Delaroche's first thoughts, crossed out in the draft, simply specified where in the museum the great "masterpieces" were hanging. But the core of the argument depends on the proposition that this unique location should be cleared of the dross of contemporary production in order that the artists of the future should not be deprived of the models for study. In that respect, the Academy commits itself again to the pedagogic function entrusted to it by the French monarchy in the time of Louis XIV, while also bringing up to date the understanding that history is the result of an implicit contract between the agents of authority and those of historiography (as emphasized by Louis Marin in his *Portrait of the King*). As Delaroche expresses it in his third proposal, the Academy should have "the means to exercise its most useful mission, that of enlightening the government on the most remarkable works of each exhibition, on the progress and vicissitudes of art whose true history would

find itself so to speak written by you [dont la véritable histoire se trouverait à bien dire écrite par vous]."[18]

One recalls here once again that art history with the sense that Franz Kugler's authority gives to it will not exist in France for another half-century—indeed Kugler's own *Handbuch der Kunstgeschichte* starts publication in 1841, the very year of the completion of the *Hémicycle*. In the absence of such an art history, Delaroche is in effect annexing the Louvre to the authoritative pedagogic function that is historically vested in the Academy, and asserting that history is the regulated transmission of the sanctioned models of the past. But it would be wrong to suppose that Delaroche was regardless of art history in a more general sense, that is to say, the well-known records of lives and doings of the great artists of the past that had survived from antiquity and been compiled afresh from the Renaissance onward. The sale catalogue of Delaroche's library, dating from the year after his death in 1856, reveals an abundant stock of books dealing with the subject, ranging from relatively modern compilations like Seroux d'Agincourt and the Abbé de Fontenay, to classicists like Félibien and de Piles, and a "rare" illustrated edition of Vasari's *Vite* from 1568.[19]

Clearly it could be said that Delaroche valued such works for their illustrations, in particular. But this is precisely the point. Sylvain Boyer has carefully studied the *Hémicycle* with a view to the contents of Delaroche's library, and has found that indeed he used Vasari's images for the representation of many Tuscan figures, such as the architects Brunelleschi and Donatello (fig. 4). But, on the other hand, he discarded Vasari's Giotto as presumably too Renaissance and preferred the earlier rendering of the painter in a Franciscan habit, which he found in the Capella dei Spagnoli of Santa Maria Novella. He also used this more contemporary source for Orcagna and Arnolfo di Cambio.[20] In other words, Delaroche appears to have been very wary of the dangers of anachronism in his selection of appropriate visual prototypes.

Curiously, this aspect of Delaroche's historicism was not really acknowledged, even by Lemonnier in his article of 1917, where Vasari's influence is recognized, but only insofar as his text bears on the criteria for the choice of the artists and architects featured. Lemonnier sees the immediate predecessor of the *Hémicycle* in Veronese's sumptuous *Marriage of Cana,* and singles out as a coloristic feature, for example, the decision to dress Raphael in white (fig. 5). In fact, it is quite true that Delaroche's early sketch for the composition depicted Raphael in a somber black robe, comparable to what he wears in Ingres's *Apotheosis of Homer.* But a small

Fig. 4. Louis Pierre Henriquel-Dupont, burin engraving, 1853, after Paul Delaroche, *Hémicycle* (detail of fig. 3). The model for Brunelleschi (seated, first left) is Vasari, while those for Arnolfo di Cambio (standing to the right) and Orcagna (seated beside Leonardo at the right edge) come from the Capella dei Spagnoli, Santa Maria Novella

drawing proves that Delaroche had actually seen the now destroyed Raphael, *Portrait of a Young Man,* then in the collection of Prince Adam Czartoryski in Paris, and thought to be a self-portrait. It is difficult to hierarchize the different possible features of this choice: the wish to vary Ingres's representation, the need for a strong color accent to offset the sobriety of Michelangelo, and the availability in Paris of this convenient historical source. But one imagines that the last of the three must have been the bottom line.

This being said, it is undeniable that, for Delaroche, the history of art is still essentially the history of the lives of the artists. It is so, not only because that is the mode in which virtually all such history has been written, from Pliny to Vasari and further. It is also the mode that fits perfectly with a pedagogic program dedicated to forming the young artists of the future. In other terms, one might say that it is a history that is by definition performative. Although it must be reconstituted with full critical awareness, it has no function higher than that which is involved in

Fig. 5. Louis Pierre Henriquel-Dupont, burin engraving, 1853, after Paul Delaroche, *Hémicycle* (detail of fig. 3). Giotto, who stands next to Poussin at the right edge, has been rendered after the portrait in the Capella dei Spagnoli. The costume of Raphael (standing at left) was altered as a result of Delaroche's study of Raphael's *Portrait of a Young Man*, which was thought to be a self-portrait

the transmission of accurate knowledge of past masterpieces to a new generation that will learn to interpret them appropriately. Here it is worth recalling Marc Gotlieb's point about the positioning of Poussin at the extreme right of the painting, where he could serve as an admonitory but also encouraging figure for the future French artists receiving their prizes in this semicircular room devised for such solemn ceremonies of initiation.[21]

Yet it would be wrong to assume that the *Hémicycle* was solely a message addressed to artists. It would be more accurate, perhaps, to say that Delaroche chose to thematize, and convert to his own, highly contested view of the future of academic painting, a popular discourse of artistic achievement—in effect, a mythology—that had come to fill the space that would later be progressively conquered by art history. One can see in one of Delaroche's earliest works this tendency to thematize a *topos* of artistic lore when in 1822 he paints *Filippo Lippi Falling in Love with His Model,* supposedly taking a prize-winning fellow pupil from Gros's studio, Pierre-Louis Roger, as his model for the handsome and bemedaled painter. If in this case Delaroche uses the *topos* to thematize romance among the young males of the studio, it also seems very possible that Horace Vernet's *Raphael at the Vatican,* shown at the Salon of 1833, was quite consciously, in the words of the critics summarized by Marc Gotlieb, "thematizing the ignoble culture of rivalry that prevailed among the old masters."[22] After all, Vernet had been pursuing his struggle with the secretary of the Académie des Beaux-Arts, Quatremère de Quincy, virtually since his arrival as director of the Villa Médicis in 1829. How could it not be significant that he chose to depict the well-reported rivalry of the Renaissance artists Raphael and Michelangelo?

Fig. 6. Frontispiece and title page from F. Valentin, *Les Peintres célèbres,* 3d ed. (Tours: Mame, 1844). Frontispiece: "Raphael exposé après sa mort dans son atelier." Vignette on title page: "Giotto dans l'atelier de Cimabue"

In this context, the *Gesamtwirkung* of the *Hémicycle,* its repeatedly noticed harmony and serenity of effect, has a distinctly utopian note to it, as if Delaroche's mission was to use the *topos* of the visualization of the artist's life not to convey a mildly subversive idea of youthful spunkiness in the studio, nor to indicate animosity among the artistic community, but precisely to show that community in the afterglow of history's equalizing verdict, as if all who had passed the test of fame were by that token in sublime and equable conversation with one another.

There is, however, perhaps another, more precise respect in which Delaroche acknowledges the popularizing discourse of art's prehistory. If one looks through a book of historical art lore like Valentin's *Les Peintres célebres,* published shortly after the opening of the *Hémicycle,* one does indeed find that art is explained in terms of a series of anecdotes and miniature biographies, beginning with the Greeks. One finds, in the humbler medium of the woodblock print, historical images that

present privileged moments in the life or death of a great artist: of Raphael exposed after his death in his studio as the frontispiece, opposite Giotto in the studio of Cimabue (fig. 6); then, one of the French soldiers invading Rome, saying to Parmigianino "Give me some of your drawings and I will save you," and Ribera tricking two would-be alchemists who visited him by selling one of his paintings for the gold that they so basely lusted after.[23] The list is not a long one, since the book is not a lavish illustrated production. But these little visualized anecdotes testifying to the power of art to overcome history's vicissitudes are supplemented by others that remain purely verbal, such as the anecdote told about the most famous antique painter of all, and the central figure of the *Hémicycle:* Apelles.

The story goes that Apelles was anxious to learn from informed criticism, and so when he finished a painting, he would exhibit it in a public place and hide nearby to hear the reactions of his fellow citizens. On one occasion, a cobbler found one of the sandals depicted by Apelles was defective, and expressed his expert view. The very next day, Apelles put the work on show again with the requisite correction. The cobbler, emboldened by his success, then took the opportunity to criticize the leg of the person depicted. Whereupon Apelles dramatically appeared from behind the painting and warned him not to push his luck: *Ne sutor ultra crepidam!* Let the cobbler stick to his last![24] I am intrigued by the possibility that Delaroche had this memorable line in

Fig. 7. Paul Delaroche, *Drapery Study for Figure of Phidias* (detail), c. 1839. Pencil on buff paper, 11 ½ × 8 ½ in. (29 × 21.5 cm). Collection of the author

mind when he gave the most sedulously detailed treatment to the sandals of his three legendary Greek artists, as can already be observed even in a preliminary drapery study for the figure of Phidias (fig. 7). There seems absolutely no reason why such a sublime situation should call for sandals; in Ingres's *Apotheosis of Homer,* Homer himself and all the figures whose feet are visible remain unshod. But just as Delaroche has insisted on the historicizing detail that these three figures should

be aged relative to one another, so he has put them all in sandals. And he has perhaps tried to forestall the criticism, not of the cobblers, but of those who know all about the famous retort to the cobbler, and can appreciate that this detail is indeed a token of the academic artist's mastery of his own science and craft.

I need to sum up at this point the general conclusions that can be drawn from this brief evocation of an artist and a work that are still very imperfectly known, in comparison with their prestige throughout Europe in the early nineteenth century. The example of Delaroche points to an aspect of the institutional development of art history that would largely be forgotten after the rise of the academic discipline in the second half of the century, namely, that history will be the responsibility of the academy, whose authority is ultimately given by the state, and directed specifically to the production of the artists of the future. As Lyne Therrien shows, this responsibility is by no means abandoned in the second half of the century. Indeed the very recent development of the Institut National d'Histoire de l'Art (INHA), which symbolically and practically involves the merging of the archival functions of the École de Beaux-Arts into a national institute dominated by the universities, is perhaps the final closing of a very long chapter of French institutional history.

At the same time, I should reemphasize that Delaroche's *Hémicycle* was a great deal more than a mere reassertion of academic authority. As it manifested itself to art historians like Kugler and Burckhardt, it stood out as the achievement of a coherent visual effect, a *Gesamtwirkung*. Drawing upon the age-old tradition of prefiguring artistic development in terms of the lives of the artists, it decisively repudiated the portrayal of the anecdote and attempted instead the representation of historical difference within a unified visual field, essentially that of the panorama. I would suggest, however, that its significance goes further, if we reflect that within the decade of its completion, a momentous transformation had taken place in the hanging of the works in the Louvre, which Delaroche had striven to protect from the invasion of inferior contemporary works. Théophile Gautier grasped the significance of the change effected by curators Jeanron and Villot immediately, and one cannot do better than quote some of the opening words from his comments, originally published in *La Presse* in February 1849:

> This so simple idea of bringing together the works of every school,
> the manners of every master, of making them follow each other chrono-
> logically in such a way that one can read as if in an open book the

origins, progress and decadence of the art of such and such a coun-
try or century, had never yet occurred to anyone. . . . No museum
curator had noticed that he had in his hands all the materials to write
the most magnificent history of painting without the least expendi-
ture of criticism or style. Ready prepared pages were waiting, and only
asked to be numbered.

Now a walk in the museum is a complete course in art
history, conducted by professors who are no less eloquent for
being mute.[25]

The fact that the Louvre was reorganized in this way, and the fact that
Gautier chose to see it as such, are surely each significant. Art history does not yet
exist. But art history has already foreshadowed its eventual epiphany.

1. Max Burckhardt, *Briefe,* ed. Jacob Burckhardt (Basel: Benno Schwabe, 1955), 2:18–19. "Wenn Du
Kugler besuchst, so sage ihm, ich sei noch nicht bei Delaroche gewesen, werde aber nächste Tage
hingehen."

2. Franz Kugler, *Kleine Schriften und Studien zur Kunstgeschichte* (Stuttgart, 1853), 3:528.

3. Ibid.

4. Burckhardt, *Briefe,* 7 (1969): 226.

5. Ibid., 232.

6. See Claude Allemand-Cosneau, "*L'Hémicycle de l'École des beaux-arts de Paris* ou l'histoire figurée
de l'art," in *Paul Delaroche: Un peintre dans l'histoire,* exh. cat. (Paris: Musée des Beaux-Arts, Nantes,
1999), 105–29.

7. Michael Ann Holly, "Burckhardt and the Ideology of the Past," *History of Human Sciences* 1, no.
1 (May 1988): 58.

8. Melanie Klein, *Love, Guilt and Reparation* (London: Hogarth Press, 1975), 263.

9. See Lyne Therrien, *L'Histoire de l'art en France* (Paris: Éditions du C.T.H.S, 1998).

10. Ibid., 289 ff.

11. Ibid., 303.

12. See Léon Rosenthal, *Du Romantisme au réalisme* (Paris: Macula, 1987), xii–xiii.

13. Henry Lemonnier, "La Peinture murale de Paul Delaroche à l'*Hémicycle* de l'École des Beaux-
Arts," *Gazette des Beaux-Arts,* 4th ser., 13 (1917): 182.

14. Quoted in Stephen Bann, *Paul Delaroche: History Painted* (London: Reaktion, 1997), 72.

15. See Patricia Mainardi, *The End of the Salon: Art and the State in the Early Third Republic* (Cambridge: Cambridge University Press, 1994), 26–27.

16. These quotations are taken from an autograph manuscript draft of Delaroche's paper given to his friend, the painter Labouchère, and preserved in the Collection Labouchère, Bibliothèque municipale de Nantes, Livre 1, fols. 656–58: "je désire vivement réussir à vous convaincre que les motifs qui me déterminent à vous en occuper aujourd'hui d'une manière plus positive n'est autre que de voir l'avenir des arts dans notre pays confié à nos soins qui sont . . . en assurer le succès et fixer la voie qu'ils devraient suivre."

17. Ibid. "Le respect dû aux chefs d'oeuvres des grands maîtres qui disputent au Vatican l'admiration des étrangers, l'intérêt de l'art qui ne permet pas que les jeunes élèves soient privés pendant une grande partie de l'année des ouvrages dont l'étude continuelle est pour eux d'un si précieux secours . . . nous imposent le devoir de demander au Roi dans l'intérêt de la gloire nationale et de la considération qui possède la France qu'à l'avenir les expositions n'aient plus lieu dans le Musée du Louvre."

18. Ibid. The Academy should have "les moyens d'exercer sa plus utile mission, celle d'éclairer le gouvernement sur les ouvrages les plus remarquables de chaque exposition, sur les progrès et les vicissitudes de l'art dont la véritable histoire se trouverait à bien dire écrite par vous."

19. See *Catalogue de tableaux anciens . . . livres à figures et sur les arts . . . qui composaient le cabinet de M. Paul Delaroche* (Paris: Maulde et Renou, 1857), 15–17.

20. See Sylvain Boyer, "La Peinture de Paul Delaroche à l'École des Beaux-Arts," *Bulletin de la Société de l'histoire de l'art français* Année 1996 (1997): 157.

21. See Marc Gotlieb, "Poussin's Lesson: Representing Representation in the Romantic Age," *Word & Image* 16, no. 1 (Jan.–March 2000): 124–43.

22. Ibid., 137.

23. See F. Valentin, *Les Peintres célèbres,* 3d ed. (Tours: Mame, 1844), passim.

24. Ibid., 21. The original story as recounted by Pliny is reprinted in Adolphe Reinach, *La Peinture ancienne (Recueil Millet)* (Paris: Macula, reprinted 1985), 328–29.

25. Théophile Gautier, *Tableaux à la plume* (Paris: Charpentier, 1880), 4.

Battling over Vasari: A Tale of Three Countries

Carlo Ginzburg

In this paper—a brief outline of a larger project—I will argue that art history, as conceived today, was decisively shaped in the first half of the nineteenth century by a number of different, and conflicting, interpretations of Vasari. The three countries I will address are Germany, Italy, and France. This sounds exceedingly ambitious, but it seemed necessary to give a sense of the comparative dimension involved. The German section will be the shortest, thanks to a wealth of recent, remarkable research on that topic. The Italian section will be more substantial. The bulk of my paper will be devoted to the French side of the story.

Germany

As is well known, the first German art historian came from an Italian background. Johann Dominicus Fiorillo (Hamburg 1748–Göttingen 1821), a member of the Accademia Clementina in Bologna who had studied painting under Batoni, began to teach art history in Göttingen in 1783. He became a full professor only in 1813—an appointment that firmly set art history within the German academic system. In his *Kunstliteratur* Julius von Schlosser praised Fiorillo's "wonderful erudition," and regarded him as a link in a longer chain of German-Italian connections that involved Giovanni Morelli and, implicitly, Schlosser himself (who added his mother's maiden name, Magnino, to his own in some of his books).[1] But only recently has a dense collection of essays, based on a conference held in Göttingen in 1994, conveyed the importance of Fiorillo as a teacher and a scholar. His friendly relationship with Christian Gottlob Heyne and August Wilhelm von Schlegel witnesses his concern with antiquarian erudition as well as with aesthetics.[2] But Fiorillo was also especially indebted to Italian *Kunstliteratur*, which he introduced into German academic art history, first by making an extensive use of Luigi Lanzi's *Storia pittorica*, then by editing the fourth edition of the German translation of the same work.[3] Gabriele Bickendorf, one of the contributors to the Göttingen conference, stressed Fiorillo's intellectual debt toward antiquarianism as part of a larger argument, which she fully developed in her book *Die Historisierung der italienischen Kunstbetrachtung im 17. und 18. Jahrhundert*.[4] Bickendorf rejects the traditional image of Winckelmann as the founding father of modern art history, as well as the connection between art

history as a discipline and *Historismus.* Art historical methods, Bickendorf argues, are rooted in a premodern tradition: seventeenth and eighteenth century antiquarianism, which led to the discovery of the link between connoisseurship and paleography, first articulated by Giulio Mancini, and still crucial in Fiorillo's approach.[5] Bickendorf's stress on concrete art historical methods is sound, but insufficient. Methods are instruments; they do not suggest either ends or lists of priorities, which must necessarily come from outside.

Fiorillo was certainly indebted to the antiquarian tradition, which focused on the revision of Vasari's *Lives.* The notion of *zeichnenden Künste,* which recurs in the titles of Fiorillo's major works, deliberately echoed Vasari's *arti del disegno.*[6] Fiorillo closely scrutinized both the sources and the various editions of Vasari's *Lives.*[7] Later one of his pupils, Carl Friedrich von Rumohr, who would later criticize Fiorillo, prepared to translate Vasari's *Lives,* only to opt for producing a revision: the project ultimately appeared as *Italienische Forschungen* (1827), a collection of essays widely considered a turning point in the discipline of art history—or, alternatively, of *Kunstwissenschaft,* the science of art.[8] Rumohr's work paved the way to the German translation of Vasari's *Lives,* published between 1832 and 1849 under the supervision of Ludwig Schorn. Rumohr himself contributed to the first volume's notes.[9] But this erudite tradition was not simply rooted in antiquarianism and connoisseurship. Rumohr's research was inspired by a passionate interest in contemporary art. The *Italienische Forschungen* ended with Raphael, a choice consistent with Rumohr's support of the *Lukasbrüderschaft*—the Nazarenes, as they had been ironically nicknamed in Rome. Rumohr had a close relationship with Friedrich Overbeck and paid a substantial sum to ensure that Overbeck's painting *Jesus Entering into Jerusalem* went to the city of Lübeck.[10] Like the Nazarenes, Rumohr underwent an aesthetic conversion to Catholicism. Like them, he regarded Raphael's early work as the climax of artistic development; Michelangelo's greatness already implied subsequent corruption. Those who regarded Italian medieval and quattrocento painting as a model for the restoration of art viewed Vasari's *Lives* as an invaluable source; they obviously did not share Vasari's perspective. The Nazarene painter and art historian Johann David Passavant had unequivocally made this point in his anonymously published *Ansichten über die bildenden Künste und darstellung derselben in Toscana* (1820).[11]

The political implications of the artistic and scholarly orientation I am referring to are well known.[12] The recovery of a lost artistic perfection meant on the one hand the rejection of modernity, which led to the French Revolution; on the

other, the recovery of a lost national identity. Overbeck's well-known painting *Italia und Germania* (1828) inspired by two drawings by Franz Pforr entitled *Friendship*, projected a personal homage to a close friend, who died in Rome in 1812 at the age of twenty-four, into a much larger framework: Italy and Germany were friends because they shared a glorious past, a sad present, and hopefully, a great future.[13]

Italy

The presence of the Nazarenes group in Rome had a lasting impact on both Italian art and Italian art history. Around 1820 a number of artists came together under the name of the Puristi, a label applied earlier to a literary movement devoted to restoring the purity of Italian language by taking as a model what they saw as the pure, simple, and chaste trecento. Both groups were inspired by a reactionary (and more or less explicitly anti-French) version of Catholicism, which the Nazarenes also took up.[14] The link between the Puristi and the Nazarenes became formally evident in 1842, when Friedrich Overbeck joined his Italian friends in signing Antonio Bianchini's *Manifesto del Purismo*.[15] As the word *Manifesto* shows, the aims of the group were artistic and (at least implicitly) political.[16]

In 1834, while lecturing at the Accademia di San Luca in Rome, a painter and a member of the Puristi, Tommaso Minardi, praised Giotto, that "most extraordinary" artist, for his "genuine and appropriate expression of human passions"; this achievement, he commented, neither the Greeks, nor Leonardo, nor Raphael had been able to surpass. Minardi invited his audience to verify his assertion by inspecting Giotto's works "where they are": in Assisi and in Florence.[17] Minardi did not mention Giotto's frescoes in Padua, a silence that may have driven Pietro Estense Selvatico, a prominent supporter of the Puristi (later he became director of the Accademia in Venice) to publish in Padua in 1836 a learned booklet entitled *Sulla cappellina degli Scrovegni nell'Arena di Padova e sui freschi di Giotto in essa dipinti* (On the small Scrovegni chapel at the Paduan Arena and the Giotto frescoes painted in it).[18] Selvatico remarked that most writers about art had ignored Giotto's Paduan frescoes. According to Rumohr, so degraded was their condition that their authenticity could not be evaluated—a comment that Selvatico scornfully dismissed, making some judicious, detailed observations on the involvement of Giotto's workshop in the project.[19] The relevance of the Scrovegni chapel, Selvatico wrote, was not only Paduan but national: a conclusion prepared by the introductory sentences of his booklet: "Destiny, it seems, lent Italy a superiority ("un primato") in the realm of the visual art—solace, so to speak, for the sad misfortunes that

afflicted this unhappy country and perpetuated its divisions, preventing her from winning the status of a nation."[20]

To stress the political implications of Italy's artistic legacy was not a novelty. Some years earlier, an introduction signed "A. M."[Achille Mauri] to a one-volume edition of Vasari's works published in Milan (1829) had pointed in a coded language—meant to circumvent Austrian censorship—that Italy's glorious artistic past would have been an ephemeral and empty fame ("gloria effimera e vana") if it would not have been matched by a not less glorious scientific tradition embodied by Machiavelli, Galileo, and Volta.[21] In his 1846 *Del primato morale e civile degli italiani* (On the moral and civil superiority of the Italians), Vincenzo Gioberti focused on Italy's artistic and intellectual superiority to launch a political program based on Catholic federalism. Selvatico's argument that Italy's artistic richness was a product of the polycentric nature of its history, and therefore of the absence of an all-powerful capital like Paris or London, struck a similar note. A group of Tuscan scholars and artists who aimed at a sort of moderate *Purismo,* both in literature and the visual arts, went in the same direction. Once again the occasion was provided by Giotto: more specifically, by the recent discovery of his fresco cycle in the Peruzzi Chapel in Santa Croce, Florence. "If one considers those works according to their times and civilization, one realizes that Giotto is replacing the Byzantine style with new types, which I am willing to call national [nazionali]": the author of this remark was Cesare Guasti, an erudite and a philologist (among other things, he was the first modern editor of Michelangelo's poems).[22] Guasti was not, he admitted, an expert on painting. But he undoubtedly articulated a widespread sentiment, namely that Giotto and Dante, his inevitable literary counterpart, were the progenitors of the Italian nation, now firmly put under the benevolent protection of the Catholic church. Guasti reprinted his essays as a little book which appeared in Florence in 1859, after the flight of the grand duke of Tuscany, in the midst of the political turmoil from which emerged a united Italy under the Savoy dynasty.

Guasti's book was dedicated to Luigi Mussini, a Purist painter close to the Nazarenes and more or less directly inspired by Gioberti. Mussini often dealt either with religious subjects or with subjects alluding to Italy's (and particularly Florence's) glorious past—topics such as the Medici Garden and the celebration of Plato's anniversary by Lorenzo the Magnificent, both studies commissioned by the French government.[23] Mussini's *Parentali di Platone* received warm praise in an essay devoted to artistic Purism and signed by Guasti as well as his friends C. Pini, Carlo Milanesi, and the latter's brother Gaetano Milanesi.[24]

Gaetano Milanesi is a name familiar to all readers of Vasari's *Lives*. He edited them twice, in 1846–55 and in 1878–85; the latter edition, though it has been superseded on all grounds, is still in print. I regret that I have not yet been able to compare those two editions. But there is no doubt that the positivist's garb in which we have come to see Milanesi was put on later: his lifelong dedication to Vasari was rooted in his early, Catholic-oriented, Purist background.[25]

France

The German and Italian receptions of Vasari in the first half of the nineteenth century show remarkable convergences and even some direct links. With the French reception we enter a totally different atmosphere. This is in itself predictable, but a closer look will bring some surprises.

A French translation of Vasari's *Lives* was published in Paris between 1839 and 1842. Each of the ten volumes was accompanied by a commentary—in fact, a series of long essays—by Léopold Leclanché, who translated Vasari's work, and Philippe-Auguste Jeanron.[26] The latter, who was responsible for the comments on volumes 1, 4, 5, 6, and 7, is today rather well known as a painter, director of the Louvre from 1848 to 1849, and a writer. But neither the posthumous publication of Madeleine Rousseau's monograph, written in 1935 nor the recent contributions by G. P. Weisberg do real justice to the relevance and impact of Jeanron's commentary on Vasari.[27] Its target is sarcastically declared in the introduction to the first volume, signed by both editors but certainly written by Jeanron: "The Germans have been able to establish that Italian art came from them, that they alone have been able to preserve this divine primitive art to which all Europe should now return."[28]

The intrinsic contradiction embodied by the Nazarenes is exposed in the life of Cimabue. "The true champions of the restoration of Catholic art" chose their saints from "all of these escapees from the Byzantine school, all of those obstinate revolutionaries"—the foremost being Cimabue's pupil, Giotto (1:51) who "appears to have brought about a revolution in his art all by himself" (1:305).[29] The same expressions surface again in Masaccio's life: "Once Giotto unfurled the flag of progress, all uncertainty ceased; from all sides they rallied to him so that advances could be made with a shared accord. This revolution, which had substituted individual liberty for the despotic unity of dogma, required only a century to bear fruit. Destruction had to be closely followed by re-education. . . . As the past was destroyed, they set up the foundations of the future. . . . Harmony presided over

anarchy. . . . The moral reformation initiated by Cimabue and Giotto imperiously asked to be turned into a material reformation."[30]

The lasting success of this conflation of an artistic and political vocabulary may prevent us from realizing its sheer originality. Jeanron was one of the very first to develop the implications of a convergence between artistic, political, and social progress. In the light of his biography this is not surprising. The son of an artisan, Jeanron participated in the revolution of July 1830, for which he received a decoration. In 1833 he sent to the Salon a painting entitled *Scène de Paris* (Parisian Scene): this is a bitter denunciation of the bourgeoisie and its betrayal of revolutionary ideals.[31] In a similar spirit, Jeanron had painted a moving portrait of Filippo Buonarroti, the old revolutionary who in a famous book had preserved the memory of the Babeuf conspiracy.[32] As a writer, Jeanron was occasionally wont to dispense with all self-control. His *Espérance,* published in 1834, is a historical vision dripping with rhetoric: "We, the soldiers of democracy. . . . The future, victory, and rest do not belong to us. All that we possess is yesterday's defeat and tomorrow's struggle."[33]

Jeanron rapidly surveys a series of heroic characters—an anonymous slave, Tiberius and Gaius Gracchus, Jesus, Luther—who articulated the longing for equality echoed in the title of his book. All this looks quite predictable (and boring); but then suddenly something unexpected leaps out. Why, Jeanron is asking, do we so admire Tiberius and Gaius Gracchus despite their utter lack of compassion for the suffering of slaves? The answer comes by the way of an analogy:

> This is how we revisit in our memories—always with pride—those eloquent pages from the history of our France, where we see the Communes, radiant with inspiration and that which is to come, working themselves up for revolt and trying out their aggrandizement.
>
> We men from the lowest ranks of the people, men who have emerged from mud, as they say, because we have been born out of an earth which our fathers' sweat and blood have moistened, we still applaud the bourgeoisie's past battles, failing to remember that is this very bourgeoisie that is oppressing us in the present.
>
> And then, the logic of the times cries to us that all of these things are supposed to happen as they do.[34]

Praising today's enemy, the bourgeoisie, for its historical achievements, and recognizing its past role in fostering progress, cannot help but sound familiar to us.

In Paris between 1830 and 1848 this sort of historicist language was shared by both French Saint-Simonians and German immigrants like Karl Marx. Jeanron's commentary on Vasari is built up on this assumption. Even a great artist like Leonardo had to bow (Jeanron wrote) to "la logique du temps," the logic of the times (4:24). This argument bore a certain resemblance to that which Vasari himself advanced at the conclusion to his great work:

> To those who think I have excessively praised some artisans either old or modern, and that drawing comparisons between the older ones and those of this era would be a laughing matter, I do not know how else to reply except that I intended to give praise not absolutely but, as they say, with respect for places, times, and other similar circumstances; in truth, taking the example of Giotto, no matter how highly praised he was in his own day, I do not know what would be said of him and other older artisans if they had existed in Buonarroti's time; moreover, the men of this century, which has reached the peak of perfection, would not have attained the heights they have reached if those who came before had not been as they were.[35]

While Vasari certainly shared Pliny's idea of artistic progress, here was a discordant note. As I have argued elsewhere, the distinction between absolute and relative progress, between *semplicemente (simpliciter)* and *secondo che (secundum quid)* ultimately derived from a cognitive model that Saint Augustine worked out to make sense of the relationship between the Old and New Testaments, between Jews and Christians.[36] In their day, Jewish religion was true, Giotto's works were excellent; but perfection came only with Christian religion and the divine Michelangelo. Having absorbed this model, Jeanron injected into it new elements. Vasari's argument "with respect for places, times, and other similar circumstances" became his *logique du temps.* He also added a political and a social dimension to Vasari's (and Pliny's) idea of artistic progress—but rejected the idea of a final fixed perfection. Significantly, Jeanron articulated his attitude in a commentary on Vasari's life of Michelangelo: a striking page, which should really be quoted in full. One passage reads: "The recollection of great men belongs to the world and fellows its law—a law which does not appear to involve rest or permanence." Appreciation of individuals and their works changes with the times: "so we must resign ourselves to making only transitory judgments subject to instant revisions. But from what

appears to be a humiliating position flows in reality the right to rise up against previous judgments and to register them only as documents, placing above all authority our own evaluation and our own consciousness."[37] Jeanron's radical perspectivism had nothing to do with skepticism. His commentary on Vasari was scattered with remarks showing his bold independence from academic judgments. In a typical passage, Jeanron scornfully refers to "our most authoritative critics," wondering whether we can believe that they are immune to "those miscarriages of justice and that horrifying despotism which sacrifice Domenichino to Lanfranco, Poussin and Puget to Lebrun and Girardon, Lesueur to Mignard, Géricault and Prud'hon to others?"[38]

Jeanron's anti-academic reading of Vasari's *Lives* can be compared (and opposed) to the academic representation of the history of art, also inspired by Vasari, which Delaroche displayed in the same years in his frescoes at the École des Beaux-Arts.[39] Jeanron conflated art and left-wing politics: his moral conviction was rooted in a strong sense of quality, devoid of any sectarian overtones. His list (which I would immediately endorse, with one exception: his preference for Domenichino over Lanfranco) included painters as different as Poussin and Géricault. Jeanron's judgments were inspired by a passionate involvement, as a painter and critic, in contemporary art.[40] In 1837 he published an article on Alexandre François Xavier Sigalon, the painter who had spent four years in Rome working on a huge series of etchings based on Michelangelo's *Last Judgment.* "The Sistine Chapel fresco is half work of art, half caricature," Jeanron wrote. "These grimacing men, these figures that twist themselves, these are the enemies, the critics, the envious upon whom Michelangelo took vengeance through his brushes. . . . Michelangelo began with a painting, but what he signed was a tract."[41] In reading this passage one is reminded that Daumier was close to Jeanron, from whom he apparently received some training as a painter.[42]

One year before, at the Salon of 1836, Jeanron had exhibited *La Charité du people, ou les forgerons de la Corrèze,* a painting which is now lost.[43] Théophile Thoré, the critic, commented enthusiastically on the painting and the painter: "M. Jeanron must make more of these moving paintings for us! . . . M. Jeanron bears a great responsibility: better than any other does he understand the direction of modern art and express it with the greatest vigor."[44]

Thoré and Jeanron had fought in the same battles against the political and artistic establishment in the wake of the July Revolution. In 1832 Jeanron had founded with Didron the journal *La Liberté, revue des arts.* In the following year, two members of the journal's editorial board, Laviron and Galbacio resigned so

they might freely evaluate the works of their friends—meaning Jeanron's paint-
ings, on which they commented at length in the book they jointly wrote on the
Salon of 1833. Laviron and Galbacio assigned Jeanron's work to the *Naturalistes*: a
label which, they explained, the Italians use to define "those who, having been
shaped in accordance with nature and nothing else, present it in all its truth and
all its power." The leader of naturalists, Caravaggio, was "a vigorous and fascinat-
ing talent that wrought a prodigious revolution among the pallid students from
the eclectic school of the Carracci, overturning all of the fashionable approaches
to painting to set up in their place the true and conscientious study of nature."[45]
Another commentator evoked, in front of Jeanron's *Scène de Paris* exhibited at the
same Salon, "the best paintings of Caravaggio and the Spanish masters."[46] This
perception must have been shared by Jeanron, who praised "the eccentric and fiery"
Caravaggio, an artist who rejected "academic miseries," in commenting on (rather
oddly) Vasari's life of Mariotto Albertinelli.[47]

 Such remarks can be regarded as a missing link in the nineteenth-century
rediscovery of Caravaggio, which is usually credited to Courbet, whose paintings
were later associated with Jeanron's under the label of "realism."[48] But one should
refrain from identifying Jeanron with a formula. With great energy and polemical
verve he articulated the sense of what Thoré called "the direction of modern art."
It was a direction that first and foremost implied a sharp divergence from con-
temporary Germany:

> Look at their painters, obsessed with imitating nature, busy with their
> useless studies of trompe l'oeil, and producing meaningless master-
> pieces of tenacity and hebetude, the very sight of which causes pain.
> Holbein's portraiture, in which care and neatness certainly rank as the
> most neglected virtues, has been followed by the German school un-
> til it has ended up as this dispiriting painting of still lifes and utensils, as
> these views from camera obscuras, as these magnifying glass effects, in
> which every hue is deadened by being combined, in which every de-
> tail catches the eye to alarm it, and in which all of the illusion revolts.[49]

Italian painting, for Jeanron, played an opposite, entirely positive role. "It is cer-
tainly quite true that within the great unity of Italian art all are struck by the most
astonishing variety."[50] He rejected labels such as "Lombard school" because they
concealed the sharp differences that existed among painters working, in this case,

in Parma, Cremona, Milan, Modena, and Mantua.[51] But beyond the diversity of
local schools Jeanron identified a recurrent, underlying element in Italian painting,
for which he suggested an original explanation: "This distinctive soberness, this em-
pire of mass, this subordination of detail, and, perhaps more important, this
conciseness in subject matter, this simplicity of pose, finally this highly legible and
clean background, against which the thinking of the Italian masters is outlined, are
all far closer than we imagine . . . to the routine appearance of Byzantine mosaics."[52]

Jeanron detected this element along centuries of Italian painting, from
Cimabue and Giotto to Veronese, Tintoretto, and beyond. He even claimed to
find. "a Byzantine place under the big brush of the Carracci, part of the school's
heritage."[53] His argument was neither provable nor disprovable, but this is beside
the point. Much more interesting for us are his conclusions, which must be read
as a description of an artistic ideal: "This empire of mass, this subordination of de-
tail . . . this conciseness in subject matter, this simplicity of pose"—these were not
mere words, but thoughts that actively directed Jeanron's discriminating eye. At
the end of his commentary on Vasari's *Lives,* Jeanron added a long digression on
the history of the miniature, which focused on Jean Fouquet's extraordinary con-
tribution to illustrated manuscript of Flavius Josephus's *Jewish History,* which
included "eleven miniatures whose composition bespoke an artistic sensibility so
profound, a style so great, a taste so exquisite that they would have sufficed to lead
us to suspect that their creator had also produced very large paintings, even if a
German writer deeply versed in our arts, whose counsel has been as useful to us as
his friendship is precious, would not have assured us that he had seen a religious
painting by this French artist at the home of M. Georg Brentano in Frankfurt."[54]

Fouquet's unnamed painting was *Saint Stephen with Etienne Chevalier,* the
left panel of the diptych now divided between Berlin and Antwerp; the unnamed
German writer was Gustav Friedrich Waagen, whose magnificent pages on Fouquet's
miniatures Jeanron translated into French, without acknowledgment.[55] As Waagen
dutifully pointed out, the reconstitution of Fouquet's oeuvre as an illuminator had
been initiated by Passavant.[56] Notwithstanding his rejection of the Nazarenes, both
as an artist and an art historian, Jeanron relied (through Waagen) on Passavant,
the Nazarene artist and art historian. One could read those Franco-German ex-
changes as evidence of connoisseurship as an art historical paradigm, ultimately
rooted in the seventeenth- and eighteenth-century antiquarian tradition, born as
a revision of Vasari's *Lives.* But the master narrative came from outside, from an
approach which took over the old Plinian idea of artistic progress, reworked by

Vasari, and conflated it with political and social progress. In other words, art history written from the vantage point of avant-garde.

Jeanron, who identified with the defeated, ended up a winner. The past he helped shape as a critic is still our past—with a few differences. We can allow ourselves to be equitable toward Nazarenes, for instance, partly because they long ago became innocuous. But the real discontinuity lies elsewhere. During the last decades art and politics have destroyed Thoré's and Jeanron's confident perception of the trajectory to be followed by modern art—and possibly the very meaning of the expression "modern art." Is the battle over Vasari over? To answer this question would require another paper.

1. J. Schlosser-Magnino, *La letteratura artistica* [1924], Italian trans. with bibliographical additions by O. Kurz (Florence: La Nuova Italia, 1977), 481. See also A. Hölter, "Fiorillo, Giovanni Domenico," in *Dizionario biografico degli italiani* (Rome: Istituto dell'Enciclopedia Italiana, 1997), 188.

2. H. G. Döhl, "Johann Dominicus Fiorillo und Christian Gottlob Heyne," in *Johann Dominicus Fiorillo. Kunstgeschichte und die romantische Bewegung um 1800, Akten des Kolloquiums,* ed. A. Middeldorf Rosengarten (Göttingen: Wallstein, 1997), 145–66.

3. See, in general, G. Bickendorf, *Die Historisierung der italienischen Kunstbetrachtung im 17. und 18. Jahrhundert* (Berlin: Gebr. Mann, 1998).

4. See also G. Bickendorf, "Fiorillo und der . . . Blick einer geübten Diplomatikers," in Rosengarten, ed., *Fiorillo,* 79–95.

5. See Bickendorf, *Die Historisierung,* 31 n. 32, for an explicit self-criticism concerning her earlier book *Der Beginn der Kunstgeschichtsschreibung unter dem Paradigma 'Geschichte.' Gustav Friedrich Waagens Frühschrift Ueber Hubert und Johann van Eyck* (Worms: Wernersche Verlagsgesellschaft, 1985).

6. J. D. Fiorillo, *Geschichte der zeichnenden Künste von ihrer Wiederauflebung bis auf die neuesten Zeiten,* 5 vols. (Göttingen, 1798 and 1808); J. D. Fiorillo, *Geschichte der zeichnenden Künste in Deutschland und den vereinigten Niederlanden,* 4 vols. (Hannover, 1815–20). See S. Roettgen, "Fiorillo und die spanische und englische Kunst—Beobachtung einer Methode," in Rosengarten, ed., *Fiorillo,* 370–87, especially 371 n. 7.

7. J. D. Fiorillo, *Kleine Schriften artistischen Inhalts* (Göttingen, 1803), 1:83–97, 99–132.

8. C. F. von Rumohr, *Italienische Forschungen,* intro. J. Schlosser (Frankfurt: Frankfurter Verlags-Anstalt, 1920); U. Kultermann, *Geschichte der Kunstgeschichte* (Munich: Prestel, 1996), 89–91. The quality of Rumohr's research is grudgingly recognized by G. Previtali, *La fortuna dei primitivi,* 2d ed. (Turin: Einaudi, 1989), 186–87.

9. See C. A. Isermeyer, "Le traduzioni tedesche delle *Vite*," in *Il Vasari storiografo e artista. Atti del congresso internazionale nel IV centenario della morte* (Florence: Istituto nazionale di studi sul Rinascimento, 1976), 805–13, especially 808.

10. G. Kegel, "Carl Friedrich von Rumohr mecenate di artisti tedeschi in Italia," in *Gli artisti romantici tedeschi del primo Ottocento a Olevano Romano,* ed. D. Riccardi (Milan: Electa, 1997), 82–93.

11. H. Belting, "Vasari e la sua eredità," in *La fine della storia dell'arte o la libertà dell'arte,* Italian trans. (Turin: Einaudi, 1990), 88–91; U. Kultermann, *Geschichte der Kunstgeschichte* (Munich, 1996), 85–86; K. K. Eberlein, "Johann Friedrich Böhmer und die Kunstwissenschaft der Nazarener," in *Festschrift für Adolph Goldschmidt* (Leipzig: E. A. Seemann, 1923), 126–38.

12. K. Niehr, "Aesthetische Norm und nationale Identität. Fiorillo und die Kunst des Hochmittelalters in Deutschland," in Rosengarten, ed., *Fiorillo,* 292–305.

13. See K. Andrews, *The Nazarenes* (Oxford: Clarendon Press, 1964); *Die Nazarener,* exh. cat. (Frankfurt am Main: Städtische Galerie im Städelschen Kunstinstitut, 1977); *I Nazareni a Roma,* exh. cat. (Rome: De Luca, 1981).

14. P. Estense Selvatico, "Del purismo nella pittura," in *Scritti d'arte* (Florence, 1859), 135–64. See S. Timpanaro, "Le idee di Pietro Giordani" (1953), in S. Timpanaro, *Classicismo e illuminismo nel Risorgimento* (Pisa: Nistri Lischi, 1965), 41–117, especially 65–67: "C'era nel loro [dei puristi] trecentismo, sia pure in forma più angusta e provinciale, quella stessa esigenza di restaurazione religiosa e di populismo reazionario che ispirava le fantasie medievaleggianti dei romantici tedeschi (da loro tanto odiati solo perché non appartenti alla tradizione letteraria italiana) e dei pittori 'nazareni' a loro ancor più affini" (67).

15. Republished in *Disegni di Tommaso Minardi (1787–1871),* exh. cat. (Rome: De Luca, 1982), 59–61. See also the entry "Antonio Bianchini," in *Dizionario biografico degli italiani.* On the date of Bianchini's *Manifesto,* see G. Previtali, *Paragone* 16, no. 163 (1963): 61 n. 1.

16. On the early history of the word *Manifesto* see K. Marx and F. Engels, *Manifesto del partito comunista,* ed. E. Cantimori Mezzomonti (Turin: Einaudi, 1962), 40–42. Among the earliest examples, the text written by Sylvain Maréchal for Babeuf's *Conspiration pour l'égalité.*

17. The text of the lecture has been reprinted in *Disegni di Tommaso Minardi,* 49–59, especially 51. See also T. Minardi, *Scritti* (Rome, 1864); G. De Sanctis, *Tommaso Minardi e il suo tempo* (Rome, 1900); I. Faldi, "Il purismo e Tommaso Minardi," *Commentari* 1 (1950): 238–46; F. Bologna, *La coscienza storica dell'arte d'Italia* (Turin: UTET, 1982), 177.

18. This edition included an appendix with some texts by d'Hancarville, which were skipped in the new edition. See Selvatico, "Del purismo nella pittura," in *Scritti d'arte* (Florence, 1859), 135–64, especially 138.

19. C. F. von Rumohr, *Italienische Forschungen* (Berlin and Stettin: Nicolai'sche buchhandlung, 1827–30), 270; P. Selvatico, *Sulla cappellina degli Scrovegni nell'Arena di Padova e sui freschi di Giotto in essa dipinti* (Padua: Tipi della Minerva, 1836), 5–6.

20. Selvatico, *Sulla cappellina*, 5–6.

21. G. Vasari, *Opere,* Nicolò Bettoni, *Biblioteca Enciclopedica Italiana,* 2 (Milan, 1829). Mauri's name is spelled in full in the edition of Vasari published in Naples, 1859. See A. Mauri, *Scritti biografici,* 2 vols. (Florence, 1878); A. Pippi, "Achille Mauri" in *Rassegna nazionale* 24 (1885); M. Berengo, *Intellettuali e librai nella Milano della Restaurazione* (Turin: Einaudi, 1980), especially 163.

22. C. Guasti, "Degli affreschi di Giotto nella cappella de' Peruzzi in Santa Croce" (June 1849), in C. Guasti, *Opuscoli concernenti alle arti del disegno ed ad alcuni artefici* (Florence, 1859), 1–11. On Guasti, see G. Gorni, in *Poeti del Cinquecento,* ed. G. Gorni, M. Danzi, S. Longhi (Milan and Naples, 2001), 1:575–76.

23. S. Pinto, "La promozione delle arti negli Stati italiani dall'età delle riforme all'Unità," *Storia dell'arte italiana* (Turin: Einaudi, 1982), 6:2, 1056, recalls Gioberti in commenting upon Luigi Mussini's *Il trionfo della verità,* 1849. See also G. Dupré, *Pensieri sull'arte e ricordi autobiografici,* (1879; Florence, 1894), 191–92, 246–47, 435; *Ingres e Firenze,* exh. cat. (Florence: Centro Di, 1968); J.-M. Marquis, "Luigi Mussini et la France," *Bulletin du Musée Ingres* 42 (Dec. 1978); *Siena tra purismo e liberty,* exh. cat. (Siena: Palazzo Pubblico, 1988); On Gioberti's approach to Plato see P. Treves, "F. Acri e il 'platonismo' italiano," introduction to Plato, *Dialoghi,* trans. F. Acri (Turin: Einaudi, 1970).

24. Guasti, *Opuscoli,* 161–78.

25. On Milanesi's positivism see P. Barocchi's introduction to G. Vasari, *Vite,* ed. G. Milanesi (Florence: Sansoni, 1973), 1:xi–xiv, although Milanesi's closeness to both the Puristi and Gioberti is surprisingly ignored. C. Dionisotti, *Appunti su arti e lettere* (Milan: Jaca Book, 1995), 52, stresses Milanesi's pre-unification Tuscan background. See also V. Marchese, *Scritti vari* (Florence, 1855), 565 ff.; "Dei puristi e degli accademici" (1846); V. Marchese, *Memorie dei più insigni pittori, scultori e architetti domenicani* (Florence, 1845–46; 4th ed., Bologna, 1878); V. Marchese, C. Pini, C. and G. Milanesi, *Manuale storico dell'arte greca, pubblicato per cura di una Società di Amatori delle Arti Belle,* intro. V. Marchese, repub. in G. Vasari, *Vite,* ed. P. Barocchi and R. Bettarini, *Commento,* vol. 1 (Florence: Sansoni, 1967).

26. G. Vasari, *Les Vies des peintres, sculpteurs et architectes,* 10 vols. (Paris, 1839–42).

27. See M. Rousseau, *La Vie et l'oeuvre de Philippe-Auguste Jeanron. Peintre, écrivain, directeur des Musées Nationaux. 1808–1877* (Paris: Réunion des Musées Nationaux, 2000), especially 129–51. See G. P. Weisberg, *The Realist Tradition: French Painting and Drawing 1830–1900,* exh. cat. (Cleveland: Cleveland Museum of Art, 1980); G. P. Weisberg, "The New Maecenas: Regional and Private Patronage of Realism in France, 1830–70," in *The European Realist Tradition,* ed. G. P. Weisberg (Bloomington, Ind.: Indiana University Press, 1982), 14–30; G. P. Weisberg, "Proto-Realism in the July Monarchy: The Strategies of Philippe-Auguste Jeanron and Charles-Joseph Traviès," in *The Popularization of Images: Visual Culture under the July Monarchy,* ed. P. ten-Doesschate Chu and G. P. Weisberg (Princeton, N.J.: Princeton University Press, 1994), 90–112 (on Jeanron as a painter). For a partial exception see Vasari, *Vite,* ed. Barocchi and Bettarini, 1:xxxii–xxxiv (but the political overtones of Jeanron's com-

mentary are overlooked). See also Bologna, *La coscienza,* 179–82 (based on the selection from Jeanron's introductions published in the Barocchi-Bettarini edition).

28. Vasari, *Les Vies,* 1:16: "Les Allemands en sont arrives à établir que l'art italien venait d'eux, qu'eux seuls ont su conserver ce divin art primitif auquel il convient maintenant toute l'Europe artistique à rétourner."

29. Ibid.: "à lui seul, il semble avoir consommé une révolution dans son art."

30. Ibid., 2:139–41: "Lorsque Giotto eut deployé le drapeau du progress, toute incertitude cessa; on se rallia à lui de toutes parts, pour aller en avant de commun accord. À cette révolution, qui avait substitute la liberté individuelle à l'unité déspotique du dogme, il ne fallut qu'un siècle pour porter ses fruits. La réedification devait suivre de près la destruction. . . . À mesure que l'on démolissait le passé, on jetait les fondements de l'avenir . . . L'harmonie présidait à l'anarchie. . . . La réforme morale entreprise par Cimabue et Giotto réclamait impérieusement la réforme materielle."

31. Rousseau, *Jeanron,* 228–29; M.-C. Chaudonneret, "Jeanron et 'l'art social': Une *scène de Paris,*" *Revue du Louvre* (1986): 317–19.

32. Rousseau, *Jeanron,* 226–27.

33. P.-A. Jeanron, *Espérance* (Paris, 1834), 167, 166: "Nous, soldats de la démocratie . . . l'avenir, la victoire et le repos ne nous appartiennent pas. Nous n'avons à nous que la défaite d'hier et la lutte de demain."

34. Jeanron, *Espérance,* 11–12:

> C'est ainsi que nous repassons toujours avec orgueil dans notre mémoire ces éloquentes pages de l'histoire de notre France, où l'on voit les Communes, radieuses d'inspiration et d'avenir, s'encourager à la révolte et s'essayer à l'agrandissement.
>
> C'est que nous, hommes des derniers rangs du peuple, hommes sortis de la boue, comme ils disent, parce que nous naissons d'une terre, que les sueurs, le sang et les larmes de nos pères ont détrempée, nous battons encore des mains à la bourgeoisie luttant dans le passé, sans nous souvenir que c'est elle, qui nous oppresse dans le présent.
>
> Et puis aussi, la logique des temps nous crie, que toutes ces choses doivent se produire comme cela.

35. G. Vasari, *The Lives of the Artists,* trans. J. Conway Bondanella and P. Bondanella (Oxford: Oxford University Press, 1991), 509–10 (I corrected the translation).

36. C. Ginzburg, *Wooden Eyes: Nine Reflections on Distance* (New York: Columbia University Press, 2001).

37. Vasari, *Les Vies,* 5:246: "La mémoire des grands hommes appartient au monde et suit sa loi; loi qui ne paraît pas être le repos ni la fixité. . . . Faut-il se résigner à ne prononcer sur eux que des jugements transitoires et subjects à d'incéssantes revisions. Mais de cette position humiliante en apparence, découle en réalité le droit de s'élever contre les jugements anterieures, et de n'en tenir compte que

comme de simples documents, en mettant en dessus de toute autorité l'examen et la conscience."

38. Ibid., 4:83: "ces dénis de justice et ce despotisme affreux qui sacrifièrent le Dominiquin à Lanfranc, le Poussin et le Puget à Lebrun et à Girdardon, Lesueur à Mignard, Géricault et Proud'hon à d'autres?"

39. See Stephen Bann's paper in this volume.

40. P. Barocchi made this point, without further qualifications: see Vasari, *Vite,* ed. Barocchi and Bettarini, 1:xxxii–xxxiv.

41. P. A. Jeanron, "Sigalon et ses ouvrages," extrait de *La Revue du Nord* 9 (1837): 1 ff., especially 14–15: "La fresque de la chapelle Sixtine est moitié une oeuvre d'art, moitié une caricature. . . . Ces hommes qui grimacent, ces figures qui se tordent, ce sont des ennemis, des critiques, des envieux, auxquels Michel-Ange a imposé la vengeance de ses pinceaux . . . Michel-Ange avait commencé un tableau, il a signé un pamphlet."

42. Rousseau, *Jeanron,* 348.

43. Ibid., 232–33.

44. T. Thoré, "Salon de 1838," *La Revue de Paris,* 3d series (1838): 2:269: "Que M. Jeanron nous fasse donc encore de ces émouvantes peintures. . . . M. Jeanron porte une grande responsabilité; c'est lui qui comprend mieux la direction de l'art moderne et qui l'exprime avec le plus de verdeur" (the same passage is quoted in L. Rosenthal, *Du Romantisme au Réalisme. Essai sur l'évolution de la peinture en France de 1830–1848* [Paris: H. Laurens, 1914], 388–89). See also Rousseau, *Jeanron,* 155.

45. G. Laviron and B. Galbacio, *Le Salon de 1833* (Paris, 1833), 368: "ceux qui, formés sur la nature et sur elle seule, la rendent dans toute sa vérité et toute sa puissance . . . [Caravaggio], ce talent vigoureux et saisissant qui fit une si prodigieuse révolution parmi les pales élèves de l'école éclectique des Carraches, et bouleversa tous les systèmes de peinture à la mode pour mettre à sa place l'étude vraie et consciencieuse de la nature."

46. Hauréau, quoted by Rousseau, *Jeanron,* 155.

47. Vasari, *Les Vies,* 4:154: "l'excentrique et fougueux Caravaggio . . . les misères professorales."

48. A. Berne-Joffroy, *Le Dossier Caravage. Psychologie des attributions et psychologie de l'art* (1959; reprinted Paris: Flammarion, 1999), 20 (on Caravaggio's rediscovery in the nineteenth century).

49. Vasari, *Les Vies,* 1:240: "Voyez leurs peintres, entichés de l'imitation de la nature, s'occuper des recherches inutiles du trompe l'oeil, et produire ces insignifiants chef-d'oeuvre de constance et d'irréflexion qui font peine à voir. La portraiture d'Holbein, dont le soin et la propreté sont assurément le moindre mérite, continuée dans l'école allemande, est venue aboutir à cette désespérante peinture de nature morte et d'ustensiles, à ce vues de chambre noire, à ces effets de verre grossissant, où chaque teinte se plombe à force de s'unir, où chaque détail accroche l'oeil et l'effraie, et dont toute l'illusion révolte."

50. Ibid., 4:xiv: "Certainement il est bien vrai que la plus étonnante variété frappe tous les yeux dans la grande unité de l'art italien."

51. Ibid., 3:292. A similar passage is quoted with much praise in Bologna, *La coscienza*, 181–82.

52. "Ce cachet de sobriété, cet empire de la masse, cette subalternisation des détails, et ce qui vaut mieux peut-être encore, cette concision du sujet, cette simplicité d'attitudes, toute ce fond enfin si lisible et si net, sur lequel se détache la pensée des maîtres italiens, touchent de plus près qu'on ne le croit . . . au spectacle habituel des mosaïques byzantines."

53. Vasari, *Les Vies*, 1:336–37: "sous le large pinceau des Carraches, la localité byzantine, héréditaire dans l'école."

54. "Onze miniatures qui annoncent dans la composition un sens artistique si profond, un style si grand, un goût si exquis, qu'elles auraient suffi pour nous faire conjecturer que leur auteur a égalé-ment exécuté des tableaux de plus grande dimension, lors même qu'un écrivain allemand de la plus haute instruction dans nos arts, et dont les conseils nous ont été aussi utiles que son amitié nous est précieuse, ne nous aurait point assuré qu'il avait vu un tableau d'église de cet artiste français chez M. Georg Brentano à Francfort-sur-le-Main."

55. Compare G. F. Waagen, *Kunstwerke und Künstler in England und Paris, 3: Kunstwerke und Künstler in Paris* (Berlin, 1839), 371–74, and Vasari, *Les Vies*, 7:240–42. According to Philippe de Chennevières's hostile remark, Jeanron's writings on art history relied upon Kolloff, "très au courant des recherches et de la littérature d'art allemande" (Rousseau, *Jeanron*, 148). I have been unable to check this.

56. Waagen, *Kunstwerke und Künstler*, 1:415. Waagen's and Passavant's works were repeatedly used by Carlo Milanesi, Gaetano Milanesi, and Carlo Pini, in their comment on Vasari's *Vite*, 13 vols. (Florence, 1846–57): see their acknowledgments (1:314 n. 2; viii, introduction). The editors' original group in-cluded also the Dominican friar Vincenzo Marchese (iii, introduction).

"Pineapple and Mayonnaise—Why Not?"
European Art Historians Meet the New World

Karen Michels

Fig. 1. Erwin Panofsky

It is the year 1933, or, to be more precise, about January 1933, and the person concerned is a German in New York: Erwin Panofsky, visiting professor at New York University, who describes to those left back in Germany his experiences with the United States, the Americans, and the American system of education (fig. 1). His English is quite good, and he has assumed the attitude of a cultural anthropologist wielding a butterfly net to search for the behavior patterns of the "other," the "foreigner," or even the "exotic." He especially enjoys collecting linguistic phenomena: As he reports to Walter Friedlaender:

> I even discovered the key word of American culture, namely "Why not," starting with the traditional invitation such as "Why don't you have dinner with me tomorrow?" and ending with a declaration of love such as "Why don't you sleep with me tonight?" Europeans do things due to emotional or rational reasons that speak for such an action whereas Americans do things when nothing seems to speak against such an action. That explains the admirable activity and hospitality but also the lack of purpose and taste to be found in America, as well as the horrible cuisine in this country. Pineapple and mayonnaise—why not? There are, of course, reasons against this combination but there will probably be no longer any Europeans capable of explaining these reasons until the average American will be able to understand them.[1]

Pineapples and mayonnaise—the combination of it, probably in a chicken salad, was unknown to Europeans at that time. Panofsky, as a representative of the Old World, regards it as a barbarian attack against good taste; it was only after the war that young Germans, in order to chase away the shackles of German roast meat and sauerkraut traditions, opened their minds and kitchens for American eating habits.

Panofsky had similar irritating experiences in the professional field: few books, few slides, and the students were lacking the humanistic education of the German Gymnasium. Structural disturbances definitely arose from the fact that the American universities were financed by private money, by donations from (sometimes even non-academic) people who then had interests in university policies. Panofsky had been a German professor and as such was used to a high degree

Figs. 2, 3. Erwin Panofsky lecturing at NYU

of independence in everything he did and said. When, after having been dismissed by the Nazi government, he was offered the opportunity to teach at the department of Fine Arts of New York University, he of course felt very grateful—but he soon got the impression of being spoon-fed to such a degree that he preferred to turn down the permanent position offered to him by NYU in 1935. In a letter to Gertrud Bing he describes being "greatly annoyed by the fact that the course announced and arranged as a 'seminar' in the Morgan Library was used for publicity purposes (partly to give some prestige to NYU, partly to prevent Mr. Morgan from having to pay taxes for his library) without my knowledge. . . . I am lecturing an audience of 60/70 persons, including 30 chinchilla ladies who are (rightly) tormented as much as when attending the Wagner operas in the Metropolitan Opera" (figs. 2, 3).[2] And ten years later, American colleagues expressed their general critique of the refugees' "pedantic" and "single-minded Teutonic" ("eingleisig-teutonischen") teaching program and requested, at least at New York University, a higher degree of popularization. This reaction was only one facet of the conflict of values ensuing from the clash of two basically different academic cultures—and it has been

under discussion again in the last years. Still today, so has been stated, art history is playing in national theatres—the European one in an "elitist," specialist and "disciplinary" setting, the American one in a "democratic," empiric, pluralistic, and society-bound context.[3]

This value conflict probably was most visible in the field of didactics. One example: the American universities normally offered survey courses that generously combined times and areas in a broad context (Northern Renaissance, Italian Painting); the refugees, however, were used to an approach focusing on special topics that were often labeled "problems" in the titles of their courses and which sounded sometimes, one has to admit, rather sophisticated, such as "Problems of Early Flemish and Dutch Painting," "Problems in the Work of Michelangelo," or even "Problems in German Painting of the Ninth and Tenth Centuries," as a course offered by Wilhelm Köhler at Harvard University in 1934. As late as 1949, Dumbarton Oaks medievalist Ernst Kitzinger, who had been invited to lecture at Harvard University for one term, suggested to the head of the department to do so by sacrificing the usual introductory session, stating that it was "more instructive for the students to concentrate on certain specific problems which have implications of a more general kind. So I would suggest a non-committal title like 'Problems in Early Byzantine Art.'"[4] Details like these show how much the refugees were used to applying a methodological approach where students should not learn to acquire manual knowledge, but to focus on the principle behind the phenomenon. By the refugee-teaching in the United States, American empiricism was confronted with the German preference for the formation of theories, and not only the students appreciated the inspiring impulses which could spring out of this confrontation.

These course titles with "problems" in their names hint at another structural difference between German and American universities: the relationship between lecturers and students who in Germany were considered as serious partners in professional discussions immediately upon entering their academic life. Having been a lecturer for twenty years almost without interruption, Panofsky in a letter to his friend Bruno Snell, classical philologist and then rector of the University of Hamburg, complained that the "*mutually* stimulating relationship" between academic teachers and students he had come to appreciate in Hamburg was generally lacking in the United States.[5] Of course, the refugees continuously tried to change the teaching conditions according to their ideals—so that their American students experienced the courses offered by the European lecturers as difficult, but also intellectually challenging sessions in which factual knowledge was more or less prerequisite;

knowledge of the latest literature was expected and seminar papers had to include a truly scholarly statement, "eine These." In Princeton, Kurt Weitzmann even modified the examination procedure, stating that he did not want to examine the memory but rather the ability to comprehend.[6] The idea that students could play a constitutive role in the intellectual development of their professors was due to one of the basic postulates of German universities, namely the indivisibility of teaching and research. The refugees only began to understand the very meaning of this principle when they were confronted with values differing from their own, but eventually this principle emerged as an identifying link within this otherwise heterogeneous group. In the United States, students were encouraged to acquire comprehensive knowledge more passively, imparted by lecturers, whereas in Germany, they were made to contribute, actively, in the educational process themselves: "The European student," Panofsky states, "knows what he wants, and the responsibility for failure or success rests exclusively on him."[7] In the United States, the educational system also had to take into account utilitarian aspects—"turn out the greatest possible number of the best possible students";[8] in Germany, it had to guarantee the academic freedom of the professors and the students—and it reflected, of course, the well-known conviction of Wilhelm von Humboldt, namely that students and professors should form an academic community, which was based solely on mutual education achieved by the acquisition of knowledge.

Fig. 4. Williams S. Heckscher

In 1970 Panofsky's student William S. Heckscher (fig. 4) undertook what was probably the most unconventional attempt to demonstrate, at a totally different level, the European alternative to the American educational system; this attempt was based on suggestions Heckscher had made as early as 1948.[9] The experiment was carried out with a small group of African American children. Its didactic aims were to prove that the development of the human intelligence potential does not depend on the ethnic group a person belongs to, rather on the quality of the education provided, and that there is no procedure that would allow for an "objective" measurement of the intelligence potential at all. In this experiment, the children were to acquire an extensive vocabulary; thus, they were given Latin lessons, learned the Greek alphabet, dealt with English poetry, and

acquired basic knowledge of paleography, epigraphy, and etymology. Referring expressly to the "malaise of the present universities" due to "undertrained (and what is possibly worse, mistrained) students, especially those choosing the humanities," Heckscher set up a scenario which mirrored the principles of German educational policy prevailing in the Weimar Republic in almost every respect. Symptomatically, he called for academic teachers who, "unconcerned with didactic methods," had the qualities of scholars and not of pedagogues and psychologists. To him, a curriculum covering a wide range—having in mind the canon of the German Gymnasium—was highly important. The influence of administrative bodies and trustees was to diminish in favor of a concentration on teaching subjects and methods. Referring to Panofsky, Heckscher demanded that knowledge already be imparted before students became adults, even if it would not be of direct use in the profession chosen. The most important didactic method was to subject the students to the "stimuli of great scholars."

In this, criticism of the American educational system—probably not possible until the refugees had established themselves within the American society—and a constructive attempt at improving the system are combined with a sociopolitical endeavor to prove wrong the prevailing theories regarding the connection between ethnic identity and intelligence and the resulting legitimacy to exclude certain sections of the population. The vehemence of this criticism is obviously due to a specific sensitivity to any theory recalling National Socialist politics. And it was perhaps not by chance that Heckscher's experiment with "underprivileged black children" took place in a very unconventional setting—on a little island, within a beautiful nature, in a very comfortable atmosphere: he carefully avoided those "Prussian" elements of German high school education that had fostered blind obedience and servility.

When, in the same year, Heckscher was asked to give his opinion about academic training in art history for the journal *Annals of Scholarship,* he came up with a bitter summary:

> I find both systems, the American and the European, equally lousy. I have strong allergic reactions to the mania for "survey-courses" for beginners, for the treatment of undergraduates as morons in perpetuity [they ARE morons but can be weaned at a much greater speed than is allowed to them]—I am saddened by the American system of treating Ph.D. candidates with kindergarten-methods. I am speechless at the neglect of Latin and the much-needed modern languages. I wonder

how it is possible that professors cannot be taught to forget about the linguistic public-relations barbarisms (they will 'address problems,' use the word 'Viable' . . . misuse the subjunctive, *et tanta multa alia*).[10]

Despite all criticism, in the end, hardly anything has changed. Humboldt's values could not be imposed on a different educational system. It was perhaps more on the level of personal relationships, in transmitting the standards of European art history to students who themselves worked as academic teachers later, that some of the stimuli imported by the refugees survived.

However, the Americans had reservations not only on the didactic, but also on the methodological level. As late as 1966, when a French translation of his *Studies in Iconology* was published, Panofsky remembered that the term *iconology* had a rather negative connotation in 1939, when the book was first published. Obviously, the term sounded so esoteric and suspicious that Francis H. Taylor, director of the Metropolitan Museum of Art, reacted to it with "a cry of fear."[11] According to him, iconology was a product of general indifference toward "human values"; it had been developed in a depressing cultural milieu so that one would not be surprised that the German students, traumatized, frustrated and desperate, had turned to the doctrines of Hitler; it reflected an attitude of mind which, if allowed to run unobstructed, would reduce the American veterans of World War II to a state in which they would sell "the apples of the Hesperides at the corners of Chicago and New York streets." The sharp reaction of another American art historian, Meyer Schapiro, is well known—but the fact that Panofsky refers to Taylor's text still in 1966, shortly before his death, hints at the ideological hostilities that the Jewish refugees had to face. As late as 1956, it still could hap-

Fig. 5. Richard Krautheimer

pen that the *Art Bulletin* returned a manuscript submitted by Sabine Gova, a German researcher today nearly forgotten, with the commentary that it was "like Panofsky's writings—too rich in ideas."[12]

But let us move on to the more agreeable part: The direct clash of two different academic cultures also had consequences that even the refugees regarded as positive. Many German-speaking art historians found that the English language

forced them to be more precise—no compound words, no multi-clause sentences. Furthermore, rhetoric efforts and the hermetic technical jargon normally used by the German-speaking scientists failed to be rewarded by the matter-of-fact Anglo-Saxon audience. Of course, it was difficult to translate terms such as *Lendentuch* (loincloth), as Adolph Goldschmidt remarked so aptly ("was heißt auf englisch 'Lendentuch'?"), or terms that cover entire philosophical concepts such as *Weltanschauung* (philosophy of life) or *Geistesgeschichte* (history of ideas). On a whole, the obligation to speak English has been felt to be liberating. Richard Krautheimer (fig. 5) found that the language, in the end, also changes the way of thinking. He also regarded it as a positive effect that English did not allow him to hide behind "Kantian categories" and "Hegelian fogs" but required him to speak in very precise terms. However, these suggestions sometimes still failed to be implemented: Horst W. (Peter) Janson (fig. 6) gave a lecture in 1955, in which he mused about America as a historico-cultural phenomenon that certainly matched the New World requirements in terms of contents but not in terms of form. Adhering to the good old tradition of multi-clause sentences, it says:

Fig. 6. Horst W. (Peter) Janson

> Der Europäer, der zum ersten Mal amerikanischen Boden betritt, pflegt vor dem Ansturm der neuen Eindrücke die Flucht zu ergreifen, indem er einerseits diese in vorgeprägte Bahnen leitet, um so der Mühe einer selbständigen Interpretation enthoben zu sein, andererseits aber auch sich selbst in vorgeprägte Bahnen leiten lässt, und nur das sieht, "was man gesehen haben muß," also Dinge, die entweder schon zum Zweck des Angesehenwerdens geschaffen wurden, oder aber zumindest–durch allzu vieles Angesehenwerden–bereits ein "Begriff" geworden sind und so die Gefährlichkeit des neuen verloren haben."[13]

Behind the typical German multi-clause structure, Janson wants to express the following: The European comes with very narrow horizons to the United States, so he only sees what he already knows, or the touristic highlights already worn out

visually. He continues: "America seems to be strange but not unknown; it always tempts us to apply European standards but soon shows that these standards are unsuitable without giving us a hint why. Thus, we are confused and helpless, feeling as if we have been placed into a world that seems to consist of known pieces, the sum of which, however, is totally different from the sum these pieces would yield in Europe."

Janson's self-critical summary of his experiences as a refugee shows that the acculturation process was found to be a burdensome, often impossible undertaking, despite the generally warm reception on the side of the United States and the Americans. Loss of language and status, a different mentality, and the absence of the familiar cultural infrastructure caused the German-speaking refugees to remain in an environment they would regard as strange until the end of their lives even if their career seemed to be successful. On the psychological level, the latent anti-Semitism in the United States showed to be another disruptive factor. Although this attitude was mainly fostered by xenophobic reactions and therefore could not in any way be compared with the racist extermination policy in Germany, it could be

Fig. 7. Walter Friedlaender lecturing at NYU

irritating in everyday life, as if well-known menaces showed up in a new garment. When Walter Friedlaender (fig. 7) wanted to visit his colleague and friend Erwin Panofsky, who was on holiday in an elegant resort in Maine, Panofsky regretted to have to inform his visitor that finding lodgings posed a problem: "The great hotels do not want any Jews."

Seen in this light, the old cosmopolitan ideal of the European scientists going back to Erasmus (that is, the ideal of an international republic of scholars) seems to be a utopian, relativistic construction. It does not embody a universal standard, rather an identifying model for life, which offers the continuity of a spiritual home, and it did so especially to the expelled intellectuals robbed of their Germanness. Like the refugees themselves, this model remained an alien element in the American society. Some of them even anticipated this: Richard Krautheimer, possessing the same anthropologist's skill of observation as did Panofsky, described his arrival in the United States as follows: "The second day in New York Max Ascoli, anti-fascist and refugee, said to me . . . 'These Americans—if only they would have green skin! In Africa they are black—in China, yellow—and you know, they are different. Here they look like you and me. But they are different.'"[14]

From a more distant point of view, I think that the clash of European and American mentality has created, in the case of our discipline, something very positive: a new art history that would have never come to light without the cultural discrepancies today more often lamented rather than approved. To me it is very obvious that today we still operate in two different theaters. It is the never-ending discussion, the continuous misunderstanding, the mutual exchange that we all benefit from, both professionally and personally. Intercultural meetings like this, inviting scholars from different national backgrounds to debate a precisely formulated question and to reflect their own behaviors, are necessary to keep the academic discourse running beyond national, ethnic, or social boundaries.

1. Erwin Panofsky to Walter Friedlaender, 3 Feb. 1932, Friedlaender Papers, Leo Baeck Archive, New York.

2. Erwin Panofsky to Gertrud Bing, 3 March 1935, Archive of the M. M. Warburg-Bank, Hamburg.

3. Thomas F. Reese, "Mapping Interdisciplinarity," *Art Bulletin* 77 (1995): 544–49.

4. Ernst Kitzinger to Frederick B. Deknatel, 21 Feb. 1949, Harvard University Archive.

5. Erwin Panofsky to Bruno Snell, 27 March 1952, PA Panofsky, Staatsarchiv Hamburg, Hochschulwesen: "Die jungen Leute sind hier, so fleißig, loyal und intelligent sie sein mögen, doch während ihrer

Universitätsjahre wesentlich rezeptiv, und wenn sie fortgehen, werden sie sofort in eine Lehr- oder Museumsstelle resorbiert, die ihrer weiteren Entwicklung meist, oder wenigstens sehr oft, ein Ende setzt."

6. Kurt Weitzmann, *Sailing with Byzantium from Europe to America: The Memoirs of an Art Historian* (Munich: Editio Maris, 1994), 154.

7. Erwin Panofsky, "Three Decades of Art History in the United States: Impressions of a Transplanted European," in *Meaning in the Visual Arts* (Garden City, N.Y.: Doubleday, 1955), 338.

8. Erwin Panofsky to Max M. Warburg, 20 Sept. 1935, Archive of the M. M. Warburg-Bank, Hamburg.

9. William S. Heckscher and Elizabeth C. Sands, "The Walltown Charitable Community Center (Experiment in Vocabulary Building)/Considering the Future (Suggestions Toward an Experimental School for Underprivileged Black Children), Durham, N.C., 1970," manuscript, Warburg-Archiv, Hamburg.

10. William S. Heckscher to Ruth Graham, *Annals of Scholarship,* 20 Aug. 1982, Warburg-Archiv Hamburg.

11. Erwin Panofsky, "Préface à l'édition française," *Essais d'Iconologie. Les thèmes humanistes dans l'art de la Renaissance* (Paris: Gallimard, 1967), 3–5.

12. Sabine Gova to Paul Frankl, 22 Nov. 1956, Frankl Papers, Germanisches Nationalmuseum Nürnberg.

13. H. W. Janson, "Amerika," manuscript, Warburg-Archiv, Hamburg.

14. Richard Krautheimer, "Anstatt eines Vorworts," in *Ausgewählte Aufsätze zur europäischen Kunstgeschichte* (Cologne: DuMont, 1988), 14: "Am zweiten Tag in New York schon sagte mir Max Ascoli, Antifaschist und Emigrant . . . 'Die Amerikaner, wenn sie nur eine grüne Haut hätten! In Afrika sind sie schwarz—in China gelb—und du weisst, sie sind was anderes. Hier sehen sie aus wie du und ich. Aber sie sind was anderes.'"

Moving Apart: Practicing Art History in the Old and New Worlds

Françoise Forster-Hahn

When Michael Ann Holly invited me to speak at this conference, I was asked to talk about my own experience as a scholar working, lecturing, publishing on two continents. Several conversations preceded today's attempt of putting into a more coherent form my impressions of recent years that art historical practice in the Old and New Worlds—in blatant defiance of the electronic age—is moving apart. Such a reflection, of course, is shaped by biography and therefore the map of art history viewed through the lens of personal experience.

Not long ago a prominent German scholar, whose own formation as an art historian is rooted in the Ulmer Verein, asked me after an intense meeting in this country: "What does it mean that American debates are so obsessively focused on the canon?" And earlier this year, I had to explain to another leading art historian from Europe why there is such a rift between those who defend art history and those who fervently promote visual culture, because he argued, "Isn't it all *Kunstwissenschaft*?" For someone who has written a dissertation on caricature in a very traditional department at a university in the very Catholic Rhineland in Adenauer's postwar Germany and never ever felt marginalized, these two questions suddenly brought into sharp focus the differences of art historical practices and their traditions: the art historian may constantly be on the move, but at the same time the practices of our discipline seem to be moving apart even though the contemporary art historian spends almost an equal amount of time in the air, on the train, or in the car as in the lecture hall, library, or study.

Having studied with Herbert von Einem in Bonn (where I was awarded my Ph.D.), with Gotthard Jedlicka in Zurich, and Hans Sedlmayr in Munich in postwar Europe, I experienced my first encounters with German emigrant art historians when I pursued research for my dissertation on eighteenth-century English and German caricature in London and found a scholarly home at the Warburg Institute. I was one of the first German Ph.D. students after the Nazi period to spend considerable time at the Warburg Institute where Leopold D. Ettlinger and Ernst Gombrich became my advisors, mentors, and friends. Before I left Bonn on this rather adventurous trip—what is today often a quick twenty-four-hour trip for a lecture or meeting—my *Doktorvater,* Herbert von Einem, called me into his

office and in a very serious tone of voice explained to me what it meant for a young German student to do research at the Warburg Institute, what was expected of me—beyond my scholarly endeavors—and what I might expect there. Coming from a family active in the resistance against Hitler, I was well aware of what my professor—who rarely if ever touched on personal issues—meant. It was these extended stays in London and my intensive discussions with Gombrich and Ettlinger which had a profound impact upon my art historical education. These conversations—I more the listener—were conducted in English when we found ourselves in public, but often shifted into the German language in private; the latter, however, only initiated by my English hosts. Gombrich, in particular, guided my research, since he had published together with Ernst Kris the *Principles of Caricature,* an investigation based on Freud's psychoanalytical studies.[1] With such a dissertation project evolving in the environment of the Warburg Library and its scholarly practices—an aesthetic perspective that the topography of the books so visually represents—there was no danger of being caught in the narrow boundaries of "high" art. My study did not only lead me, quite naturally, to theories and principles of other disciplines, it also pointed me to a German historiographical tradition that is largely forgotten or unabsorbed in this country.

The literature on caricature, its history, and social function is a good case in point. One of the comprehensive early studies on the history and nature of caricature was Eduard Fuchs's *Die Karikatur der europäischen Völker vom Altertum bis zur Neuzeit,* a two-volume publication that appeared in a second edition in 1902.[2] His book *Das erotische Element in der Karikatur,*[3] published in a first version in 1904, was not on the open shelves then, but safely stored in Bonn's University Library in the so-called *Giftschrank* (poison cabinet). However, it is part of a whole series of early volumes on the popular arts and the social and cultural contexts in which they were produced. These studies pointed to a map of our discipline that was inclusive rather than exclusive. Furthermore, they also alerted to a line of art historical writing that had an ancestry in the art history department of Bonn University.

Like modern-day cultural institutions, where every component of the building bears the name of a donor, the Kunsthistorisches Institut, newly rebuilt after the Second World War, prominently features the names of our professional ancestors over the doors leading to the study rooms: the Anton-Springer-Zimmer, the Carl-Justi-Zimmer, the Paul-Clemen-Zimmer. Of the three, only Justi made it into a recent edition of the *Brockhaus Lexikon,* while Springer is the only one to whom Michael Podro devoted a well deserved critical analysis.[4] Did we know who they were or what

their work stands for? Barely. Of course, we had read the books of the "master biographer Carl Justi"—*Winckelmann und seine Zeitgenossen* (1866–72), *Diego Velasquez und sein Jahrhundert* (1888), *Michelangelo. Beiträge zur Erklärung der Werke und des Menschen* (1900 and 1909);[5]—we knew Paul Clemen's work, closest to us in time,[6] but Anton Springer? Even though I was assigned the Springer-Zimmer, I understood little how his work and art historical position might link up to my own. As Michael Podro so acutely observed: "The art historian most similar to him in theoretical stance in the next generation—the generation which included Heinrich Wölfflin and Alois Riegl—was Aby Warburg."[7] The leap from the Springer-Zimmer in Bonn to the Warburg Institute in London was not so big after all!

Anton Springer (1825–1891),[8] who had received his Ph.D. at Tübingen University in 1848 with a dissertation on Hegel's conception of history, taught in Bonn from 1852 to 1872. In both his dissertation and his *Habilitationsschrift* he argued against Hegel's philosophical system, trying to prove the inner contradictions of Hegel's dialectical method. As a scholar and teacher he went on to establish art history as an academic discipline firmly grounded in a historical approach. In a postscript to *Bilder aus der neueren Kunstgeschichte* (1869) Springer wrote: "And alongside this psychological characterization [of artistic activity], art history must describe the milieu in which these artists worked, the influences to which they were exposed, and the heritage that they administered and built upon. This can be referred to as the drawing up of the historical, specifically the cultural-historical, background." And he goes on to argue against the separation of these cultural "considerations" from "art historical narration."[9] It was the integration of a concise formal description and analysis of the work of art into its historical, social, and cultural fabric that he proposed. Perhaps it had a certain logic that Springer, who had begun his career as a political journalist fighting against reactionary forces in 1848, giving a lecture course and publishing on the history of the age of revolution[10]—would write a history of art weaving visual analysis with critical interpretation of the conditions of historical and social life. As a teacher he brought this integrative approach also into the classroom. One of his many, later prominent, students, Count Harry Kessler, describes his teacher as follows: "Springer, an inveterate democrat and pan-German firebrand, retreated from politics into art history, but the fighting spirit stayed with him. His lectures were speeches: we were his parliament."[11]

It is revealing to read how Springer reflected upon his own life and achievements as a scholar in his autobiography *Aus meinem Leben*[12] and how the immediately following generation of art historians and writers perceived his scholarly contri-

bution to the new academic discipline. If there is one dominant assessment, it is the emphasis upon the political dimension of Springer's work and the inseparable connection between his role as a political journalist and as a creative scholar, who formulated a keenly historical and integrative approach to the study of art. In his essay on Springer for the *Allgemeine Deutsche Biographie* of 1893 Paul Clemen calls him "an art historian and political writer"[13] whose political opposition and subsequent persecution by the Prussian government profoundly hindered his university career. But Clemen also recognized how political position and activity informed Springer's innovative scholarly methodology: by firmly demarcating the history of art from any superficial cultural narrative and one-sided connoisseurship he was able to transplant the study of art into the historical field establishing the new area of study as an independent and methodologically concise academic discipline.[14] As Hubert Janitschek emphasized in his analysis of Springer's methodology, in his dissertation on Hegel's interpretation of history, "in which the twenty-three-year-old one disproves Hegel from Hegel, Springer sets forth that state, religion, science and art cannot be separated from one another and that therefore also our knowledge of the historical condition of an epoch can only be acquired through the knowledge of all these manifestations of the 'Zeitgeist.' Thus the significance of art within historical development and historical formation was already fully recognized here."[15]

Despite a distanced and strained personal relationship with his colleagues in Berlin, Springer's integrating method links his work to the tradition of the "Berlin School," the writings of Carl Friedrich von Rumohr (1785–1843), Franz Kugler (1800–1858), Gustav Friedrich Waagen (1794–1868), and Carl Schnaase (1798–1875). In contradiction to Hegel, these art historians—Rumohr, Kugler, Schnaase, and Springer—not only positioned art within the complexities of social life, but lastly attributed to the work of art an active role shaping social, religious, and cultural life. Rather than understanding art as merely representing or expressing thought, they perceived art as an active agent in the production of meaning.[16]

Already in 1832 Carl Friedrich von Rumohr had turned against a "misunderstood idealism" in the interpretation of the visual arts and argued against Lessing's theory of beauty. Usually stereotyped as the founder of archival research and a staunch advocate of the study of sources and documents, Rumohr's writing about art is in fact much broader and more theoretically informed than recognized today.[17] In his book *Drey Reisen nach Italien. Erinnerungen* (1832) Rumohr devotes the entire first part to a theoretical discourse about the position of the visual arts within their larger

milieu ("Umgebung") characterizing "the best subject" of the arts not as separate, but integrated into the larger whole "as more general circumstances of the time, history, religion, the course of intellectual formation, even the temper of the receiver, powerfully obtrude upon what one calls here the subject of art."[18]

This emphasis upon the interdependency of art and history dominates the methodological approach of the Berlin School. When Franz Kugler reviewed Gustav Friedrich Waagen's *Künstler und Kunstwerke in England und Paris* (1837–39), a publication of his prominent Berlin colleague, Kugler stresses the central function which Waagen's detailed survey of the history of collecting and connoisseurship assumes in this narrative, because these presentations "form, after all, an important cultural-historical moment, and it might lead to significant results, if they . . . would also be applied to the other European countries." What mattered for the critic Kugler most of all was Waagen's ability to give the reader "a reliable view of the terrain" in which the art he discussed was rooted.[19]

As Ernst Heidrich had already succinctly recognized before the First World War, when he wrote his essays on the history and methodology of our discipline, Alexander von Humboldt provided an influential paradigm. The quote from Humboldt's *Kosmos* that precedes the second edition of Kugler's pivotal *Handbuch der Geschichte der Malerei*, revised by Jacob Burckhardt (1847), illuminates the goal of the authors to produce a book for the history of culture, "in which also the less developed and the ruined, even what is only known through tradition find their place as witness of the century in question" (fig. 1).[20] When Kugler characterized in his own preface for this second edition[21] the author's new "tendency"—as opposed to the idealism and philosophy of the Romantic period—he referred to the choice of Humboldt's lengthy quote as a defining motto: "Details of reality . . . everything that belongs to the field of variability and actual contingency cannot be constructed from ideas [philosophical concepts]. World description and world history are therefore on the same rank of empiricism."[22] And as Humboldt continues, a reflective interpretation of both, world description and world history, and the meaningful ordering of the appearances of nature and of the events of history, being deeply intertwined, eventually lead to clarity and to the laws of science which are the ultimate goal of all human inquiry. With this motto from Humboldt's *Kosmos,* both Kugler and Burckhardt emphasize the shift in philosophical theory from the aesthetics of the Romantic period. It is no surprise then to find that Springer too made reference to Humboldt's *Kosmos* when he discussed the place of art within world history.[23]

HANDBUCH

der

GESCHICHTE DER MALEREI.

Einzelheiten der Wirklichkeit, sei es in der Gestaltung oder Aneinanderreihung der Natur-
gebilde, sei es in dem Kampfe des Menschen gegen die Naturmächte, oder der Völker gegen
die Völker, alles, was dem Felde der Veränderlichkeit und realer Zufälligkeit angehört, kann
nicht aus Begriffen abgeleitet (construirt) werden. Weltbeschreibung und Weltgeschichte
stehen daher auf derselben Stufe der Empirie : aber eine denkende Behandlung beider, eine
sinnvolle Anordnung von Naturerscheinungen und von historischen Begebenheiten durchdringen
tief mit dem Glauben an eine alte innere Nothwendigkeit, die alles Treiben geistiger und
materieller Kräfte, in sich ewig erneuernden, nur periodisch erweiterten oder verengten
Kreisen, beherrscht. Sie führen (und diese Nothwendigkeit ist das Wesen der Natur, sie ist
die Natur selbst in beiden Sphären ihres Seins, der materiellen und der geistigen) zur Klarheit
und Einfachheit der Ansichten, zur Auffindung von Gesetzen, die in der E r f a h r u n g s -
W i s s e n s c h a f t als das letzte Ziel menschlicher Forschung erscheinen.

Alexander von Humboldt, Kosmos.

ERSTER BAND.

Fig. 1. Title page from Franz Kugler, *Handbuch der Geschichte der Malerei,* 2d ed., rev. by Jacob Burckhardt
(Berlin: Duncker and Humblot, 1847)

The aesthetic principles of the Berlin School are of course not divorced from the production of art itself. Already in 1800, in his journal *Propyläen*, Goethe had criticized art in Berlin as being prosaic: "there seems to be at home in Berlin naturalism with its demand for reality and usefulness, and the prosaic spirit of the time manifests itself there most of all. Poetry is displaced by history."[24] It was the sculptor Johann Gottfried Schadow who immediately defended the arts in his home town in *Eunomia* in a firm point by point rebuttal: "I would be glad," he wrote, "if we possessed a characteristic sense of art and though this is regarded in the *Propyläen* as belonging on the bottom rung, it is nevertheless the only one that will enable us Germans to produce works of art in which one would see us as ourselves."[25] Rather than separate the formulation of theoretical discourse from the production and consumption of art we might focus also on the reciprocity between the two.

This anti-Hegelian tradition and the enormous diversity of art historical approaches—Springer (1825–1891) being of the same generation as for instance Conrad Fiedler (1841–1895) and Adolf von Hildebrandt (1847–1921) and writing, in part at least, simultaneously with Alois Riegl (1858–1905), Heinrich Wölfflin (1864–1945), and Wilhelm von Bode (1845–1929)—contributed to a variety of methodologies that made room for critical choices.

Returning to the postwar years after 1945: while the immeasurable loss of art historians through Nazi persecution radically disrupted the historical continuity of the discipline, the critical reception of some Jewish and emigrant art historians (Panofsky) came earlier, of others (Warburg) much later. Since a large number of German emigrant art historians had a profound impact on the writing and teaching of art history in Great Britain and the United States, the commonalities between the continents, particularly in the area of iconographic studies, were profound. When this phase was followed in the late 1960s and 1970s on both sides of the Atlantic by a wave of Marxist studies and a social history of art, the affinities remained strong—with all differences in tone and modulation. It was only afterward, when younger American scholars began to be swept away by postmodernism and French theories that a rift developed in the reflection and practice of what a modern history of art should be and how this "new art history" was applied.

Is it simply a stubborn clinging to old-fashioned ways in the Old World or is it perhaps the long tradition of diversity, a vast variety of different approaches and subjects of study, which have prompted a more careful, but also a more critical response to recent theories? Are Europeans hopelessly old-fashioned and

conservative as some Americans claim, or are Americans predominantly focused on a critical system of concepts such as the "gaze," "representation," "ritual," or "performativity" (to name just a few) divorced from historical grounding and the work of art itself, as some Europeans assert? Is what I define as "moving apart" conditioned by the different historical circumstances and traditions?

Let me conclude by briefly pointing to a current book project in Germany that the editors define in direct response to an American publication: Andreas Köstler (Ruhr-Universität, Bochum) and Thomas Hensel (Kunsthochschule für Medien, Cologne) are planning a complementary volume to the *Kunstgeschichte. Eine Einführung* (Introduction to Art History) edited by Hans Belting, Heinrich Dilly, Wolfgang Kemp, Willibald Sauerländer, and Martin Warnke—a classic in Germany, first published in 1985, but little-known here.[26] The new volume will present a variety of different methodological approaches, but focus on one central object and its history: Berlin's Museum-Island. The editors' statement of purpose sharply illuminates the difference I have tried to trace. After referring to the recent (1990) shift of our discipline to a plurality of methodologies, a multiplicity that does no longer allow for a clear separation, they write: "The newer theoretical literature is restricted to a collection of recent methodological approaches by individual scholars. In the most recent ambitious attempt of an 'Introduction,' Robert Nelson and Richard Shiff's *Critical Terms for Art History* (1996),[27] one can observe the final fracturing of methodology into abstract concepts such as *'art history,' 'representation,'* or *'gaze.'* To us, the conception of different methodological approaches seems especially meaningful, when these are concentrated on one single object."[28] The advertisement for *Critical Terms for Art History* by the University of Chicago Press—as does the title of the anthology—underlines this fracturing into individual abstract units of meaning such as "representation," "sign," "originality," etc., each term pointing to a different set of thoughts.[29] In the Old World, the concept of comparative analyses concentrated on one single object and its history constructs a unifying principle framing different approaches; in the New World, the collection of individual theoretical essays presents a fractured picture of diverse possibilities: on one side, there is the attempt at preserving historical continuity and aesthetic coherence, on the other, the preference for an examination of abstract terms in highly individualized systems of thought.

I gratefully acknowledge the generous support of the following institutions: an extramural grant of the University of California, Riverside, supported my studies abroad; the staff of the Kunstbibliothek, Staatliche Museen–Preussischer Kulturbesitz, Berlin, and of the Library at the Clark Art Institute, Williamstown, Massachusetts, assisted my research with their expertise. Pan Wendt, as Graduate Research Assistant at the Clark Art Institute, helped with the bibliographical searches, and Barbara Wotherspoon patiently provided clerical assistance.

1. Ernst H. Gombrich and Ernst Kris, *Caricature* (London: The King Penguin Books, 1940). Revised (with E. H. Gombrich) as "The Principles of Caricature" in Ernst Kris, *Psychoanalytic Explorations in Art* (London: George Allen and Unwin Ltd., 1953), 189–203. Ernst Kris first explored the subject in "Zur Psychologie der Karikatur," *Imago* 20 (1934): 450–66.

2. Eduard Fuchs, *Die Karikatur der europäischen Völker vom Altertum bis zur Neuzeit,* 3 vols. (Berlin: A. Hoffmann & Co., 1901–4).

3. Eduard Fuchs, *Das erotische Element in der Karikatur* (Berlin, 1904). Enlarged and revised: *Geschichte der erotischen Kunst,* 3 vols. (Munich: Albert Langen, 1908–28).

4. Michael Podro, *The Critical Historians of Art* (New Haven and London: Yale University Press, 1982, reprinted 1984), 152–58. However, all three scholars are listed in *Deutsche Biographische Enzyklopädie,* ed. Walther Killy and Rudolf Vierhaus (Munich: K. G. Saur); Springer, 1998, 9:420; Justi, 1997, 5:388; Clemen, 1995, 2:339.

5. Justi (1832–1912) taught in Bonn from 1872, when he became the successor of Springer, to his retirement in 1901. C. Justi, *Winckelmann und seine Zeitgenossen,* 3 vols. (Leipzig, 1866–72); *Diego Velasquez und sein Jahrhundert,* 2 vols. (Bonn: Cohen, 1888); *Michelangelo. Neue Beiträge zur Erklärung der Werke und des Menschen,* 2 vols. (Berlin: Grotesche Verl.-Buchhandlung, 1909). See also Wilhelm Waetzoldt, *Deutsche Kunsthistoriker. Von Sandrart bis Rumohr,* 2d ed. (Berlin: Bruno Hessling, 1965), 2:239–77, 296. Udo Kultermann, *Geschichte der Kunstgeschichte. Der Weg einer Wissenschaft* (1966), rev. new ed. (Munich: Prestel, 1990), 124–26; English ed.: *The History of Art History* (New York: Abaris Books, 1993), 128–30. See also Udo Kultermann, *Kleine Geschichte der Kunsttheorie,* 2d rev. ed. (Darmstadt: Wissenschaftliche Buchgesellschaft, Primus Verlag, 1998).

6. Paul Clemen (1866–1947), Justi's successor at the University of Bonn, taught there from 1902 to 1936 and at Harvard University from 1907 to 1909.

7. Podro, *The Critical Historians of Art,* 158.

8. Waetzoldt, *Deutsche Kunsthistoriker,* 2:106–29, 292. Kultermann, *Geschichte der Kunstgeschichte,* 116–19; Kultermann, *History of Art History,* 119–23; Podro, *The Critical Historians of Art,* 152–58.

According to Waetzoldt (2:281–84) the important dates of Springer's career are: 1852, *Venia legendi in Bonn;* 1852–57, *Kunsthistorische Briefe;* 1855, *Handbuch der Kunstgeschichte,* 6 vols.; 1866, *Wege und Ziele der deutschen Kunst;* 1869, *Bilder aus der neueren Kunstgeschichte;* 1892, *Albrecht Dürer;* 1892, *Aus meinem Leben* (ed. Jaro Springer).

9. From "Kunstkenner und Kunsthistoriker," in *Bilder aus der neueren Kunstgeschichte,* here quoted in English trans. from Kultermann, *History of Art History,* 119. Anton Springer, *Bilder aus der neueren Kunstgeschichte,* 2d rev. ed., 2 vols. (Bonn: Adolph Marcus 1886). See "Kunstkenner und Kunsthistoriker," 2:399.

10. Waetzoldt, *Deutsche Kunsthistoriker,* 107–8.

11. Harry Graf Kessler, *Gesichter und Zeiten, Erinnerungen,* ed. Cornelia Blasberg and Gerhard Schuster (Frankfurt am Main: Fischer, 1988), 192. Here quoted in a modified English translation from Kultermann, *History of Art History,* 120.

12. Anton Springer, *Aus meinem Leben. Mit Beiträgen von Gustav Freytag und Hubert Janitschek* (Berlin: G. Grote'sche Verlagsbuchhandlung, 1892).

13. Paul Clemen, "Anton Springer," in *Allgemeine Deutsche Biographie,* ed. Historische Commission bei der Königl. Akademie der Wissenschaften (Leipzig: Duncker and Humblot, 1893), 35:315–17, especially 315.

14. Ibid., 317.

15. Hubert Janitschek, "Anton Springer als Kunsthistoriker," in Springer, *Aus meinem Leben,* 359.

16. Michael Podro, *The Critical Historians of Art,* on "Rumohr's Response to Hegel," 27–30; "Schnaase's Prototype of Critical History," especially "Art as Culturally Autonomous: A Response to Hegel," 40–42; and "Springer's Rejection of Hegel," 152–54, and "Springer's Alternative Aesthetics," 154–58.

17. For an earlier revisionist assessment, also of Karl Schnaase, see Ernst Heidrich, *Beiträge zur Geschichte und Methode der Kunstgeschichte,* intro. Heinrich Wölfflin (Basel: Benno Schwabe & Co. Verlag, 1917). More recently: Heinrich Dilly, *Kunstgeschichte als Institution. Studien zur Geschichte einer Disziplin* (Frankfurt am Main: Suhrkamp, 1979), 116–32.

18. Carl Friedrich von Rumohr, *Drey Reisen nach Italien. Erinnerungen* (Leipzig: F. A. Brockhaus, 1832).

19. Franz Kugler, "Kunstwerke und Künstler in England und Paris. Von Dr. G. F. Waagen, Director der Gemäldegalerie des Königl. Museums zu Berlin. 3 Theile, Berlin, 1837–1839," in *Kunstblatt* 22, no. 44 (25 May 1841): 173–77, especially 174.

20. Heidrich, *Beiträge zur Geschichte und Methode der Kunstgeschichte,* 70–71. Heidrich, who died in the war in 1914, never published his studies. They only appeared in print in 1917 with an introduction by Wölfflin. Burckhardt's quote is taken from his preface in Franz Kugler's *Handbuch der Geschichte der Malerei seit Constantin dem Grossen, unter Mitwirkung des Verfassers umgearbeitet, und vermehrt von Dr. Jacob Burckhardt,* 2 vols., 2d ed. (Berlin: Duncker and Humblot, 1847), 1:ix.

21. Ibid., 1:viii.

22. Ibid., 1: title page. "Einzelheiten der Wirklichkeit, sei es in der Gestaltung oder Aneinanderreihung der Naturgebilde, sei es in dem Kampfe des Menschen gegen die Naturmächte, oder der Völker gegen die Völker, alles, was dem Felde der Veränderlichkeit und realer Zufälligkeit angehört, kann nicht

aus Begriffen abgeleitet (construirt) werden. Weltbeschreibung und Weltgeschichte stehen daher auf derselben Stufe der Empirie aber eine denkende Behandlung beider, eine sinnvolle Anordnung von Naturerscheinungen und von historischen Begebenheiten durchdringen tief mit dem Glauben an eine alte innere Nothwendigkeit, die alles Treiben geistiger und materieller Kräfte, in sich ewig erneuernden, nur periodisch erweiterten oder verengten Kreisen, beherrscht. Sie führen . . . zur Klarheit und Einfachheit der Ansichten, zur Auffindung von Gesetzen, die in der *Erfahrungs-Wissenschaft* [emphasis in the original] als das letzte Ziel menschlicher Forschung erscheinen."

23. Anton Springer, *Kunsthistorische Briefe. Die bildenden Künste in ihrer weltgeschichtlichen Entwicklung* (Prague: Friedrich Ehrlich, 1857), 8–10.

24. Goethe published his critical interpretation of the visual arts in Berlin in "Flüchtige Übersicht über die Kunst in Deutschland," *Propyläen* 3 (1800), reprinted in *Goethes Preisaufgaben für bildende Künstler 1799–1805,* ed. Walther Scheidig (Weimar: Hermann Böhlaus Nachfolger, 1958), 125–27, especially 126. See also Scheidig's very thorough discussion of Goethe's knowledge of artistic production in Berlin and Schadow's response, 130–43. Cf. F. Forster-Hahn, "Aspects of Berlin Realism: From the Prosaic to the Ugly," in *The European Realist Tradition,* ed. Gabriel Weisberg (Bloomington: Indiana University Press, 1982), 125.

25. Ibid., 125–26. Schadow's critical response, "Über einige in den *Propyläen* abgedruckte Sätze Goethes die Ausübung der Kunst in Berlin betreffend," which succinctly characterized the visual arts in Berlin, appeared in the journal *Eunomia* 1 (1801), reprinted in *Gottfried Schadow, Aufsätze und Briefe nebst einem Verzeichnis seiner Werke,* ed. Julius Friedlaender, 2d. ed. (Stuttgart, 1890), 44–45. See also Scheidig, *Goethes Preisaufgaben,* 125–27. For a recent discussion of the Goethe-Schadow controversy see also *Johann Gottfried Schadow, Kunstwerke und Kunstansichten, Ein Quellenwerk zur Berliner Kunst- und Kulturgeschichte zwischen 1780 und 1845,* ed. Götz Eckardt, 3 vols. (Berlin: Henschelverlag, 1987), 1:62, 2:449–50.

26. Hans Belting, Heinrich Dilly, Wolfgang Kemp, Willibald Sauerländer, and Martin Warnke, *Kunstgeschichte, Eine Einführung,* 4th ed. (Berlin: Dietrich Reimer, 1985).

27. *Critical Terms for Art History,* ed. Robert Nelson and Richard Shiff (Chicago: University of Chicago Press, 1992).

28. The editors in a letter to the author, 23 May 2001.

29. University of Chicago Press, *List of Publications,* 2002, 16.

PART TWO

QUESTIONING MYTHS AND
MASTER NARRATIVES OF ART HISTORY

Her Majesty's Masters

Mieke Bal

The most characteristic question that Dutch intellectuals ask about art is neatly packed in the opening sentence of Ernst van de Wetering's 1996 book, *Rembrandt: The Painter at Work:* "Is every Rembrandt a Rembrandt?" It is the question of attribution, and it generates a discourse in which the determination—through, mostly, judgment—of the "hand" of the artist leads to the reconfirmation or rejection of "mastery."

I feel slightly out of place here, because it is not possible for me to speak to the art history scene in the Netherlands; I can only speak about the reasons why I cannot do so. But those reasons *are* relevant to the topic of this conference, for they concern the iron curtain that constitutes the boundary between the discipline of art history and the rest of the academy in my country. Since I am on the other side of that iron curtain, I can rarely visit and invite back. I have tried both but to no avail, which is truly the main reason why I cannot speak to the topic of this conference from within the experience of art history. That the closed nature of the Dutch art history community has to do with the topic becomes clear when one compares it to my access to the discipline in France, Germany, the United Kingdom, and the United States—about which I can say more than about the current state of art history in my own country.

One aspect of the closure is national, in a double sense: Dutch national scholarship focuses on Dutch national heritage. As Mariët Westermann writes in the beginning of her forthcoming article in *Art Bulletin* on the state of the study of Netherlandish art, the overwhelming majority of people, funding, and interest is tied up with reconfirming the same heroes throughout that art.

That this renewed obsession with the canon is a genuine case of neo-nationalism in the Dutch academy is clear from two phenomena. One is the less than original move to jump on the bandwagon of interdisciplinarity—made harmless by turning it into simple multidisciplinary grouping—through the recent creation of a "new" center for the study of—the *Golden Age!* It, too, is proudly named after that shamefully nationalistic nineteenth-century term. This continued predominant interest in a few decades of the seventeenth century—only rarely interrupted, and only then with the Italian Renaissance—makes it difficult for those

few colleagues working on contemporary art to get funding for projects, despite the fact that student interest is in inverse proportion to this distribution of means and power. As one consequence, no love is lost between art history and the world of contemporary art practice. This, in turn, translates into an absolute severance of any possible ties between art history and studio art students.

Within this setting, of course, Rembrandt scholarship commands a near-monopoly. This is the second symptom of (neo-)nationalism. The funds that pour into the Rembrandt Research Project (RRP) are gigantic; the influence the team leaders have over appointments, fellowships, publication opportunities, and more is almost unlimited; and the intellectual effect on the practice of art history, if I may say so, is disastrous.[1] Don't misunderstand me: that people devote their lives to the great master in the service of a national heritage is fine by me. What I do take issue with are the misunderstandings this tunnel vision of the discipline produces: this near-exclusive focus on the combination of Dutch glory and mastery has produced a disturbing new cult of mastery itself. It pervades a culture reputed for its progressiveness and tolerance. The question I find most interesting is this: why does the academic community behave like schoolchildren, bowing to the master instead of exercising the autonomous critical judgment it is supposed—and is even paid—to do?

For this reason alone—the bond between attribution scholarship, judgment, and mastery—an analysis of this discourse seems warranted.[2] Part of my current project at the Getty, called "The Anthropomorphic Imagination," includes just such an analysis. The section on the discourse of the "hand" is devoted to a critique of slippages, first between the painting and the persona of the artist, and then, between the artist and the critic, who totally identifies with the artist. In this paper, I will give a rhetorical analysis of this "hand" discourse.

I will argue that through the act of judgment, mastery is claimed for the master painter and gained by the master expert. Judgment on the "hand" is not only relevant for the composition of the corpus. It is also, inherently, an entrance into all kinds of other judgments, including on personality and aesthetic, and even on personal choices. Moreover, since such mastery is conquered through the promotion of nationalist values, I have called this paper "Her Majesty's Masters." My point here will be that the identity of the "masters" shifts in the process.

Consider the example of *The Polish Rider* (fig. 1). Following suggestions made in the early 1980s by the RRP, this painting tends to be divided into two parts, one considered to be "authentic" (autographically painted by the artist called

Fig. 1. Rembrandt van Rijn (Dutch, 1606–1669), *The Polish Rider*, 1657. Oil on canvas, 46 x 53 ⅛ in. (116.9 x 134.9 cm). The Frick Collection, New York

"Rembrandt"), the other labeled as being "from Rembrandt's studio." It is this painting that stirred the minds of many, both scholars and members of the public, and, perhaps, contributed to the deadlock that temporarily upset the publication rhythm of the *Corpus*.[3]

The most recent "hand" discourse published by RRP scholar van de Wetering revises the criteria somewhat. Unity—a lack of which would be deadly for the painting—is no longer an absolute criterion. Until recently the RRP team classified the paintings as "A" (accepted), "B" (uncertain), and "C" (rejected). In the new, revised version of the RRP's discourse, *The Polish Rider* is again used as a paradigmatic example. They have now dispensed with the "C" category, and the disunified nature of the painting is no longer necessarily a criterion for rejecting authorship. The analysis in the pre-publication announcement that anticipates volume 4—to

me a very convincing and illuminating one—neither elaborates on nor justifies the relative weight that each part of a multi-hand painting is given in relation to the judgment "Rembrandt/Not Rembrandt" that is ultimately passed. For this reason alone—the bond between hand and judgment—an analysis of this discourse seems warranted. And as long as that weighing has not led to a fundamental revision of the hand discourse in general, the tension inherent in the co-presence of what I will analyze below as the three *topoi* of the hand, will remain unresolved.

I will make my case first through a concrete example from the RRP, then propose an interpretive framework for it, in what I call "the anthropomorphic imagination." A summary historical positioning of this discourse as profoundly modernist will then follow, placing it first in the context of art history, then in the context of art. In between, however, I will sketch the rhetorical figurations involved and the way these facilitate the bond between attribution and judgment. In conclusion, I will outline some thoughts about the "why" of the underlying projections.

Portrait of the Artist as a Young Man

The *Corpus* dates an early self-portrait 1629, when Rembrandt was twenty-three (fig. 2). In this and other self-portraits of the young artist, the discourse equates the style to the man—as though the style is a living, evolving man. Here is an example of that discourse: "These two *tendencies*—a preference for subdued contrast between light and dark, or even a uniform soft lighting, and a greater autonomy for the brush stroke from depicted form—can *now* be detected in a number of works of which only one is dated 1629."[4] The tendencies described constitute the style, but the word "tendency" itself indicates a person having, doing, or perhaps even being the style; style is personified. This quotation already shows the temporal nature of the evolution that characterizes the experts' "Rembrandt." "Now" pinpoints a moment in that evolution. In a discourse of progress, the text sketches a portrait of the artist as a young man.

Who is this man who can be reconstructed through style? Most certainly he is a good student of his master. In this first *Corpus* volume, he is young, as would be expected. The critic looks at this young man encouragingly. The discrepancy in age between the artist and the connoisseur leaves its traces. The discourse sounds like that of a beaux-arts professor evoking the memory of a former student who pursued a brilliant career. For instance, it judges the *Repenting Judas* from 1628 as "slightly unbalanced," but still considers it the work of a good student, even if it is perhaps a bit too ambitious: "It is as if this slightly unbalanced character was an

outcome of Rembrandt's *almost excessive striving* to bring perfection to this ambitious history painting."[5] The figure of the "student" is used to personify style. Abstract nouns help obfuscate the subject of the verbs from which the nouns derive, so that causality can be alleged: "The *reintroduction* of a richer color-scheme and the strikingly careful *rendering* of the materials, too, may well *stem from the same cause.*"[6] A few pages later, the same student is considered unable to paint his own portrait.[7]

Fig. 2. Rembrandt van Rijn, *Self-Portrait,* 1629. Oil on panel, 35 ¼ × 29 in. (89.5 × 73.5 cm). Isabella Stewart Gardner Museum, Boston

All this language, which gives readable and specific shape to the anthropomorphic imagination, surrounds the discussion of the 1629 self-portrait. Rembrandt himself is alleged against his own work. He often painted, drew, and etched his own face. Nevertheless, despite their fame, these contorted faces—which are usually considered studies, or *tronies,* and which the Rembrandt House Museum in Amsterdam sells printed on T-shirts—are used to undermine the status of the painted self-portraits, and to reduce them either to studies, or, as we will see in a moment, to something else altogether. The argument rests on the assumption of coherence within the early oeuvre, which is seen by the *Corpus* writers as generating rather than solving problems: "Rembrandt must initially have reacted in a number of different ways to the difficulties this subject-matter [the self-portrait] brought with it, especially in a large format. This is at least how it seems to the art historian, who finds it extremely difficult to find *consistent criteria* for his attributions among the, on the whole, meager range of common features displayed by these paintings, both between themselves and in comparison to history paintings from the same period."[8]

We see here how the discourse of development ("initially") entails condescendence based on identification, in which the critic appears to know as a fellow

artist what "difficulties" the young Rembrandt must have been facing. This teleological discourse shows the artist as a young man, as an apprentice—ultimately, as the apprentice of the master writing so knowingly about him. The discourse also produces a norm of coherence that in turn installs the mechanism of exclusion. Whatever breaks the coherence will be designated as "not Rembrandt." Such is the rhetoric of purification. In the case quoted above, the art historian does not find sufficient visual evidence to question his own criteria, which are dominated by the need for coherence.

Of course, there are different ways of looking at the 1629 self-portrait with the artist in mind. Mariët Westermann recalls the importance of self-presentation in the art market of the time.[9] H. Perry Chapman also interprets the painting in terms of personal ambition. In her important study of Rembrandt's self-portraits she offers, among other interpretations, the notion that covering his eye, as the artist did in this painting, is a specific proposition of meaning, for the "self" as artist.[10] In her view, the device gives the face the meaning of spiritual depth and poetic sensibility recognized as melancholia. The suggestion is that the artist purposefully creates a persona. This strategy would give him the kind of mastery that comes with the commodification of the figure of the artist, on which Svetlana Alpers also wrote so eloquently.[11] The key term here is "ambition," a term that also figures in the discourse of the RRP.

My view is much in line with Chapman's, but it veers in a slightly different direction. The self-portrait in question strikes me, too, as the work of a young artist. About the same time that the RRP wrote their comments, I wrote about it in a way that avoids the double shift that characterizes the discourse on the artist's hand. In *Reading Rembrandt,* I explained that this very early 1629 self-portrait evokes uncertainty. The face reveals symptoms of vanity that make the painting seem idealized. If the moustache, mouth, arrogant eyebrows, and straight nose are not telling enough, when combined with the hairstyle, hat, gown, and light there is little room for doubt that the painting is idealized.[12]

On the other hand, this very feature signals insecurity, as does the hesitant eye, directed almost, but not quite, at the viewer. What does the self consist of in the case of this novice artist? The idealization of self and his insecurity refer to what this artist wants to be: a subject making objects, a subject whose identity is in the work. This painting has the features not only of a proud and insecure young man, but also of a masterpiece, as required by the guilds or, more likely in the case of this artist, by the court or city patrons. It has the carefully accomplished

strokes that display his craft: the varied surface-substances of the hair, feather, scarf, chain, velvet, jewel, tender wrinkles, and the slightly shiny reflection on the nose. It also offers the vehicles through which this painter will create his own painterly image: the empty background, the off-centered lighting, the nearly monochrome palette. The proud and insecure young painter aspires through this work to the status and identity of master.

The self is represented as both conforming to the standards of quality (handsome and skilled) and being different (insecure and original). It identifies the artist as a disclosing subject: as someone talented yet inexperienced, still with a soft moustache, and eager to secure a place in relation to the world and to others. These contradictions of narcissism establish the relationship with the self in otherness.[13]

This image is all we have; nothing more. The art historical desire to reconstruct the hand of the real Rembrandt would consider preposterous such a discourse of self and identity, of narcissism, a discourse that smacks of psychoanalysis. Needless to say, my discourse is based on the human figure or person, and it is anachronistic. Yet I offer it as meaningful for today because it gives an understanding of an individual's self-presentation, though we live in an age suspicious of both individualism and romantic visions of artistic genius, and because it does justice to a "preposterous" view of history, in which an endorsement of the present helps us understand and interact with the past. Most importantly, this description identifies features of the painting that we make into signs with which to establish its meaning.[14]

Does my description represent the artist's intention? Certainly not. No documentation exists that could even approximate that intention. No viewer, expert or otherwise, can speak for the artist, and any attempt to do so is a figment of the anthropomorphic imagination. What my description does, though, is to link the picture to thought—but not through mediation of the "hand" personified. I admit that the thought here is inevitably an interpretation that could only result from the actual contact between, not the merging of, the seventeenth-century canvas and the twenty-first-century critic. This thought, as it emerges from the encounter between object and viewer, receives articulation in the latter's discourse (mine, that is). And, although it is anthropomorphic in its own way, my description is not produced by the imagination.

Let me now juxtapose this description to a quote from the RRP that forms part of the argument for the autograph quality of the painting. Like my description, theirs is an interpretation of the work's meaning: "Worldly finery is *retained*

in the cap with ostrich plume, the colourful cloak and the chain, but a more em-phatic allusion to the transitoriness of things is missing. Bearing in mind Rembrandt's tendency . . . to eliminate express symbolic attributes . . . one can *assume* that in this case too the idea of Vanitas is not, or not entirely, abandoned."[15]

This passage comes from the chapter on the painting's style. Since the premise of *Corpus* is that stylistic analysis constitutes the most reliable method for understanding the work historically, and thereby for authenticating the pictures, it can be assumed it is also a reliable key for the identification of the hand. The fact that there is an interpretation within the attribution itself speaks of the shifts among artwork, artist, and critic.

In view of this, I contend that in this passage the authors of *Corpus* over-rule their own premise. They translate the obvious vanity of Rembrandt's self-presentation from style into iconography; in doing so they do not interpret it as personal ambition, rather as the culturally sanctioned theme of the vanity of earthly things in the face of unrelenting death—Protestant austerity, a *vanitas*. This theme subordinates Rembrandt's self-image to a cultural cliché from which, in the same passage, they say he was trying to distance himself. Even on the terms of the RRP, which are not mine, this hardly seems likely. This is the research team's twentieth-century vision of Rembrandt's place in his culture, not a historically valid reconstruction; nor is it grounded in visual evidence. It is particularly relevant for my argument about the discourse on the hand that this overruling of the visual image is explicitly stated.

But more is at stake in this distraction from the image than a mere repu-diation. The negative discourse ("not entirely abandoned") points to a willful overruling of the artist's intention that is purportedly evident in the *Corpus.* Take the word *tendency:* we have seen it before; it is a ratchet between the double per-sonification, first of the hand into an implied artist, and second, of the interpretation by the critic. According to the authors of the *Corpus,* Rembrandt has a visible aver-sion to this kind of flat iconography. In other words, they are saying, even if Rembrandt didn't want to incorporate iconographical symbols, he nonetheless should have, therefore we can just interpret the work as a traditional *vanitas*. This is, indeed, the discourse of a master guiding his pupil. Instead of authenticating the picture, the question of its hand authenticates the discourse of mastery.

Moreover, the appeal to the most general subject (vanity) demonstrates the tendency of iconography to also overrule specificity. The meaning of the im-age is not grounded in the depiction, or in the subject (self-portraiture), but in

something that this painting is not: a *vanitas*. This use of iconography as a method for reading disqualifies it for visual analysis. It has little bearing on the identification of the hand. In contrast, it does sketch, in stark contours, the profile of the critic as master. It establishes, that is, the critic as the creator of the hand, as "implied artist." For the spectator, the visible retreats in favor of the invisible. This is logocentrism in full swing. And, as always with logocentrism, the cultural artifact, the thing we treasure and that circulates among us as a binding element—the work—disappears.[16]

Through this example, the claim I am making becomes stronger and more specific, going beyond detecting logocentrism and anti-visualism in this discourse of visual refinement. My claim is that the very attempt to determine what does and does not belong to an artist's oeuvre—what does or does not stand up to being autograph—necessarily implies the displacement of mastery from artist to expert. For only by means of that shift is the expert able to attribute to the later master those early works that are, to use the condescending discourse implied, promising but not yet sufficiently able to solve the problems whose solution will determine the true masterpieces of the master. This discourse is by definition couched in the past-future tense.

The Anthropomorphic Imagination

Appreciating that *The Polish Rider* can be the product of different hands and still be "a Rembrandt" alleviates some—but certainly not all—of the effects of what I call the "anthropomorphic imagination." The question of the "hand," or attribution, is a subject of discussion in both literary studies (Shakespeare) and art history. It will remain important for art history, museums, and owners of artworks as well as for culture at large, for the "anthropomorphic imagination" is at its heart.

This term indicates an almost compulsive tendency to approach representations that "look like" human beings through the lens or frame of anthropomorphism. The tools of analysis are thus made congruent to its objects. This telescoping of object and analysis yields a number of tendencies that, I contend, affect the status of the results. One such tendency is the conflation of the artwork with the maker's intention, in a one-to-one relationship. Another is the unification of the artwork, to resemble a unified human being anxious to hold himself together. A third is the disembodiment of art, art making, and art viewing or reading.

Although the humanities are divided according to the fundamentally different ontological status of their objects, in the humanistic disciplines, whose

mission it is to study and understand the manifold representations of, among other things, the human form or agent, the distinctions between the visual figure and literary character are not so clear. In literary studies, characters are often deprived of their mobility and changeability, to become stock figures considered primarily in their communality. They come to stand for the themes and abstractions they are claimed to embody. My example of this early self-portrait is a case in point.

An overemphasis on recurrent plot elements leads to a continued projection of features from character to character, a process helped by the identity of the proper name. This emphasis on plot projects on characters a kind of stability comparable to that of the fixed image. In visual studies—here, considered especially in the discipline of art history—figures are almost compulsively endowed with narrative background. This often happens because they are seen as illustrating earlier literary texts, as in history paintings. Moreover, actions are attributed to them. Paradoxically, the two disciplines thus blend into each other when they are preoccupied with their most essential objects and deploying their most traditional methods. As a consequence of this dual tendency, the human figure in images becomes the focus of a narrative movement that tends to lead the viewer away from her uniquely specific interaction with the visual image, whereas the student of literature is invited to imagine static figures where, strictly speaking, none are called for.

This crossover between the two disciplines is often not recognized as such, yet it is both pervasive and compelling. For this reason, I consider it a kind of cross-disciplinary humanistic unconscious, an unreflected compulsion to step into the other discipline or medium at the very moment one is attempting to hold on to the boundaries between them. This humanistic unconscious comprises a reluctance to endorse the confrontational aspects of reading and looking. It also comes with a desire to project the work's "other" in an escape from specificity. And, it frequently produces a tendency to project one's own or one's social group's preoccupations onto the object of analysis. Thus, analysis becomes self-mirroring. The term "anthropomorphic imagination" points to the various aspects of this cluster in order to understand its operations. I contend that the interpretation that the authors of the *Corpus* proposed for this early self-portrait can be seen in light of these consequences of the humanistic unconscious. The first two consequences should be clear in the fragment as I have analyzed it above. The third will be hinted at below.

The anthropomorphic imagination is, I contend, inherent in the attribution discourse. Put succinctly, the "who?" of the question of hand is answered through

comparison. It intervenes in the decisive phase of an attribution, after having grouped on the basis of resemblance, and eliminated on the basis of difference, the alleged works of the master whose corpus is being established through our own figuration.

Bernard Berenson phrases it clearly: "We then return to the search of resemblances between our unknown work and the works of the two or three candidates for its authorship, he to be adjudged the author with whose works ours has in common the greatest number of characteristics affording *an intimate revelation of personality.*" [17] We see here both the shift from the painted surface to the author, and the shift on which the latter shift is based, that from art to psychology, which I consider the bottom—or perhaps "fault"—line of the discourse of the hand. But whereas the methods and techniques have changed dramatically since Berenson's time, these two shifts, which the anthropomorphic imagination naturalizes, remain in place. And it is this that characterizes the hand discourse historically.

To understand what the anthropomorphic imagination does with and through the hand, I will mention some of the figurations invoked to both represent and obliterate this relationship. They take the shape of figures, understood in its double meaning of human shape and figure of rhetoric. The narrative aspects of the hand can easily be foregrounded in the discourse of attribution. I will foreground the figuration of the *imago* of the artist through prior personifications that naturalize a number of rhetorical moves.

Berenson's statement of methodological principle is not an isolated incident in his programmatic book *Rudiments of Connoisseurship.* His text is replete with insistent anthropomorphisms. For example, he turns anthropomorphic thinking into the explicit principle of the trade, when he writes: "Connoisseurship is based on the assumption that perfect identity of characteristics indicates identity of origin." [18] And a bit later: "identity of characteristics always indicating identity of authorship." [19] This anthropomorphism requires an analysis of the concept within the framework of the present study with respect to three distinct but related aspects.

As one can see, the search for both the master's hand and the identity of the artwork is replete with anthropomorphic reasoning, the logic of which warrants analysis. Below I will argue that the notion of the hand, too, is embedded in modernist aesthetics and epistemology. But, due to the integration of these two features of dealings with the hand, both the conception of art and that of authorship are, in a profound but unacknowledged way, anachronistic. Given art history's commitment to a historical approach to art, this deserves spelling out.

A Short History of the Hand

The conflation of analysis with judgment that subtends the hand discourse may have a long history, but the place of expertise in scholarship as we know it is not so old. Let me being by briefly situating the question of the hand historically, in two distinct ways. First, I will look at two examples of the hand discourse, one from Berenson, writing at the beginning of the twentieth century, and one from Max Friedländer, writing some forty years later. The discourse of these two connoisseurs of Italian art, who still rank among the master-connoisseurs of the twentieth century, is not only profoundly anthropomorphic in the sense outlined above, but also deeply invested in judgment. Then, I will consider the fundamental anachronism of this discourse as itself historically contingent. Both aspects position the discourse of the hand in a profoundly modernist framework.

In his studies on Italian art, Berenson sets a model for the double identification we have seen at work here. He uses the word *hand* casually but, inevitably, anthropomorphically. For example, when he recognizes "the youthful hand of some gifted disciple,"[20] the mention of the hand immediately leads to a characterization of the painter as youthful, hence, gifted. Like another young Rembrandt, he will be considered with indulgence and encouragement, but, of course, mastery will be withheld. Berenson dreams on about the causal connection between the "unwonted charm" of the paintings and "the fact that their painter was not then twenty years old."[21] Dreamy impressionistic descriptions such as this shift the discourse from the intellectual—connoisseurs like to call it "scientific"—to the imaginative. As we have seen, this shift allows the identification between figure and artist, then artist and expert, to pass, unnoticed, to the expert.

There is one specific figuration that facilitates the double shift. The leap from artwork to artist can be concealed by focusing on the depicted hand. In the middle of the same little book, Berenson combines the thematized, depicted hand with the painter's unique hand. This use of the term is comparable to the way E. M. Forster uses the term *storyteller.* Berenson discusses the hand of the depicted figure in his detailed account, first published in 1902, of more or less telltale body parts that belie the artist's hand. He notes that "the hands are not the rivals, in expression, of any of the features, [because], until relatively recent times, they do not seem to have been regarded as indications of individual character."[22] He concludes that hands are among "the most applicable" criteria of authenticity.[23] An anthropomorphic duplication occurs here, that, as I have shown in the example above, is a structure of the hand discourse. Here, too, the identification is itself double,

from figure to master, and from master to expert. The former is a fully recognized part of the project of connoisseurship; the latter passes unnoticed.

The quotation demonstrates both identifications. That hands have become indicators of individuality is, without a doubt, a consequence of the individualizing device of fingerprinting. But Berenson, unwittingly, writes about the preoccupation with "individual character" itself—both the belief in the possibility of practicing it and the urge to do so—from the vantage point of that preoccupation. Connoisseurship itself, that is, stems from that belief, and that urge.

At stake are the values—newly reinvested in modernism—of identity and truth. By means of literary forms such as interior monologue and subject-centered imagination, modernist literature explored the impermeable boundary of individual identity. The hand fits into this paradigm. But whereas Marcel Proust suggested that identity is not independent of its construction by the affectively engaged "other," the question of attribution splits identity into an overt search for the result of individuality—personal style—and a less overt, perhaps (partly) unconscious, search for its cause—in artistic genius.

The conflation of connoisseurship with individualism, and the grounding of its method in the conflation of origin with articulation, is even more explicit—although, again, it seems to remain unnoticed—by Friedländer in 1942, in what can be characterized as a handbook of art criticism. He writes: "The hallmark of *originality* is the individual character which is peculiar to the work and all its component parts; in a manner of speaking, the *resemblance* to the creator of that which is created."[24] Originality is, of course, that tenaciously modernist word that, through the root "origin," binds authenticity to aesthetics, a bond that is all but obvious. But the word "resemblance" is more to the point here.

This noun indicates that the image of the artist is read off the painting and shaped like (the critic's interpretation of) the latter. Since all we know of this artist is his work, the logic is projective, like that of religion. There, God is said to have created man in his image and likeness. But the implied author of that passage (Genesis 1:27) is the clearest example of man's interpretative projection. Forged by the anthropomorphic imagination, the anthropomorphic God strolls in the garden, seeks shade against the harsh midday sun, and rages with jealousy.[25]

Berenson comes unsettlingly close to recognizing the historicity of connoisseurship itself when, as mentioned above, he interprets depicted hands as themselves indicators of authenticity. Speaking of depicted hands, and alleging Anthony Van Dyck, he mentions that in this artist's hand, these hands become class

and time bound, because subject to fashion.[26] Time underlies fashion, and this is true also in academic endeavors. Hence my interest in also positioning the hand discourse historically, not to unearth its genealogy, but to provide a framing for analyzing the anthropomorphic imagination at work in its practice in the present.

As I will argue below, the question of the hand is, before anything else, a profoundly modernist one. As can be said of early art history in general, it is also bound up with class and the capitalism that increasingly defined it. That experts such as Berenson and Friedländer were not only among the best connoisseurs but also collectors surprises no one. But the modernist character of connoisseurship is also aesthetic, in the sense that aesthetics is itself a modern preoccupation. After all, Morelli was a contemporary of Manet. But, as a recent study of Morelli demonstrates, in many respects we are still living within modernism, in spite of intellectual, artistic, and political movements that proclaim, and articulate a position for, the opposite. This is certainly the case for connoisseurship.[27]

As late as 1999, Jaynie Anderson was able to write in the present tense while recalling those "formative years" of art history: "An important part of being an art historian, indeed, an indispensable skill, *is* the ability to be a connoisseur, that is to identify the makers of works of art by a close analysis and comparison of individual paintings."[28] Anderson, in other words, sees Morelli's approach as continuous with today's academic discipline. This makes the claim, argued below, for the profoundly modernist nature of connoisseurship, still relevant.

The historical position of connoisseurship with regard to Rembrandt is no different from that of Italian connoisseurship as represented by Berenson and Friedländer; it follows the latter closely. Although catalogues of Rembrandt's paintings, raisonnés or not, have been appearing for a long time, the question of the hand that triggered the exercise of purifying the great painters' corpuses has received its full meaning and deployment only in more recent times. Bredius's catalogue, perhaps the first systematic attempt at purifying the corpus, appeared in 1936.[29] But before continuing my historical remarks on this discourse, let me first sketch its visibility: the figurations through which it can be perceived.

Topoi of the Hand

Rhetorically, anthropomorphism's effect resides in three elements, or *topoi*. First, and most obviously, it lies in the conflation of physical, stylistic, and structural— what Berenson and his predecessor Morelli called "morphological"—visual properties, with the temporal contiguity indicated in the word *origin*. In other words, it stems

from the conflation of synchronic state with diachronic genesis—of articulation with origin. The stakes are high, and given the autographic nature of painting, the consequences for the cultural availability of artworks, are severe. In addition to the stakes of the art market itself, I am particularly concerned about the suppression of public availability and funding for the study of works whose hand has been judged doubtful.

This strong presence of anthropomorphic thinking is acted out beyond the sole quest for artistic origin. As the diacritical approach—the search for differences and similarities—to the morphology of artworks suggests, the political stake of this conflation is the artist's individual uniqueness. This is the second *topos* of the hand, steeped in a profound and unquestioned individualism. And it is often at odds with the evidence of collective practice, such as workshops, where the master's guidance of his students is an integral part of his mastery. The breaking point, of course, has been *The Polish Rider.*

The third *topos* of the anthropomorphic imagination—the fictionalizing figurations of anthropomorphs—is properly imaginary. It lends itself best for analysis within the framework of this article because it permeates the identity of the expert as much as that of the artwork. It becomes visible, but as the tip of the iceberg only, in the rhetorical language of attribution. It is most visible in the figure of personification. This rhetorical master-figure of the anthropomorphic imagination is pervasive in humanistic writing. It presides over art history and literary studies, philosophy and religious studies alike. This makes an analysis of it relevant beyond the boundaries of art history alone.

The hand is the anthropomorphic synecdoche (part for the whole) for autographic authenticity. Sometimes it is replaced with the word "brush," which connotes a similar metonymic thrust, linking the brush steeped in paint to the hand of the artist on the one side, and the canvas we look at on the other. But here is the catch. Mostly, both words—*brush* and hence, as its synonym, *hand*—indicate style, not directly autography. Yet, in the practice of connoisseurship, style has traditionally been the criterion par excellence of the true artistry that betrays authorship.[30]

Hand, brush, and style are practically interchangeable in attribution writing. Yet, strictly speaking, they have three distinct relationships to the historical figure they allegedly point to. The first is (part of) the artist, as a person of flesh and blood, although mostly dead. The second is the instrument that mediates between that body and the canvas-becoming-artwork. The third resides only in the artwork—if it resides anywhere at all. This conflation-turned-concept, mostly used

rather casually, thus imports a substantial body of thought into the discourse of attribution. The hand, a body part turned unreflected concept as part of the humanistic unconscious, comprises all three of these notions. Each is considered an index of the individual, unique, genius artist whose legacy must be isolated from contamination by other art. It is these rhetorical *topoi* that underlie the analyses in this article. I suggest that they facilitate the otherwise unlegitimized power of the attribution experts to judge.

The Implied Artist and His Judge

In this section, I will suggest that as the site of evidence of authentic authorship, the hand is less the hand of the maker than the personified result of the expert viewer's interpretation. Standing for the judgment of authenticity expressed in van de Wetering's opening sentence, the hand is the artist as the interpreter sees him in his work. The search for the hand clothes critical views in scholarly and sometimes scientific garb.

The hand is supposed to be physically contiguous with the painter as well as the painting. Hence, there is a "truth" to be discovered. And that is the historical fact that a certain person actually hand-made the work that we look at in the present. Difficult as it is to prove, it is surely not unthinkable that a judgment of authenticity is right and certain. I am not challenging that possibility; nor am I challenging those cases where this result has been reached: I lack both the expertise and the motivation to do so. And even if I have doubts about the unshakable belief in the cultural relevance of the many expansive—and expensive—research projects devoted to the search for the hand, I am not arguing for the dismissal of those results. What I am interested in is discerning displacements and shifts in the discourse of the hand—from hand to mind, or intention, where *hand* refers to the craftsman who handled the brush whereas the constructed intention is a reading grounded in the modern age.

The authorship of Rembrandt's *Danae,* for example, has never been doubted (fig. 3). Arguments for its authenticity, therefore, need not be extensive. Although comprehensive examination has been performed—analysis of ground, X-rays, paint, varnish—for comparison with doubtful works, the conclusion that it is "wholly convincing as to its authenticity" is simple.[31] Most of the analysis in this case in fact reveals something else: a reworking at a later date, but by the same hand. This is deduced mostly from stylistic and iconographic aspects and attributed to Rembrandt's "changed iconographic intentions." The latter conclusion can only

Fig. 3. Rembrandt van Rijn, *Danae,* 1636. Oil on canvas, 72 ⁷/₈ × 79 ⁷/₈ in. (185 × 203 cm). The State Hermitage Museum, St. Petersburg

be the product of the implied artist, hence, of the interpreting scholars, rather than of the hand. This provenance is bound up with the specific logocentrism analyzed above. For, obviously, wherever we look, the artist's mind is nowhere to be seen.[32] Primarily, thanks to the hand, culturally pervasive projections can safely be attributed to the artist. In turn, the figure of the artist, relegated to a distant past and beyond answerability, is excused—because of his remote strangeness, undoubted and constant greatness, and tradition—from picturing what makes our contemporary morality uneasy. This is one way in which socially problematic views in the present can be protected by the golden glow of heritage, whereas they are, de facto, rearticulated by our contemporaries.

What concerns me here is the power to judge, which the hand qua implied artist gives the critic. In this prominence of judgment, the anthropomorphic imagination works effectively. Broadly sketched, the relationship between the discourse of the hand and the critic, and in her wake, the general spectator or reader, is subject to the peculiar reversal at work in the example of the self-portrait. As we have seen in the commentary on the 1629 self-portrait, the master artist from the past, subjected to the analysis performed in the present, is de facto subjected to the master expert as student is to teacher. Between the painting or sculpture and the scholar, the process of reading leads to the work of fleshing out the dimly lit features of the long-gone artist. Through the time of the discipline's tenure, opinions about where that hand could most readily be detected have changed. It has been placed, for example, in the overall design, the paintbrush, the picture's mood, the earlobe, the treatment of the theme, or the resemblance to work by contemporaries. But the basic craft of attribution flourishes today more than ever before, with as its most fundamental standard, "quality." Before all else, the connoisseur is a judge.

This works a bit tautologically, since only the "greatest" are subjected to the expertise of a state-funded team. Hence, the quality of the artwork is a given. But, in a very fundamental way, it is not: it is established, time and again, by the expert, combined with the reputation, earlier scholarship, and coincidences of provenance and conservation. That unquestioned given is the standard by which to judge candidate works.[33]

It becomes clear, however, that judgment is not a given, but a painstakingly constructed attempt to turn subjective encounters into universal values, when we consider the history of judgment in Western art. In the narrow sense, this history begins, predictably, in the Renaissance, in Italy, in the wake of Giorgio Vasari. Jakob Rosenberg's study of quality in art—a purportedly objective feature—turns out to be a history of judgments—the critic's act. This history of the shift from artwork, via artist, to critic is itself a modernist attempt to assign universal validity to the time-bound endeavor of history-writing. Such historical specificity is repeated within this history when the longevity of judgment itself becomes an argument in favor of the objectivity of judgment.

This becomes explicit when Rosenberg writes in his conclusion that the criteria he just sums up "are valid criteria, *because* they have sustained themselves through the ages, from the fifteenth century to well into the twentieth."[34] He goes on to acknowledge that his criteria are limited to a few media only, but he expresses confidence that they can be extended, albeit with amendments. My

point here is that the reasoning that derives validity from longevity will tend to restrict increasingly the scope of criteria, so as to reduce the possibility of these criteria being changed.[35]

Indeed, Rosenberg merges the ongoing objectification of his criteria with the limitation to a single one: form. Somewhat exasperated, he writes: "Could we not at least *approach* an absolute scale of quality, to the degree that we can more definitely refute those judgments that contradict so strikingly our own reaction?"[36] And, quoting one of his earlier texts, he sketches his utopian vision: "Yet if we have gathered sufficient experience in the evaluation of the single great masters as compared to their surroundings, a certain general notion of the nature of great art will gradually develop, a standard of judgment which may work even without direct comparison."[37]

In the first of these two statements, the desire for absolute criteria goes hand in hand with a wavering use of the shifter "we." This pronoun can refer to the art historical community as a whole, or to a more limited group of people. In this respect, it seems relevant to suggest that the immediate opponent here is Roger Fry's admiration for "Negro art." The second statement harbors a desire to make the quintessential method of connoisseurship—comparison—redundant. For, as the sentence appears to acknowledge, this method is relative, and thus contradicts the absolute nature of judgment.

Instead, the judgment based on the hand is, before anything, a proposition, subjectively contrived and presented. But the discourse of the hand, including its para-synonyms *brush* and *style,* rhetorically makes us forget the origins of the judgment.[38] This forgetfulness might well be the undercurrent that affectively inflects the tone of Rosenberg's pronouncements. But, unlike Baron von Münchausen, one cannot pull oneself out of the marshes by the hair. The absolute quality sought can never exist. Yet, even if many would beg to differ, Rosenberg's sentences sound completely normal, acceptable, reasonable. This is due to the effect of the figure of personification that binds judgment with the hand discourse. First, attached to the hand is a body that changes with age, a psyche that is gleaned from scarce data, and a genius that resides in a mind. So far, the personification follows the structure of synecdoche. The person who fleshes out the features of this character, turning it into a plausibly realistic figure, is the art historian in the guise of connoisseur. Attribution coincides with judgment. We have seen this clearly in the moments, quoted above, where the expert, turning peculiarities into flaws, talks down to the young artist.

The rhetorical structure that bestows the power to judge on the expert and subordinates the artist to him is the following. First, the hand—read from the paintbrush but also off the other details, composition, and mood—is projected onto the figure of the artist. But here too, although in a different rhetoric that seems to be characteristic of such attributions in the visual domain, the reader-critic-expert cannot help but figure himself into the picture. A revealing dialectic occurs between the two personifications—of the artist whose hand is being redistributed among paintings as well as among their eager owners by means of narratives about him, and of the labor of the critic dispensing judgments that flesh that implied artist out. As a result, the ordinary viewer is barred from meaning-making. But the viewer is integral to the process of art. In itself, the hand is corporeal. It is a trace of the person speaking, a mold, a mirror, and an index of the subject. One can ask what a hand can be in a non-animate object that can only act, make, or literally, or figuratively, manipulate, through the viewer whose response is the only evidence of its agency. This less than clear relationship between the artist's alleged hand and the judge who responds to the work, and who, in responding, produces the hand, is a product of the anthropomorphic imagination.

One of the consequences of this shift from work to critic is the inevitable anachronism of the interpretation. When we discuss visual art, the question of history cannot be ignored. With the example above, I have willfully used a language that many will find anachronistic. I now wish to claim that the clash between past and present in that instance is not exactly anachronistic, since it partakes of a double historical positioning. In contrast, not in spite of, but because of, the shift from work to critic, even the most careful historical attitude blinds itself to itself, to its own position in history. Through that oblivion, such writings become anachronistic. This is because the critic assumes that he is reconstructing that which he is, at least in part, constructing in terms of his own self, in the present. The hand is often represented by a variety of stand-in figures far removed from the author.

Instead of using the temporal logic of historical reconstruction, I focus on the two synchronic moments involved and the implications of each. Now another shift occurs, from work to approach. For the metonymic logic is quite powerful in the dogmatically historical study of art. As a result, in the tradition of art history the hand imposes a problematic temporal sequentiality. The hand is in continuity with the work of art, at least in the case of autograph art. It is relatively easy to keep it distinct from personification and close to materiality. Yet these differences are underplayed in the discourse of attribution.

In the name of his discipline's commitment to historicism, art historian Gary Schwartz offers a severe and convincing critique of connoisseurship. He points at what he calls the ahistoricism of connoisseurship: "connoisseurship incorporates ahistorical values which are irreconcilable with the historical ones *that have grown increasingly important to me in recent years.*"[39] The emphasized phrase situates Schwartz's view historically.

I concur with Schwartz when he says that connoisseurship incorporates ahistorical values, but I think these values are themselves in fact strongly historical. I do not think that connoisseurship as an endeavor is ahistorical, rather that it is profoundly historical in its commitment to modernist values. And the primary value that is the engine of the connoisseurship project is the establishment of individualized corpora; the reconstruction of what a given artist, whose recognized greatness warrants the effort, has left his heirs to curate. To reconstruct is to assume there is a historical reality, a truth that must be unearthed and humbly dusted clean of later accretions; it is to search for a hard, trans-historical core and restore it to its initial splendor. To construct, on the other hand, is to come forward with an object, or rather a cultural process, that is contemporary, not from the seventeenth century but from the twentieth or twenty-first centuries. This mutable object has no "hard core"; it acts and stimulates, and is antagonistic to all stability.

Construction, compared to the task of reconstruction, is inevitably subject to deconstruction. And deconstruction means to explode from the inside all attempts to reconstitute. This deconstruction also puts all the pretensions, all the circular and contradictory arguments, all the hierarchies and established assumptions—the *doxa*—in doubt. The difficulty of keeping the two identities involved in hand-hunting distinct is compounded by the desire for truth implied in the belief that reconstruction is possible. Alongside individualism, truth is another strong modernist value. It is a concatenation of four factors of truth that constitute the maker's authority and are inherent in the very idea of the artist as hand. They are: subject, intention, origin, and cause of the work of art.

The reason I prefer to speak of anachronism rather than ahistoricism, as Schwartz does, is that it is a consequential temporal figure, not a temporal vacuum. It indicates a relationship between present and past expressed in a strong investment in reaching or reconstructing the past through repression of the untenability of the goal. If I insist on the term *anachronism*, it is for the dual purpose of laying bare this conflict and aligning the rhetoric of anachronism with that of personification, so that the specific form of the anthropomorphic imagination can

become apparent. I also prefer it because it facilitates making the distinction between unreflected and self-aware anachronisms.

The historical embedding of connoisseurship in modernism, in turn invested in anachronism, makes a case for the understanding of the anthropomorphic imagination as an inevitable yet problematic grounding of the discourse of the hand. The language in which the artist's hand is discussed is well known. "Masterpiece," "authenticity," "style," and—most literally an index of the indexical hand—"brushstroke" are the most overt, fondly used terms of endearment that justify the value we heap upon art. "Unity," "purity," "consistency of vision," and "comparative taste" travel with them, as an unavowable undertow. "Masterpiece"— a piece of the master. The indefinite article makes the phrase ambiguous. I want it to be. For, as the phrase has it, "a Rembrandt" is a piece of the master's handmade work, but, metaphorically, also of the man himself. In this notion I see the shadow of a perverse love triangle based on a dangerously excessive but untold double identification. As a result, the work gets purified of everything that clung to it throughout the centuries, so that only the material traces are left behind of an artist about whom we know just the legend. Even in those cases where more abundant documents are available—there is only scant information about Rembrandt's life—we will never get to know the artist's mind, sentiments, joys, and pains, nor the way he lived and practiced his art within a social world, surrounded by students, colleagues, friends, rivals, and enemies. All we are left with are a few traces, just enough to patch together an artist's life, a genius's hagiography; and a few objects, elaborated, over-layered, never "pure." We work—now and *a posteriori*—with the unavoidable *Nachträglichkeit,* in an aftermath that intersects past and present moments, and places the former forever out of reach of the latter. Instead of seeing this as a limitation to be overcome, I see it as a beneficial insight that helps make the work on the hand more complex and meaningful, providing we endorse the fact that we, now, have a hand in the construction of that "hand." To begin with, by asking the question: "Whose hand?"

Posterity's Hand

But we, posterity, are at work in the study of art, including the endeavor of attribution. According to the prefix "post" lodged within the noun "posterity," we speak to the work. The work is our recipient, and we are its senders. We send to it a succession of messages and, like any recipient, the work responds to them. The work changes, since our messages determine it and constitute the "you" that we address as a first person.[40]

Posterity, especially at work with a corpus, also evokes posthumous, since the corpus of the work is dead, heavily dead, as described by philosopher Jean-Luc Nancy, in *Corpus,* his short, poetic meditation on the relationship between the human subject and death.[41] We, posterity, turn our funeral prayers into this corpse and beg for its resurrection.

Why does this posthumous heaviness matter so much to us? In a different context, Nancy speculates that the emotions that inform this investment are evidence, certainty, of indexical presence: "on devine l'angoisse formidable: 'voici' n'est donc pas sûr, il faut s'en assurer. Il n'est pas certain que *la chose même* puisse être là. *Là,* où nous sommes, n'est peut-être jamais que reflet, ombres flottantes."[42] Here authenticity is a protection against the doubt that we, the hub of the indexical touch, have enough reality to sustain that role. In this respect, the meaning of *post* as "mail" becomes a little less metaphorical. "Un toucher, un tact qui est comme une adresse,"[43] is a remedy against this angst about our own corpus, "your own body."[44]

Perhaps something like this angst underlies the strange perseverance of the RRP, despite the long interruption in the publication of its *Corpus.* As I was writing this paper, I learned of the imminent publication of volume 4 of this huge project, soon to be followed by volume 5. It will have changed from the heavily modernist project I am describing here. As I mentioned earlier, under the pressure of criticism and their own changing insights, the team no longer divides the cultural Rembrandt into "A," "B," and "C." Greater acceptance of collaborative works, where the hand of the master is supplemented by that of a pupil guided by him, and a less precise conception of what constitutes a Rembrandt allow us to raise questions of studio practice anew. Further progress in scientific research—and more recognition of the scientists' contributions—narrows the margin of error. I am eager to learn if the tone and rhetoric of the new volumes have also changed.

There are indications that they have. Van de Wetering's recent article states explicitly: "researchers like us should not be considered 'authorities,' but rather providers of information, arguments, and sometimes personal opinions as to the (non) autographic nature of certain paintings."[45] Interestingly, though, a page later he writes that the team has shifted "the methodological emphasis more and more to connoisseurship, as it was not expected that Rembrandt's own works and those of other painters from his workshop could be distinguished from each other through scientific methods."[46] He thus unwittingly reiterates the relevance, even for today, of a rhetorical analysis of the hand discourse. Indeed, he proceeds to give an example—and, again, I hasten to add, a convincing one—that espouses

the tone of the earlier, modernist connoisseur. It is the case of a work that I would like to call an *allo-portrait,* a self-portrait by a different artist, or hand. Like Morelli, van de Wetering mentions the earlobe, nose, eyelids, and other represented body parts as clues.[47] The hand is alleged so as to be able to reject one painting and question the unity of another.[48] The latter mention of the hand is part of the analysis of *The Polish Rider* as a collaborative work: "A plausible conclusion . . . is that two hands were involved in the painting of the boot."[49] The article ends on the useful remark that the explanation offered in the article "takes full account of the curious discrepancies in *The Polish Rider* but will hopefully reopen viewers' eyes, where necessary, to the unmistakably Rembrandtesque qualities of this exceptional painting."[50]

Here, "quality" is qualified as "Rembrantesque," a qualifier frequently used to describe Rembrandt-like features of non-autographic works. This choice of idiom seems cautious, but it also begs the question of the current position of the RRP team toward the historically specific issue of the hand.

In view of the necessary historicization of work—between old masterpiece and contemporary labor—it will remain relevant to ask how *their* work becomes *the* work, as long as the RRP's *Corpus* remains incomplete, yet its authority, often challenged theoretically, is unquestioned in practical terms. For they are the experts who, like strict masters in a modernist exercise of purification, forbid us to believe in the magical powers of art, so that we won't notice the "self-perpetuating system of institutionalized value judgments" that is their own magic trick. And where lies their authority? In the collapse of "his" body and "your own body," in the *corps-à-corps* of corpus work.[51]

Thus, not just a double identification but a double mastery is at the crux of the discourse of the hand. Among all the critical voices raised by the endeavor of establishing the *Corpus* on the basis of purification, that of Gary Schwartz has had a decisive role. His article "Rembrandt Research after the Age of Connoisseurship," published in 1993, provides us with the statistics, history, analysis, and outcome of the dilemma posed by the enterprise. It convincingly shows the contradictions that emerge from a project based on an inextricable tangle of the criteria of quality, authorship, and authenticity, all three of which are mixed with a sense of morality never totally absent from Dutch thought. Schwartz's arguments remain valid. But art history's persistence, eight years after Schwartz's critique, in using connoisseurship to police all analysis—a practice rampant in scholarship on Steen, Vermeer, Hals, and van Gogh, to name just those I know closely—has compelled me to further probe

this discourse, not in order to question the specific judgments, which would amount to stepping into the very discourse I am analyzing, but to understand their status. In the context of my analysis of anthropomorphism, I have sought to analyze rhetorically a discourse on the hand that could be considered a master discourse, and which, in fact, arises from the confusion between different types of mastery.[52]

We have yet to find out why we continue to endorse and imitate, in the classical sense of mimesis, this discourse of purification, which is, after all, anti-cultural. For this we still do, despite having identified the flaws of its principles as well as its intellectual and scientific weaknesses. Why do we continue to endorse a discourse that denies the collective cultural relationship we have with works of art that, rightly or wrongly, are labeled Rembrandt? I would posit that it is now no longer a matter of knowing *whether* we need to recognize the premises that make the enterprise logically untenable but rhetorically sustained. Instead, if its censoring power is ever to be undermined, I believe it is necessary to understand *why* and *how* we nevertheless continue to accept it. In other words, my interlocutors in this paper were not the authors of the RRP volumes, nor their predecessors, rather the many audiences who are so eager to be seduced by such a discourse. My analysis has been rhetorical: it undertook to analyze some of the assumptions rhetorically set up within the first three volumes of the RRP's collective work titled *Corpus*.

Carlo Ginzburg, writing about the connoisseur and medical doctor Giulio Mancini, pointed out that we share an assumption with seventeenth-century learned gentlemen in Rome: "It is an assumption not declared, since (wrongly) it is taken to be obvious: it is that between a canvas by Raphael and any copy of it (painted, engraved, or today, photographed) there is an ineradicable difference."[53] This early figure of the "hand man" (connoisseur) remains fascinating. Here, suffice it to say this assumption is neither self-evident nor necessarily false. It is in the nature of assumptions that they elude the true/false test altogether. But, in order to make them pass for obvious while they are not, they are dressed up in rhetorical garb, here, that of anthropomorphism.

Between source—the hand, the model, the figure—and reaction—the artist or the spectator—subjectivity goes around in circles. These circles ripple with centrifugal force throughout the cultural milieu, contribute in small ways to the posterity of the work, and, in the end, turn into vicious circles that threaten to destroy art itself, becoming the negation of the artist as "other," of the work as "self," and of art as "action." But this death of art had already been announced by that little word, *corpus*.

As I have indicated, what concerns me here is the power to judge that the hand qua implied artist gives to the critic. In this prominence of judgment, the anthropomorphic imagination works effectively. Broadly sketched, the relationship between the discourse of the hand and that of the critic and, in her wake, of the general spectator or reader, is subject to the peculiar reversal at work in the example of the *Self-Portrait.* As we have seen in the commentary on this painting, the master artist from the past, subjected to the analysis performed in the present, is de facto subjected to the master expert in the same way as the student is to the teacher. Through the time of the discipline's tenure, opinions about where that hand could most readily be detected have changed. But the basic craft of attribution flourishes today as never before, with as its most fundamental standard: quality. The connoisseur is, before all else, a judge.

That unquestioned authority is the standard by which candidate works are judged. In the Calvinistic climate of the Dutch academy, the purification of the most purely Dutch art is a form of nationalism, as anachronistic as the institutions of "artistic genius" and "monarchy." In the service of Her Majesty, the mastery of Rembrandt determines the unspoken mastery of a few over many. And that, of course, is the most antidemocratic value of all.

1. The RRP was established in order to revisit the corpus of paintings so far attributed to the master, so as to "purify" the corpus of misattributions. The results are being published in a series of books titled *A Corpus of Rembrandt Paintings.* Three volumes have appeared to date—in 1982, 1986, and 1989—and volumes 4 and 5 have been announced as forthcoming.

2. Ernst van de Wetering, "Thirty Years of the Rembrandt Research Project," *IFAR Journal* 4, no. 2 (2001): 14–24. The formulation "Rembrandt / Not Rembrandt" echoes the title of an astounding pair of books that accompanied the exhibition in the Metropolitan Museum of Art in 1995. See Hubert von Sonnenburg, *Rembrandt/Not Rembrandt in the Metropolitan Museum of Art: Aspects of Connoisseurship,* vol. 1: *Paintings: Problems and Issues* (New York: The Metropolitan Museum of Art, 1995), and Liedtke et al., *Rembrandt/Not Rembrandt in the Metropolitan Museum of Art: Aspects of Connoisseurship,* vol. 2: *Paintings, Drawings, and Prints: Art-Historical Perspectives* (New York: The Metropolitan Museum of Art, 1995).

3. See Anthony Bailey, *Responses to Rembrandt: Who Painted "The Polish Rider"? A Controversy Reconsidered* (New York: Timken, 1994), for the debate on *The Polish Rider.* Van de Wetering's "Thirty Years of the Rembrandt Research Project" explains the current position of the (entirely renewed) group on this painting.

4. J. Bruyn, B. Haak, and S. H. Levie, et al., *A Corpus of Rembrandt Paintings,* Stichting Rembrandt Research Project (The Hague, Boston, London: Martinus Nijhoff, vol. 1: 1982; vol. 2: 1986; vol. 3: 1989), 1:5 (emphasis added).

5. Ibid., emphasis added.

6. Ibid., emphasis added.

7. On the ideological implications of grammar, see Günther Kress and Robert Hodge, *Language as Ideology* (London: Routledge & Kegan Paul, 1979); the authors subsequently extend their views to visual imagery in their *Social Semiotics* (Ithaca and London: Cornell University Press, 1988).

8. Bruyn et al., *Corpus* 1:8; emphasis added.

9. Mariët Westermann, *Rembrandt* (London: Phaidon, 2000).

10. H. Perry Chapman, *Rembrandt's Self-Portraits: A Study in Seventeenth-Century Identity* (Princeton, N.J.: Princeton University Press, 1990).

11. Svetlana Alpers, 1988 *Rembrandt's Enterprise. The Studio and the Market* (Chicago: University of Chicago Press, 1988).

12. I allow myself this lengthy reiteration—it is not a literal quotation—of my earlier writing because that book is out of print and hard to find, and also because I wish to demonstrate that "reading for the artist" is not, by definition, based on the anthropomorphic shifts I am analyzing here.

13. Bal, *Reading "Rembrandt": Beyond the Word-Image Opposition* (New York: Cambridge University Press, 1991), 309–10; modified.

14. In a book entirely devoted to the young Rembrandt's ambition to establish himself as a master painter, Alan Chong also connects the 1629 self-portrait to the ambition of the young painter. His text further acknowledges the changes made to the face as we (think we) know it, but chalks that up as indifference to verisimilitude. Thus the author de facto excludes the face from the signs of ambition. See *Rembrandt Creates Rembrandt: Art and Ambition in Leiden, 1629–1631,* ed. Alan Chong, exh. cat. (Boston: Isabella Stewart Gardner Museum, 2000), 93.

15. Bruyn et al., *Corpus,* 1:223; emphasis added.

16. Logocentrism is the tendency, characteristic of Christian hermeneutics, to reduce a text to the summary content or lesson that it allegedly harbors. As the case at hand shows, this critical term can be applied equally well to visual images.

17. Bernard Berenson, *Rudiments of Connoisseurship* (1902; reprinted New York: Schocken Books, 1962), 123; emphasis added.

18. Ibid., 122.

19. Ibid., 123.

20. Ibid., 29.

21. Ibid., 30.

22. Ibid., 134.

23. Ibid., 144.

24. Max J. Friedländer, *On Art and Connoisseurship,* trans. Tancred Borenius (1942; reprinted Boston: Beacon Press, 1960), 242; emphasis added.

25. See Mieke Bal, *Lethal Love: Literary Feminist Readings of Biblical Love Stories* (Bloomington, Ind.: Indiana University Press, 1987), chapter 5, for this interpretation of the creation story.

26. Berenson spells the name Van Dijke. I use the spelling now more common.

27. A good introduction to the discourse of Morelli of the early 1870s, before his major publications, is a recently published collection of Morelli's letters to Melli and Zavaritt; see *Collecting Connoisseurship and the Art Market in Risorgimento Italy: Giovanni Morelli's Letters to Giovanni Melli and Pietro Zavaritt (1866–1872),* intro. Jaynie Anderson (Venice: Istituto Veneto di Scienze, Lettere ed Arti, 1999).

28. Ibid., 61, emphasis added. Anderson puts due emphasis on the political aspect of connoisseurship. She sees this political thrust in "the development of national cultural policy" and opposes it to the "venal" aspect sometimes attributed to connoisseurship. Without wishing to exaggerate the *inherent* venality—the conflation of knowledge with capital—I think this distinction is a bit naïve in the face of the intricate intertwinement of the latter and nation states in the period she discusses.

29. *The Paintings of Rembrandt,* ed. A. Bredius (Vienna: Phaidon, 1936), not paginated. In the last page of the introduction he says, "It is the intention of this book to publish anew, subject to the most conscientious restriction, the complete oeuvre of Rembrandt's brush, which has lately been very considerably extended by additional attributions."

30. Bredius uses "brush" and "hand" interchangeably on the last page of his introduction and throughout the notes.

31. Bruyn et al., *Corpus,* 3:222.

32. I refer to Mieke Bal, *Travelling Concepts in the Humanities: A Rough Guide* (Toronto: University of Toronto Press, 2002), chapter 7, for an extensive argument against intentionalism.

33. I cannot develop here the many meanings that this act of judgment has in the practice of art history and art appreciation. This, and the especially important case of Artemisia Gentileschi, was treated by Nanette Salomon, "Judging Artemisia," public lecture, 24 March 2002, The Metropolitan Museum of Art, New York.

34. Jakob Rosenberg, *On Quality in Art: Criteria of Excellence, Past and Present* (Princeton, N.J.: Princeton University Press, 1967), 229, original emphasis.

35. Salomon, "Judging Artemisia," offers a sharp analysis of the paradigmatic reasoning of judgment in Vasari.

36. Rosenberg, *On Quality in Art,* 230, original emphasis.

37. Ibid., 230–31.

38. The term *para-synonym* refers to words that share some but not all semantic properties with each other. Among *hand, brush,* and *style* there is no ordinary synonymy, only the rhetorical one in the practice of attributionist discourse. Hence, the need to use the more complex term here.

39. Gary Schwartz, "Connoisseurship: The Penalty of Ahistoricism," *Artibus et Historeae* 18 (1988): 205, emphasis added.

40. This, according to Emile Benveniste's linguistics, see his *Problèmes de linguistique générale*, vol. 1 (Paris: Gallimard, 1966), English ed., *Problems in General Linguistics,* trans. Mary Elizabeth Meek (Coral Gables, Fla.: University of Miami Press, 1971); and, implicitly, J. L. Austin's philosophy of language, in *How to Do Things with Words* (Cambridge: Harvard University Press, 1975). On the inscription of posterity in artworks, see Michael Ann Holly, *Past Looking: Historical Imagination and the Rhetoric of the Image* (Ithaca and London: Cornell University Press, 1996).

41. Jean-Luc Nancy, *Corpus* (Paris: Editions Métailié, 2000), 10.

42. Ibid., 8, original emphasis in text.

43. Ibid., 19.

44. The masculinist investment in the hand as proof of authenticity is tersely pointed out by Andrew Perchuk, a propos of Pollock, in *Masculine Masquerade: Masculinity and Representation,* ed. Andrew Perchuk and Helaine Posner (Cambridge, Mass.: MIT Press, 1995): "And certainly Pollock's insertion of his physical presence into the surface of the paintings . . . is part of the overall masculine masquerade that Pollock wanted to project—and it is intimately connected to the works' projection of authenticity. In answer to Hofmann's observation that he didn't paint from nature, Pollock responded: 'I am nature'" (37–38). I find it interesting that he said this in an interview with the woman he lived with, Lee Krasner (*Arts,* April 1967, 38). A little later Perchuk writes: "Though Pollock eschewed the misogynist directness of de Kooning's attack on the markers of femininity . . . his debasement of the painting . . . his going beneath the figure into formlessness, is violence directed at a feminized construction" (39).

45. Van de Wetering, "Thirty Years of the Rembrandt Research Project," 14.

46. Ibid., 15.

47. Ibid., 20.

48. Ibid., 21, 23.

49. Ibid., 23.

50. Ibid., 24.

51. Schwartz, "Connoisseurship," 205.

52. Of course, questioning the status of judgments does impact on the judgments themselves. I am simply positioning my own argument elsewhere, and in order to avoid confusion I leave the assessments of the judgments themselves to scholars better equipped than I to make them. See Gary Schwartz, "Rembrandt Research After the Age of Connoisseurship," *Annals of Scholarship* 10, nos. 3–4 (1993): 313–35.

53. Carlo Ginzburg, "Clues: Morelli, Freud, and Sherlock Holmes," in *The Sign of Three: Dupin, Holmes, Peirce,* ed. Umberto Eco and Thomas A. Sebeok (Bloomington, Ind.: Indiana University Press, 1983), 95.

Reading Dutch Art: Science and Fiction in Vermeer

H. Perry Chapman

It was a cultural encounter, almost twenty-five years ago, to confront the Dutch art history establishment as an American, a woman, and writing a dissertation on Rembrandt's self-portraits. Their bemused response to my project was put most succinctly by the museum director, who said simply, "I wouldn't dare to speculate about that." This past semester, my graduate seminar "Art and Money in the Seventeenth-Century Netherlands" made me even more acutely aware than usual of national traditions in the study of Dutch art and of the distance between Dutch art history, which is rigorously fact based, and the American inclination to interpret more speculatively.

The seminar began with the Germanic tradition and Hegel, Max Weber, and Arnold Hauser's sweeping socioeconomic explanations of Dutch painting as the product of Protestant capitalism.[1] But we spent much of our time examining research into the economics of artistic production, collecting, and the art market, the fruits an archives-based social science tradition with deep roots in the Netherlands. The Dutch, in studying their own art, have long valued documentation over interpretation, description over analysis. The Dutch historian A. T. van Deursen, in 1991, put it thus: "Our goal is both simple and modest. Description must precede explanation; and so long as much of the description remains uncertain, any detailed attempt at explanation must be premature."[2] This may seem like naïve objectivity, yet the positivist tone set by the founding fathers of Dutch art history resulted in an extraordinary legacy of resources for the student of Dutch art. If the Netherlands is a researcher's paradise, it is because of Willem Martin, whose work on Jan Steen established the Dutch strand of socioeconomic studies, Abraham Bredius, the handwritten file card remains of whose systematic search in the archives are still consulted at the Rijksbureau voor Kunsthistorische Documentatie (Netherlands Institute for Art History), and Cornelius Hofstede de Groot, who published inventories of artists' collections and, in 1906, all of the then known documents concerning Rembrandt.[3] Within the past fifteen to twenty years, economists and social historians (some turned art historians) Michael Montias, Marten Jan Bok, Hans van Miegroet, and Neil de Marchi have conducted research that has redefined the "open market," produced unimagined insights into the art trade, and

even determined the "price of invention."[4] All of this was eye-opening to my students, who nevertheless breathed a sigh of relief when we got to more familiar territory: the bold, still economics-based interpretations by American art historians—of the imagery of marketing by Elizabeth Honig and Svetlana Alpers's Rembrandt as *homo economicus*.[5]

A second project this semester took me to an opposite extreme from economics—to fiction, which had me thinking that as the trans-Atlantic standoff between overly cautious and wildly irresponsible winds down, the scholarly divide(s) may now have to do less with national traditions than with the outer limits, the margins, of art history. I had been invited by Loyola College in Maryland to be one of the speakers—the art historian—in a series of lectures on *Girl with a Pearl Earring* by Tracy Chevalier, the best-selling historical novel set in Vermeer's house and studio. I have always been interested in encounters of fiction and art. One of my first brushes with art history was in tenth-grade English class, when reading Somerset Maugham's *Moon and Sixpence* led me to investigate Paul Gauguin. I learned then that I found real artists and real paintings more compelling than literary ones. Yet ever since, I have been disinclined to separate the art object from its individual maker and I have remained fascinated by those artists who, like Gauguin, cast themselves as larger than life. Much of my work has focused on both how artists—Rembrandt, Jan Steen—crafted themselves through their paintings and how their biographers and critics have constructed them.[6] Recently I have turned to Vermeer, whose challenge for me is that he was, and remains, so singularly self-effacing. Vermeer is currently of great interest to those at the margins of art history—the archivists, economists, and scientists at one extreme and the fictionalizers at the other. His awesome naturalism draws the scientifically inclined, at least some of them hoping to uncover the secrets of his studio practice. The human quality of his pictures and the difficulty of access to the people he paints, as to Vermeer himself, appeals to the different sensibilities of those who want to tell stories in the domain of the psyche, whether as art historians or as novelists. Hence the topic of this paper is science and fiction at the margins of Vermeer studies, and what it tells us about ourselves as art historians.

Science

By science I mean broadly the range of empirical approaches from archival to technical. Vermeer is at once the positivist's dream and nightmare. Compared to many Dutch painters, he confounds our yearning for true facts. I take the painter seen

from the back in *The Art of Painting* (see fig. 1)—is he or is he not Vermeer?—to be emblematic of our lack of access to Vermeer. In relative terms, we know next to nothing about him; he is a phoenix and a sphinx. Rembrandt and Steen were among the countless artists featured in the biographies of Arnold Houbraken, the Vasari of seventeenth-century Dutch painting; Vermeer, one of the few painters of note that Houbraken omits, had no early biographer. He appears only briefly, in a history of Delft, as the phoenix who rose from the ashes of the painter Carel Fabritius.[7] The Rembrandt documents published by Hofstede de Groot fill a volume and the findings since would fill another. In contrast, the comparable Vermeer documents fill a few pages; Théophile Thoré, writing as William Bürger, the proverbial mid-nineteenth-century discoverer of Vermeer, repeatedly called him the Sphinx of Delft. Though blamed for creating a romantic myth, it remains that Thoré based his notion of Vermeer's mystery not only on the inscrutable marvel of his pictures but also on enough solid research to figure out that comparatively little could be known about Vermeer the person.[8] We know, for example, nothing of his education and artistic training beyond the brief poetic reference to Fabritius. For all its claim to be about Vermeer, Michael Montias's documentary study *Vermeer and His Milieu* is really more about Vermeer's relatives, although it presents the monumental finding that Vermeer had a patron, Pieter Claesz van Ruijven, who owned a large percentage of his works. Montias, an economist whose specialty was Soviet block prices and wages and whose idea of a vacation spot was the Delft archives, is just one of the many outsiders who have galvanized the study of Dutch art.[9]

Vermeer's paintings make him the positivist's dream; their naturalism, seeming visual truthfulness, or feigned objectivity prompt scientific investigations like no others, much of which occurs beyond the limits of art history, in conservation labs and architects' studios. A survey of the Vermeer literature yields diagrams, line drawings, X-rays and auto-radiographs, mock-ups of various sorts, and micro-photographs, many of which have been tremendously revealing. In 1950 P. T. A. Swillens, convinced that Vermeer represented accurately exactly what he saw, plotted out the spaces of his pictures and determined that he painted most of his genre scenes in five rooms of his house (fig. 1). Swillens produced floor plans of the no longer extant house.[10]

The likelihood that Vermeer used a camera obscura (the lenses for which he could have obtained from his fellow townsman Anthonij van Leuwenhoek) led to debate and a spate of articles detailing just what he might have learned from the study of optics and how he might have employed such an optical device.[11] Many

photos were published which aimed to demonstrate that Vermeer could have achieved certain visual effects, particularly those having to do with the reflection of light, only if he had used a camera obscura. It was general consensus that "used" meant that he studied the effects of viewing through a camera obscura; but emphatically *not* that he relied on the device in a purely mechanical way for, say, tracing.

Conservation scientists, often working in museums in conjunction with art historian curators, most notably Arthur Wheelock, have produced insights into Vermeer's ways of working and inventing. X-radiography and auto-radiography have let us see below the paint surface and into Vermeer's mind, revealing that he frequently altered his compositions as he painted.[12] The early *A Maid Asleep* (The Metropolitan Museum of Art, New York)

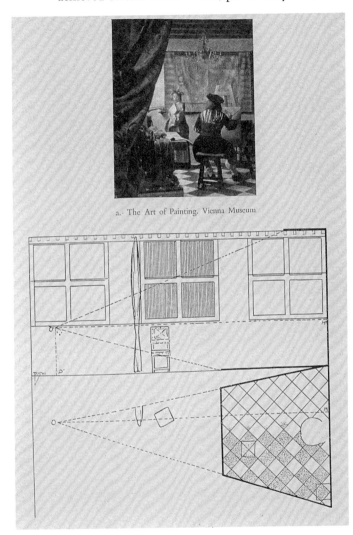

a.· The Art of Painting. Vienna Museum

Fig. 1. Diagram of Vermeer's *Art of Painting,* from P. T. A. Swillens, *Johannes Vermeer: Painter of Delft, 1632–1675* (Utrecht and Brussels: Spectrum, 1950)

takes on different meaning—the old description of the picture as a "a drunken, sleeping maid at a table" makes more sense—when we know that Vermeer painted out the man and dog that originally stood in the doorway.[13] Microphotography—revealing, perhaps, that our faith in the lens is akin to that which has been attributed to Vermeer—has brought us closer to seeing the phenomenon of his brushwork.

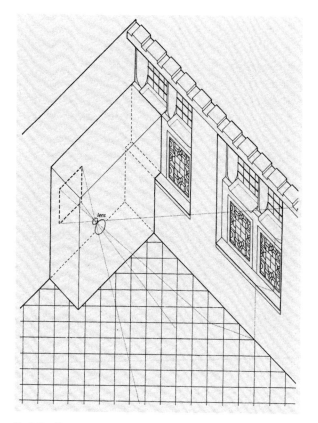

Fig. 2. Possible arrangement for Vermeer's camera obscura, from Philip Steadman, *Vermeer's Camera: Uncovering the Truth Behind the Masterpieces* (Oxford: Oxford University Press, 2001)

Examining the precise way in which Vermeer could lay down paint to achieve exactly the effects he wanted sends shivers down the spine because it gives us the illusion that we can almost see him at work at his easel.[14]

Recently Vermeer's system has gained renewed attention. The discovery, by Jorgen Wadum, of the Mauritshuis conservation lab, that many of his pictures have tiny pinholes at their vanishing points led to the conclusion that he must have used some kind of device involving strings to construct his perspectivally correct spaces.[15] Alternatively, and most recently, Philip Steadman, a British professor of urban and built form studies, has demonstrated—attempted to demonstrate, I should say—that Vermeer's pictures can only be the product of using, that is painting with or more likely painting from inside, a camera obscura (fig. 2). Despite its optimistic title, *Vermeer's Camera: Uncovering the Truth Behind the Masterpieces,* Steadman's book is surprisingly compelling. For it and a BBC documentary, Steadman reconstructed in miniature and full size Vermeer's *Lady with a Gentleman at the Virginals* (British Royal Collection). He also photographed his mockup of the *Concert* (Isabella Stewart Gardner Museum, Boston), but without people (fig. 3).[16] I take the uninhabited re-creation of this picture to be emblematic of the scientific extreme, of those who would be perfectly happy had Vermeer painted just the rooms and the light. I take this, too, as my cue to shift to fiction.

Fiction

In the Netherlands, when fiction intruded into the science of art history, it was as hoax and jokes, as positivism subverted. Rembrandt inspired serious archival mis-

chief from some of the very founders of Dutch art history: a 1906 supplement to Hofstede de Groot's *Urkunden über Rembrandt* purported to present twelve new archival findings, half of which were pure fabrications, an in-joke to the Rembrandt cognoscenti who could presumably distinguish the fakes, but a peril to later, less-discerning young scholars.[17] More recently, completely openly, but more astonishingly, Gary Schwartz, an American long residing in Holland, published a documents-based study of Rembrandt and his clients in which he invented responses to the seven known letters from Rembrandt's hand.[18] Schwartz's fabrication may have come at the height of the history *cum* fiction approach—think Simon Schama's *Dead Certainties*—but it also fit within, and strained against, the tradition of his adopted land.

When fiction intruded into the early twentieth-century project of reconstructing Vermeer's oeuvre, it was as the scandal of Han van Meegeren's forgeries.

In 1937 Bredius published and the Boymans Museum in Rotterdam acquired a *Christ at Emmaus* as a newly discovered Vermeer. Widely acclaimed as a long lost early Vermeer, it provided evidence that, just as suspected, Vermeer's artistic roots lay in the Utrecht followers of Caravaggio. When, in 1945, Van Meegeren was accused of selling a Vermeer (the national heritage) to a Nazi, Hermann Goering, he owned up to a lesser crime, forgery. His reason: revenge at the art establishment that had rejected his own art. And what better way to get at them than to call into question their collective connoisseurial eye and their science, which had determined the authenticity of the fakes. Though mistaking these for Vermeers seems inconceivable to

Fig. 3. Three-dimensional reconstruction of Vermeer's *Concert*, from Philip Steadman, *Vermeer's Camera: Uncovering the Truth Behind the Masterpieces* (Oxford: Oxford University Press, 2001)

us, in 1945 it took a team of scientific investigators and an extensive court hearing to shake faith in the pictures.[19] Still they had to see for themselves: in jail awaiting

trial, Van Meegeren was asked to paint another Vermeer (fig. 4). Convicted in 1947, he died before serving his one-year sentence.

The current spate of novels, movies, and an opera, are, of course, motivated quite differently by varied impulses to understand or to create aesthetically

Fig. 4. Han van Meegeren painting *Christ Among the Scribes in Prison*, 1945

in conjunction with Vermeer. The novels, especially, have great popular appeal and are part of a long tradition, which in Vermeer's case began with Marcel Proust, that seems to be flourishing as never before. Tracy Chevalier's *Girl with a Pearl Earring* is both a good read and a true historical novel in that it is the product of sufficient research and knowledge of Vermeer's pictures to effectively place the reader in seventeenth-century Delft.[20] Chevalier constructs much of her plot around a (post-) modernist fiction of Vermeer's studio. He keeps his studio locked and the family out; only the protagonist-maid, Griet, who is possessed of a special visual acuity, is allowed in. There, the two see aesthetically eye to eye in a tale of unrequited love. The appeal to the art historian is that Chevalier's narrative is firmly based in Vermeer's paintings, some of which feature squarely in the plot, others of which are evoked.

Take *The Little Street* (fig. 5), which Vermeer painted probably between about 1658 and 1660. For decades the positivists have been intent on finding exactly where this no longer, if ever, extant house was. Swillens published it as the building across the canal that ran behind the Vermeer family home, the inn "Mechelen," which Vermeer's father purchased in 1641, from which Vermeer and his wife had moved by 1660 (to go live with his mother-in-law), which Vermeer's mother operated until she leased it to a shoemaker in 1669, but which Vermeer still owned when he died in 1675. Because the house across the canal, formerly the Old

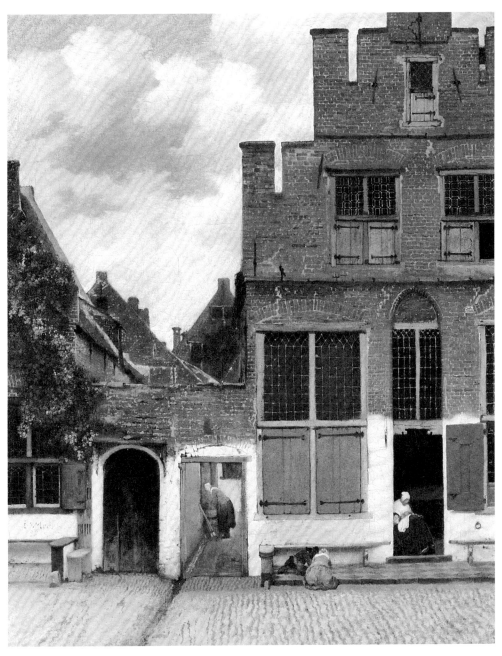

Fig. 5. Johannes Vermeer (Dutch, 1632–1675), *The Little Street*, c. 1658–60. Oil on canvas, 21 ¹/₁₆ × 17 ¹/₈ in. (53.5 × 43.5 cm). Rijksmuseum, Amsterdam

Men's Home, had recently been demolished to make way for the new Saint Luke's Guildhall, Swillens posited that Vermeer's picture in some way commemorated the original building.[21] Currently, two competing studies locate the house in *The Little Street* definitively on different Delft canals a few blocks away from each other; one is by an urban archaeologist, the other, on Steadman's website, identifies it as the same building Swillens thought it was, the house behind the inn "Mechelen."[22] Steadman shifts Swillens's overlay by a bay and provides a photograph taken around 1875 as proof, thereby seeming to confirm that *The Little Street* represents the view Vermeer could see from the windows of the room at the back of the inn. If this is so, then it raises the possibility that at least for part of his career, Vermeer may have worked not in the house where he lived with his wife, many children, and mother-in-law; but that instead, to get to his studio, he crossed the Market Square to return to the inn where he grew up.[23]

The novelist, unplagued by uncertainties as to where Vermeer really worked, imagines the house in *The Little Street,* which in reality probably stood behind his mother's inn, to be Vermeer's home and studio. Griet's arrival at her new place of employment evokes this familiar place. "Four girls were sitting on a bench beside an open door of a house."[24] The baby starts squirming, the girls arguing, and we get the sense that the oldest means trouble. Chevalier has set up the eternal question about Vermeer, a question prompted by the documents: how is it that this man, who lived and, we have long assumed, worked in a small house crowded with wife, mother-in-law, maid, and eventually eleven children, could paint such calm and quiet pictures? The novelist, at liberty to speculate in ways that art historians are not, has given us an answer already. He does it to get away from it all. Vermeer's wife is hyperactive, attention deficit: "The woman looked as if she had been blown about by the wind . . . Her cap was askew . . . curls hung about her forehead like bees which she swatted at impatiently . . . Her collar needed straightening . . . [She] could not fix her attention . . . her eyes darting about the room."[25]

Although the novel evokes house and bench, the scene Vermeer paints differs. The argument as to whether it represents a real place or not has tended to obscure what is of perhaps greater interest to the art historian, that is, the craft, invention, artistry, creativity, call it what you will, that went into making it a re-markably satisfying picture about an ideal of home. Though titled *The Little Street,* it was first and more appropriately described as "a view of a house standing in Delft." This was in the catalogue of the 1696 sale of twenty-one pictures by Vermeer from the estate of Jacob Dissius, which Dissius had presumably inherited from

Pieter Claesz van Ruijven, the "patron," who bought regularly from Vermeer.[26] The appeal of a picture of a somewhat rundown modest and old-fashioned house to a gentleman accustomed to finer living may have been in its nostalgic, picturesque evocation of a simpler past.[27] The woman guarding the threshold of her house and the maid performing her duties down the side alley model ideal domesticity. They engage in two seemingly natural tasks, sewing and cleaning, that signified the virtue essential to woman's role as protector of the domestic realm; and they keep in compositional check their faceless, perhaps somewhat subversive charges, the only two children Vermeer painted, who are down on their knees playing probably knucklebones.[28]

When Griet finally gains admittance to the locked studio, she is struck that "It was an orderly room, empty of the clutter of everyday life. It felt different from the rest of the house, almost as if it were in another house altogether."[29] The *Woman with the Pearl Necklace* (Staatliche Museen zu Berlin, Berlin) is the first painting she sees. My intention is not to deconstruct Chevalier's novel, but to consider how it at once prompts us as art historians to re-examine Vermeer and frees us to speculate in ways we otherwise might not. If (over-) scrutinizing the novel's accuracy led me to criticize its implausible treatment of Vermeer's studio practice, its errors, nevertheless, opened up the possibility of imagining Vermeer at work. Vermeer's fictional studio practice is premised on the empiricist assumption that he could paint only from the model in front of him. Griet becomes his co-slave to nature. The image of her surreptitiously dusting his studio, taking excruciating care to precisely reposition the still life objects and drapery he has set up to paint, raises questions about the practical realities to which we will never have access. The *Woman with the Pearl Necklace* supposedly represents the wife of Vermeer's patron. No matter how far-fetched, the notion of an elite client, instead of a paid model or family member, posing—for a most unlikely long time—for what I take to be a genre picture is a reminder of how little we know about the relation between Vermeer and van Ruijven, who came from different social strata but came together over art. Once freed from the mind-set of critical art historian, it is possible to appreciate how much about Vermeer's art Chevalier gets absolutely right. Her Griet is a sensitive viewer who looks at objects on a table and sees that, in the *Woman with the Pearl Necklace,* they look "exactly the same, except cleaner and purer."[30] Only she grasps the significance of what Vermeer sees in the camera obscura. And she notices that he takes liberties with visual reality. Vermeer's altering of this composition becomes part of the plot. Griet's surprise at finding the map gone from

the picture leads to a dialogue that deepens the bond between painter and maid: "'Does it please you that the map is gone?' 'It is a better painting now,'" she dares to reply.[31]

Later in the book Chevalier sets up a contrast between the true Vermeer, who paints introspection, and the Vermeer who lets himself be pushed around by other people, a dichotomy that speaks to our suspicions that some of Vermeer's pictures are perhaps out of character for him. Vermeer paints nothing—and, as far as I can tell, does absolutely nothing—from May to July. Then Van Ruijven decides that he wants a picture of his wife looking out. *The Girl with a Wine Glass* (fig. 6), in which a woman with an alarmingly awkward smile looks directly at the viewer as a gentleman encourages her to drink, has long puzzled art historians as an anomaly of uncomfortable extroversion in Vermeer's oeuvre.[32] In the novel, it had already led to scandal. "Van Ruijven had wanted one of the kitchen maids to sit for a painting with him . . . before [it] was finished she was carrying Van Ruijven's child."[33] In fiction, the unseemly happens when Vermeer paints against his "true self." Van Ruijven's next demand is to have his picture painted with the maid Griet; even with Vermeer's mother-in-law willing to play procuress, he does not get his way.

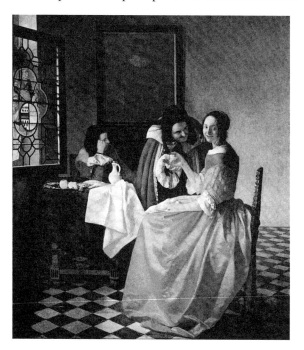

Fig. 6. Johannes Vermeer, *The Girl with a Wine Glass*, c. 1659–60. Oil on canvas, 30 ½ × 26 ¼ in. (77.5 × 66.7 cm). Herzog Anton Ulrich-Museum, Brunswick

The novel's thematizing of extroversion and introversion plays out through Griet's new role as artist's model. *Young Woman with a Water Pitcher* (fig. 7), the essence of Vermeer's interiority, is the first picture for which Griet poses. The baker's daughter had been, and will be, posing for months on end, but she has fallen sick from standing in the cold by the open window. Her hardship does not prepare us for the fate of poor Griet, when Vermeer paints her as *Girl with a Pearl Earring* (fig. 8) at the novel's climax. In lieu of ravishing her, he forces her to pierce her

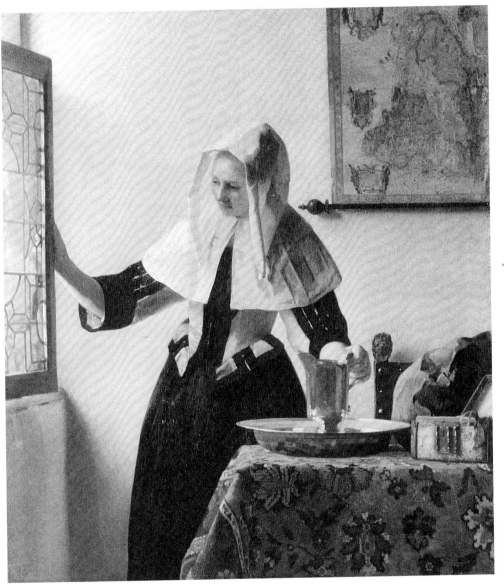

Fig. 7. Johannes Vermeer, *Young Woman with a Water Pitcher*, c. 1664–65. Oil on canvas, 18 × 16 in. (45.7 × 40.6 cm). The Metropolitan Museum of Art, New York. Marquand Collection, Gift of Henry G. Marquand, 1889 (89.15.21)

own ear. Among Vermeer's works, this is a picture of unusual, though not singular, directness; the natural immediacy with which she turns toward and opens up to the viewer is unlike anything else Vermeer paints. Chevalier has chosen the right picture for the center of her novel.

It is probably not much of an exaggeration to say that *Girl with a Pearl Earring* is the painting by Vermeer that most completely confounds both the diagrammers and the iconographers. We may come closer to understanding it when

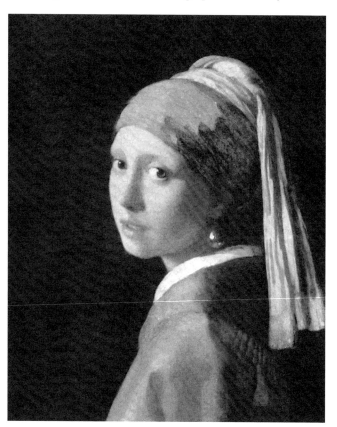

we take into account the impropriety of direct address in the seventeenth century. The immediacy of Vermeer's girl is reminiscent of painting in Utrecht, where it has been speculated that Vermeer trained.[34] For example, Hendrick Terbrugghen's exotically turbaned *Bacchante Squeezing Grapes* (The J. Paul Getty Museum, Los Angeles) spills out of her clothes as she leans forward to entice with her grapes; and for Jan Steen's *Oyster Girl* (Mauritshuis, The Hague), who offers herself along with her spiced aphrodisiacal oysters, immediacy is akin to proposition. In contrast, Vermeer achieves immediacy, real presence, a purer intimacy, without tainting the model. By this I mean

Fig. 8. Johannes Vermeer, *Girl with a Pearl Earring*, c. 1665–66. Oil on canvas, 17 ½ × 15 ⅜ in. (44.5 × 39 cm). Royal Cabinet of Paintings, Mauritshuis, The Hague

that he confounds the convention that the girl who addresses the viewer offers her body. Yet Vermeer's transformation of pictorial tradition—the art historical explanation—cannot account for why he achieved such brilliant intimacy only once. Chevalier's fiction that Griet drew him out of himself, if only momentarily and only so far, may be as good an explanation as any.

Chevalier's fictional artist bears a striking resemblance to the Vermeer that has been crafted by some of his most sensitive, stimulating art historical interpreters. Lawrence Gowing arrived at his powerful image of Vermeer's artistic personality essentially by psychoanalyzing his paintings. Both Chevalier's novel and Gowing's notion of Vermeer are based on the idea, derived from the paintings, that Vermeer kept his distance from humanity, and from women especially. Gowing writes of Vermeer's detachment, evasiveness, perpetual withdrawal. In saying "His nature excluded directness," and in alluding to his "fear of humanity," Gowing constructs a Vermeer who hides from women behind the camera obscura, who compositionally separates man from woman, and who buffers himself from humanity with tables and chairs. In Gowing's words, as in Chevalier's novel, "attention of man to woman is finally identified with the attention of a painter to his subject."[35] Women are so foreign to him that he can break through only with paint, most fully in *Girl with a Pearl Earring*. It makes for a riveting but sad story; but is it a Van Meegeren version of Vermeer?

Both the science and the fiction capture the popular imagination. And each in its own way promises to "uncover the truth behind the masterpieces." What can we as art historians learn from those who scrutinize Vermeer from the margins of our discipline and institutions, besides that they sell more books? I don't think it is simply that the world divides into those who marvel at Vermeer's ability to render the visible world and would be perfectly happy if he painted no people, and those for whom his people (and what is suggested but unseen and unknowable about them) are the real interest. Art historians are more inclined to value the scholarly rigor of economics and science. The historical novel offers a different kind of access. If the human interest factor drives the urge to fictionalize Vermeer, then it may be that the novelist's freedom to invent draws us back to, keeps us on track with, the painter's freedom to invent. Fiction's value is that it satisfies our desire to push beyond the limits of scholarship, to resist the many ways our discipline says "I wouldn't dare to speculate about that."

1. Georg Wilhelm Friedrich Hegel, *Vorlesungen über die Ästhetik* (1832–45; reprinted Frankfurt: P. Lang, 1986), I, vol. 13, 23–24; Max Weber, *The Protestant Ethic and the Spirit of Capitalism,* trans. Talcott Parsons (1905; reprinted London: G. Allen and Unwin, 1930); Arnold Hauser, *The Social History of Art* (New York: Alfred A. Knopf, 1951). See also *The Golden Age of Dutch Painting in*

Historical Perspective, ed. Frans Grijzenhout and Henk van Veen (New York: Cambridge University Press, 1999).

2. A. T. van Deursen, *Plain Lives in a Golden Age* (Cambridge: Cambridge University Press, 1991), ix.

3. W. Martin, *Jan Steen* (Amsterdam, 1924); Cornelius Hofstede de Groot, *Die Urkunden über Rembrandt (1575–1721)* (The Hague, 1906).

4. John Michael Montias, *Artists and Artisans in Delft: A Socio-Economic Study of the Seventeenth Century* (Princeton: Princeton University Press, 1982); John Michael Montias, "Cost and Value in Seventeenth-Century Dutch Art," *Art History* 10 (1987): 455–66; John Michael Montias, "Socio-Economic Aspects of Netherlandish Art from the Fifteenth to the Seventeenth Century: A Survey," *Art Bulletin* 72 (1990): 358–73; John Loughman and John Michael Montias, *Public and Private Spaces: Works of Art in Seventeenth-Century Dutch Houses* (Zwolle: Waanders Publishers, 2000), Marten Jan Bok, "Art-Lovers and their Paintings: van Mander's *Schilder-boeck* as a Source for the History of the Art Market in the Northern Netherlands," in Wouter Kloek et al., *Dawn of the Golden Age: Northern Netherlandish Art 1580–1620,* exh. cat. (Amsterdam: Rijksmuseum, 1993), 136–66; Wouter Kloek, "The Painter and His World: The Socioeconomic Approach to Seventeenth-Century Dutch Art," in *Golden Age in Historical Perspective,* 224–46; Neil De Marchi and Hans J. Van Miegroet, "Art, Value, and Market Practices in the Netherlands in the Seventeenth Century," *Art Bulletin* 76 (1994): 451–64; Neil de Marchi and Hans van Miegroiet, "Pricing Invention: 'Originals,' 'Copies,' and their Relative Value in Seventeenth-Century Netherlandish Art Markets," in *Economics of the Arts: Selected Essays,* ed. V. A. Ginsburgh and P.-M. Menger (Elsevier Science, 1996), 27–70.

5. Elizabeth Alice Honig, *Painting and the Market in Early Modern Antwerp* (New Haven, Conn.: Yale University Press, 1998); Elizabeth Alice Honig, "Desire and Domestic Economy," *Art Bulletin* 83 (2001): 294–315; Svetlana Alpers, *Rembrandt's Enterprise: The Studio and the Market* (Chicago: University of Chicago Press, 1988).

6. H. Perry Chapman, *Rembrandt's Self-Portraits: A Study in Seventeenth-Century Identity* (Princeton: Princeton University Press, 1990); H. Perry Chapman, "Jan Steen, Player in His Own Paintings," in H. Perry Chapman, Wouter T. Kloek, and Arthur K. Wheelock, Jr., *Jan Steen: Painter and Storyteller,* exh. cat. (Washington, D.C.: National Gallery of Art, and Amsterdam: Rijksmusuem, 1996), 11–23; H. Perry Chapman, "Jan Steen as Family Man: Self-Portrayal as an Experiential Mode of Painting," *Nederlands Kunsthistorisch Jaarboek* (1995): 368–93; H. Perry Chapman, "Persona and Myth in Houbraken's Life of Jan Steen," *Art Bulletin* 65 (1993): 135–50; H. Perry Chapman, "Jan Steen's Household Revisited," *Simiolus* 20, nos. 2/3 (1990/1991): 183–96.

7. Arnold Houbraken, *De groote schouburgh der Nederlantsche konstschilders en schilderessen,* 3 vols. (Amsterdam, 1718–21). Dirck van Bleyswijck, *Beschryvinge der Stadt Delft* (Delft, 1667); see John Michael Montias, *Vermeer and His Milieu: A Web of Social History* (Princeton: Princeton University Press, 1988), 104, 326.

8. William Bürger [Théophile Thoré], *Musées de la Hollande. Amsterdam et La Haye. Etudes sur l'Ecole Hollandaise*, 2 vols. (Paris, 1858–60), 1:272–73; 2: 81–84; William Bürger [Théophile Thoré], "Van der Meer de Delft," *Gazette des Beaux-Arts* 21 (1866): 297–330, 458–70, 542–75. On Vermeer's critical reputation, see Ben Broos, "Un celebre Peijntre nommé Vermeer," in *Johannes Vermeer*, exh. cat. (Washington, D.C.: National Gallery of Art, and The Hague: Royal Cabinet of Paintings Mauritshuis, 1995–96), 59–61; Christiane Hertel, *Vermeer: Reception and Interpretation* (New York: Cambridge University Press, 1996); Dedalo Carasso, "A New Image: German and Dutch Thought on Dutch Art, 1775–1860," in *Golden Age in Historical Perspective*, 108–29; Frances Suzman Jowell, "Vermeer and Thoré-Bürger: Recoveries of Reputation," in *Vermeer Studies*, ed. Ivan Gaskell and Michiel Jonker, Studies in the History of Art 55, Center for Advanced Study in the Visual Arts Symposium Papers 33 (Washington, D.C.: National Gallery of Art, 1998), 35–57; Arthur K. Wheelock, Jr., and Marguerite Glass, "The Appreciation of Vermeer in Twentieth-Century America," in *The Cambridge Companion to Vermeer*, ed. Wayne E. Franits (New York: Cambridge University Press, 2001), 161–81.

9. Montias, *Vermeer and His Milieu*, especially chapter 13, "Vermeer's Clients and Patrons"; also John Michael Montias, "Recent Archival Research on Vermeer," in *Vermeer Studies*, 93–109.

10. P. T. A. Swillens, *Johannes Vermeer, Painter of Delft 1632–1675* (Utrecht and Brussels: Spectrum, 1950).

11. Charles Seymour, Jr., "Dark Chamber and Light-Filled Room: Vermeer and the Camera Obscura," *Art Bulletin* 46 (1964): 323–31; D. A. Fink, "Vermeer's Use of the Camera Obscura—A Comparative Study," *Art Bulletin* 53 (1971): 493–505; Arthur K. Wheelock, Jr., *Perspective, Optics and Delft Artists around 1650* (New York: Garland, 1977); idem., *Vermeer and the Art of Painting* (New Haven, Conn.: Yale University Press, 1995), 17–19 and passim; Philip Steadman, *Vermeer's Camera: Uncovering the Truth Behind the Masterpieces* (Oxford: Oxford University Press, 2001).

12. Arthur K. Wheelock, Jr., and C. J. Kaldenbach, "Vermeer's *View of Delft* and His Vision of Reality," *Artibus et Historiae* 6 (1982): 9–35; Arthur K. Wheelock, Jr., "Pentimenti in Vermeer's Paintings: Changes in Style and Meaning," in *Holländische Genremalerei im 17. Jahrhundert: Symposium Berlin 1984*, ed. Henning Bock and Thomas W. Gaehtgens, *Jahrbuch Preussischer Kulturbesitz* 4 (1987): 385–412; Arthur K. Wheelock, Jr., *Vermeer and Art of Painting*, passim.

13. Seymour Slive, "'Een dronke slapende meyd aen een tafel' by Jan Vermeer," in *Festschrift Ulrich Middeldorf*, ed. Antje Kosegarten and Peter Tigler (Berlin, 1968), 452–59; Maryan Wynn Ainsworth et al., *Art and Autoradiography: Insights into the Genesis of Paintings by Rembrandt, Van Dyck, and Vermeer* (New York: Metropolitan Museum of Art, 1982), 18–26; Walter Liedtke, *Vermeer and the Delft School*, exh. cat. (New York: Metropolitan Museum of Art, and London: National Gallery, 2001), 372–74.

14. E. Melanie Gifford, "Painting Light: Recent Observations on Vermeer's Technique," in *Vermeer Studies*, 185–200.

15. Jorgen Wadum, "Vermeer in Perspective," in *Johannes Vermeer*, 67–79.

16. Steadman, *Vermeer's Camera,* chapter 5, "Reconstructing the Spaces in Vermeer's Paintings," and chapter 7, "More Evidence, from Rebuilding Vermeer's Studio," pls. 5, 6, 7, and 8.

17. M. C. Visser, *Die Urkunden über Rembrandt. Erstes Supplement* (The Hague: Martinus Nijhoff, 1906). M. C. Visser was a pseudonym of Willem Martin, Cornelius Hofstede de Groot, Wouter Nijhoff, and T. Morren. See Seymour Slive, *Rembrandt and His Critics, 1630–1730* (The Hague: Martinus Nijhoff, 1953), 45 n. 1; Gary Schwartz, "Form Follows Dysfuntion 144: The Rembrandt Hoax," e-mail newsletter dated 11 Nov. 2001, in *Het Financieele Dagblad* (10 Nov. 2001).

18. Gary Schwartz, *Rembrandt, His Life, His Paintings: A New Biography with All Accessible Paintings Illustrated in Color* (New York: Viking, 1985), 106–16.

19. Among the mounds of technical evidence amassed in the extensive technical examinations of the forged Vermeers, X-rays of *The Last Supper* proved that Van Meegeren had used (and obviously destroyed) a picture by Hondius as his canvas. On the inquiry and technical report of 1946, see P. B. Coremans, *Van Meegeren's Faked Vermeers and De Hooghs: A Scientific Examination* (Amsterdam: J. M. Meulenhoff and London: Cassell & Co., 1949). On the Van Meegeren affair, see also Sepp Schüller, *Forgers, Dealers, Experts: Strange Chapters in the History of Art* (New York: G. P. Putnam's Sons, 1960), 95–89; Hope B. Werness, "Han van Meegeren *fecit,*" in *The Forger's Art: Forgery and the Philosophy of Art,* ed. Denis Dutton (Berkeley: University of California Press, 1983), 1–57.

20. Tracy Chevalier, *Girl with a Pearl Earring* (New York: Dutton, 1999). See also the novel by Susan Vreeland, *Girl in Hyacinth Blue* (New York: MacMurray & Beck, 1999), and the opera *Writing to Vermeer,* with music by Louis Andriessen and libretto by Peter Greenaway, which had its U.S. premier in New York's Lincoln Center on 11 July 2000.

21. Swillens, *Johannes Vermeer,* 94. Compare Arthur K. Wheelock, Jr., and Ben Broos in *Johannes Vermeer,* 104–5, for the argument that the scene in *The Little Street* is an invention or a composite.

22. Kees Kaldenbach, "*Het Straatje* van Johannes Vermeer: Nieuwe Langendijk 22–26?" *Bulletin Koninklijke Nederlandse Oudheidkundige Bond* 99, no. 6 (2000): 238–49, discusses the archaeological evidence for locating the site; Philip Steadman, "A Photograph of *The Little Street,*" http://www.vermeerscamera.co.uk/essayhome.htm (viewed 28 Jan. 2002). For a map, see Kees Kaldenbach, "Vermeer Geography: Homes of Artists and Patrons in the Age of Vermeer," in *Cambridge Companion to Vermeer,* xxi-xxiv.

23. Steadman, *Vermeer's Camera,* 61–62, 98–100, discusses inconclusively whether the studio was in the inn "Mechelen" or in Vermeer's mother-in-law's house or neither. Montias, *Vermeer,* 132, 154–55, speculated that he may have kept a studio in the inn even though the inventory taken after Vermeer's death indicates that he had a studio in his mother-in-law's house.

24. Chevalier, *Girl,* 14.

25. Ibid., 4.

26. Montias, *Vermeer,* 200, 363–64.

27. For this argument, see Chapman, "Women in Vermeer's Home: Mimesis and Ideation," in *Wooncultuur in de Nederlanden/The Art of Home in the Netherlands 1500–1800,* ed. Jan de Jong et al., *Nederlands Kunsthistorisch Jaarboek 2000* 51 (Zwolle: Waanders Publishers, 2001), 239–45.

28. On household cleanliness and domestic virtue, see Simon Schama, *The Embarrassment of Riches: An Interpretation of Dutch Culture in the Golden Age* (New York: Alfred A. Knopf, 1987), especially part 3, "Living and Growing;" and Wayne E. Franits, *Paragons of Virtue: Women and Domesticity in Seventeenth-Century Dutch Art* (New York: Cambridge University Press, 1993). For the Dutch home, Mariët Westermann, *Art and Home: Dutch Interiors in the Age of Rembrandt,* exh. cat. (Denver: Denver Art Museum, and Newark: Newark Museum, 2001).

29. Chevalier, *Girl,* 33.

30. Ibid., 36.

31. Ibid., 64.

32. Nanette Salomon, "From Sexuality to Civility: Vermeer's Women," in *Vermeer Studies,* 309–26, offers the most cogent explanation of Vermeer's shifting treatment of women.

33. Chevalier, *Girl,* 126.

34. Montias, *Vermeer,* 73, 107. But compare Leonard J. Slatkes, "Utrecht and Delft: Vermeer and Caravaggism," in *Vermeer Studies,* 81–91, and Liedtke, *Vermeer and the Delft School,* 147.

35. Lawrence Gowing, *Vermeer* (London: Faber and Faber, 1952; reprinted Berkeley: University of California Press, 1997), 26–54.

History and Image: Has the "Epistemological Transformation" Taken Place?

Georges Didi-Huberman

We rarely look critically at how we practice our discipline. We often refuse to question the stratified and not always glorious history of words, categories, or literary genres that we use on a daily basis to produce our historical knowledge. Because it is never long before this archaeology unearths entire regions of censure or things unconsidered, it always ends up provoking a debate, or at least intervening in one. Years ago, when discussing the crucial importance of Nietzsche's genealogy for the epistemology of history, Michel Foucault rightly claimed that "knowledge, even under the banner of history, does not depend on 'rediscovery,' and it emphatically excludes the 'rediscovery of ourselves.' History becomes 'effective' to the degree that it introduces discontinuity into our very being . . . knowledge is not made for understanding; it is made for cutting."[1] The debate, whose epistemological—indeed, institutional—framework I would like to evoke here, is sparked by this sole question in the form of a fold, a folding: what relationship between history and time does the image impose on us? And what consequence does this have on the art historian's practice?

Already we can see the problem concealed by this folding: doing the history of art inevitably forces us to play these two terms as critical tools that can be applied to one another. So, the point of view of history casts beneficial doubt on the value systems contained, at a given moment, in the word *art*. But the point of view of art—or, at least, that of the image, the visual object—reciprocally casts beneficial doubt on the models of intelligibility contained, at a given moment, in the word *history*. What is our "given moment" in France, then?

Undoubtedly, it is one in which crisis and hegemony are mixed: at the same time that the historical discipline is invested with greater power—of expertise, prediction, jurisdiction—it seems to be losing its epistemological coherence. At the same time that history entertains doubts about its method and its stakes, it is still enlarging its fields of competence: art and the image are henceforth fodder for the "ogre-historian,"[2] and so much the better.

Yet, if in its own naming, the history of art contains the critical return of art onto history and of history onto art, the critical return of the image onto time, and of time onto the image to which I have referred, then art history cannot

simply be considered as a particular branch of history. The question to ask instead is this: is doing art history doing history in the usual sense and practice? Or rather, doesn't art history deeply modify the epistemic schema of history itself? Hans Robert Jauss wondered "whether art history can in fact do anything else but borrow its overall coherence from pragmatic history."[3] Indeed, I think that art history must do something else: it showed itself capable when it provided history with an analytically rigorous and conceptually inventive model during a moment marked by the names Wölfflin, Warburg, Schlosser, Wind, and Riegl. Art history then showed itself to be as philosophically audacious as it was philologically rigorous, and this is why it could play its pilot role among historical disciplines in general, just as linguistics would do later, during the advent of structuralism.

Another reason for refuting Jauss's judgment is that the overall coherence that might be substantiated by history today, and from which art history might borrow, does not really exist. Michel Foucault, again, stated it well: "The epistemological transformation of history is not yet accomplished today. However, it does not date from yesterday"[4]—a way of saying that the eternal return and anachronism are fundamental questions in history.[5] Here, then, we are in the precise folding of the relationship between time and history. That being the case, shouldn't one ask the historical discipline itself what it wants to do with this folding: occult the anachronisms that emerge from it, and so silently crush time under history—or open up the fold and allow paradox to flourish?

Let's allow paradox to flourish: all history is anachronistic. This means that in order to take stock of "historical life"—one of Burckhardt's expressions—knowledge, as the discipline of history understands it, should learn to make its proper models of time more complex, move across the depths of multiple memories, weave together the fibers of heterogeneous time, recompose rhythms in disconnected tempi. Anachronism takes on a renewed, dialectical status from this complexification. As the accursed share of knowledge as the discipline of history understands it, anachronism—in its very negativity, in the power of its strangeness—encounters a heuristic chance through which it, eventually, attains the status of a native share, essential to the very emergence of the objects of this knowledge. To speak like this about knowledge as the discipline of history understands it, then, is to say something about its object: it is to offer the hypothesis that all history is about (of) anachronisms. I mean, at the very least, that the chronological object itself is only thinkable according to its anachronistic counter-rhythm.

Folding—a dialectical object, then. A double-faced thing, a rhythmic

beating. What do we call this object if "anachronism" eventually describes only one side of its oscillation? Let's venture another step, let's venture a word in order to give substance to this hypothesis: at the hinge between time and history, there is what I would call a symptom. Symptom: a difficult word to make out.[6] It does not designate an isolated thing, or even a process that can be reduced to one or two vectors, or an exact number of components. It is an intricacy of the second degree. It is something other than a semiological or clinical concept, even if it entails a certain understanding of the (structural) weight of dysfunctionality. At the very least, this notion denotes a dual, visual and temporal, paradox, which is understandably of interest to our field of interrogation: images and time.

The visual paradox is one of apparition: a symptom appears, a symptom arises, and in this way, it interrupts the normal course of things according to a law—as sovereign as it is subterranean—that resists trivial observation. What the image-symptom interrupts is nothing else but the course of representation. Yet, in a sense, it supports what it contradicts, so it may be considered from the angle of an unconscious of representation. As for the temporal paradox, we will have recognized it as proper to anachronism: a symptom never arises at the right moment, it always appears *contretemps,* like a long-felt sense of disquiet that returns to disturb our present. And, there again, it does so according to a law that resists trivial observation, a subterranean law that composes multiple durations, heterogeneous times, and interlaced memories. Therefore, what symptom-time interrupts is nothing else but the course of chronological history. Yet, it also supports what it contradicts: so it may be considered from the angle of an unconscious of history.

Since this assertion was first made in the French context of the *École des Études en Sciences Sociales,* it seems legitimate to pose the following question: how does this all too quickly summarized hypothesis carry on the lessons of the *Annales* school and of so-called new history, and how does it break with them? Once again, the question of anachronism reveals itself to be crucial in a debate whose lines of fracture it seems to delineate. As for the melodic line, if I can call it that—as for historical continuity—the critical character of a history that "presents problems" and, at the same time, breaks with the linearity of historical narrative *(récit)* has frequently been affirmed.[7] In his *Archaeology of Knowledge,* Michel Foucault described "distinct emergences," shifted, heterogeneous thresholds through which the history of the same object could introduce a "chronology that is not even, nor homogenous."[8] Why, then, should we reject anachronism if all it expresses are the critical aspects of temporal unfolding itself?

As for measure—the cutting apart of durations—all of the human sciences have affirmed the complex and differentiated character of the great temporal orders—from long durations to micro-historical references, from global structures to local singularities. Sociologists and anthropologists have acknowledged a "multiplicity of social times."[9] Fernand Braudel recognized that there "is no unilateral history" and consequently affirmed the over-determination of historical factors.[10] Reinhart Koselleck asked: "How in a given present, are the temporal dimensions of past and future related?"[11] Paul Veyne criticized euchronic fantasy and pleaded for an "inventory of differences" capable of "clarifying the originality of the unknown" at the risk of scrambling "continuous narrative" as well as periodic succession.[12] Why, then, in the name of periodization—the "principal instrument for rendering significant changes intelligible"[13]—should we reject anachronism, when all it expresses is the highly complex and symptomatic aspect of these very changes?

Finally, as for tempo—as for the slowness or speed of rhythms—it is impossible to see what might justify the taboo against anachronism in a discipline that has recognized, once and for all, the coexistence of *heterogeneous durations.* In 1958 Fernand Braudel wrote that "the long duration introduces itself among the different times of history as a burdening, complicated, and often novel figure."[14] The situation, as we know, has changed; the *longue durée* has since become a privileged, if not dominant, paradigm for historical research.[15] Yet, along with it, a spontaneous fear in the face of the heterogeneous—anachronism appearing as the heterogeneous or *disparate element of time,* and one felt to provoke irrationality—has engendered something like a defensive reaction, an internal resistance to the founding hypothesis.

On the one hand, the *polyrhythm* of history has been reduced to a register whose poverty would amuse any musician: the "quick time" of an event-based history; the time of slowly changing realities; the "quasi-immobile history" of the long duration.[16] On the other hand, the sensation that time breaks up into bits has been averted—how does one do history if time spreads itself out?—by pulling the long duration from the side of an "immobile history" dominated by massive "systems" and perpetual "regulations."[17] Finally, and above all, an approach that separates these different rhythms has been privileged, while the real problem has consisted in thinking through their composite formation; that is, their anachronism. One must not claim that there are historical objects relevant to this or that duration: one must understand that in each historical object, all times encounter one another, collide, or base themselves plastically on one another, bifurcate, or even become entangled with each other.

Can one make anachronism a paradigm for historical inquiry? To do so, as Nicole Loraux has written, is to already "attach oneself to everything that extends beyond the time of ordered narration: from flashes of enthusiasm to islands of immobility."[18] And what is a symptom, if not precisely the strange conjunction of these two heterogeneous durations: the sudden opening and the apparition (flash) of a latency or a survival (an island of immobility)? What is a symptom, if not precisely the strange conjunction of difference and repetition? Attention to the repetitive as well as to the always unpredictable tempi of its manifestations—the symptom as a non-chronological play of latencies and crises—is perhaps the most simple justification for the necessary introduction of anachronism into the historian's models of time.

It is no accident that Nicole Loraux's text "Éloge de l'anachronisme" (In Praise of Anachronism), ends by re-posing the still-burning question as to what the historian, the historian of ancient Greece in particular, should do with Nietzsche and Freud.[19] It is common knowledge that Nietzsche and Freud did not hesitate to make deliberate, anachronistic use of Greek mythology and tragedy. But reproaching their use of anachronism as a principal flaw—the major historical error, the irredeemable sin—means simply refusing to pay attention to the lesson borne by anachronism onto the very terrain of thinking about time, and therefore, about history. Nietzsche's anachronisms are consistent with a certain idea of repetition in culture, implying a certain critique of nineteenth-century historicist models. Freud's anachronisms are consistent with a certain idea of repetition in the psyche—death drive, repression, return of the repressed, *Nachträglichkeit,* etc.—implying a certain theory of memory.

Before even examining the impact and the fertility of these models of time in certain, specific domains of the history of images—as I have tried to do with regard to Aby Warburg's concept of *Nachleben*—one may note the extent to which the historian still avoids the question, just as one would flee a fundamental sense of disquiet. This is a more general sign of history's very complex relationship to philosophy and, furthermore, to psychoanalysis. Even Jacques LeGoff—one of the most prolific and open of our historians—refuses to grant Nietzsche the slightest place in his large methodological bibliography. Moreover, he voluntarily asserts Fustel de Coulanges's well-known aphorism ("There is a philosophy and there is a history, but there is no philosophy of history") as the, yet again, damning judgment of Lucien Febvre: "To philosophize—that which in the mouth of a historian signifies . . . the gravest of crimes."[20]

Things seem even more confused where the omnipresent (and therefore impossible to contain as a "territory") domain of the psyche is concerned. In 1938 Lucien Febvre claimed to be "resigned in advance" to the "disappointing" nature of the relation between history and psychology.[21] Why? Precisely because the psyche is a constant source of anachronisms: "the psychology of contemporary psychologists has no possible use in the past, nor does the psychology of our ancestors have possible global application to the men of today."[22] To support his claims, Lucien Febvre gave the example of the ancient arts of dying, claiming that their "kind of psychological cruelty—at least to our judgment—transports us, suddenly, singularly, far from ourselves and from our mentality."[23] As if in 1938 mankind had finished with "psychological cruelty." As if cruelty, in the psyche and in the practice of men did not have its own long history, its survivals, and its eternal returns.

Yet, one cannot dismiss the psychic object from the field of history without major inconsistency. In 1941 Lucien Febvre was discovering the "history of sensibility": "a new subject. I do not know one book that deals with it."[24] He was not, however, unaware of Huizinga. But he was unaware, or pretended to be unaware, of Warburg, Lamprecht, Burckhardt, and all of German *Kulturgeschichte*.[25] Once again, he reiterated that the danger of anachronism lay in wait. He referred to Charles Blondel and his *Introduction to Collective Psychology* in order to explain the historian's other nagging problem: subjectivism where, by definition, the affective life evolves.[26] He nonetheless paved the way for a history of mentalities and a historical psychology, which developed in France over the following four or five decades. In 1961, for example, Robert Mandrou defended a "historical psychology," which came with the notion of "mental equipment" in the bargain, its theoretical foundations located in Lucien Febvre on the one hand, Henry Wallon and Jean Piaget on the other.[27]

That same year Georges Duby offered a methodological synthesis of the history of mentalities that took up, one by one, all of the precautions that Lucien Febvre had already laid out: while necessary, psychology exposes the historian to naïveté and anachronism, dangers that the more objective notion of "mental equipment" should protect one from. Charles Blondel, Henri Wallon, and Emile Durkheim (his notion of collective consciousness revisited in mentality), and Anglo-Saxon social psychology provided Georges Duby with his fundamental references for defining the word *psyche* in relation to history.[28] In parallel, Jean-Pierre Vernant defended a historical psychology, which claimed Ignace Meyerson as its founding father.[29]

The notable exception constituted by Michel de Certeau's work mitigates this overall impression: the French historical school followed, in all—bad—logic, the lessons of the French psychological school.[30] It thus adopted, without any specific discussion of the concepts themselves, a tacit position of rejection, or even irrational resentment, of psychoanalysis. Jean-Pierre Vernant's silence about Freud, which Nicole Loraux remarks upon with surprise, was first Ignace Meyerson's silence. In his own psychology of artworks and his own psychology of the dream, he wanted to ignore Freudian psychoanalysis, so he even refused to refute it.[31] As for Jacques Le Goff, he considered psychoanalysis to be among the more "interesting evolutions, but with as yet limited results,"[32] of the so-called new history, and saw psychoanalysts as theoreticians dominated by "the temptation to treat memory like a thing, [those who] drive toward the quest for the atemporal and seek to evacuate the past."[33] That psychoanalysis is finally reduced to a "vast antihistorical movement" is what, in the end, led to a view of Freud's work that was completely biased by references to Pierre Janet, Fraisse, or Jean Piaget.[34]

What is missing, then, from historical psychology is, quite simply, a theory of the psychic.[35] What impoverishes the history of mentalities is, quite simply, that its operational notions—mental equipment in particular—stem from an outdated positivist psychology that above all, lacks a concept of the unconscious. Some historians seem to have sensed that such theoretical laziness—or fear—in place of the psychic or the cultural, or whatever else in history resists positivist objectification, leads to an impasse. Recently Roger Chartier, among others, has called into question the lacunae left by a social history, preoccupied with "globalities" or with simple "divisions," and "territorial definitions," incapable of doing justice to the *porousness*—the expression is mine—of the cultural field. He therefore proposed a "cultural history of the social" in the space and in place of the social history of culture (a permutation Aby Warburg had already put to work a century ago). And, by way of an operational concept, he proposed representation as a recourse to what he called the "general crisis of the social sciences." He understood representation as "notional equipment that was used by contemporaries," and as an even greater structural device, of the kind that Louis Marin succeeded in bringing out in his analyses of the classical sign and the iconography of power during the seventeenth century.[36]

It is a fair proposition in its own way—but it goes only half the distance. On the one hand, it takes into account the crucial position of images—mental or reified—in any historical psychology, and in any historical anthropology: a richness fleshed out in the work of Jean-Pierre Vernant's or Jacques Le Goff's followers.[37]

On the other, it still refuses to note that the problematic of the image—I mean the image as an operational concept and not as a simple iconographical support—implies two major critical inflections or reversals: we cannot produce a consistent theory of the image without a thinking about the psyche that includes the symptom and the unconscious; that is, a critique of representation.[38] Similarly, we cannot produce a consistent notion of the image without a thinking about time that includes difference and repetition,[39] symptom and anachronism; that is, a critique of history as unilateral submission to chronological time. These critiques must be made, not from the outside, but from inside of the historian's practice.

Is this an ambitious, and paradoxical program in this time of reigning positivism? Perhaps. Nevertheless, the intuition behind this work is that such a program was envisaged long ago, and up to a certain point, has been realized. But it has not been recognized, it has not been *read* as such. So, on behalf of a history of images (art history in the traditional sense, a history of representations, as some would prefer to understand it), I will take up the formula employed by Michel Foucault with regard to history in general: its epistemological transformation is not yet accomplished—even though it does not date from yesterday.

From when does it date, then? From where does this epistemological transformation come to us (and it is an epistemological transformation that art history owes itself to return to as urgently as psychoanalysis, in Lacan's day, had to redefine its own epistemological transformation through a re-reading of Freud)?[40] It comes to us from a handful of German historians—I am thinking, above all, of Warburg, Walter Benjamin, and Carl Einstein—contemporaries of Freud, non-academic historians more or less plainly rejected by the university, all unable to get their *Habilitation,* extra-sensitive to the waves of history, and engaged as much in the practical constitution of their objects of study as in philosophical reflection on the episteme of their discipline. They share two types of points in common, which are essential to our subject: they put the image at the center of their historical practices and their theories of historicity; the conception of time they deduced from their practices and theories was driven by the operational notion of anachronism.

As far as time is concerned, this constellation was contemporaneous with—sometimes indebted to, often critically so—the great philosophical works that flourished at the end of the 1920s, in particular Husserl's *Lessons for a Phenomenology of the Intimate Consciousness of Time,* and Heidegger's *Being and Time.*[41] During this same period Warburg was composing his *Mnemosyne Atlas,* and Benjamin began his construction of the *Arcades Project.* But, one must also broaden one's

scope and refer to Georg Simmel's or Ernst Cassirer's reflections on history—as well as the reflections of other stars in the constellation: Ernst Bloch, Franz Rosenzweig, Gershom Scholem, and later, Hannah Arendt.[42]

As far as the image is concerned, the constellation formed by these thinkers cannot be dissociated from the aesthetic upheavals of the first three decades of the twentieth century. It is impossible to understand the history of culture as practiced by Benjamin—practiced in such a way that one must question its anachronistic effects on knowledge—without taking into consideration the contemporary significance of Proust, Kafka and Brecht, but also of Surrealism and cinema. It is impossible to understand Carl Einstein's critical battles on the very terrain of history without James Joyce and Cubism, Musil, Karl Kraus, or the films of Jean Renoir. Prior to them, Warburg had provided the means for understanding the historical and anthropological sedimentations resulting from this sort of involvement with living art. Far from aestheticizing their historical method, all of these thinkers made the image—against the grain of traditional art history—a vital, lively, and highly complex question: a veritable central nervous system, the dialectical hinge par excellence of historic life in general. Atypical historians such as Kracauer, Giedion, or Max Raphael, among others that I am surely forgetting, would be worth rediscovering in this anachronistic constellation which seems so distant from us today.[43]

But why does it seem distant? Walter Benjamin responded for all by writing in 1940, in his *Theses on the Philosophy of History:* "Our generation is paid to know [it], since the only image it will leave behind is one of a generation conquered. This will be its legacy to those who come later."[44] It would also be fair to say that this entire generation of German Jews paid dearly for knowledge—it will have literally paid with its own flesh to feel liberated within the gay historical science. Two of the three authors committed suicide in 1940, upon the approach of a historical sentence that had been tracking them over their long years of exile. Twenty or so years earlier, the third, Aby Warburg, sunk into madness, as if into a fissure that had been torn open by the first worldwide earthquake. The anachronistic thinkers I refer to perhaps practiced history as amateurs, if by this we mean they invented new heuristic paths and did not hold university chairs. Yet, history took hold in them, which is another thing all together.

Evoking Ernst Bloch and Walter Benjamin along with Gustav Landauer, Georg Lukács, Erich Fromm and others, Michael Löwy fills out this constellation by insisting on the "permanent revolution" brought about by minds that synthesized

German Romanticism and Jewish Messianism. From here, he writes, surged "a new conception of history, a new perception of temporality, breaking with evolutionism and the philosophy of progress." Löwy adds that this generation of "unarmed prophets" appears "strangely anachronistic" today, forming nonetheless—or for this very reason—"the most up-to-date-thinking charged with utopian explosive potential."[45] Now, it seems to me that what he says about political theory and the philosophy of history applies to the history of art.

When one enters Aby Warburg's house and library in Hamburg today—emptied of its books under the Nazi threat one catastrophic night in 1933—one is struck by a small room full of dossiers and old papers, which reunite the destinies of all of the German art historians, Jews for the most part, who had to emigrate during the 1930s.[46] *This Archiv zur kunstgeschichtlichen Wissenschaftsemigration* bears witness to the great fracture which art history—so scientific and sure of itself—wrongly believes it has recovered from today.

The fracture to which I refer has divested us of our own founding moments, nothing less. The "epistemological transformation" of art history took place in Germany and in Vienna in the first decades of the twentieth century: with Warburg and Wölfflin, with Alois Riegl, Max Dvořák, Julius von Schlosser, and a few others, including Panofsky.[47] It was a moment of extraordinary fertility because the general presuppositions of classical aesthetics were called into question by a rigorous philology, and because this philology, in turn, was relentlessly questioned and reoriented toward a critique capable of posing the problems in precise philosophical terms. One could summarize the situation that has since prevailed by saying that World War II shattered this movement and the postwar era buried its memory.

It is as if this fertile movement was dead twice over: first destroyed by its enemies, then denied—its traces abandoned—by its own heirs. The majority of Warburg's disciples emigrated to the Anglo-Saxon university world. This world was ready to welcome them, but was not intellectually ready to take in an entire Germanic fund of thought, with its own references, its stylistic turns and turns of thinking, its untranslatable words. Warburg's disciples had to change languages, and therefore, vocabulary. They kept the philological tools, but left aside the critical ones—Fiedler's aphorisms, Alois Riegl's *haptisch,* the concept of *Einfühlung,* notions stemming directly from Freudian psychoanalysis, dialectics, or phenomenology. All of this gave way to a vocabulary that was deliberately more pragmatic, more "positive," as they say, and more scientific, or so they believed. In renounc-

ing their language, the art historians from a murderous Europe ended up renouncing their theoretical reflection. In a sense, this is entirely comprehensible. For example, one understands that after 1933 Panofsky never once cited Heidegger, one understands that he had to plainly reject this vocabulary, which was not only "antiquated" but also contaminated by its proper destiny.[48] In a certain sense, the "defeated generation" itself was defeated a second time.

In France, of course the problem has posed itself differently, but the results will have been the same: a rejection of German art history because of an explosive situation—but resulting in a rejection of the style of thinking and the ensemble of conceptual demands with which art history had constituted itself as the avant-garde of thought.[49] It is not easy to reread texts by this "anachronistic constellation" today. I am from a generation whose parents wanted to listen to all of the world's music, except the German language. Therefore, beyond the intrinsic difficulty of these texts, my entrance into them bears the mark of a real uncanniness of language: feeling at home in an extremely foreign tongue, in which one has to grope one's way around, which one uses perhaps a bit emphatically, and which frightens a little when one thinks of its prestigious and tragic history.

It is a necessary re-reading, however. In closing, it corresponds to a three-fold wish, a triple stake: archaeological, anachronistic, and prospective. Archaeological, in order to dig across the thick layers of forgetting still accumulated by the discipline at the site of its proper foundations. Anachronistic, in order to go back from today's sense of disquiet to those our direct fathers no longer felt close ties with. Prospective, in order to reinvent, if possible, a use value for concepts marked by history—Benjamin's "origin," Warburg's "survival," Carl Einstein's "modernity"—concepts which could, today, invest our debates on images and time with a certain actuality.

Essay translated from the French by Vivian Rehberg.

1. Michel Foucault, "Nietzsche, la généalogie, l'histoire" (1971), *Dits et Ecrits 1954–1988, II* (Paris: Gallimard, 1994), 147–48. Available in English as "Nietzsche, Genealogy, History," in Foucault, *Language, Counter-Memory, Practice: Selected Essays and Interviews,* trans. Donald F. Bouchard and Sherry Simon (Ithaca: Cornell University Press, 1977), 153–54.

2. See Jacques Le Goff, *L'Imaginaire médiéval. Essais* (Paris: Gallimard, 1985); *Image et histoire* (Paris: Publisud, 1987); *Annales ESC* 68, no. 6 ("Mondes de l'art"), 1993; Jacques Baschet and Jean-Claude Schmitt, dirs., *L'Image. Fonctions et usages des images dans l'Occident médiéval* (Paris: Le Léopard d'or,

1996). The "ogre historian" is the title given to a collection of essays in honor of Jacques Le Goff: *L'Ogre historien. Autour de Jacques Le Goff,* ed. Jacques Revel and Jean-Claude Schmitt (Paris: Gallimard, 1998).

3. Hans Robert Jauss, *Toward an Aesthetic of Reception,* trans. Timothy Bahti (Minneapolis: University of Minnesota, 1982).

4. Michel Foucault, *L'Archéologie du savoir* (Paris: Gallimard, 1969), 21.

5. Which leads Paul Veyne to say, at the same time, that "Foucault revolutionizes history" and that history, as such, "does not have a fixed methodology." See Paul Veyne, *Comment on écrit l'histoire* (Paris: Le Seuil, 1971), 146–51 and 383–429.

6. See, in particular, Georges Didi-Huberman, *Invention de l'hystérie. Charcot et l'Iconographie photographique de la Salpêtrière* (Paris: Macula, 1982); *Devant l'Image* (Paris: Editions de Minuit, 1990), 195–218; *La Ressemblance informe, ou le gai savoir visuel selon Georges Bataille* (Paris: Macula, 1995), 165–383; "Dialogue sur le symptôme (avec Patrick Lacoste)," *L'Inactuel* 3 (1995): 191–226; *L'Image Survivante: Histoire de l'art et temps des fantômes selon Aby Warburg* (Paris: Editions de Minuit, 2002), 271–514.

7. See François Furet, "De l'histoire-récit à l'histoire problème" (1975), in *L'Atelier de l'histoire* (Paris: Flammarion, 1982), 73–90.

8. Foucault, *L'Archéologie du savoir,* 243–47. See Gilles Deleuze, *Foucault* (Paris: Editions de Minuit, 1986), 55–75 ("Strata or Historical Formations: the Visible and the Enunciable").

9. See Georges Gurvitch, *La Multiplicité des temps sociaux* (Paris: Centre de documentation universitaire, 1958); Alain Gras, *Sociologie des ruptures. Les pièges du temps en sciences sociales* (Paris: Presses Universitaires de France, 1979), in which the author addresses the questions of "heterogeneous times" and the "reversal of tendencies," of "fluctuations," "invariances," and "ruptures," etc.; Alfred Gell, *The Anthropology of Time: Cultural Constructions of Temporal Maps and Images* (Oxford-Providence: Berg, 1992).

10. Fernand Braudel, "Positions de l'histoire en 1950," *Ecrits sur l'histoire* (Paris: Flammarion, 1969), 20–21: "We no longer believe in the explanation of history by one or another dominant factor. There is no unilateral history. It is neither exclusively dominated by the racial conflicts whose shocks and agreements would have determined an entire human past, nor by powerful economic rhythms, factors in progress and in debacles; nor in constant social tensions, nor by this diffuse spiritualism in which Ranke sees the individual and vast history in general sublimated; nor by the reign of technique, nor by demographic growth, this vegetal sprouting that has belated consequences on collective life . . . Man is differently complex."

11. Reinhart Koselleck, *Futures Past: On the Semantics of Historical Time,* trans. Keith Tribe (Cambridge, Mass.: MIT Press, 1985), xxiii. See also 92–115 and 267–88.

12. Veyne, *Comment on écrit l'histoire,* 42 (against "the idea that all events of an epoch have the same physiognomy and form an expressive totality"), and *L'Inventaire des différences* (Paris: Le Seuil, 1986), 248 ("History must restore the lost meaning of particularities"). On the critique of periodization, see

Périodes. La construction du temps historique, ed. Olivier Dumoulin and Raphaël Valéry (Paris: Editions de l'EHESS-Histoire au présent, 1991); Daniel Shabetai Milo, *Trahir le temps (histoire)* (Paris: Belles Lettres, 1991).

13. Jacques Le Goff, *Histoire et mémoire* (Paris: Gallimard, 1988), 218.

14. Braudel, "Histoire et sciences sociales. La longue durée" (1958), in *Ecrits sur l'histoire,* 54.

15. See Michel Vovelle, "L'histoire et la longue durée" (1978), in *La Nouvelle Histoire,* ed. Jacques Le Goff (Paris: Complexe, 1988), 77–108. Emmanuel Le Roy Ladurie, "Événement et longue durée dans l'histoire sociale: l'exemple chouan" (1872), *Le Territoire de l'historien* (Paris: Gallimard, 1973), 169–86.

16. Fernand Braudel, *La Méditerranée et le monde méditerranéen à l'époque de Philippe II* (1949; reprinted Paris: Armand Colin, 1966), XII–XIV; Le Goff, *Histoire et mémoire,* 27–28 and 231. The triviality of this manner of cutting history—reducing it to the simple binary slow/fast—was remarked upon by Bernard Lepetit, "De l'échelle en histoire," in *Jeux d'échelles. La Micro-analyse à l'expérience,* ed. Jacques Revel (Paris: Gallimard-Le Seuil, 1996), 75: "Historiography has generally privileged two dimensions of the plurality of time: long tendencies and cyclical oscillations. The marriage of these temporal categories has long been the basis for the ordering of research results: on the one hand the structure . . . and on the other the narrative of the circumstances." See also Vovelle, "L'histoire et la longue durée," 102: "I believe that the dialectic of short lengths of time and long lengths of time will be quickly outmoded and historically outdated."

17. Emmanuel Le Roy Ladurie, "L'Histoire immobile," *Annales ESC* 29, no. 3 (1974): 673–92. See also François Dosse, *L'Histoire en miettes. Des "Annales" à la "nouvelle histoire"* (Paris: La Découverte, 1987), 105–18 and 231–35.

18. Nicole Loraux, "Éloge de l'anachronisme en histoire," *Le Genre humain* 27 (1993): 37.

19. See Didi-Huberman, *L'image survivante.*

20. Le Goff, *Histoire et mémoire,* 257. Elsewhere he claims not to appreciate Paul Veyne's predilection for "psychological explanation and the privileged recourse to philosophical notions and vocabulary." As for the citation of Lucien Febvre, it ends with a final "interdisciplinary" twist: "It is a question of making sure that [the historian and the philosopher], while remaining in their positions, do not ignore their neighbor to the point of becoming hostile, or at least as stranger, to him." Lucien Febvre, "Leur histoire et la nôtre" (1938), *Combats pour l'histoire* (Paris: Armand Colin, 1992), 282.

21. Febvre, "Histoire et psychologie" (1938), in *Combats pour l'histoire,* 207.

22. Ibid., 213.

23. Ibid., 214.

24. Febvre, "La Sensibilité et l'histoire" (1941), in *Combats pour l'histoire,* 221.

25. See the dossier ("Cultural History") devoted to this question in *Revue germanique internationale* 10 (1998).

26. Febvre, "La Sensibilité et l'histoire," 223.

27. Robert Mandrou, *Introduction à la France moderne (1500–1640). Essai de psychologie historique* (1961; reprinted Paris: Albin Michel, 1994), 11–13 and 91–104.

28. Georges Duby, "Histoire des mentalités," in *L'Histoire et ses méthodes,* ed. Charles Samaran (Paris: Gallimard, 1961), 937–66. See also Le Goff, "Les Mentalités. Une histoire ambiguë," in *Faire de l'histoire, III. Nouveaux objets,* ed. Jacques Le Goff and Pierre Nora (Paris: Gallimard, 1974), 76–94.

29. See Jean-Pierre Vernant, "L'histoire et psychologie," *Revue de synthèse* 86, nos. 37–39, (1965): 85–94; "Pour une psychologie historique" (1987), in *Passé et présent. Contributions à une psychologie historique,* ed. Riccardo Di Donato (Rome: Edizioni di Storia e Letteratura, 1995), 3–9; and in the same volume, "Les Fonctions psychologique et les oeuvres" (1989), 9–14.

30. See Michel de Certeau, *L'Ecriture de l'histoire* (Paris: Gallimard, 1975), 289–358 ("Freudian Writings").

31. See Ignace Meyerson, "Remarques pour une théorie du rêve. Observations sur le cauchemar" (1937) and "Problèmes d'histoire psychologique des oeuvres: spécificité, variation, expérience" (1953), in *Ecrits, 1920–1983. Pour une psychologie historique* (Paris: Presses Universitaires de France, 1987), 81–91 and 195–207. See also *Les Fonctions psychologiques et les oeuvres* (Paris: Vrin, 1948).

32. Jacques Le Goff, "L'Histoire nouvelle" (1978), in *La Nouvelle histoire,* 57.

33. Le Goff, *Histoire et mémoire,* 55 and 169.

34. Ibid., 33–36, 54, and 105–110.

35. See, for example, Alain Dufour, *Histoire politique et psychologie historique* (Geneva: Droz, 1966), 9–35, in which not a single technical psychological concept is discussed, utilized, nor even evoked.

36. Roger Chartier, "Le monde comme représentation," *Annales ESC* 44, no. 6 (1989): 1505–20, where he cites Louis Marin, *La Critique du discours. Étude sur la 'Logique de Port Royal' et les 'Pensées' de Pascal* (Paris: Minuit, 1975). Since then, see Chartier, *De la Représentation* (Paris: Gallimard-Le Seuil, 1994). See also the parallel reflections of Alain Boureau, "La compétence inductive. Un modèle d'analyse des représentations rares," in *Les Formes de l'expérience. Une autre histoire sociale,* ed. Bernard Lepetit (Paris: Albin Michel, 1995), 23–38 where, in the end, hope is placed in cognitive psychology as an operative tool for a "history of representation."

37. See François Lissarrague, *Un Flot d'images. Une esthétique du banquet grec* (Paris: Adam Biro, 1987); Françoise Frontisi-Ducroux, *Du Masque au visage. Aspects de l'identité en Grèce ancienne* (Paris: Flammarion, 1990); Jean-Claude Schmitt, *La Raison des gestes dans l'Occident médiéval* (Paris: Gallimard, 1990); Jean Baschet, *Les Justices de l'au delà. Les représentations de l'enfer en France et en Italie (XIIe–XVe siècles)* (Rome: École française de Rome, 1993).

38. See Georges Didi-Huberman, *Devant l'image,* 171–218, and "Imitation, représentation, fonction. Remarques sur un mythe épistémologique," *L'Image. Fonctions et usages des images dans l'Occident médiéval,* the Érice Symposium Papers, 1992, ed. Baschet and Schmitt (Paris: Le Léopard d'Or, 1996), 59–86.

39. See Gilles Deleuze, *Différence et répétition* (Paris: Presses Universitaires de France, 1968), 7–9 and

337–39, where it is clearly established that to rethink time with difference and repetition is, in the same movement, to critique the classical notion of representation.

40. See Jacques Lacan, "La Chose freudienne, ou sens du retour à Freud en psychanalyse" (1956), in *Écrits* (Paris: Le Seuil, 1966), 401–36.

41. Edmund Husserl, *Leçons pour une phénoménologie de la conscience intime du temps* (1928); Martin Heidegger, *Being and Time* (1927; reprinted San Francisco: Harper, 1991). For a historical glimpse of these reflections on time see Krzystof Pomian, *L'Ordre du temps* (Paris: Gallimard, 1984), 323–47.

42. See Georg Simmel, *Les Problèmes de la philosophie de de l'histoire. Une étude d'épistemologie* (1892–1907); Ernst Cassirer, "La Philosophie de l'histoire," trans. F. Capeillères and I. Thomas, in *L'Idée de l'histoire. Les inédits de Yale et autres écrits d'exil* (Paris: Le Cerf, 1988), 51–67; Ernst Bloch, *Heritage of Our Times* (1935; reprinted Berkeley: University of California Press, 1962); Hannah Arendt, *Between Past and Future: Six Exercises in Political Thought* (London: Faber and Faber, 1954), 3–15 ("The Gap between Past and Future," "Tradition and the Modern Age," "The Concept of History: Ancient and Modern"). On this constellation of thinkers about history, see above all the beautiful book by Stefan Moses, *L'Ange de l'histoire. Rosenzweig, Benjamin, Scholem* (Paris: Le Seuil, 1992).

43. See Siegfried Kracauer, *The Mass Ornament: Weimar Essays (1920–1931),* trans. T. Y. Levin (Cambridge and London: Harvard University Press, 1995), and "Time and History" (1963), in *History and Theory: Studies in the Philosophy of History,* supplement 6 (1966): 65–78; Siegfried Giedion, *The Eternal Present: A Contribution on Constancy and Change* (London: Oxford University Press, 1962), (volume 1, page vii, has an exergue by Ezra Pound: "All ages are contemporaneous"); Max Raphael, *Prehistoric Cave Paintings,* trans. Norbert Guterman (New York: Pantheon, 1945).

44. Walter Benjamin, "Thesis on the Philosophy of History" (1940), XII, in *Illuminations: Essays and Reflections,* trans. Harry Zohn (New York: Schocken Books, 1968), 260. [Translator's note: The phrase cited by the author does not appear in this English translation but does appear in the French version: "Sur le Concept de l'histoire" (1940), in Walter Benjamin, *Écrits français,* ed. J.-M. Monnoyer (Paris: Gallimard, 1991), 345.]

45. Michael Löwy, *Rédemption et utopie. Le judaïsme libertaire en Europe centrale. Une étude d'affinité élective* (Paris: PUF, 1988), 7–10 and 249–58, on the "new conception of history and temporality." See also Hans Meyer, *Allemands et Juifs: La révocation. Des Lumières à nos jours* (1994), trans. J.-C. Crespy (Paris: Presses Universitaires de France, 1999), where he evokes Hugo von Hofmannsthal, Karl Kraus, Otto Weininger, Arnold Schönberg, Anna Seghers, Hanns Eisler, Max Brod, Stefan Zweig, etc. Discussing Walter Benjamin, Hannah Arendt insisted on his physically anachronistic characteristics: "His gestures and the way he held his head when listening and talking; the way he moved; his manners, but especially his style of speaking, down to his choice of words and the shape of his syntax; finally, his downright idiosyncratic tastes—all this seemed so old-fashioned, as though he had drifted out of the nineteenth century into the twentieth the way one is driven onto the coast of a strange

land." Hannah Arendt, *Men in Dark Times* (New York: Harcourt Brace Jovanovich, 1955), 172.

46. See H. Dilly, *Deutsche Kunsthistoriker, 1933–1945* (Munich-Berlin: Deutscher Kunstverlag, 1988).

47. See in particular, Udo Kultermann, *The History of Art History* (New York: Abaris Books, 1993), 157–226.

48. See Erwin Panofsky, "Three Decades of Art History in the United States: Impressions of a Transplanted European" (1953), reprinted in *Meaning in the Visual Arts* (Chicago: The University of Chicago Press, 1955, edition 1982), 321–46. On the manipulation of German vocabulary, including philosophical vocabulary, by the Nazis, see Victor Klemperer, *LTI, la langue du IIIe Reich. Carnets d'un philologue* (1947), trans. E. Guillot (Paris: Albin Michel, 1996).

49. See Pierre Francastel, *L'Histoire de l'art, instrument de la propogande germanique* (1940) (Paris: Librairie de Médicis, 1945).

PART THREE

WHAT ART HISTORY IS,
OR WHAT IT DOES

A Neglected Tradition?
Art History as *Bildwissenschaft*

Horst Bredekamp

The Image and the Arts: An Artificial Split

Because the meaning of the German word *Bild* includes *image, picture, figure,* and *illustration,* the term *Bildwissenschaft* has no equivalent in the English language. It seems as if this linguistic difference is deepening an ongoing distinction between English- and German-speaking art history.

In Austria and Germany the principal elements of the discipline were created around 1900 and continued to be developed until 1933. After 1970 a major revival of art history as *Bildwissenschaft* took place in German art history. Advertisements, photography, non-art mass photography, film, video, and political iconography became regular subjects. When digital and net art became feasible, they were almost immediately included within the history of art.[1] Historically, then, two essential points comprise *Bildwissenschaft:* first, art history embraced the whole field of images beyond the visual arts, and, secondly, it took all of these objects seriously.

In the English-speaking world, though, the proliferation of media has not been the only complicating factor in reaching a consensus on how *Bildwissenschaft* should be defined. In a very recent advertisement of the journal *Visual Studies,* we find the following statement: "The cross-disciplinary and multi-modal nature of the journal will be reflected by the coverage of anthropology, sociology, cultural studies, media studies, visual culture, symbolic interaction, documentary photography . . . information technology, visual literacy, visual intelligence and communication studies."[2] Visual studies therefore is everything that the narrowest definition of art history is not.

This kind of separation of art history and visual studies in the English-speaking world has been a significant development in Germany and Austria as well, where similar efforts to establish a *Bildwissenschaft* by completely excluding art history have been undertaken. Perhaps because modern scholars have internalized this development the memory of what *Bildwissenschaft* once was is now in danger of being lost. Recently it has been argued that art history had failed as *Bildwissenschaft* because it never confronted modern media; iconology would have become a *Bildwissenschaft* if Erwin Panofsky had not encapsulated this method into an

analysis of Renaissance allegory.[3] Therefore, following the tradition of the nineteenth century, art history has been forced to neglect the media arts and deal only with works of "high" art.[4]

This argument, which comes from a leading art historian whose name stands for a very open-minded conceptualization of the discipline, can be taken as symptomatic. The concept of art history as *Bildwissenschaft* is obviously the object of a conscious amnesia; one has to reconstruct it and ask for the reasons for this general oblivion.

Bildgeschichte through Photography

Heinrich Dilly argued more than twenty years ago that the rise of academic art history at German universities in the nineteenth century would have been impossible without photography.[5] It is indeed astonishing how early, how enthusiastically, and, at the same time, how self-consciously some of the leading art historians praised the new medium. In contrast to the rejection of photography by artists, art critics, and members of their own discipline,[6] these scholars' work thus constituted a new perspective toward *Bildgeschichte.*

Alfred Woltmann, an art historian in Karlsruhe who tried to practice art history in a scientifically precise fashion and rename it artscience *(Kunstwissenschaft),* enthusiastically defended photography in 1864: "Photography has partly assisted, displaced or paragonized woodcut and engraving, but it has enlarged, facilitated, and improved the tools and aims of artistic re-creation infinitely."[7] And, in 1865, nearly twenty years before world famous scientists like Robert Koch argued that "the photographic picture of a microscopic object can under certain circumstances be more important than [the object] itself,"[8] Hermann Grimm, who would become the first full professor of art history at Berlin University in 1873, called for a collection of art historical photographs, arguing that these archives could become "today of higher importance than the greatest galleries of originals."[9] Grimm articulates here what Erwin Panofsky later called, ironically, the "rejection of originals,"[10] thus naming the basic conflict in art history: that it depends largely on the autopsy of the original but that it questions it also through the lens of photographic-founded knowledge. Wilhelm Lübke, probably the most popular art historian of the nineteenth century,[11] did not even see a conflict. In 1870 he saw that photography reproduced the breath of artistic originality as an immediately apprehensible sediment left over from "full animation."[12] Anton Springer, Germany's first academic full professor of art history, defended photography in media-historical

terms: as book printing put an end only to bad calligraphers, and as calligraphers had forced book printing to become an art, so the manual graphic arts would not be destroyed by photography; on the contrary, photography would strengthen their artfulness. Finally, Jakob Burckhardt actually spoke of photography as a treasure of *aura*. The danger that great works would disappear and lose their power would be averted by photography.[13]

These pioneers of academic art history gave voice to the nineteenth-century belief in technically aided objectivity,[14] but they recognized at the same time that photography was more than just a duplication of an object. Instead, they opened up the study of the technological act of reproduction by analyzing its autonomy. From Wölfflin's 1897 critique of photographic sculpture-reproduction[15] one can draw a straight line to Panofsky's brilliant 1930 essay on the original and the facsimile. Panofsky, after starting with the confession that facsimile reproductions are neither right nor wrong but have to be judged in their own stylistic realm, comes to the conclusion that the eye has to sharpen its capacity to draw distinctions all the more as originals and reproductions seemingly become identical.[16]

Also, slide projection, which by 1900 had become standard in academic art history,[17] was not only used as a didactic instrument but as an autopoetic guide to research. For Grimm the multiplying projection had the same analytic approach as the microscope. He valued the slide projection over the naked eye for its higher standard of representation of the artist's originality.[18] How much Grimm relied on slides to construct art history as *Bildwissenschaft* can be demonstrated by the fact that he hardly cared for books. When Heinrich Wölfflin succeeded Grimm as the chair of art history in Berlin in 1901, he found 1300 publications, but 15,000 slides.[19]

Using these slides, Wölfflin was able to demonstrate and at the same time reflect upon his bipolar *Kunstgeschichtliche Grundbegriffe* through his magical style of double projections. By developing his categories from examples of high art, Wölfflin meant them to be helpful to understand the visual culture of whole epochs in the broadest sense. He never used the term *Bildgeschichte*, but he did call art history the "development of modern seeing," which is in fact a broader and deeper concept.[20]

Grimm, Lübke, Springer, Burckhardt, Wölfflin, and Panofsky come together in that they include photographs and slides inside the circle of the estimation of originals and that they value projections as research tools of the highest order. Through the use of a mass of reproductions and slides they all tried to underline and strengthen the aura of the reproduction and at the same time increase the number of objects of study to develop new levels of art historical tools in agreement

with statistical methods. In enlarging the circle of art history's estimation of reproduction media, they changed art history profoundly toward *Bildwissenschaft.*

From Photography to Mass Media

Photography was of course not only taken as a subject but also as an object of research. Alfred Lichtwark, director of the Hamburger Kunsthalle, supported both artful and amateurish photography. His proposal to collect in both directions has been followed by the Hamburg Museum of Arts and Crafts since 1897.[21] Through this concept of embracing not only artful photography but also daily life snapshots, art history had become a *Bildwissenschaft* in the full sense of being dedicated both to the arts and to non-art images.

During the First World War, films, postcards, posters, and the illustrated press created an unparalleled concentration of the visual media; in 1917 the head of the German army, General Ludendorff, ordered seven hundred cinemas to be built along the frontlines, as "the war has demonstrated the overwhelming power of images and the film as a form of reconnaissance and influence."[22] In a strange coincidence, in the same year Aby Warburg collected and analyzed the whole *Bildmaterial,* expanding Lichtwark's methodology. It was an almost obsessive trial to take part in the war through its images. Consequently, Warburg defined himself as a "picture-historian, but not as an art historian."[23]

But the opposition turned into a marriage. In reaction to the propaganda of the First World War, Warburg worked on the "picture press campaigns" during the Reformation;[24] "the horror-fantasy of the ongoing war will be inconceivable without a picture-historical analysis of the belief in monsters."[25] In the introduction of his article Warburg argued that art history could fulfill its responsibility for the arts only by enlarging the field to include "images in the broadest sense."[26]

This article became the founding text not only for political iconography but also for the history of visual media. Its methodology led to the conception of art history as a "laboratory of cultural-scientific picture-history."[27] "Each day," Warburg wrote again in 1917, "turns me more and more into a historian of the image."[28] Not only Warburg's snake ritual essay but also, of course, his typologies of stamps demonstrate the concreteness of his approach.[29] Warburg strongly emphasized the value of a picture beyond the limits of the arts; they were, for him, the "nervous organs of perception of the contemporary internal and external life."[30]

The *Bilderatlas "Mnemosyne"* shows the product of Warburg's concept of art history as *Bildwissenschaft* or, as he wrote in 1925/26, "across the work-of-arts-

history toward a science of pictorial shape" as its final goal.[31] To give one example, which has been analyzed recently by Charlotte Schoell-Glass: the last plate compiles scenes of eucharistic sacraments, sacrifices, and self-sacrifices like the hara-kiri sheet on top of the middle column.[32] The center of this stripe is filled by scenes of the concordat between Mussolini and Pope Pius XI in July 1929, which Warburg witnessed in Rome. He contrasted the abandonment of the church's authority over Rome with the brutish appearance of the fascists in a confident act of the highest symbolic order.

Especially telling is the presentation of a sheet of the 29 July edition of the *Hamburger Fremdenblatt*. An image shows the pope during the procession. This photograph is juxtaposed with pictures of a Japanese golfer, a group of other golfers, a golf champion, the mayor, a French harbor commission, a rowing race, a students' convent, young people departing for England, a famous swimmer, and two racehorses. The craziness of this mixture was a product of a revolution in the daily press that had taken place in the twenties in Berlin. Images overtook the textual space without any coherency, turning each gaze into journals like the *Berliner Illustrirte Zeitung* into a dadaistic event. The images were chosen less for their sense and more for their formal aspects.[33]

Significantly, Warburg did not cut out the photograph of the pope but pinned up the whole crazy quilt sheet. He wanted to find a sense even in what he characterized as a "salad of pictures" *(Bildersalat)*. All the scenes apart from that of the pope are "self-confident representations of human excellencies" *(selbstzufriedene Schaustellungen menschlicher Vortrefflichkeit),* and the sportsmen are "competing dynamics" *(wettstreitende Dynamiker)* in a sphere of "mundane content" *(zufriedene Diesseitigkeit).* The images constitute an antagonistic pole in relation to the pope giving up his worldly reign. But although occupying the most space within the image, the procession is overlapped by the swimmer, thus overshadowing the "hoc est corpus meum" through his ostentatious "hoc meum corpus est." The dialectical tension thus turns into a "barbaric lack of style" *(barbarischen Stillosigkeit).*[34] As Warburg takes a seemingly banal photograph as seriously as a fresco by Raphael, he represents the essence of art history as *Bildwissenschaft,* which claimed to invest an unhindered energy in even the seemingly marginal and worthless.

Film and *Bildwissenschaft*

Warburg's groundbreaking Schifanoja lecture from 1912 ended with the confession that he had only been able to perform a "cinematographic projection."[35] It was

apparently more than a *captatio benevolentiae*.[36] Franz Wickhoff's analysis of *Vienna Genesis* from 1895 had attempted already to project the cinematographic gaze back into the history of art. Sergey Eisenstein at least saw *Vienna Genesis* as a paradigmatic study of running action and as an essential impulse for the training of his film eyes.[37]

Victor Schamoni's 1926 art historical dissertation on the possibilities of the absolute film, which he did with Martin Wackernagel in Münster,[38] developed a theory of the film by using similar categories of ornament, movement, and synaesthetics. His central term is *rhythm,* which he transfers from architectural structures to film sequences.

But nobody saw more cinematographic rhythms than Panofsky. He was a film maniac, and the only thing he objected to on his first trip to New York in 1931 was that "the cinemas are extremely lousy."[39] In a long review article on Dürer in which he too judged Wikhoff's *Vienna Genesis* to be a "cinematographic split up,"[40] he saw in some of Dürer's works "cinematographic" sequences.[41] And in a glowing letter from 1932 Panofsky compared Greta Garbo to Dürer; in the silent movies she had developed a style "which relates to the regular art of acting as graphics to painting." By limiting herself to silent movies she had established an autonomous style similar to Dürer's mastership in copperplate print. But when she talked she acted, according to Panofsky, like a watercolored etching done by Rembrandt.[42]

The letter sounds as if Panofsky had his book on Dürer already in mind, which he published eleven years later. He compared Dürer's workshop with Walt Disney's atelier,[43] and he even analyzed the portraits according to cinematographic categories,[44] confirming to his friend Siegfried Kracauer "that we both learned something from the movies!"[45] The same is true of the Leonardesque *Codex Huygens,* in which Panofsky saw not only the "kinetic possibilities" but also the "'cinematographic' representation" and the preformation of "the modern cinema."[46]

"On Movies"

Panofsky's "On Movies" was published within the same time frame as these observations.[47] With this essay we touch on the unwritten history of art history as *Bildwissenschaft* in the U.S.

Alfred Barr, the young, newly designated director of the Museum of Modern Art in New York, traveled to the Netherlands, the Soviet Union, and Germany, where he got strongly favorable impressions of the Bauhaus: "'A fabulous institution . . .

painting, graphic arts, architecture, the crafts, typography, theater, cinema, photography, industrial design for mass production—all were studied and taught together in a large new modern building.'"[48] This experience, as is well known, became the model of New York's Museum of Modern Art[49] and its founding of the film library in 1935, which later would be called the Vatican of film history. It was strongly supported by Panofsky. In a letter from early 1936 he declared his lecture "On Movies" a support for MoMA's film collection: films "are at least as worthy of being collected as pictures and books; I even became a member of the Advisory Committee for this film collection," which, he continued ironically, "does not exclude that on a minor level I am still interested in art history."[50] Given Panofsky's enthusiasm for film and MoMA's film library, one understands why in his film essay he defined cinema as the only relevant art of modernity.

At almost exactly the same time that Panofsky wrote his essay, Walter Benjamin's "The Work of Art in the Age of Its Technical Reproduction" was published in New York in its French version.[51] Nobody, as far as I know, has ever touched on this coincidence nor on the fact that Jay Leyda, a collaborator of Eisenstein and the new curator of the MoMA film library, asked for the German version of Benjamin's article so he could publish an English translation under the auspices of the film library. Horkheimer, disgusted by the article, hindered the plan in full panic, as did Adorno in 1938, when Meyer Shapiro also asked for the German *ur*-text.[52]

There is no direct evidence known, but it seems possible, if not certain, that Panofsky got to know Benjamin's text through the MoMA film library. They knew each other; Benjamin wanted to collaborate with the Warburg Library in Hamburg, and, although he could not succeed, Panofsky respected his *Trauerspiel*-book.[53] Benjamin maintained his admiration of Panofsky; when he had to defend his article in June 1935 in Paris, he prepared himself by rereading Panofsky's article on perspective.[54]

The reception of Benjamin's article was more or less nonexistent before the sixties; its fame came as a politically correct answer to McLuhan's *Understanding Media*. The only significant reaction, in my view, was Panofsky's second, enlarged edition of his "On Movies" in 1947. In this text he strengthened everything that Benjamin had denied. Even the slogan of the "magic of the multiplying arts,"[55] which Panofsky had put forward in the Dürer book, can be seen as an affront to Benjamin's theses about the loss of aura through reproduction.

Nevertheless both are united in the long-established media-historical approach to art history as *Bildgeschichte* and thus agree that film, like the visual arts

before, has to do with questions of life and death. Benjamin focuses on "shock,"[56] whereas Panofsky nominates four essential elements of film as folk art: horror, pornography, humor, and a clear-cut moral.[57]

Bildwissenschaft and Visual Studies

Art history as *Bildwissenschaft,* never excluding seemingly low art objects from its field of research, has been influential for Claude Lévi-Strauss's structuralism and Pierre Bourdieu's *habitus* theory, to name just two general fields of study.[58] Of course it was never forgotten in art history; Giulio Carlo Argan spoke in favor of art historians as *Bildhistoriker,* which Ernst Gombrich's work, reaching from studies of Renaissance iconology to *Art and Illusion,* represented in its full sense.

But to come back to the problem mentioned at the beginning of this essay: although in the English-speaking world there are of course many art historians who, like David Freedberg, represent art history as *Bildwissenschaft,* one has the impression that, for example, Barbara Stafford and James Elkins are perceived not as regular art historians anymore, but as heretical "visual studyists"[59] and that W. J. T. Mitchell is not seen as a builder of bridges but as one who has burned them.[60] This kind of camp thinking is disastrous for both sides—and for art history on both sides of the Atlantic. The separation of visual studies from art history and the retreat of the more conservative members of this discipline onto precious little islands would put an end to art history as *Bildgeschichte.* Seen through the lens of, say, 1930, the success of the turn to the visual in our epoch seems to depend on whether art history projects its precision of description, its formal and contextual analysis toward all fields of historical *Bildwissenschaft* or if it turns itself into a splendid second archaeology.

I would like to thank James Elkins, Irving Lavin, and Barbara Stafford for their critical readings of this paper, which was presented in different versions at the Getty conference "Frames of Viewing," Berlin, 2002, and the Clark Art Institute conference "The Art Historian." Special thanks also to Jay Williams, who edited the present text for *Critical Inquiry.*

1. Some significant examples, although published in later years, may be sufficient: Henriette Väth's magnificent dissertation "Odol: Reklame—Kunst um 1900" (Ph.D. diss., Giessen, 1985; see also Henriette Väth-Hinz, *Odol: Reklame-Kunst um* 1900 [Giessen: Anabas, 1985]) on the mouthwash Odol around 1900 as a forerunner of surrealism; Bodo von Dewitz, "'So wird bei uns der Krieg geführt!'

Amateurfotografie im ersten Weltkrieg" (Ph.D. diss., Munich, 1989) on soldiers' photographs in World War I; Martin Warnke, "Politische Ikonographie," in *Bildindex zur politischen Ikonographie*, ed. Martin Warnke (Hamburg, 1993), 5–12; Edith Decker's fundamental work on Nam June Paik, *Paik: Video* (Cologne: DuMont, 1988); and Hans Dieter Huber's historicization of the reflection of Internet art in art history, "Digging the Net—Materialien zu einer Geschichte der Kunst im Netz," in *Bilder in Bewegung: Traditionen digitaler Ästhetik,* ed. Kai-Uwe Hemken (Cologne: DuMont, 2000), 158–74.

2. Web page for *Visual Studies,* http://www.tandf.co.uk/journals/routledge/1472586X.html

3. See Hans Belting, *Bild-Anthropologie: Entwürfe für eine Bildwissenschaft* (Munich: W. Fink, 2001), 15.

4. Ibid., 17.

5. See Heinrich Dilly, *Kunstgeschichte als Institution: Studien zur Geschichte einer Disziplin* (Frankfurt am Main: Suhrkamp, 1979), 149. The more recent literature is given in Wiebke Ratzeburg, "Mediendiskussion im 19. Jahrhundert: Wie die Kunstgeschichte ihre wissenschaftliche Grundlage in der Fotografie fand," *Kritische Berichte* 30, no. 1 (2002): 22–39, and Ingeborg Reichle, "Medienbrüche," *Kritische Berichte* 30, no. 1 (2002): 40–56.

6. See Elizabeth Anne McCauley, *Industrial Madness: Commercial Photography in Paris, 1848–1871* (New Haven, Conn.: Yale University Press, 1994), 274–77, 292, and Dorothea Peters, '. . . die Teilnahme für Kunst im Publikum zu steigern und den Geschmack zu veredeln': Fotografische Kunstreproduktionen nach Werken der Berliner Nationalgalerie in der Ära Jordan (1874–1896)," in *Verwandlungen durch Licht: Fotografieren in Museen & Archiven & Bibliotheken,* ed. Landschaftsverband Rheinland und Rundbrief Fotografie (Dresden, 2000), 168, 173.

7. "Die Photographie hat Holzschnitt und Kupferstich theils sekundirt, theils verdrängt, theils zum Wettkampf herausgefordert, Mittel und Aufgaben der künstlerischen Nachschöpfung aber in das unendliche erweitert, erleichtert, vervollkommnet"; Alfred Woltmann, "Die Photographie im Dienste der Kunstgeschichte," *Deutsche Jahrbücher für Politik und Literatur* 10 (1864): 355. Compare Elisabeth Ziemer, *Heinrich Gustav Hotho, 1802–1873: Ein Berliner Kunsthistoriker, Kunstkritiker, und Philosoph* (Berlin: D. Reimer Verlag, 1994), 199.

8. "Das fotografische Bild eines mikroskopischen Gegenstandes ist unter Umständen für wichtiger, als diesen selbst"; Robert Koch, "Zur Untersuchung von pathogenen Organismen," *Mittheilungen aus dem kaiserlichen Gesundheitsamte* 1 (1881): 11. See also Thomas Schlich, "Die Repräsentation von Krankheitserregern: Wie Robert Koch Bakterien als Krankheitsursache dargestellt hat," in *Räume des Wissens: Repräsentation, Codierung, Spur,* ed. Hans-Jörg Rheinberger, Michael Hagner, and Bettina Wahrig-Schmidt (Berlin: Akademie-Verlag, 1997), 165–90.

9. He meant the *Photoalbum* to be perhaps "wichtiger heute als die grösten Gallerien von Originalen"; Herman Grimm, *Über Künstler und Kunstwerke* (Berlin: F. Dümmler, 1865), 38.

10. "Trotz meiner Abneigung gegen Original-Kunstwerke fand ich die Tizian-Ausstellung sehr schön";

Erwin Panofsky to Fritz Saxl, Aug. 1935, in *Korrespondenz 1910–1968,* ed. Dieter Wuttke, 5 vols. (Wiesbaden: Harrassowitz, 2001), 1:848.

11. See "Wilhelm Lübke," *Metzler Kunsthistoriker Lexikon: Zweihundert Porträts deutschsprachiger Autoren aus vier Jahrhunderten,* ed. Peter Betthausen et al. (Stuttgart: Metzler, 1999), 249.

12. "In voller Beseelung"; Wilhelm Lübke, "Photographien nach Gemälden des Louvre: Herausgegeben von der photographischen Gesellschaft in Berlin," *Kunst-Chronik* 5, no. 1 (1869): 45. Compare Ratzeburg, "Mediendiskussionim 19. Jahrhundert," 33.

13. Katja Amato, "Skizze und Fotografie bei Jacob Burckhardt," in *Darstellung und Deutung: Abbilder der Kunstgeschichte,* ed. Matthias Bruhn (Weimar: VDG, Verlag und Datenbank für Geisteswissenschaften, 2000), 47–60.

14. See Lorraine Daston and Peter Galison, "Das Bild der Objektivität," in *Ordnungen der Sichtbarkeit: Fotografie in Wissenschaft, Kunst, und Technologie,* ed. Peter Geimer (Frankfurt am Main: Suhrkamp, 2002), 57.

15. See Heinrich Wölfflin, "Wie man Skulpturen aufnehmen soll," parts 1 and 2, *Zeitschrift für bildende Kunst,* n.s. 6 and 7 (1896, 1897): 224–28, 294–97.

16. See Erwin Panofsky, "Original und Faksimilereproduktion," *Deutschsprachige Aufsätze,* ed. Karen Michels and Martin Warnke, 2 vols. (Berlin: Akademie Verlag, 1998), 2:1078–90, especially 1088; compare Michael Diers, "Kunst und Reproduktion: Der Hamburger Faksimilestreit-Zum Wiederabdruck eines unbekannt gebliebenen Panofsky-Aufsatzes von 1930," *Idea* 5 (1986): 125–37, and Anna M. Eifert-Körnig, "'. . . und sie wäre dann nicht an der Reproduktion gestorben,'" in *Der Photopionier Hermann Krone: Photographie und Apparatur—Bildkultur und Phototechnik im 19. Jahrhundert,* ed. Wolfgang Hesse and Timm Starl (Marburg: Jonas Verlag, 1998), 267–78.

17. See Reichle, "Medienbrüche," 42.

18. See Herman Grimm, *Beiträge zur Deutschen Kulturgeschichte* (Berlin: W. Herts, 1897), 359–60.

19. See Reichle, "Medienbrüche," 50.

20. "Entwicklung des modernen Sehens"; Heinrich Wölfflin, *Kunstgeschichtliche Grundbegriffe: Das Problem der Stilentwicklung in der neueren Kunst* (Basel: Schwabe, 1991), 23.

21. See Alfred Lichtwark, *Die Bedeutung der Amateur-Photographie* (Hamburg: Druck der Actiengesellschaft "Neue Börsen-Halle," 1894), and Ulrich Keller, "The Myth of Art Photography: A Sociological Analysis," *History of Photography* 8, no. 4 (1984): 252.

22. Quoted in Friedrich Kittler, *Grammophon, Film, Typewriter* (Berlin: Brinkmann and Bose, 1986), 129. The German reads: "Der Krieg hat die überragende Macht von Bild und Film als Aufklärungs- und Beeinflussungsmittel gezeigt" (197).

23. "Sagte zu ihm: ich sei Bildhistoriker, kein Kunsthistoriker"; Michael Diers, *Warburg aus Briefen: Kommentare zu den Kopierbüchern der Jahre 1905–1918* (Weinheim: VCH, 1991), 230 n. 142.

24. "'Bilderpressefeldzüge'"; Michael Diers, *Schlagbilder: Zur politischen Ikonographie der Gegenwart*

(Frankfurt am Main: Fischer Taschenbuch Verlag, 1997), 28.

25. "'Denn ganz abgesehen von dem Stück Aufhellung über Luther und seine Zeit, ist und bleibt ohne eine bildgeschichtliche Untersuchung des Monstra-Glaubens die Funktion der Greuelphantasie im jetzigen Kriege unfaßbar'"; Diers, *Schlagbilder,* 29.

26. "Bilder . . . im weitesten Sinn"; Aby Warburg, *Die Erneuerung der heidnischen Antike: Kulturwissenschaftliche Beiträge zur Geschichte der europäischen Renaissance,* in *Gesammelte Schriften: Studienausgabe,* ed. Horst Bredekamp et al., 2 vols. (Berlin: Akademie Verlag, 1998), 2:490.

27. "Laboratorium kulturwissenschaftlicher Bildgeschichte" (ibid., 2:535). This is misleadingly translated in the English version as "laboratory of the *iconological science of civilisation*"; Warburg, *The Renewal of Pagan Antiquity: Contributions to the Cultural History of the European Renaissance,* trans. David Britt (Los Angeles: Getty Research Institute for the History of Art and the Humanities, 1999), 651.

28. "'Jeder Tag'. . . 'macht mich mehr und mehr zum Bildgeschichtler'"; Diers, *Schlagbilder,* 31.

29. See Ulrich Raulff, "Idea Victrix-Warburg und die Briefmarke," *Vorträge aus dem Warburg-Haus,* vol. 6, ed. Wolfgang Kemp et al. (Berlin: Akademie Verlag, 2002).

30. "Nervöse Auffangsorgane des zeitgenössischen inneren und äußeren Lebens"; Ernst Gombrich, *Aby Warburg* (Berlin, 1981), 355.

31. "Ueber die Kunstwerkgeschichte zur Wissenschaft von der bildhaften Gestaltung"; Diers, *Schlagbilder,* 48 n. 34. See Aby Warburg, *Der Bilderatlas "Mnemosyne,"* ed. Martin Warnke and Claudia Brink (Berlin: Akademie Verlag, 2000); this is the official edition. Georges Didi-Huberman has recently given a new interpretation of its interaction with the contemporary media and avant-garde; see Georges Didi-Huberman, *L'Image survivante: Histoire de l'art et temps des fantômes selon Aby Warburg* (Paris: Editions de Minuit, 2002).

32. See Charlotte Schoell-Glass, "Aby Warburg's Late Comments on Symbol and Ritual," *Science in Context* 12, no. 4 (1999): 621–42.

33. See Kurt Korff, *"Die Berliner Illustrirte,"* in *50 Jahre Ullstein, 1877–1927* (Berlin: Ullstein, 1927), 290–92.

34. Warburg, *Mnemosyne-Atlas, Begleittexte zur Ausstellung Aby Warburg—Mnemosyne, Akademie der bildenden Künste* (Vienna, 1993), pl. 79, 2.

35. "Kinematographisch scheinwerfern"; Warburg, *Die Erneuerung der heidnischen Antike,* 2:478.

36. On Warburg and "the image in motion," see Philippe-Alaid Michaud, *Aby Warburg et l'image en mouvement* (Paris: Macula, 1998), 79.

37. See Sergei Eisenstein, *The Film Sense,* trans. and ed. Jay Leyda (1942; London, 1986), 148; Werner Hofmann, "Alles hängt mit allem zusammen," *Eisenstein und Deutschland: Texte Dokumente Briefe,* ed. Akademie der Künste (Berlin, 1998), 205; and Karl Clausberg, "Wiener Schule—Russischer Formalismus—Prager Strukturalismus: Ein komparatistisches Kapitel Kunstwissenschaft," *Idea* 2 (1983): 152, 174.

38. See Victor Schamoni, "Das Lichtspiel: Möglichkeiten des absoluten Films" (Ph.D. diss., Münster, 1926).

39. "Kinos sind unter allem Hund, worüber alle besseren Menschen sehr unglücklich sind" (Panofsky to Dora Panofsky, 14 Oct. 1931, *Korrespondenz*, 1:401).

40. "'Kinematographisch zerlegende' Darstellungsverfahren"; Panofsky, "Albrecht Dürers rhythmische Kunst," in *Deutschsprachige Aufsätze*, 1:400.

41. "Durch eine Zerlegung des Bewegungsablaufs in mehrere kinematographisch aufeinanderfolgende Einzelphasen" (ibid.; see also 1:402, 403 n. 26).

42. Panofsky to Dora Panofsky, 9 Jan. 1932, *Korrespondenz*, 1:470.

43. See Panofsky, *Das Leben und die Kunst Albrecht Dürers* (1943; Darmstadt: Wissenschaftiche Buchgesellschaft, 1977), 35–36. See also Siegfried Kracauer and Erwin Panofsky, *Briefwechsel, 1941–1966*, ed. Volker Breidecker (Berlin: Akademie, 1996), 204.

44. See Panofsky, *Das Leben und die Kunst Albrecht Dürers*, 281.

45. "Das kommt daher, daß wir beide etwas von den Movies gelernt haben!"; Panofsky to Dora Panofsky, 23 Dec. 1943, in Panofsky and Kracauer, *Briefwechsel, 1941–1966*, 27.

46. Panofsky, *The "Codex Huygens" and Leonardo da Vinci's Art Theory* (London: Warburg Institute, 1940), 24, 27, 128; see also 29 and 123.

47. Irving Lavin, "Panofsky's Humor," in Panofsky, *"Die ideologischen Vorläufer des Rolls-Royce-Kühlers" und "Stil und Medium im Film"* (Frankfurt: Campus Verlag, 1993), 9–15; 9–13 gives an inspired analysis of the new American style of Panofsky's piece. "On Movies" was the original title of Panofsky's "Style and Medium in the Motion Pictures." See Panofsky, *Three Essays on Style*, ed. Irving Lavin (Cambridge, Mass.: MIT Press, 1995), 91–128; Lavin's "Panofsky's Humor" appears in expanded form as that collection's introduction.

48. Sam Hunter, introduction, *The Museum of Modern Art, New York: The History and the Collection* (New York: Abrams, 1984), 11.

49. Barr himself proposed as first director Gustav Hartlaub, head of the Kunsthalle in Mannheim, a specialist in the Renaissance, who at the same time had brought the avant-garde into the museum, who had created the term Neue Sachlichkeit, and against whom the campaign of degenerate art was directed for the first time; see Kracauer and Panofsky, *Briefwechsel, 1941–1966*, 211 n. 531. As Barr remembered, the museum was organized in the first two decades according to the model of the German *Kunstvereine*. The *Kunstvereine* were interested in and open to all levels and aspects of visual culture; already in 1839 a number of them had arranged exhibitions on photography; see Ulrich Pohlmann, "'Harmonie zwischen Kunst und Industrie': Zur Geschichte der ersten Photoausstellungen (1839–1868)," in *Silber und Salz: Zur Frühzeit der Photographie im deutschen Sprachraum 1839-1860,* exh. cat. (Cologne: Edition Braus, 1989), 498.

50. "Ich bin sogar Mitglied des Advisory Committee für diese Film-Sammlung, was aber nicht auss-

chließt, daß ich mich in mäßigem Umfang immer noch für Kunstgeschichte interessiere" (Panofsky to Saxl, 25 Mar. 1936, *Korrespondenz,* 1:893).

51. See Walter Benjamin, "L'Oeuvre d'art à l'époque de sa reproduction mécanisée," trans. Pierre Klossowski, in *Zeitschrift für Sozialforschung* 5, no. 1 (1936): 40–68.

52. See Rolf Tiedeman and Hermann Schweppenhauser, "Anmerkungen der Herausgeber," in Walter Benjamin, *Gesammelte Schriften,* ed. Tiedeman and Schweppenhauser, 7 vols. in 14 (Frankfurt am Main: Suhrkamp, 1972–89), 1:3:1029, 1030.

53. See Hugo von Hofmannsthal to Panofsky, 12 Dec. 1927, *Korrespondenz,* 1:246; see also Gerhard Scholem to Saxl, 24 May 1928, ibid., 1:276; Saxl to Scholem, 17 June 1928, ibid., 1:286; and Panofsky to Saxl, ibid., 1:289.

54. See Tiedeman and Schweppenhauser, "Anmerkungen der Herausgeber," in *Gesammelte Schriften,* 1:3:1050, and "Anmerkungen der Herausgeber," ibid., 7:2:679.

55. Panofsky, *Albrecht Dürer,* 2 vols. (Princeton, N.J.: Princeton University Press, 1943), 1:45.

56. Benjamin, "Das Kunstwerk im Zeitalter seiner technischen Reproduzierbarkeit" (third version), *Gesammelte Schriften,* 7:1:379 n. 16.

57. See Breidecker, "'Ferne Nähe': Kracauer, Panofsky, und 'the Warburg tradition,'" in Kracauer and Panofsky, *Briefwechsel, 1941–1966,* 197.

58. See Horst Bredekamp, "Words, Images, Ellipses," in *Meaning in the Visual Arts: Views from the Outside: A Centennial Commemoration of Erwin Panofsky (1892–1968),* ed. Irving Lavin (Princeton, N.J.: Princeton University Press, 1995), 363–71.

59. Compare Katerina Duskova's review of several of Elkins's works in *Art Bulletin* 84 (Mar. 2002): 188.

60. Mitchell attacks the false originality of visual studies as a narrow encapsulation of art. See W. J. T. Mitchell, "Showing Seeing: A Critique of Visual Culture," in *Art History, Aesthetics, Visual Studies,* ed. Michael Ann Holly and Keith Moxey (Williamstown, Mass.: Sterling and Francine Clark Art Institute, 2002), 231–50.

The History of Art and Archaeology in England Now

Eric Fernie

Academic disciplines are defined by a number of factors, but chiefly by the university departmental system and by more or less formal ties with other institutions. They are also, however, affected in other less obvious ways, including how they are labeled and the attitudes of those who work in them. In this paper I attempt to assess the weak position of the history of art in this respect in comparison with the stronger identification of archaeology, and then ask how this position relates to the core aims of the discipline.

History of Art

The history of art is a centrifugal discipline, those who practice it readily ceding parts of its subject matter to other disciplines, such as architectural history. Traditionally the history of art covered the fine arts, which meant architecture, sculpture, and painting, the inclusion of architecture being flagged in, for example, Vasari's *Lives of the Most Excellent Italian Architects, Painters, and Sculptors,* and the phrase "architecture, mistress of the arts."[1] Today this is clearly no longer the case. In a word association exercise with university-bound students visiting the Courtauld on a recent open day, I asked them to respond with the first thing that came into their heads on my saying the word "art." The immediate and apparently sole response was "painting." When the exercise was repeated with painting disallowed, the result was "sculpture." Thereafter, despite four or five further tries, the group made no mention of architecture, preferring "artist," "genius," "decoration," etc.

They have a great deal of encouragement to think this way. To take four indications more or less at random, there is first the practice of using the phrase "history of art and architecture" in book titles, as in the Pelican/Yale series. Second, there is the assessment of the quality of research conducted in British universities every few years by the Funding Councils. In this, the relevant unit of assessment is entitled "The History of Art, Architecture and Design," thereby excluding both architecture and design from the history of art. The three categories were not forced on the scholarly community by the Funding Councils, but arrived at because of pressure from the academics themselves.[2] Third, the College Art Association indicates the same attitude in an American context, in that its membership form for

2002, in asking applicants to identify their interests, offers one list of options headed "Art and Architectural History," and another headed "Visual Arts" which excludes architecture completely. It does this while including industrial design, which might be considered in many respects as close to architecture as any of the other arts. Fourth, and most important, is the professional legal status of the architect, in sharp contrast to the status of painters and sculptors.[3]

In addition to architecture and design, other areas of study which have been distanced from the history of art include photography, television, film, and digital media. All of these can of course be studied in contexts other than the art historical, but as primarily visual media they are close to the core material of the discipline. This is especially so if the subject matter of the history of art is defined broadly, as, for example, objects made to have a visual impact.[4] Another indication of the centrifugal character of the history of art is a tendency on the part of many art historians who import and use techniques from other disciplines to suggest that the really worthwhile methods are the imported ones. There are also those who have been trained as art historians but define themselves as something else, a historian for example, despite the fact that their current subject matter is art historical and even of the same area of specialization as their art historical degrees. John Onians, when editor of *Art History,* urged colleagues to submit articles on design history which they had been discussing with him, only to meet the response that they couldn't possibly publish in an art history journal. The history of art is therefore characterized by a weak sense of identity.

Archaeology

Archaeology, by contrast, is characterized by a strong identification with the discipline. There are a number of ways in which this is evident. Most straightforward and even accidental is the fact that archaeology is a unified concept, a single word, which lends itself to metaphorical use, as in "the archaeology of knowledge." In this it is like architecture, as in "the architectures of computing systems," whereas the labels "the history of art" and "art history" are discursive descriptions and therefore in this sense ineffectual.[5]

Second, in the same United Kingdom Research Assessment Exercise mentioned above, the relevant unit is called simply Archaeology, not Prehistoric, Classical, and/or Industrial Archaeology or some other combination. This keeps the discipline identified with a single label, the reverse of the case with the History of Art, Architecture and Design.[6]

Third, archaeologists pursue an ideal of considering the totality of a site, seeing an object, for instance, not in isolation, but in its physical, topographical, economic, and other contexts. One of the core interests of the history of art, on the other hand, has been an investigation of the link between the individual maker and the individual work, which one can see might lead to an ignoring of wider considerations. In recent years art historians have, of course, emphasized the importance of context, much to the benefit of the discipline. Yet it remains the case that because of the centrality of the manufactured object, the art historian's remit does not cover the whole of the material record like that of the archaeologist.

Finally, one of the most important differences between archaeology and the history of art is the identification of archaeology with the sciences rather than the humanities. The division between the sciences and the humanities is significant for a number of reasons, but chiefly because of the drift toward science as the norm in research. There are numerous indications of this drift, such as the way in which German ideas concerning knowledge and research are commonly translated into English. Thus Karl Popper's *Logik der Forschung*, which might be rendered as "the logic of discovery," is entitled in its English translation *Logic of Scientific Discovery*, while Moritz Schlick's *Wissenschaftliche Weltauffassung*, literally something like "a knowledge-based comprehension of the world" becomes *Viewing the World Scientifically*. The implication appears to be that, at least in the English speaking world, proper research is scientific research.[7] The Funding Councils (those of the Research Assessment Exercises) have a view on this as well, in that they appear to support a distinction between research and scholarship, the latter a weasel word applicable only to the humanities and intended to save money. One position paper on the impact of research observes that the "lone scholar" in a library is in fact doing nothing but waiting for inspiration, which, it adds, anyone can do.[8]

It is not clear what follows from these observations. There are certainly advantages to art historians in the open-ended approach, in terms, for example, of applications of new techniques and ideas, but equally we might ask ourselves why so many academics working in the tradition of Winckelmann, Riegl, Wölfflin, and Panofsky are reluctant to identify with the parent discipline. That in turn might lead to a consideration of what can be done to make it less coy, to borrow Donald Preziosi's telling adjective.[9]

Research/Questions/Explanation

There are, however, more important things than labels. Philip Pullman, when asked what sort of writer he considered himself to be, is reported to have replied, "I am

not a writer, I write stories." In other words, do not ask what you *are,* ask what you *do.* And we can go further: describing what you do is still about you, whereas the real issue for historians is, what question do you want answered and what do you need to do in order to answer it?[10] The central issue is then, or should be, not identity, but explanation.[11]

That in turn raises the question, what sorts of methods should we use in attempting to explain? Out of the hundreds of fundamental methods which could be mentioned, one of the most important, namely analysis, has a special relevance to the history of art and archaeology. With this method, the object of interest is taken apart, metaphorically and often literally, with the implicit assumption that none of its parts belong together unless they can be proved to be so. Analysis is a powerful tool with a proven track record, but it can nonetheless mislead. This is especially the case when what is being investigated is an object made to fulfill a particular purpose, such as a work of art, rather than, for instance, an excavation site determined by extraneous factors such as the erection of a new building. In this case the opposing assumption, that all parts of the object belong together unless they can be proved to be otherwise, can be helpful and indeed indispensable. This can be seen in the restoration of paintings, as conservationists have in recent years combined the analytical approach with a much less intrusive one that starts with the object considered as a whole, rather than as a presumed original layer with additions to be removed. The assumption that all parts belong together is also useful in the study of pre-modern buildings, where it is often difficult to distinguish between variations which were intended as part of the design and those introduced either during construction or subsequently.

As a somewhat anecdotal illustration of this distinction between the two different assumptions, and of one weakness of the analytical approach, I would like to describe a visit I paid to the mid-twelfth-century church of Saint Mary at Hemel Hempstead in Hertfordshire. Having examined the chancel and its rib vaults, the primary reason for the visit, I walked into the east end of the nave. This is aisled and the arches of the arcades are decorated with a variety of moldings. I noted that the first arch on the south side had a standard chevron molding, while the first arch on the north side had a more complicated arrangement with two syncopated rows of chevron. Applying what has become a near standard analytical formula according to which builders of the period are assumed to have kept up to date in the decorative forms they used, and hence that later forms did not constitute part of the original design, I proposed that the south arch, the simpler,

had been built first, and the north one next. The second and subsequent arches on both north and south sides had moldings without chevron, which fitted well with a shift in this phase of the building into the more restrained aesthetic of the 1160s and 1170s. It also supported the same model of explanation based on changes of mind with which I had begun.

At the west end, however, the north arch has the same simple chevron as that on the southeast arch, and the south one the same as that on the northeast arch. Therefore, far from being due to changes of mind in the interests of using up-to-date forms, the arrangement of arches in the nave had clearly been designed to form a unit, with the end bays marked by different moldings from those in the middle. The types of moldings forming diagonal pairs underline the unity of the space of the nave, as well as, in all probability, symbolizing the liturgy of the church's consecration.[12] The literature on the building contains what can only be described as a valiant attempt to reconcile the evidence with the analytical, change of plan explanation, namely that the nave must obviously have been begun from both ends at once.[13]

The assumption that variations are due to changes of mind is a popular one in the study of medieval buildings, even where the evidence is against it, as here.[14] The reasons for this preference are not clear, but a possible cause is the great nineteenth-century argument between scientists and the church over whether species were designed by God or resulted from evolutionary processes of chance and circumstance. The church comprehensively lost the argument, with the result that "design" is still tainted as an unscientific explanation, apparently lacking the rigor of a thoroughly analytical approach.

To conclude, attitudes toward the identity of disciplines can have important consequences, often to do with power and influence, but of much greater importance than matters of labeling are those concerning the questions we want answered and how we answer them.

I would like to thank Dana Arnold and Richard Plant for their helpful comments on the text and Pat Rubin and Sandy Heslop for the Borghini and Hugh of St. Victor references respectively.

1. G. Vasari, *Le Vite de Piu Eccelenti Architetti, Pittori, et Scultori Italiani . . .* (Florence, 1550). It is of interest, however, that the title of the second edition has the order painting, sculpture, architecture, and that during its preparation Vincenzo Borghini exhorted Vasari "to put in order the material of living artists, especially important ones, so that this work may be finished and perfect in all respects

and a universal HISTORY of all the painting and sculpture of Italy etc., which is the purpose of your writing" (K. Frey, *Der Literarische Nachlass Giorgio Vasaris* [Munich, 1923, 1930], II, letter no. cdlvii, p. 98, 11 August 1564), a possible indication that even in the sixteenth century, painting and sculpture took precedence over architecture.

2. 2001 *Research Assessment Exercise: The Outcome* (Higher Education Funding Council for England et al., 2001), 99.

3. There is a case for having the builders carry the responsibility for structural safety, leaving architects to design freely, as they used to do. It is surprising how recent this legally defined professional status of the architect is. To quote John Wilton-Ely, "The Rise of the Professional Architect in England," in *The Architect: Chapters in the History of the Profession,* ed. S. Kostof (Oxford: Oxford University Press, 1977), 204: "By 1900 the battle for a closed profession as opposed to the pupilage system was largely over, although a reluctance to legislate over the ability to design continued until 1931 and 1938 when two Architects' Registration Acts were passed, ensuring that the architect's calling had become a legal title controlled by Parliament."

4. Compare the *Bildwissenschaft* outlined by Horst Bredekamp in his essay in this volume.

5. On "the history of art" versus "art history," see J. Onians, editorial, *Art History* 1 (1978). One of the most important points about the relationship between the history of art and archaeology is the fact that they are both a part of history. This is obvious in the case of the history of art, if only from the name, but not with archaeology, which is often presented as if it were a parallel discipline to history. On this question see E. C. Fernie, "History, Archaeology and Architectural History," Proceedings of the Joint Symposium of the Royal Historical Society and the Society of Architectural Historians of Great Britain, held at Sheffield, 5–7 April 2002, forthcoming.

6. 2001 *Research Assessment Exercise,* 96.

7. D. Edmonds and J. Eidinow, *Wittgenstein's Poker* (London and Munich: Harper Collins, 2000), 118, 131, 136.

8. *The Impact of Research* (HEFCE/AHRB, 2001), paragraphs 2.18, 2.19.

9. D. Preziosi, *Rethinking Art History: Meditations on a Coy Science* (New Haven, Conn.: Yale University Press, 1989).

10. Or, as Karen Michels demonstrates in her paper, for the prewar generation of German-speaking art historians, what problem do you want to confront?

11. On "explanation," see M. Baldwin, C. Harrison and M. Ramsden, "Art History, Art Criticism and Explanation," *Art History* 4 (1981): 432–56.

12. "The line drawn from the left corner of the east unto the right corner of the west, and the other line from the right of the east unto the left of the west, do express the Cross, and also the gathering in of both Peoples: according as Jacob blessed the children of Joseph with his hands crossed." Hugh of St. Victor, "Mystical Mirror," first half of the twelfth century, in his description of the ceremony

of consecration of a church; translation from J. M. Neale and B. Webb, *The Symbolism of Churches and Church Ornaments* (Leeds: T. W. Green, 1843), 207.

13. *The Victoria History of the County of Hertford* (London: St. Catherine Press, 1908), 2:225–26.

14. E. C. Fernie, "The Use of Varied Nave Supports in Romanesque and Early Gothic Churches," *Gesta* 23 (1984): 107–17.

Art History as Anthropology: French and German Traditions

Michael F. Zimmermann

Visual Studies and Anthropology: Debates about Methods

The anthropological question is on the agenda of art history. Early in the 1990s visual studies (or visual theory and culture) became a challenge to the identity of the discipline. They confronted the history of art with the history of non-artistic images—with photography, film, design, and publicity. The foundations of visual studies were laid out by Keith Moxey, Michael Ann Holly, Norman Bryson, and W. J. T. Mitchell between 1991 and 1994.[1] In 1996 the quarterly *October* published a "Questionnaire on Visual Culture."[2] In the same issue, the critic and art historian Hal Foster published an article whose title, "The Archive without Museums," alluded to André Malraux's "museum without walls"—the English title of his famous *Le Musée Imaginaire* (1947).[3] Hal Foster accepted visual studies not without scepticism, and only by insisting on the historical conditions of the new methodological approach. According to him, visual studies tended toward reducing any image to an immaterial set of visual information, destined to circulate within the orbit of an economy of the image—an economy ruled according to the laws of semiotics and of psychoanalysis. They neglect the differences between images according to genres, media, or their character as artworks or commercial visual products. In the new economy of the image, a virtual "archive without museums," all the images exist simultaneously, independent of any framing historical narration. According to Foster, paradigms of history—such as origin, tradition, continuity, or rupture—are pushed into the background. Consequently, historical discourses are supplanted by models of anthropology.

Even if Foster defends art history against visual studies, he holds the methodological change to be inevitable. For him, the new methodology ultimately has not been conceived by Moxey, Holly, Bryson, and Mitchell. In the final instance, visual studies are for Foster the form any debate about art and images takes in the age of the internet, of the circulation and increasing availability of images on all screens, of globalization and of post-capitalism. Foster, thus, only accepts visual studies considering the changing place of art in the media system of the arts. In the same number of *October*, Rosalind Krauss discusses the new approach, under the ironic title "Welcome to the Cultural Revolution."[4] Whereas the visual studies

debate of 1996 focused on the methodological instruments of the interpretation of images and artworks, the actual discussion about art history as anthropology concentrates on the subject matter of a future, globalized science of the image, and history of art.

October 77 brought up the question: visual studies—but how? Now it seems to be time to ask: art history as anthropology, but how? In spring 2001 the biennial conference of the association of German art historians (Deutscher Kunsthistorikertag) in Hamburg addressed the issue. Hans Belting proposed a new anthropological methodology, whereas others, such as Martin Warnke and Horst Bredekamp, claimed that Aby Warburg might be a predecessor and a model for such an approach.[5]

Warburg is undoubtedly also a godfather of the anthropological consideration of art early in the twentieth century. The 1897 photograph of Aby Warburg visiting the Pueblo Indians in Arizona, by now an icon of art history, is reproduced here from Hans Belting's book *Bild-Anthropologie* (fig. 1).[6] Guillaume Apollinaire is one of the first art critics sensitive to an anthropological interpretation of culture. His studio is illustrated in André Malraux's book *La Métamorphose des dieux,* published posthumously in 1976 (fig. 2).[7] I will further attempt in this article to compare two approaches to art history as anthropology—the model of Belting and that of Malraux. The comparison is not merely meant as polemics. Hal Foster and Rosalind Krauss had welcomed the visual studies with a certain sense of irony. Seemingly, I am convinced that an anthropological turn of art history is inevitable. Rituals around man—whether non-Western or post-human—cannot be considered without skepticism—nor can rituals around the end of art. As Foster and Krauss have introduced the historical perspective in their consideration of visual studies, it is time to historicize art history as anthropology: when and how was art history confronted with the anthropological

Abb. 2.24: Aby Warburg bei den Pueblo-Indianern, 1895

Fig. 1. Aby Warburg in 1895, from Hans Belting, *Bild-Anthropologie* (Munich: Wilhelm Fink, 2001), 51

question? Why is it posed so urgently in 2002—the year of *Documenta II,* directed by the Nigerian Okwui Enwezor?

The Encounter of Art History and Anthropology: Two Key Issues

Art history has always had an anthropological perspective. As a child of historicism, it had to accept the paradox of values that seemed absolute in their time, but relative as seen from our historical perspective.[8] Values, at the same time absolute and relative, are also at the foundation of evaluating artworks as modern: The value of modernity is absolute for contemporaries, but only relative for posterity. The paradox of absolute and relative, eternal and transitory is also, historically, behind the first prominent definition of modernity. As defined by Charles Baudelaire in his 1862 essay on Constantin Guys, "modernité" is "l'éternel dans le transitoire."[9] That is tantamount to defining within the transitory, that part of our life, experience, and memory that will fall into oblivion, that will disappear in the obscurity of history, a special value that will not only last for some time, but must be considered as eternal, thus absolute. If art history is a

Fig. 2. Guillaume Apollinaire's studio, from André Malraux, *La Métamorphose des dieux,* vol. 3, *L'Intemporel* (Paris: Gallimard, 1976), 243

child of historicism, then so is modernity: only a society that accepts itself as modern can read its past while leading toward its own values as its own prehistory, also as full of values in itself, as "immediate toward God" (Leopold von Ranke).[10]

 The cultures who had come in contact with the Western world only after colonialism were long considered to be ahistorical, and were refused the right to a history of their own.[11] Those peoples who seemed to be without history faced the so-called Western or "civilized" tradition with foreign, if not strange, values. Western knowledge about these cultures was stored and administrated by ethnologists, not historians,[12] and the peoples' objects were considered to be evidence of "primitive"

early states of mankind—mankind in its childhood. Only a post-historicist, consciously modern society could consider these objects as works of art and allow them into its art collections and museums. Our culture is a concept, a world that continuously changes in the course of such encounters. The writings of Belting and Malraux that I will consider here are all addressed to us, an imaginary community of authors and readers, a community now conceived to be mankind after globalization.

Ever since Western cultures were fascinated by cultures whom they deprived of a history, that fascination was motivated by a search for modernity. Impressionists looked at Japanese woodcuts—which in turn had already been influenced by Western art—in order to find pictorial formulas for contemporary events.[13] In 1867 Monet confronted his family and friends with the sea—certainly not the eternal world ocean of Romanticism.[14] It was in that encounter with a radiant, secularized nature that Monet redefined his view of the entrepreneurial society of the Second Empire. He borrowed a pictorial formula Hokusai had invented about 1820 for his view of Mount Fuji.[15] Monet took the pictorial formula from Japan to express what he identified as modern, since Japan was for him—as for his contemporaries—the only surviving "antique" culture, a society in harmony with nature and thus without "history" in the Western sense.[16] This appropriation took place only five years after Baudelaire had defined modernity as the eternal within transiency. In a deeper sense, Hokusai's composition is fascinating because of its anachronistic character in the context of Parisian culture of the 1860s: although it is ostensibly situated out of Monet's own time and out of his tradition, it enables him to express what he appreciated as absolutely modern in his own experience.[17] What was absolutely modern finds itself guided by what was radically different.

Hal Foster had welcomed anthropological perspectives for their capacity to transcend the traditions and mental inhibitions of the *Geisteswissenschaften,* the *sciences humaines,* and the humanities. Anthropology was for him an antidote against paradigms such as origin and tradition—against history as a model of causality and in favor of presence, of coexistence of artworks and artful objects, in front of us, or in the "museum without walls" and his successor, the "archive without museums."[18] Georges Didi-Huberman argued that anachronism was the radical form of coexistence of heterogeneous objects within the synchronic spaces of museums and archives, whether imaginary or not. As a radical form of heterogeneity within the homogenic continuum of history, it is history's other side. As such, the encounter of the historically explained artwork with the ahistorical, anachronistic object has always been the other of art *history* itself.[19]

In Monet's *Terrasse à Sainte-Adresse,* the present is constructed through the remote: Japan expresses Monet's own modernity. From Japan, he takes the means to actively alienate what was familiar to him and his contemporaries, to present the everyday life of his time as at once close and far away, or to express what was the eternal within the transitory in his own vital experience.[20] From Impressionism to Cubism, and its encounter with what Carl Einstein called *Negerplastik* (Negro sculpture), such anthropological encounters across cultural borders were always also concerned with the medium.[21] Monet in his *Terrasse à Sainte-Adresse* superimposed the medium of Japanese woodcuts onto easel painting in the European tradition—a window open to the world. The illusionistic gaze, its visual empowerment of the landscape, and the visual sign-poem according to the Oriental tradition mutually cancel each other out.[22]

Indeed, it is not only the encounter with non-Western art that brings up the anthropological question; in the arts, it is most often the development of the media, whether those of art or the media of popular or commercial culture, that motivates an exchange with the most foreign cultures. Often it is only through the analysis of their visual media—whether fetishes, ancestors' statues, or tattoos—and of the ritual practices they are part of, that Western cultures learned to take seriously what they continued to consider as primitive.

Ever since media have been criticized, such a criticism brings up the anthropological question, even independent of any consideration of foreign cultures. *Presence against history* is not the only key issue of anthropology. *The body within and against the medium* is another touchstone of the anthropological question. How can man—whether his appearance or his inner essence—be translated into an image? That question is radically anthropological and radically artistic. Aristotle defined imitation—mimesis—to counter Plato, whose *Republic* had condemned theater and images as spoiling young people's fantasy, thus useless for education.[23] Aristotle reduces mimesis to theater, and the theater to the basic drive of children to play and imitate adults and other people. For Aristotle that drive is distinctly human, therefore it cannot be bad. Thus Aristotle reduces the images and their media to the body of man, never just being, but also enacting himself. When mimesis and its media are in a crisis, it always reverts to the body displaying itself. In 1927, Antonin Artaud played the role of the monk Jean Massieu in Karl Dreyer's film *La Passion de Jeanne d'Arc*—a film intensely playing with physiognomy, gestural, and body language, thereby rhyming medieval traditions with modern popular theater and photography.[24] Artaud, who loved the intense presence of bodies and

faces in the silent cinema, later strongly argued against the mix of sound and image in the movies after 1928. He wanted bodies to be set free from representation

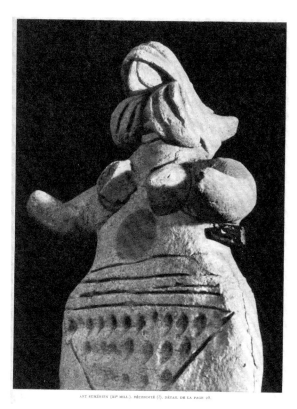

ART SUMÉRIEN (IIIᵉ MILL.). FÉCONDITÉ (?). DÉTAIL DE LA PAGE 25.

Fig. 3. Sumerian statuette, detail, from André Malraux, *Psychologie de l'art. Le Musée imaginaire* (Geneva: Skira, 1947), 29

and the need to fulfill roles according to traditions of the bourgeois theater and of social norms. In his utopia of a total theater, the body as a medium of expressing drives and desires should be set free from word, language, and drama. When he posed for photographs made for the photo-collages *Le Théâtre Alfred Jarry et l'hostilité publique* (Alfred Jarry's theater and public enemies) in 1930, he was already trying to redefine an imaginary stage for the stasis of such bodily expressions.[25] Long before he invented his Theater of Cruelty, he tried to express himself exclusively through the medium of his body.[26]

It is through such paradoxes—presence against history, the body within the medium, and the body against it—that anthropology challenges art history. But as latent (and logical) oppositions of its leading affirmations, both of these provocations have always been part of art history and its dialectics.[27] Whether to emphasize similarity or otherness, art history is always searching for comparisons, and never ceases to search the meaning of traditions it (re)constructs in other arenas. And the development of media has always urged art history to reinvent its own media, from graphic reproductions to photography, from Heinrich Wölfflin's double slide projections to the illustrated art book, from the digital image to databases of images and video on the internet. Furthermore, with any revolution of the artistic media—from collage to video installation—art history's horizons expanded beyond what was previously accepted as art. To search herself beyond herself, that was the mission, the teleology of art history. The identity of art history is unstable within an essentially open structure, but if art history

projects her continuing border crossing into a comprehensive, global horizon, the horizon *tout court* of man as such, structures are essentially closed.[28] The end of art history, the end of mankind, would be the end of its capacity to reinvent itself, to reinvent representation. Globalization seems to impose a perspective of the passed future onto art history, a future when it will everywhere encounter only itself, when the whole of visual culture will already be part of art history's horizon, when nothing new remains to be discovered.

Image Anthropology According to Hans Belting

Our "borrowed" illustrations show a Sumerian statuette from about 2000 B.C., reproduced in Malraux's *Musée imaginaire* of 1947 (fig. 3), and a statuette from the Jericho culture, belonging to the museum in Damascus but now in the Louvre,

Amman (Jordanien), Archäol. Museum (Leihgabe im Louvre). Detail der Figur Abb. 6.7 aus Ain Ghazal, ca. 7000 v.Chr. Modelliert in Kalk und Lehm über einer inneren Armatur (vgl. Kap. 6.3) Gesamthöhe 105 cm

Fig. 4. Sculpture from Ain Ghazal, Jordan, detail, cover page illustration in Belting, *Bild-Anthropologie*

from about 7000 B.C., reproduced by Belting—the detail with the face as cover-page for his book (fig. 4). A key for Belting's argument is what he sees as the analogy between the body and the medium.[29] For him, the body is not just a subject of art, but the artwork in itself becomes a body, whether as a magic substitute for the body of a dead person or as a metaphor for the body's integrity, or its openness toward eternity, or its disintegration. Belting is interested in bodies of art—in art as art. Before the Egyptians made mummies, the Jericho culture created sculptures by covering the skulls of the dead with restorations of their faces in plaster. Belting interprets statuettes such as this as symbolic substitutions for the dead person during the burial, used before the body can be substituted through its restitution as a sculpture.[30] Examples of other substitutive bodies as artworks would be the

wax statues of English kings or queens, which held the monarch "alive" before the coronation of the successor; the lost wax sculptures of Florentine patricians in adoration; the *voti* in the Florentine Chiostro degli Voti at Santissima Annunziata; or the sculpture-body dressed up in a dead woman's clothes in a church in Bavarian Swabia (fig. 5). Magic rituals guarantee the supposed identity of the dead and its substitutive body—for example the opening of the mouth of an Egyptian sculpture.[31] The Greek enlightenment challenged that form of magic substitution: Orpheus, although he was able to force open the doors to the underworld through his songs, realizes, according to Belting's interpretation of the famous relief of the fifth century, that the Eurydice whom he met was only her shadow, forever condemned to stay in the realm of shadows. Shadows—that is what images are by now—*eidola,* as for Plato. Orpheus symbolically regrets the end of the magic power of images to keep the dead alive.[32]

Belting's interpretation of later images, such as the effigy in a portrait, owes much to strategies of interpretation developed from Mikhail Bakhtin to Friedrich Kittler: the body becomes a symbol of the text—an example being Gargantua's body in Rabelais's famous novel. Jan van Eyck's portrait known as *Timotheus* (National Gallery, London) is inscribed "Leal souvenir" (truthful remembrance), a motto that refers to the image in the double sense of its truthfulness and its survival not as an object, but as part of memory. For Kittler, the *Doppelgänger* had been a quintessentially textual body. From Edgar Allan Poe to Vladimir Nabokov, someone inscribes himself into a text, whether into a diary or into letters to the beloved. He starts to generate a double of himself, however, in a new narrative perspective (whether in literary or in visual imagination), generally more pictorial, more iconic, or, as in Nabokov, cinematographic. The double even can kill the original.[33] Also for Belting, idols and bodies are inscribed into a form of historical dialectics. Idols become ideal images that tend to inscribe themselves into our bodies. We enter into a dialectic of the body and the image. Foucault's history of ideologies inscribed into bodies is kept alive through the rebellion of those bodies against the eidola they have to conform to. So far, and with an emphasis on the body and the image, I agree with Belting. I do not subscribe to his statement that the dialectics of bodies and images have come to an end. Our culture of digital images and bodies reduced to a formula, the DNA, for him, is about to abolish that human dialectics. He is convinced that we assist the erosion of that dialectics, the dissolution of both of its elements, the image and the body. Photography had been, ideally, a *leal souvenir,* testifying to the instantaneousness of the moment it documents. In the

digital image, as reworked through a program such as Photoshop, that indexicality, that truthfulness, gets lost. Images no longer have to refer to anything. We see the world more through images than through our own experience.[34]

On the other hand, gene technology allows the creation of bodies according to preconceived cultural images. Designer babies do not even have to know the ideology behind their being blue-eyed, blond, and having just the right predisposition for height. With the dialectics of bodies and images, the dialectics of nature and culture comes to an end. Strangely enough, Belting sees this end as inevitable.[35] In recent discussions he positions himself in the context of the American post-human debate: Foucault argued against humanism because it always prescribes a certain idea of the human (generally a Western idea) as a norm. The advocates of the post-human isolate that argument from the horizon of emancipation in order to justify biotechnological babies. If I cannot prescribe a certain idea of the human, there is no norm to forbid the construction of humans according to its parents' ideas or stereotypes. Belting argues that no national ethic commissions can ever stop that process—a process that may end in a biotechnological aristocracy.

Belting even anticipates that the dialectics of body and image is gone, and he describes this as a process nobody can or should try to stop. However, he defends that dialectics as the only conceivable guarantee of human value.[36] That position makes him—like Jean Baudrillard—the prophet of an inevitable apocalypse. Only in the evening's twilight does Athena-Urania's owl start her flight of wisdom, her eyes wide open. She regrets the era of man, of his image. Art historical anthropology is a negative theology. A visual metaphor characterizes and criticizes that vision better than any argument. I want to confront the wide-open eyes of Urania's owl with the "eyes wide shut" (to borrow from Stanley Kubrick) that Man Ray photographed in 1929, in which open eyes are just painted onto the closed eyelids of a woman (fig. 9). These are the "eyes wide shut" of negative theology.

André Malraux and His Anthropological Universe

For André Malraux, art as anthropology always has been a ritual, and about ritual. In 1996 Jean-François Lyotard, in what would be his last book, the biography *Signé Malraux,* uncovered the mythic hero Malraux as a mythopoeic product of his author, André.[37] Lyotard ruthlessly tells us the story of the lower-middle-class child living with his mother, grandmother, and aunt in suburban Bondy. André wants to forget the small world he stems from, the cures and cares of all these mothers. Married at the age of twenty to Clara Goldstein, a wealthy woman of German

Jewish origin, by the time he was twenty-two he had already lost her money through his adventurous stock speculations. Now, in 1923, French Indochina lures him into the muds of its rainforests: at Bantea Srey in Cambodia there is an Angkor temple, not yet declared a national monument, still shrouded with vegetation. After an adventurous trip into the outside world—material for his novel *La Voie royale* (The Royal Way, 1930), Malraux discovers the cultural collapse of his time—the clash of civilizations, of Western individualism and Eastern ahistorical meditation, worlds whose fascination for each other would mutually destroy themselves.[38] The West for Malraux will be infected with Eastern nirvanas, and the East with Western individualism. But Malraux has more concrete reasons for his adventurous pilgrimage to Bantea Srey. He saws down five reliefs from the old temple in order to end his financial ruin. Caught by a corrupt colonial administration, he is imprisoned, and condemned, but is soon freed after the intervention of the Parisian intelligentsia.[39]

Abb. 4.20: Kaufbeuren/Crescentialkloster, Votivfigur aus Wachs

Fig. 5. Wax portrait, from Belting, *Bild-Anthropologie*, 102

Lyotard, who tells the whole story —against Malraux's well-known *Anti-Mémoires*—is merciless. But even for him, Malraux is still a hero, albeit a negative hero, behind his mythical world. Malraux's truth is in his lies. His frustration over his criminal act of vandalism turns Malraux into a political activist. In 1925 he leaves again for French Indochina in order to codirect the resistance against colonialism. In Shanghai, he would play a role in the Communist Party, which at the time fought the colonial powers siding with Chiang Kai-shek's Kuomintang, who soon would crush his former allies.[40] His experience as a political activist is the material for the novel *La Condition humaine* (Man's Fate) that would earn him, in 1933, the Prix Goncourt.[41] Behind the human fight for freedom, Malraux always sides with rebellion, linked less to any attainable utopia

than to a symbolic act of self-affirmation, to the human as always involved in an act of becoming. For the heroes, whether Chinese or Western, the human condition is present as something going beyond their goals and perspectives, their identities and conflicts. Politics is transformed into a ritual of a transcultural myth of the human, a rebellion against death. One of the rebels, Katow, has a final act of heroism: he leaves to two fellow prisoners the poison pill that might have killed him painlessly, then he submits himself to the cruelest execution.[42] Already in 1926 Malraux had published a novel, the exchange of letters between a twenty-five-year-old Frenchman, A. D., and his twenty-three-year-old Chinese partner Ling-W.-Y., under the ironic title *La Tentation de l'occident* (The Temptation of the West). Ling writes to A. D. from Paris to China and vice

LA DAME D'ELCHÉ. « LE CADRAGE D'UNE SCULPTURE, L'ANGLE SOUS LEQUEL ELLE EST PRISE, UN ÉCLAIRAGE ÉTUDIÉ SURTOUT... »

Fig. 6. Ibero-Phoenician bust, detail, from Malraux, *Psychologie de l'art*, 25.

versa. In mutually expropriating the other of his culture, each protagonist finds a negative identity, identifying himself in a joint hypercompensation to what was different from the other.[43]

When, from 1936 to 1937, Malraux organizes a bomber battalion against Spanish fascism, he was about to publish the first idea for his work on world art, first envisaged under the title *Psychologie de l'art* (Psychology of Art). His courageous fight against fascism became a book, and a film, both titled *L'Espoir* (Hope).[44] Revolt, is both an aesthetic and a collective ritual. When the pilots crash against the Pyrenees, the local peasant population would free the wounded corpses of their martyrs from their old-fashioned aircrafts in order to bring them down to the

valley in a quasi-religious procession.⁴⁵ Film as new medium created a new form of mythic ritual.

The new form for the aesthetic ritual was the book with photographic illustrations. The book as a medium is the *Imaginary Museum* title of the first volume of Malraux's *Psychology of Art* published after 1947, and republished, five years later, as *Les Voix du silence* (Voices of Silence).⁴⁶ Light would transform an early Iberian sculpture (fourth or fifth century B.C.) into a woman's face whose elegance meets modern standards (fig. 6). Photography makes distance present. Malraux introduces a heightened auratic presence—to use Walter Benjamin's term—into these volumes he arranged as quintessential books about art. In antiquity, he makes us meet with modern elegance. Photography assimilates formats, so a minuscule scroll relief becomes abstract, such as Gislebertus's *Eve* in Autun, assimilated, in its turn, to a Scythian gold ornament.

Anthropology originates in the encounter of Western and foreign values, of a clash of humanism into a transcultural human condition. Malraux, once a political fighter close to communism, a d'Annunzio of the left, becomes a secretary of state under Charles de Gaulle, and he organizes the television coverage of prominent burials, such as the burial in 1964 of Jean Moulin in the Parisian Pantheon. He also turns into a negative theologian of art. What transforms a fetish into a work of art? There are no fundamental differences between an idol of fecundity from the New Hebrides and a Cycladic idol. It is, for Malraux, the fight against death that turns these votive sculptures into icons of the human, fighting against the eternal repetition of the cycles of meaningless life, against nihilism, desperation, and death. The most perfect works, for him, are those in the state of development, works such as Michelangelo's Rondanini *Pietà,* which during the process of its elaboration was ruined in a way that perfection becomes impossible, or else, is attained through its never being attainable (fig. 7). For Lyotard, the Rondanini *Pietà,* or its reproductions in the book, are a *mise en abime,* a symbol of Malraux's own inconceivable humanism.⁴⁷

MICHEL-ANGE. PIETÀ RONDANINI.

Fig. 7. Michelangelo's Rondanini *Pietà,* from Malraux, *Psychologie de l'art,* 102

Anthropology and Modesty

In 1998 Belting published *The Unknown Masterpiece,* its title borrowed from Balzac.[48] He tells the story of modern art—of *Large Bathers, Large Glasses, and Black Squares*—as a story of the impossible work, in the final instance of Freenhofer's impossible painting, of a dreamt-of work nobody can ever fulfill, an attempt that after long rumors is uncovered as nothing but a dirty mix of paint. Lost being in the world is reflected in the mirror of artworks. The twilight of the gods is prolonged to an arctic night, its own seemingly endless agony.[49] Recently an exhibition in the Center for Art and Media in Karlsruhe—Belting's home institution—revealed the "iconclash" of impossible images from the icon of Christ's true face (Claude Mellan's single-spiraling-line etching *The Veil of Saint Veronica,* inscribed "formatur unicus una," 1649) through Kasimir Malevich's *Black Cross* (1923, State Hermitage Museum, St. Petersburg) to Nam June Paik's staging of a sculptural Buddha who mechanically "contemplates" his own image on a video screen (1974, Stedlijk Museum, Amsterdam).[50]

Abb. 3.12: Hiroshi Sugimoto: Regency, San Francisco, Fotografie aus der Serie „Interior Theaters", 1992

Fig. 8. Photograph by Hiroshi Sugimoto, 1992, from Belting, *Bild-Anthropologie,* 78

For Belting, as for Malraux, art—after its disenchantment during the enlightenment, and after the end of the Occidental tradition—is a rebellion of man against death, an upheaval against the lack of sense, a resistance against the consequences of the loss of religion. Art is transformed into a post- or meta-religion, and it expresses itself in quasi-religious rituals. Art is human within the post-human, it is religious within the post-religious. For Belting as for Malraux, the *concrete impulse* imposing new forms of artistic development, and of art history, was due to the media. However, both rhyme the media revolution with an anthropological revolution. In Belting's vision, the Internet kills the human, substituted by post-human avatars and clones. But by doing so, it makes the human

Fig. 9. Man Ray, *Emak Bakia* (Don't Bother Me), film still showing Kiki closing her eyes, revealing a pair of eyes the artist painted onto her eyelids, 1926

appear as the substantial content of a humanistic art history. The omnipresence of images, convertible even into human clones, creates a global sphere where the human circulates in its abolished forms. For Malraux, the imaginary museum of book illustrations and photographic reproductions, in the last instance, is the modern medium of our industrialized fantasy. In *Les Voix du silence* he explains that only a post-religious culture in the tradition of the enlightenment could discover the post-religious idea of man.[51] The enlightenment, here, is that aspect of humanity the eighteenth century succeeded in handing over from the Occidental tradition to the global human condition. In the imaginary museum, man endlessly, everywhere meets man, human faces, gazes, smiles.[52] The human for Malraux is what man has lost, first—but not only—in the Occidental or Western world. It is lost, but still present in all the attempts to gain it back. For Belting as for Malraux, art history is practiced as anthropology, and thereby as a religion of which they become the priests or prophets. Or, better, as the shadow of a religion.

Okwui Enwezor, chairing *Documenta 11*—the first "globalized" one—in Kassel, followed an opposite strategy for staging world art. In a series of interviews he insisted that he did not attempt at exhibiting a post-colonial, global vision of the *condition humaine* as such. Even when confronted with arrogant intellectual criticism, he persisted in modestly refusing to answer to questions inquiring about his master plan. Instead of transforming the *Documenta* into a temple of anthropological art, he invented strategies for defining different places of reflection and proceeded to organize decentralized and multiple encounters with what appeared to be unforeseeably new. It was a strategy of openness, deceiving all those who had expected him to stage a monumental show of lost unity.[53] However, even if we try to resist, with Enwezor, the temptations of ritual, the question of an encounter of world art with the Western tradition is inescapable. But it should be treated in historical, contingent terms.

A prerequisite would be to operate more systematic distinctions within the field of visual culture and the approaches to it. There should be a more systematic focus not on the common history of visuality or its homogeneous history, but on the differences between visual production and art within that overall field of visuality.[54] How did the porous border between art and non-artistic visual production develop within the media system of images? Why did art and art history constantly reinvent itself, and how did that happen? Historical inquiry would have to focus on these questions. If technical and commercial innovations of pictorial media have obliged art to change, changes in art did not always follow technological innovations in media. Whereas in the Renaissance art largely profited from technical inventions such as oil painting or the woodcut, or from new forms of visual projection such as perspective, after the Industrial Revolution, especially after photography and the mass-produced and commercially distributed image, art seemed to systematically attempt to do something else. Cultural formulas of art, once transformed into commonplace images—what Greenberg calls "kitsch"— through capitalist marketing and distribution, become obsolete for art.[55]

The encounter of a Western tradition—a tradition still far from renouncing to its hegemony—with colonial or post-colonial worlds enters into that interplay of art and industrial image production. On the one hand, ever since Japonism, the interest in African art, Pacific cultures, and surrealist appropriations of extra-European cultures helped Western art to reinvent itself. Pushed by that "kitsch" at seeking new formulas, and once the repertoire of popular images such as *images d'Epinal,* luboks, or Bavarian votive painting was exhausted, artists explored and often productively misinterpreted non-Western repertoires. On the other hand, artists in the de-colonized countries through (critical or ironic, playful or deconstructive) appropriations of Western projections try to reconstruct their traditions damaged or partly lost through the effects of colonial and capitalistic domination. Even using the archives of Western culture, they succeed in taking up suppressed identities, including Western projections.

That exchange, these strategies of appropriation (whether ironic or subversive) promise new insights into the logic of the image and of the institutions of its production, distribution, and reception—insights that go beyond an understanding only of "non-Western" countries. Thus, the hegemonic strategies Western art uses to renew itself through appropriations of "exotic" art, the projections and fantasies linked to its importation, are mirrored in the anti-hegemonic strategies of post-colonial cultures to reappropriate these appropriations, and by that to play

the game of global culture according to rules that have not been imposed onto them. Instead of staging ends in visions of (lost) unity, a historical anthropology of art should retrace the history of these exchanges and encounters: on the one hand, that of art and the non-artistic image, and on the other hand, that of the images of the Western tradition and of extra-European, colonial, and post-colonial cultures. Even in a globalized world, the horizon remains open.

1. *Visual Theory: Painting and Interpretation,* ed. Norman Bryson, Michael Ann Holly, and Keith Moxey (New York: Harper Collins, 1991); W. J. T. Mitchell, *Picture Theory* (Chicago and London: University of Chicago Press, 1994); *Visual Culture: Images and Interpretation,* ed. Norman Bryson, Michael Ann Holly, and Keith Moxey (Hanover, Mass. and London: University Press of New England and Wesleyan University Press, 1994).

2. "Questionnaire on Visual Culture," *October* 77 (summer 1996): 25–70.

3. Hal Foster, "The Archive without Museums," *October* 77 (summer 1996): 97–119.

4. Rosalind Krauss, "Welcome to the Cultural Revolution," *October* 77 (summer 1996): 83–96.

5. "Was War Kunstgeschichte im 20. Jahrhundert?" (What Was Art History during the Twentieth Century?), 26th Deutscher Kunsthistorikertag, veranstaltet vom Verband Deutscher Kunsthistoriker e.V. und der Universität Hamburg (21–25 March 2001). Two sessions were especially important for the issue: "The Iconic Turn—Kunstgeschichte als Bildgeschichte und Wissenschaft" (The Iconic Turn—Art History as History and Science of the Image), directed by Michael Diers, in which Hans Belting addressed "Bild/Körper—auch eine Mediengeschichte" (Image/Body—Another Media History), preceded by papers from Gottfried Boehm ("Bild/Theorie/Geschichte"); Gerhard Wolf ("Bild/Orte"); and Horst Bredekamp ("Bild/Technik"). In the session "Konstruktionen der Kunstgeschichte—Inhalte und Institutionen" (Constructions of art history—discourses and institutions), Michael Ann Holly and Keith Moxey controversially discussed "Iconology's Nachleben" and the possibility of reviving a Warburgian approach.

6. Hans Belting, *Bild-Anthropologie* (Munich: Wilhelm Fink, 2001).

7. André Malraux, *La Métamorphose des dieux,* vol. 3, *L'Intemporel* (Paris: NRF Gallimard, 1976), 243.

8. Heinrich Dilly, *Kunstgeschichte als Institution. Studien zur Geschichte einer Disziplin* (Frankfurt am Main: Suhrkamp, 1979); *Altmeister moderner Kunstgeschichte,* ed. Heinrich Dilly (Berlin: Reimer, 1990).

9. Charles Baudelaire, "Le peintre de la vie moderne," in *Oeuvres complètes* (Paris: Calmann Lévy, 1950), 884–85; Hans Robert Jauß, "Literarische Tradition und gegenwärtiges Bewusstsein der Modernität," in *Literaturgeschichte als Provokation,* 6th ed. (Frankfurt am Main: Suhrkamp, 1979), 11–66, especially 52–56, about Baudelaire, and 57–66 for a refutation of Benjamin's interpretation.

10. Leopold von Ranke, quoted in Hans-Georg Gadamer, *Wahrheit und Methode. Grundzüge einer philosophischen Hermeneutik,* 3d rev. ed. (Tübingen: Mohr, 1972), 191–99. In this book Gadamer had for the first time stressed the importance, in a general sense, of experiencing art for understanding history, and in a more concrete sense, of Immanuel Kant's aesthetics for historicism.

11. According to Ranke, history was the form of existence for Occidental (as opposed to Oriental) cultures. See Gadamer and Karl Hinrichs, *Ranke und die Geschichtstheologie der Goethezeit* (Göttingen: Musterschmidt, 1954). Lévi-Strauss redefined peoples without history as peoples without writing. See his conferences broadcast as "Myth and Meaning" by CBC in December 1977, especially the second, about "primitive" and "civilized" thinking. Claude Lévi-Strauss, *Mythos und Bedeutung. Fünf Radiovorträge,* ed. Adlebert Reif (Frankfurt am Main: Suhrkamp, 1996), 27–46.

12. For the connections among historicity, hegemony, and power, see Gérard Chaliand, *Les Faubourgs de l'histoire* (Paris: Calmann-Lévy, 1984); Gayatri Spivak, "Subaltern Studies: Deconstructing Historiography," in *Other Worlds: Essays in Cultural Politics* (New York: Methuen, 1987); Edward W. Said, *Culture and Imperialism* (New York: Knopf, 1993).

13. Klaus Berger, *Japonismus in der westlichen Malerei* (Munich: Prestel, 1980); Shuji Takashina et al., *Le Japonisme,* exh. cat. (Paris: Réunion des Musées Nationaux, 1988); J. Thomas Rimer with Gerald D. Bolas, *Paris in Japan: The Japanese Encounter with European Painting,* exh. cat. (St. Louis: Washington University Gallery of Art, 1987).

14. For Monet's painting in Sainte-Adresse, see Robert L. Herbert, *Monet on the Normandy Coast: Tourism and Painting, 1867–1886* (New Haven and London: Yale University Press, 1994), 9–19; Carla Rachman, *Monet* (London: Phaidon, 1997), 72, 73–74.

15. For contemporary discussions of Japanese prints, see John Sandberg, "The Discovery of Japanese Prints in the Nineteenth Century before 1867," *Gazette des Beaux-Arts* 71 (1968): 295–302; Giovanni Peternolli, "La fortuna critica di Hokusai in Francia nel XIX secolo," *Paragone* 27, no. 315 (1976): 48–72. See also Geneviève Aitken and Marianne Delafond, *La Collection d'estampes Japonaises de Claude Monet* (Paris: Bibliothèque des Arts, 1983), 70, no. 59.

16. Elisa Evett, "The Critical Reception of Japanese Art in Late Nineteenth-Century Europe" (Ph.D. diss., Cornell University, 1980).

17. Georges Didi-Huberman has developed a radical notion of anachronism from Carl Einstein in "L'Anachronisme fabrique l'histoire," in *Études germaniques* 53, no. 1 (1998): 29–54, further developed in his *Devant le temps* (Paris: Minuit, 2000), 159–232. He insists that for Einstein, history can only be *present* as collage and montage operating at an active estrangement in confrontation to *the present.* The chapter "L'Image-combat" is intentionally largely based on an interpretation of Carl Einstein's *Negerplastik* (Leipzig: Verlag der Weissen Bücher, 1915). In the introduction of his book (9–54), Didi-Huberman generalizes anachronism as a necessary character of all historic work, of the paradoxical actuality of history that can only be achieved inasmuch as history is not actual. Here I

refer more to Didi-Huberman's discussion of Carl Einstein than to his general approach—which would have to be historicized, in my opinion, as a form of the presence of history. However, I do not attempt to criticize what appears to me to be a general refutation of models of continuity—in such a discussion, Gadamer would have to be introduced as antipode to Didi-Huberman—but I more modestly prefer to insist on strategies of interpretation instead of metahistorical perspectives. I am convinced that Didi-Huberman has in a striking way changed our idea of how history became something else after Cubism and the avant-garde movements.

18. Foster, "The Archive without Museums."

19. See note 17.

20. In order to elaborate more precise—and necessarily historically relative—instruments of interpretation on the basis of Einstein's notion of anachronism, it is necessary to see it within a broader field. Benjamin's definition of the "aura" as appearance of the faraway within closeness ("einmalige Erscheinung einer Ferne, so nah sie sein mag") may be related not only to anachronism as historical distance, but also to strategies of active estrangement (in German, *Verfremdung;* in Russian, *ostranenje*). See Walter Benjamin, "Das Kunstwerk im Zeitalter seiner technischen Reproduzierbarkeit," *Gesammelte Schriften* (1974; reprinted Frankfurt am Main: Suhrkamp, 1991), 471–508. On the notion of "aura," see 478–82; the discussions of this theory are too numerous to be documented here. The notion of active estrangement *(ostranenje)* is roughly contemporary with Einstein's "anachronism." See Viktor Sklovskij, "Die Kunst als Verfahren" (1916), in *Russischer Formalismus,* ed. Jurij Striedter, 5th ed. (Munich: Wilhelm Fink, 1994), 1:3–35 (text in Russian and German). The best discussion of the historical background and consequences of that theory is in Aage A. Hansen-Löve, *Der russische Formalismus. Methodologische Rekonstruktion seiner Entwicklung aus dem Prinzip der Verfremdung* (Vienna: Verlag der Österreichischen Akademie der Wissenschaften, 1978), 19–42, 238–73. Here, the confrontation of historical closeness to historical distance is seen as a matter of strategies that have their histories. However, in Sklovskij's texts, the notion of *ostranenje* still oscillates between strategy and characteristic of any artwork. Whether or not anachronism/*ostranenje*/*Verfremdung*/active estrangement characterize all or only some artworks, it is necessary to describe strategies of introducing the anachronistic and to see their development and reception in a historical perspective.

21. Einstein, *Negerplastik,* 1915.

22. Joachim Ritter, *Landschaft. Zur Funktion des Ästhetischen in der modernen Gesellschaft* (Münster: Aschendorff, 1963, reprint 1978); Norman Bryson, *Vision and Painting: The Logic of the Gaze* (London: Macmillan, 1983), 87–96.

23. A. Eusterschulte, "Mimesis," in *Historisches Wörterbuch der Rhetorik,* ed. Gert Ueding (Damstadt: Wissenschaftliche Buchgesellschaft, 2001), 5: cols. 1232–94.

24. Photograph of Antonin Artaud in the role of the Monk in Karl Dreyer's *La Passion de Jeanne d'Arc* (1927), private collection, Paris. See Alain Virmaux, *Antonin Artaud et le théâtre* (Paris: Seghers,

1970); Paule Thévenin, *Antonin Artaud, ce désespéré qui vous parle* (Paris: Seuil, 1993).

25. Antonin Artaud and Roger Vitrac, *Le Théâtre Alfred Jarry et l'hostilité publique*, 1930, photographic album, two copies: Paris, Bibliothèque Littéraire Jacques Doucet and Marseille, Bibliothèque Municipale; reproductions in *Antonin Artaud. Oeuvres sur papier,* ed. Germain Viatte and Bernard Blistène, exh. cat. (Paris: Réunion des Musées Nationaux, 1995), 240–41.

26. Antonin Artaud, "Le Théâtre et son double," in *Oeuvres complètes* (Paris: NRF-Gallimard, 1938, reprint 1978), 4:7–96; see especially "Le Théâtre de la cruauté. Premier manifeste," 86–96 and 310–12, note.

27. In a discussion opposing the absolute of history and its logic of becoming to the absolute of the present and its logic of contingency, Hegel is a key figure. See Judith Butler, *Subjects of Desire: Hegelian Reflections in Twentieth-Century France* (1987; reprinted New York: Columbia University Press, 1999). See also Jacques Derrida, *Glas,* trans. John P. Leavey, Jr. and Richard Rand (Lincoln: University of Nebraska Press, 1986), and the volume discussing Glas, *Hegel after Derrida,* ed. Stuart Barnett (London: Routledge, 1998), especially the essay by Jean-Luc Nancy, "The Surprise of the Event," 91–105.

28. The Hegelian vision of a totalized—thus necessarily inescapable—development of a "thinking" art toward its own end(s) is fully developed in Stephen Melville, "Counting / As / Painting," in Philip Armstrong, Laura Lisbon, and Stephen Melville, *As Painting: Division and Displacement,* exh. cat. (Columbus, Ohio: Wexner Center for the Arts, Ohio State University; Cambridge, Mass. and London: MIT Press, 2001), 1–26; and Stephen Melville, "Des Marques (ce qui reste de Hegel) ou Daniel Buren en tant que peintre," in *La Part de l'oeil. Revue de pensée des arts platiques* 17/18 (2001–2): 182–95.

29. Belting, *Bild-Anthropologie,* 22–33.

30. Ibid., 150–54.

31. Ibid., 87–113, 143–64.

32. Ibid., 168–76.

33. Mikhail Bakhtin, *Rabelais and His World,* trans. Hélène Iswolsky (Cambridge, Mass. and London: MIT Press, 1968); Friedrich Kittler, "Romantik—Psychoanalyse—Film. Eine Doppelgängergeschichte," in *Eingebildete Texte. Affären zwischen Psychoanalyse und Literaturwissenschaft,* ed. Jochen Hörisch and G. C. Tholen (Munich: UTB 1348, 1985), 118–35. See also Tanja Zimmermann, "Der Doppelgänger als intermediale Figur—Wahnsinn als intermediales Verfahren. Zu Nabokovs Otcajanie / Despair," in *Wiener Slawistischer Almanach* 47 (2001): 237–80. For the notion of projection reified in the figure of the *Doppelgänger,* see Otto Rank, *Der Doppelgänger. Eine psychoanalytische Studie* (facs. ed. of 1925 ed., Vienna: Turia & Kant, 1993). T. Zimmermann's interpretation of the *Doppelgänger* in nineteenth- and twentieth-century Russian literature is based on a reading of psychoanalytical projection in terms of media projection.

34. Belting, *Bild-Anthropologie,* 213–39.

35. Ibid., 38–50.

36. Ibid., 21–33.

37. Jean-François Lyotard, *Signé Malraux* (Paris: Grasset et Fasquelle, 1996), trans. *Gezeichnet: Malraux,* (Munich: Deutscher Taschenbuch Verlag, 2001). His text is written like an anti-text of Malraux's autobiography and other texts about himself. See André Malraux, *Anti-Mémoires* (Paris: Gallimard, 1967), 107–257. Significantly, the volume contains also some novels. Malraux here mostly remembers his political life after 1945, with some flashbacks to the period of his antifascist fight after 1936. An exploitation of various texts, excerpts, and interviews by Malraux, rearranged according to his biography, is Roger Stéphane, *André Malraux: Entretiens et précisions* (Paris: Gallimard, 1984). For a biography that—unlike the one by Lyotard—does not attempt at any deconstruction of the myth of Malraux, see Axel Madsen, *Malraux: A Biography* (London: W. H. Allen, 1977).

38. André Malraux, "La voie royale," in *Romans* (Paris: Pléiade, 1976), 173–311.

39. Lyotard, *Gezeichnet: Malraux,* 119–64; see also Madsen, *Malraux,* 56–77.

40. Lyotard, *Gezeichnet: Malraux,* 164–202; see also Madsen, *Malraux,* 78–113.

41. André Malraux, "La Condition humaine," in *Romans* (Paris: Gallimard, 1976), 313–566.

42. When the colonial officer came in order to lead the prisoners to execution—they were meant to be thrown alive into the fire oven of a steam locomotive—he found that two of the younger prisoners were already dead. "L'officier regarda Katow:—Morts? Pourquoi répondre?—Isolez les six prisonniers les plus proches!—Inutile, répondit Katow: c'est moi qui leur ai donné la cyanure. L'officier hésita:—Et vous? Demanda-t-il enfin.—Il n'y en avait que pour deux, répondit Katow avec une joie profonde. 'Je vais recevoir un coup de crosse dans la figure,' pensa-t-il. La rumeur des prisonniers était devenue presque une clameur.—Marchons, dit seulement l'officier" (ibid., 544).

43. André Malraux, *La Tentation de l'occident* (Paris: Grasset, 1926). The book is dedicated "A vous, Clara, en souvenir du temple de Benteai-Srey." Ling's conclusion to the fictive exchange of letters between 1921 and 1925 reads: "Comment exprimer l'état d'une âme qui se désagrège? Toutes let lettres que je reçois viennent de jeunes hommes aussi abandonnés que Wang-Loh ou que moi-même, dépouillés de leur culture, écoeurés de la vôtre. . . . L'individu naît en eux, et avec lui cet étrange goût de la destruction et de l'anarchie, exempt de passion, qui semblerait le divertissement suprême de l'incertitude si la nécessité de s'échapper ne régnait en tous ces cœurs enfermés, si la pâleur d'immenses incendies ne les éclairait." And he goes on to propose a purely negative awakening of Chinese identity. From European ideas of justice, his Chinese fellows knew only injustice, from European happiness only suffering (200–201, 202–3). "La force des nations a beaucoup grandi lorsqu'elle s'est appuyée sur l'étique de la force; quels seront donc les gestes de ceux qui accepteront de risquer la mort au seul nom de la haine? Une Chine nouvelle se crée, qui nous échappe à nous-mêmes. Sera-t-elle secouée par l'une de ces grandes émotions collectives qui l'ont, à plusieurs reprises, bouleversée?" A. D. concludes (208): "La force échappe deux fois à l'homme. A celui qui l'a créée, d'abord; à celui qui la vuet saisir, ensuite." For A. D., this mutual expropriation of one culture through the other one, in the final instance is the agent of a tragic liberation of its own identity (213): "Quelque jeunes hommes

s'attachaent à la transformation du monde qui se fait en eux. Elle leur donne la différence dont leur esprit a besoin pour vivre." (215) "Pour détruire Dieu, et après l'avoir détruit, l'esprit eropéen a anéanti tout ce qui pouvait s'opposer à l'homme."

44. André Malraux, "L'Espoir," in *Romans,* 567–992.

45. In the novel, Malraux alludes to the visual medium: "Derrière Scali et Magnin ne venait plus que le cercueil. Les brancards, l'un après l'autre, passaient le torrent: le cortège, de profil se déployait sur l'immense pan de roc aux ombres verticales.—Voyez-vous, dit Scali, j'ai eu autrefois. . . . Regarde ça: quel tableau! Scali rentra son histoire; sans doute eût-elle tapé sur les nerfs de Magnin comme la comparaison d'un tableau et de ce qu'ils voyaient tapait sur les nerfs de Scali" (ibid., 968).

46. Henri Zerner, "André Malraux ou les pouvoirs de la reproduction phtographique," in *Écrire l'histoire de l'art. Figures d'une discipline* (Paris: Gallimard, 1997), 145–56, 166–67; Rosalind Krauss, "Postmodernism's Museum without Walls," in Reesa Greenberg, Bruce W. Ferguson and Sandy Nairne, *Thinking about Exhibitions* (London and New York: Routledge, 1996), 341–48.

47. Lyotard, *Gezeichnet: Malraux,* 385.

48. In an era of end(s) of painting, evidently Freenhofer is in the air. See Georges Didi-Huberman, *La peinture incarnée. Suivi de "Le Chef-d'œuvre inconnu" par Honoré de Balzac* (Paris: Minuit, 1985); Balzac's novel is on 133–56.

49. Hans Belting, *Das unbekannte Meisterwerk. Die modernen Mythen der Kunst* (Munich: Beck, 1998), especially the last chapter about art after Marcel Broodthaers as remembrance of itself, 469–90. See my critical review of this book: "Ritual um die verlorene Mitte? Hans Belting über die sich selbst überlassene Kunst der Moderne," *Kunstchronik* (Jan. 1999): 47–51.

50. Bruno Latour and Peter Weibel, *Iconclash: Beyond the Image Wars in Science, Religion, and Art,* ed. Peter Weibel et al., exh. cat. (Cambridge, Mass.: MIT Press, 2002). The advisory committee of this ambitious show at the ZKM Karlsruhe comprised Hans Belting, Boris Groys, Denis Laborde, Marie-José Mondzain, and Heather Stoddard. The authors of the voluminous catalogue discuss different and even contradictory positions. Belting published two essays in the section "Are There Limits to Iconoclasm?": "Beyond Iconoclasm: Nam June Paik, the Zen Gaze, and the Escape from Representation" (390–411) and "Invisible Movies in Sugimoto's 'Theaters'" (423–27). The first essay discusses Paik's *Zen for Head* (1962), *Zen for Film* (1964), *TV-Buddha* (1974), and *Paik as Video-Buddha* (1974) in connection with Paik's homage to John Cage, concluding that "only the Zen gaze, which we are invited to apply here, offers access to a silence against which, ultimately, no image can win." The second essay is about Hiroshi Sugimoto's Theaters, photographs of cinemas: a film shown on the screen photographed with an extremely long exposure is reduced to a white screen enigmatically illuminating the architecture of the empty hall (fig. 8). "The difference of absolute and relative comes to mind." We are close to a vision of art history as a way toward the absolute(ly empty).

51. André Malraux, *Les Voix du silence* (Paris: Pléiade, 1952), 605–8 (the most significant passages on

history substituting the absolute of art to the absolute of religion).

52. The Menil Collection in Houston has been influenced by Malraux and shows some of the characteristics of his anthropological approach. See Dominique de Menil, Walter Hopps, et al., *The Menil Collection: A Selection from the Paleolithic to the Modern Era* (New York: Abrams, 1987).

53. See Okwui Enwezor, "Die Black Box. Einleitung," in *Documenta 11 Platform 5: Ausstellung,* exh. cat. (Ostfildern-Ruit: Hatje Cantz, 2002), 42–55. See also the publication of the other platforms, such as *Democracy Unrealized. Documenta 11—Platform 1,* ed. Okwui Enwezor et al. (Ostfildern-Ruit: Hatje Cantz, 2002).

54. See W. J. T. Mitchell's critique of Jonathan Crary, *Techniques of the Observer: On Vision and Modernity in the Nineteenth Century* (Cambridge, Mass. and London: MIT Press, 1990), in W. J. T. Mitchell, *Picture Theory* (Chicago and London: University of Chicago Press, 1994), 19–34.

55. Greenberg's notion of "kitsch" is, of course, based on a model of exchange between art and non-artistic production of images. In that case, it is an exchange in only one direction, from high to low. See Clement Greenberg, "Avant-Garde and Kitsch," *Partisan Review* (fall 1939) reprinted in his *The Collected Essays and Criticism: Perception and Judgments, 1939–1944,* ed. John O'Brian (Chicago and London: University of Chicago Press, 1986; reprint 1988), 1:5–23. See also the volume synthesizing some of the debate of that essay: *Pollock and After: The Critical Debate,* ed. Francis Frascina (New York: Harper and Row, 1985). For the visual arts, the exchange of art and non-artistic visual production is discussed in Thomas Crow, *Modern Art in the Common Culture* (New Haven and London: Yale University Press, 1996); for a comparison of Greenberg's position to that of Meyer Schapiro, see 8–21. Toward the end of the 1920s and before Stalinist oppression, the Russian Formalists developed a model of exchange between art and non-art that operates in two directions, taking into account not only strategies of borrowing and banalizing high art for mass-produced text and images, but also artists' strategies of "importing" material from popular culture, vernacular, class jargon, mass-produced images, "primitive" art, etc. See Jurij Tynjanov, "Über die literarische Evolution," in *Russischer Formalismus,* 433–60; Boris Ejchenbaum, "Das literarische Leben," ibid., 463–480 (both texts in Russian and German; to my knowledge, there is no English translation). For a first introduction to Russian Formalism, see Krystina Pomorska, *Russian Formalist Theory and Its Poetic Ambiance* (The Hague and Paris: Mouton, 1968), 21–42. The best discussion, is in, again, Hansen-Löve, *Der russische Formalismus,* 369–425.

PART FOUR

LEGACIES, PRACTICES,
REFLECTIONS

Languages of Art History

Charles W. Haxthausen

Today artists not only travel freely around the world but often establish studios on more than one continent, so that to talk about French, German, Japanese, or American art is becoming quaintly anachronistic. Ambitious exhibitions are often joint enterprises between curators of different nations who speak and write in different native languages; the international scholarly conference and its resulting publication have become a commonplace. In this increasingly global culture the topic of national traditions of art history might seem to be a matter of purely retrospective interest, an assessment of a phase of disciplinary history that is coming to a close. The Clark Conference "The Art Historian: National Traditions and Institutional Practices" and the present collection of essays resulting from it suggest that this is far from the case.

Reading these essays, one quickly comes to appreciate the sheer vastness of the topic, to which a dozen or so papers can hardly do justice. Despite the rich variety of explorations of this topic that are published here, a number of relevant questions are ignored or barely touched upon. Here I wish briefly to consider three: the relationship between a nation's museum collections and its tradition of art historical scholarship; the intercultural nature of so much art historical writing, in which a scholar or critic formed by one national tradition interprets art produced by another; and, finally, the question of language and translation.

Joseph Alsop once dubbed art history and art collecting "the Siamese Twins"; always "closely linked together . . . in the manner of Siamese twins, they have always had a shared bloodstream of ideas and critical viewpoints."[1] I was reminded of Alsop's observation as I read Mieke Bal's lament about what she characterizes as the narrowness of the art historical establishment in the Netherlands. "Dutch national scholarship focuses on Dutch national heritage," which amounts to a "predominant interest in a few decades of the seventeenth century." One wonders, does this limited focus have something to do with the narrow scope of Dutch museum collections, in which little older art outside of that produced in Holland can be seen? Do not the collections of a country have an effect on its art historical discourse? The rulers of the Habsburg, Wettin, and Wittelsbach dynasties collected widely, and their taste resulted in the great museums of Vienna, Dresden, and

Munich, respectively. Did not the character of such collections, with their masterpieces of, for example, Italian, Dutch, Flemish, French, and Spanish painting, have an impact on the agendas of the art historians who studied, taught, and wrote among such collections? Alois Riegl's work as a curator of textiles at the Austrian Museum of Art and Industry and its impact on his scholarly development is a case in point.[2] Obviously one cannot make this into a rule—the glorious collections of the Prado have not produced a Spanish school of art history that matches them in scope and international prestige, and, conversely, the United States has produced several great historians of European architecture. Moreover, as Horst Bredekamp and Michael Zimmermann remind us, photography has played a major role in art history since the later nineteenth century. And, obviously, the ease, speed, and frequency of foreign travel in the last half century have dramatically altered and enriched the study and practice of art history. Nevertheless, the relationship between national traditions of collecting and traditions of scholarship would have been interesting to explore.

Art history takes the form not merely of the meeting of word with image, of one historical moment with another ("anachronism," as Georges Didi-Huberman calls it), it is often an encounter between different cultures. This raises the interesting issue of how much influential scholarship on, say, Italian Renaissance art, has been written by German-speaking art historians—the Swiss Heinrich Wölfflin and the German Erwin Panofsky are two of the more conspicuous examples. With temporal distance we can see more clearly how each was shaped not only by his time but by a national intellectual culture. The reader of their texts encounters Italian art seen through a lens that has been ground on German intellectual traditions— Adolf von Hildebrand, for example, in the case of Wölfflin; Ernst Cassirer and Alois Riegl, among others, in the case of Panofsky. The influence of the philosophy of Martin Heidegger on German art history in the years after World War II is another example—one could multiply the examples endlessly. (Carlo Ginzburg's essay on the nineteenth-century German, French, and Italian responses to Vasari shows how the respective circumstances in these countries influenced the interpretation of a classic art historical text.) Obviously art historians are not formed exclusively by texts written in their native languages, and some were born into bicultural families and have not identified with a single national culture. Yet there is no denying the role of national culture in shaping art historical interpretation.

The belated reception of French Impressionism in Germany offers a particularly fascinating case of the influence of the intellectual culture of one nation

on its interpretation of the art of another. Although identified primarily with the period from the 1860s to 1880s in France, Impressionism became a major factor in the German art world—for artists, critics, and collectors—only in the 1890s, and it was seen as the dominant artistic tendency into the first decade of the new century, even as Fauvism and Cubism were emerging in France. The peak of Impressionism's reception in Germany coincided with a dramatic growth of interest in the work of Ernst Mach and Friedrich Nietzsche, and this led to some peculiarly German interpretations of this artistic tendency.

To be sure, German critics could agree with their French counterparts on the particulars of Impressionist vision, but in some cases their cultural perspective gave a peculiar twist to the words of some of Impressionism's own French advocates, particularly with regard to what might be called the cognitive implications of Impressionist perception. The French poet Jules Laforgue, in a catalogue essay that accompanied the first exhibition of Impressionist paintings to be seen in Germany, in 1883, and reprinted in the German magazine *Kunst und Künstler* in 1904, had stressed the dissociation of tactile knowledge from optical appearance that occurred in an Impressionist painting: "A natural eye forgets tactile illusions and their convenient dead language of line, and acts only in its faculty of prismatic sensibility. It reaches a point where it can see reality in the living atmosphere of forms, decomposed, refracted, reflected by beings and things, in incessant variation. Such is the first characteristic of the Impressionist eye."[3] Stephane Mallarmé had made a similar observation in 1876: "the eye should forget all else it has seen, and learn anew from the lesson before it, should abstract itself from memory, seeing only that which it looks upon, and that as for the first time."[4]

Mallarmé and Laforgue viewed these qualities of Impressionist art with equanimity; they celebrated Impressionist vision as a primarily aesthetic phenomenon. Yet for some commentators in early twentieth-century German-speaking Europe, Impressionist perception assumed a more unsettling significance. For the Austrian critic Hermann Bahr, writing in 1904, Impressionism was not merely an innovative technique of painting: it was, more profoundly, a way of perceiving and experiencing the world that was profoundly unsettling:

> Those who have not yet begun to doubt the eternal truth of appearances will not be able to enjoy a style of painting whose greatest charm is in images that flare up before our eyes and then vanish again into mist. Those who still believe that what we isolate and delimit in our

> thought, organizing the world so as to function in it, is "really" isolated
> and delimited, who do not feel that all is in constant flux, one thing
> seeping into another in ceaseless metamorphosis, never being but only
> becoming, will curse a manner of painting that blurs all boundaries, dis-
> solves everything in a dance-like flicker and shimmer and does so with
> a relish that must seem diabolical.[5]

Thus undermining faith in the truth of appearances, Bahr continued, Impressionism took from "pious people their comfortable, solid, secure world to hurl them out into the dizziness of churning transformations."[6] It is hard to recognize in these words the art that is today the seemingly inexhaustible subject of blockbuster exhibitions that draw hordes of visitors to American museums!

Bahr's interpretation of Impressionism was one mediated through the writings of the physicist Ernst Mach, which were being discovered by intellectuals just as Impressionism was becoming widely known in German-speaking Europe. In this view Impressionism was not a celebration of light, color, and modern life but an expression of modern epistemological uncertainty.

Mach's *Analysis of Sensation,* first published in 1886, attracted wide notice only at the turn of the century: between 1900 and 1906 it went through four editions. Bahr experienced Mach's *Analysis of Sensation* as a revelation when he read it around 1904.[7] It was, he asserted, thanks to Mach that he now understood Impressionism not merely as a painting technique but as an expression of the modern experience of the world. In reality there were no things, there were only sensations of color, of space, of time—everything was in constant flux. Chapter after chapter of Mach's book, he continued, conjured up paintings by Manet, Degas, and Renoir; whatever he did not at first understand in the text became clear when he recalled their pictures. It was only a matter of time, he concluded, until one simply summed up Mach's worldview as the "philosophy of Impressionism."[8]

Like Bahr, the art historian Richard Hamann was also acutely conscious of the cognitive implications of Impressionism, and he identified it closely with the thought of Nietzsche and Mach. But in his book *Impressionimus in Leben und Kunst* (Impressionism in Life and Art, 1907), he took a much more expansive view of Impressionism than earlier critics. Wilhelm Worringer concisely summed up what was new in Hamann's approach in his review of the book: "Up to now the catchword Impression was used only with reference to painting: that this character of modern painting can now be freely extended to all aspects of culture proves the de-

gree to which modern painting is the medium for the expression of modern feeling and therefore the true art of our time."[9] Profoundly influenced by the German historian Karl Lamprecht, who saw the visual arts as the primary index of the collective psyche of an entire era, Hamann elevated Impressionism from a movement in painting to a pervasive *Weltanschauung,* and he interpreted every aspect of European culture of the previous quarter-century as the expression of a single ethos. The culture's defining characteristic was *Reizsamkeit,* a refined, intense sensitivity to every stimulus, a condition Lamprecht saw as a product of entrepreneurial capitalism and the vicissitudes of the market. The Impressionist artist, poet, or composer was a delicate seismograph, set vibrating by every fugitive sensation or experience; his response was essentially passive, reactive. Isolating the fugitive optical stimulus from the storehouse of visual memory, Impressionism valued richness of sensation over order. For Hamann, Impressionism was "the manifestation of a collective being *(Gesamtwesen),* of a Zeitgeist," a worldview with a consistent psychological character. This was expressed in music, literature, philosophy, ethics, and even extended to the political and economic sphere, in which Impressionism was manifest in liberalism, "the demand for individual freedom," and laissez-faire capitalism. The common core of all of these expressions was the resistance to wholeness, to synthesis of any kind. The Impressionist ethos was pervaded by an extreme subjectivism, "a boundless individualism and egotism," and the decadence of this ethos was apparent in the character of Impressionist art: The "destruction of form, the bent and broken, the dissolved and disturbed had supplanted the beauty of form."[10]

Hamann's moral critique of Impressionist culture, largely forgotten today, became a foil for the construction of the concept of "Expressionism." If painting, as Hamann had argued, was a symptom of the Impressionist worldview, then a change in painting must herald a change in the larger culture and its ethos. Significantly, it was Wilhelm Worringer who first applied Hamann's principle to the new art, not merely to the art of Germany but of all Europe. Following Worringer's lead, other German critics like Willhem Hausenstein, Adolf Behne, Paul Fechter, and Ludwig Coellen now defined "Expressionism" less by a close examination of the actual qualities of the new art than by constructing a set of antitheses to Impressionism as defined by Hamann. This dialectical viewpoint opposed the abstraction of Expressionism to the naturalism of Impressionism; objectivity(!) to subjectivity, spirituality to materialism, a religious worldview to a positivistic one. And on this basis many of them prophesied the renewal of religious belief and the coming of an anonymous, collective style, such as had not

been seen since the Middle Ages.[11] Their concept of Expressionism embraced not only Van Gogh, Gauguin, and Hodler, but Matisse, Picasso, and every other innovative Post-Impressionist artist. This need to match the art to this historiographic interpretation led to some remarkable distortions and misreadings. In Cubism, for example, Hausenstein wrote that Picasso's sensuousness has been

> transubstantiated. It is spiritualized, transfigured. It has become religious. For the artist who has become religious the object has decomposed into a thousand fragments of existence; here the Impressionist worldview meets the religious worldview of Cubism. But in contrast to the Impressionist, the Cubist artist is not content with the sensory aspect of appearance; he wants all of appearance and more than all of it—he want what lies beyond things. . . .
>
> Because Picasso harbors an artistic religiosity within the depths of his sensory experience, he succeeds in achieving, in a single glance, an overview of the world in the logic of its mysticism, making it present on a single surface by means of his strange handwriting.[12]

Not until after the war did most of the critics recognize these illusions for what they were, and that realization triggered an outbreak of cultural pessimism.

Art criticism was of course not monolithic in Germany. Daniel-Henry Kahnweiler and Carl Einstein, both hostile to Expressionism, both articulate proponents of Cubism, developed interpretations of that art that surpassed in sophistication anything written at the time by French commentators. The German-born Kahnweiler was no outsider; the Paris dealer of Braque and Picasso gave the titles to many of their Cubist pictures. Yet his classic interpretation of their art, *Der Weg zum Kubismus* (The Rise of Cubism), was profoundly influenced by German thought—by his reading of Kant, Georg Simmel, and the neo-Kantian theory of Conrad Fiedler.[13] Carl Einstein, the German critic who stands alongside Kahnweiler as the most important early commentator on Cubism, offered an even more Fiedlerian reading of Cubism. Following Fiedler's theory that the true function of art was not aesthetic but cognitive, Einstein saw Cubism as a phenomenon whose significance went far beyond painting: it held the promise of a fundamental transformation of the subjective construction of the world. In other words, by changing artistic form the cubist transformed human vision, and by changing vision he transformed all the coordinates of thought.[14]

This role of national intellectual culture raises the issue of language and translation, which is not broached in these essays—surprisingly, since it is has been and so obviously remains a factor in shaping "national traditions and institutional practices." Norman Bryson once wrote, in critiquing the failures of structuralism, that "the misfortune of the French is not to have translated Wittgenstein; instead they read Saussure."[15] The teaching of art history in the Anglophone world and the intellectual formation of future scholars have surely been profoundly affected by the arbitrary pattern of translations of art historical texts from other languages. The radically different translation histories of Riegl and Wölfflin offer a dramatic example. Wölfflin's early book on the Italian Renaissance, *Die klassische Kunst* (Classic Art, 1899) appeared in English only four years after its German publication; a new translation appeared in 1952, in a popular edition by Phaidon Press, and remained continuously in print for the next two decades. Wölfflin's most widely read work, *Kunstgeschichtliche Grundbegriffe* (Principles of Art History), first published in 1915, was translated into English in 1932; Dover reprinted that edition in 1950, and it has been in print ever since, with the result that Wölfflin and his method were known to virtually any well-taught Anglophone art history major. Riegl, on the other hand, had to wait nearly a century for translation. Not until 1985, eight decades after his death, did a book by Riegl appear in English: it took eighty-four years for Riegl's *Die spätrömische Kunstindustrie* (Late Roman Art Industry) to be translated, ninety-seven for *Das holländische Gruppenporträt* (The Group Portraiture of Holland, 1902/1999), and ninety-nine years for *Stilfragen* (Problems of Style, 1893/1992).

An even stranger case is that of Aby Warburg—strange because although the Bibliothek Warburg moved from Hamburg to London in 1933, becoming the Warburg Institute, sixty-six years were to pass before the major corpus of Warburg's work was translated into English. And Riegl and Warburg are only some of the most conspicuous examples. Reading Françoise Forster-Hahn's recollections of her art historical training at the Kunsthistorisches Institut in Bonn, with its study rooms named after Anton Springer, Paul Clemen, and Carl Justi, I was struck by how meaningless these names will be to most Anglophone students of art history today—only one book each by Justi and Clemen has been translated into English, and none by Springer. Stephen Bann writes in his essay that the collective "ego of art history has been, very specifically, a German ego." Yet, an American or Briton who does not read German can still acquire only a fragmentary and distorted sense of the development of that collective ego.

This arbitrary pattern of translation continues into the present. The writings of two prolific authors included in the present volume, Horst Bredekamp and Georges Didi-Huberman, which address some of the most fundamental questions in the practice of art history today, remain largely unknown to those who do not read, respectively, German or French, because little of their work has been translated into English.[16] The issue of the relationship of *Bildwissenschaft* (literally "the science of images") to art history, which Bredekamp examines in his essay and which is currently a hotly debated topic in the German-speaking world, has mostly run parallel to our own debates about "visual studies," and yet these two debates have mostly been carried on separately in their respective languages.[17] It is noteworthy that most of the texts Bredekamp cites in building his case for the German antecedents of *Bildwissenschaft* are untranslated. Similarly, a majority of the sources that Didi-Huberman cites in his essay must be read in French.

One may protest that it is the business of art historians to learn these languages. Yet, after more than three decades of teaching graduate students I am more sober about the reality. Because of relaxed standards in high school and undergraduate language requirements, the majority of American students begin graduate study of art history without true proficiency in a second language. And even though they pass exams in two or three foreign languages by the time they receive the doctorate, these tools usually deteriorate if they are not used regularly. Most scholars tend to read only those things in foreign languages that are directly relevant to their own research; they do not find the time to follow broader disciplinary debates in those languages. It may be utopian to expect that it could be otherwise, but this reality, I believe, will ensure the persistence of distinct national traditions of art history even if, in other respects, the art world becomes more globalized.

1. Joseph Alsop, *The Rare Art Traditions: The History of Art Collecting and Its Linked Phenomena Wherever These Have Appeared* (New York: Harper & Row, 1982), 109–10.

2. Margaret Olin also makes a point about the impact of Riegl's childhood experience of the multinational character of the Empire on his approach to art history: *Forms of Representation in Alois Riegl's Theory of Art* (University Park, Pa: Pennsylvania State University Press, 1992), 17–18.

3. Jules Laforgue, "Impressionism," in *Impressionism and Post-Impressionism, 1874–1904,* ed. Linda Nochlin (Englewood Cliffs, N.J.: Prentice Hall, 1966), 16.

4. Stephane Mallarmé, "The Impressionists and Edouard Manet," reprinted in Penny Florence,

Mallarmé, Manet & Redon: Visual and Aural Signs and the Generation of Meaning, Cambridge Studies in French (Cambridge: Cambridge University Press, 1986), 12.

5. Hermann Bahr, *Dialog vom tragischen* (Berlin: S. Fischer Verlag, 1904), 111–12.

6. Ibid., 113.

7. Ibid., 114.

8. Ibid.

9. Wilhelm Worringer, "Richard Hamann. Der Impressionismus in Leben und Kunst," *Montashefte für Kunstwissenschaft* 1, no. 4 (1908): 338.

10. Richard Hamann, *Der Impressionismus in Leben und Kunst* (Cologne: M. Dumont-Schauberg, 1907), 9, 12, 50, 155, 158, 192.

11. See my article, "A Critical Illusion: 'Expressionism' in the Writings of Wilhelm Hausenstein," in *The Ideological Crisis of Expressionism: The Literary and Artistic War Colony in Belgium 1914–1918,* ed. Rainer Rumold and O. K. Werckmeister (Columbia, S.C.: Camden House, 1990), 169–91.

12. Wilhelm Hausenstein, introductory text to *Neue Kunst: Katalog der II. Gesamtausstellung,* exh. cat. (Munich: Neue Kunst Hans Goltz, 1913), 18.

13. On this see Yves Alain Bois, *Painting as Model* (Cambridge, Mass.: MIT Press, 1990), 66–69.

14. For this formulation I am indebted to Georges Didi-Huberman, *Devant le temps histoire de l'art et anachronisme des images,* Collection "Critique" (Paris: Editions de Minuit, 2000), 163–64.

15. Norman Bryson, *Vision and Painting: The Logic of the Gaze* (New Haven, Conn.: Yale University Press, 1983), 77.

16. At this writing only one book by Bredekamp and two by Didi-Huberman exist in English translation: Horst Bredekamp, *The Lure of Antiquity and the Cult of the Machine: The Kunstkammer and the Evolution of Nature, Art, and Technology,* trans. Allison Brown (Princeton, N.J.: Marcus Wiener Publishers, 1995); Georges Didi-Huberman, *Fra Angelico: Dissemblance and Disfiguration,* trans. Jane Marie Todd (Chicago: University of Chicago Press, 1995), and *Invention of Hysteria: Charcot and the Photographic Iconography of the Salpêtrière,* trans. Alisa Hartz (Cambridge, Mass.: MIT Press, 2003).

17. See, for example the responses to the questionnaire on visual culture in *October* 77 (summer 1966). The responses came exclusively from Anglophone scholars.

Babel and Pentecost: Looking Back on the Conference from Half a Year's Distance

Willibald Sauerländer

Reading at my desk in parochial Munich half a year after the Clark Conference "The Art Historian: National Traditions and Institutional Practices" through a dozen of the lectures delivered at this occasion has been an astonishing, fascinating, but—frankly spoken—also bewildering experience. The clash between—better, perhaps, the mixture of—American, Dutch, English, French, German, and Italian voices resounded with Babylonian confusion of tongues, but also with the Pentecostal polyglot. The discourse of art history on both sides of the Atlantic chatters more lively than ever before, but the speakers sound often as different from one another as chalk from cheese. The impression the reader gets from the vagrancy of these texts is one of stimulating diversity but also of irritating perplexity. It shows a discipline in all the heat of expansion but also on the brink of dissolution.

We are told, "The history of art is characterized by a weak sense of identity" (Eric Fernie) and who would dare to contradict the cool laconism of this statement? Coming from one of the English participants in the conference this verdict denounced especially the weakness of institutional coherence in the discipline. English institutions separate, so we are told, the study of art history from the study of the history of architecture. This is a special case of academic incoherence, which has its parallel in polytechnic schools in France and Germany. Incoherence is—as the conference amply demonstrated—characteristic for the present state of art history.

In general, many of the lectures resound with inherent insecurities, doubts, attacks, but also hopes and new perspectives. The conference took place in a climate of intellectual change. One lecturer asked, "Comment faire de l'histoire si le temps se dissémine?" (Georges Didi-Huberman). Chronos in evaporation? Following the example of such Parisian *maître-penseurs* as Ferdinand Braudel, Henri Focillon, or Nicole Loraux, the French speaker asks us to decompose the linear time of traditional art history—the time of evolution, of sequences, of progress—into a polyrhythmical movement of anachronisms, recurrences, and apparitions. The logic of time is dissolved, the linear art historical chronometry is replaced by the myth of *eternal retour*.

A similar dissolution—a no less profound metamorphosis—happens with the traditional space of art history, its eurocentric geography. Art history has long

been a European discipline. Its discourse—its reasoning and methods—has been shaped by the study of the development of European art from the Middle Ages to modernity. Its attitude toward non-European art—African, Chinese, tribal—was a sort of aesthetic colonialism. Chinese landscapes and porcelains were appreciated as precious and stimulating exoticisms and African masks as telling examples for the lure of the primitives. In post-colonial days, in front of the horizon of political and economic globalization, such a patronizing European attitude toward the art of the "Third World" is doomed. In the last paper of the conference we heard the aesthetic and prophetical pronouncement: "I am convinced that an anthropological turn of art history is inevitable" (Michael Zimmerman). Eurocentric art history has become parochial and therefore it is condemned to be melted into a universal anthropology of the image, into a new *Bildanthropologie,* to use the term that leading German art historian Hans Belting has coined for this hoped-for discipline. This dream of a forthcoming *Bildanthropologie* brings us close to the slogan "the end of history." The goal would no longer be the study of art or of history in any traditional sense, but a fundamentalist vision of the image of man, body, death, everywhere and always from the prehistoric caves to the clone.

There is another new comrade who emerged—or returned—during the last decades on the margins of traditional art history: "visual studies"—or to use again a German term, *Bildwissenschaft. Bildwissenschaft* faces us with a more complex problem than *Bildanthropologie.* It has a more solid basis. One of the lecturers has clearly described the problems involved: "In order to be named *Bildwissenschaft* art history has first(ly) to embrace the whole field of images beyond the visual arts and, secondly, to take all of the these objects seriously as works of highest value" (Horst Bredekamp). This is admittedly a concise program but it leaves us still with the crucial and endless question of how to maintain the fictitious distinction between visual information and art. Can art history survive without some kind of belief in art?

To sum up: the art historian who emerges from the readings of these collected essays lectures is a protean figure, a kind of chameleon. He or she appears as the old-fashioned connoisseur under attack (Mieke Bal), as the sociologist of architectural "signs" (Eric Fernie), as the traditional reader of images and texts (Stephen Bann and Carlo Ginzburg), as the reticent *Bildwissenschaftler* who tries to save the art historical ark in the flood of visual studies (Horst Bredekamp), and finally as the prophet announcing a forthcoming *Bildanthropologie,* which will fundamentally transform the traditional eurocentric art history (Michael Zimmermann).

But how does this protean, destabilized image of the art historian concur with the subtitle of the conference, "National Traditions and Institutional Practices?" With this question we are back to the tension between Babel and Pentecost. Can the dissonant voices of the twelve speakers coming from the Old and New Worlds be perceived as so many expressions of national and mental diversities, or do they echo the worldwide confusion of a discipline in profound metamorphosis? The answer is not easy and it must be an ambivalent one. Listening to Carlo Ginzburg or Stephen Bann we are on the traditional ground of national, mental, cultural, and political diversities among the old European countries—Italy, France, and Germany. Art history started in each of these countries in a different way but also with different intentions. If we listen to Mieke Bal's acrimonious critique of the intellectual blindness of and dogmatism of the Rembrandt Research Project we certainly hear a specific Dutch sound, but the crisis of connoisseurship is a general phenomenon. Her ironic statements "analysis becomes self-mirroring" or "the 'hand' is less the hand of the maker than the personified result of the expert viewers' interpretation" could be applied with equal justification to many examples from other nations. It remains always Babel and Pentecost. If we listen to Horst Bredekamp and Michael Zimmermann we hear German speakers, insisting in a German way on principles and raising far-reaching postulations. But the problems Bredekamp and Zimmermann deal with, *Bildwissenschaft* and *Bildanthropologie,* are of universal importance for the future of the field. It was Alain Schnapp, the archaeologist from Paris with an East European background—and not the art historians—who raised no dogmatic postulates but enriched the conference with a beautiful and sensitive performance about cultural history polarized between the Far East and the ancient world, a lecture on memory which is petrified in the stones and which lives on as a permanent echo in the voices of poets. Monuments are silent as the dead. The poems open the gates to a universal perception on Mnemosyne. Schnapp's lecture showed how anthropology of culture could be turned toward new humanism.

The planning of the conference "The Art Historian: National Traditions and Institutional Practices" was an American project. But only one lecture discussed the institutional practice of art history in America. Deborah Marrow gave a substantial report on the worldwide activities of the Getty Trust and especially of the Getty Research Center for the History of Art and the Humanities. This talk pretended not to discuss intellectual problems. It simply described a new American practice of global art history. The Getty Center invites scholars from all around the globe to discuss and study topics of general interest. With its

enormous financial power it helps to restore and save the monumental heritage of mankind in different parts of the first and third worlds. In certain corners of Europe one hears an envious and indignant murmur against the capitalist imperialism of such global activities. It would be more reasonable to recognize that the Getty Trust puts into useful practice just that kind of universal art history which the theorists of the anthropological turn are postulating. There is—who would dare to deny it?—a Western, possessive bias connected with the expansion of interest and help into other civilizations. But the same is true of the ambitious European project of *Bildanthropologie.*

For the time being art history remains—alas!—a Western project. No Chinese, Indian, Islamic, or Japanese speakers were heard at the conference. It was a Euro-American event. But Deborah Marrow's lecture revealed still another lacuna of the program. The institutional practice of the art historian was—one is tempted to say automatically—identified with academia and theory. One heard not a word about art historians in museums, laboratories, in the offices for the conservation of historical monuments, in the media, the press, and the art market. But in Europe most art historians work in these institutions and in this public sector. Moreover, given the shortage of jobs young art historians explore new professional territories. One meets them as advisors in banks, in all sorts of cultural agencies, they develop programs for the cultural entertainments of elderly people and in one German city an art historian has been hired by the police because of his expertise as a physiognomical semeiologist. There were good reasons to limit the conference to academia and theory. But we should not forget that the institutional practice of the art historian in today's society is much more manifold, and that art historians become more and more what one may call "leisure therapeutists."

Another American lecture at the conference was Perry Chapman's paper "Reading Dutch Art: Science and Fiction in Vermeer." Her text begins with a blunt distinction between Dutch rigorously fact-based art history and an American inclination to interpret more speculatively. This statement is—as all generalizing judgments on national mentalities and habitudes—an oversimplification. Not all Dutch cultural historians were fact-based diggers in the archives, and not all American art historians are inclined to speculation. Perry Chapman would certainly admit this qualification, and she herself seems to think that her neat confrontation with Dutch positivism and American speculation is somewhat worn out by recent movements "which may have to do less with national traditions than with the (expanding) outer limits of the field." This is an important argument. The new discourses in

art history—the discussions about visual studies, anthropology, and gender, to only name a few—are not enclosed in national traditions but are "Pentecostal." And yet this argument has to be qualified. Even in these domains the universal discourse resounds with national voices.

Chapman's proper topic was "Science and Fiction in Studying Vermeer. " Her meditating about the interpretation of Vermeer's paintings was a subtle discussion of a general hermeneutic dilemma: there can never be a total and comprehensive interpretation of any work of art. The scientists who try to analyze Vermeer's hallucinating illusionism—and to discover the instruments that made such optical delusions feasible—fell short of the emotional or seductive appeal of the figures and the faces appearing in the interior of the master's paintings. Here fiction comes in. But one may ask: can fiction reveal the secret breakthrough, the speaking silence into which Vermeer's mysterious figures are submerged? Or does fiction sound above Vermeer's silence with its own narrative delusion—the delusion of the novel and the anecdote? There is no rational end to the problems of ekphrasis. But Chapman's unprejudiced lecture reminds us how insecure the art historian has become in discussing the "truth" of paintings.

Art history in Europe and in America, their similarities and their dissimilarities, were the hidden main topic—the keynote—of the conference. One may even be more specific. The importation of German-style *Kunstgeschichte* into American academia seventy years ago may be history now, but its consequences—stimulations, influences, irritations, resentments—remain present and resounded again and again with the lectures at the conference. One could not help to entertain the suspicion that Erwin Panofsky's classic text: "Three Decades of Art History in America: Impressions of a Transplanted European," which was first published in 1953 in a collective volume called *The Cultural Migration: The European Scholar in America,* served as the founding charter for the program. But turning back to this moving yet dated text in 2002 faces us with a number of problems. Half a century ago Panofsky could still confess an unquestionable belief in art history as a humanistic discipline, which had been shaped during the nineteenth century at the German universities, passed on by the German mandarins from Hegel to Riegl to Wölfflin. He cited approvingly an American colleague who had explained that art history's "mother tongue is German." After the rise of barbarism in Germany, art history was transplanted to America as the citadel of academic and civic freedom. Panofsky was extremely thankful to America for its generous hospitality and he was never reluctant to recognize the achievements of American art historians

before the arrival of the transplanted Europeans. Nevertheless his attitude toward art history in America, such as he discovered it after his arrival in the 1930s, resembled the attitude of the so-called Graeculi, who flocked to ancient Rome from Greece in order to teach the uneducated Romans philosophy and rhetoric. Karen Michels's amusing talk "'Pineapple and Mayonnaise—Why Not?' European Art Historians Meet the New World" gives a lively description of the clash between the two different academic cultures and reminds the reader also of that attitude of scholarly, cultured, and intellectual superiority the transplanted Germans could occasionally parade in their new environment. One could easily add further examples to her talk. Nevertheless, the arrival of the transplanted Germans—many of whom belonged to the academic elite of their field—has, as is well-known, profoundly transformed, enriched, and enlarged the stature of art history in America. The intellectual history of the discipline in America over the last fifty years has to a large degree been dominated by the reception of and the reaction against German-style *Kunstgeschichte* as it had been imported by the transplanted Europeans. Even in 2002 the program of the Clark Conference resounds with the *longue durée* of the American reaction to German *Kunstgeschichte*.

But half a century after the publication of Panofsky's classic text one may ask whether the intellectual relation between European and American art history has not been reversed and if the Americans have not now taken the role of the Graeculi. This is a complex question, and the answer can neither be an unqualified "yes" nor a clearcut "no." Much of the fieldwork in the discipline, such as the physical study of monuments or the scrutinizing of documents, is still and will probably always remain centered in Europe. There is a practical and ideological reason for this unavoidable division of labor between art historians from the Old and the New Worlds. The sheer expertise of the Europeans who spend most of their professional life in the neighborhood of monuments and archives often promotes a positivistic attitude of superiority—an inborn conceit—which Perry Chapman has amusingly illuminated by citing the devastating comment of a Dutch colleague: "I wouldn't dare to speculate about this." A deeper ideological consequence of this European superiority in fieldwork is the emotional attachment to national heritage—*les lieux de mémoire*—which Mieke Bal has brilliantly mocked in her lecture on "Her Majesty's Pictures." Such a possessive attachment is by no means a Dutch specialty. The same attachment is found in all European countries, it is fostered by governments and local authorities, it shapes institutions and careers, it incites series of books on "national" art history in France, Italy, Spain, and since the reunion

of 1990, alas, again in Germany. One can only say "*felix* America," which is free from these national parochialisms and will hopefully never imitate them.

But there are other domains and facets of art history, where the situation is really reversed and where Europeans can now learn from their American colleagues, who have explored new ways of reasoning and speculation and who have become the true masters of certain sectors of art history. In her lecture "Moving Apart: Practicing Art History in the Old and New Worlds," Françoise Forster-Hahn describes what a curious bird she seemed to be working during the 1950s in a "respectable" German seminar on such a "low" subject as caricature. She tells also how surprised she was to find in England academic advisors who felt no reluctance to share her interest in such a low topic. But her story has a complex background. These open-minded English advisors were two immigrants from Central Europe: Ernst Gombrich from pre-1938 Vienna and Leopold Ettlinger from the late years of Weimar Germany. In Freud's Vienna and even in serious Germany during the days of Eduard Fuchs there has existed a curiosity for studying "low" images—caricature, pornography. But this illicit curiosity had been kept at the margin of official, respectable art history and rarely penetrated the sanctuaries of academia. The Nazis, who had their own reasons to be afraid of visual denigration, had in 1933 no great difficulty doing away with such indecencies. Since the Romantics, German art historians had been under the awe-inspiring spell of high art, which was held to have a transcendental meaning but not a social message. In no other language does one speak about the "Ehrfurcht vor dem Kunstwerk," and in no other country does art history come so close to a kind of religion. One may have hoped that after 1968 the pseudo-religious may have vanished and largely that seems to be the case. But it was striking to hear Horst Bredekamp's comments on—even against—the open program of "visual studies" in America that are announced as embracing "sociology, media studies, information technology, communication studies, and so on." I am not writing without genuine sympathy for Bredekamp's warnings. But although Bredekamp was one of the scholars who has done the most to deframe traditional German art history, his warning against the expansion of visual studies resounds still with the old German conviction that high art is untouchable and holy. Even now there remain national and mental idiosyncrasies which seem insurmountable. They can be irritating, even vexing, but perhaps they are one of the richnesses of the field.

Seventy years after the arrival of the transplanted Europeans the American discourse on the history of art has gained its proper voice, and for certain questions

and in some fields the American voice has become the leading one. The lingua franca of art history is no longer German, but English, especially American English. American art historians have the disadvantage but also the advantage of greater distance from the dark shadow of monuments, from the national heritages. To the few remaining highbrow Europeans, Americans may still seem like "innocents abroad." Compared to the forbiddingly serious European colleague, the American art historian displays a greater productive naïveté. The transfer of linguistic and literary theory into art history—from texts to images—has been easier and also more fruitful in America than in Europe, with the great burden of its iconic tradition. The flowering of gender studies since 1970 was more lively, imaginative, perhaps also more obsessive in America than in Europe because Americans are less afraid to project their proper social problems into the images of the past. They are less afraid of art and less afraid of the archives. In a multicultural society with great Asian and black minorities, the study of non-European art—the ethnographical more than the anthropological study—seems to be a natural answer to the civic neighborhood of a polygenetic population. In this perspective *Bildanthropologie* looks like a very eurocentric project. So Europeans have a lesson to learn from American-style art history.

Finally there is one sector of art history where Americans are really the new Graeculi. Over the last fifty years the study of the history of modern art has become an American domain. The American scholars are here the best archivists and the most intelligent analyzers. This is true not only for the art of the twentieth century, but for the study of modernity at least since the time of Baudelaire. The interpretation of French Impressionism as the *imaginaire* of modern Paris was an American discovery, perhaps a reflection of the American metropolis: New York, Chicago. One could say that America—New York—has stolen the history of modern art. American art historians have discovered a field which they could identify with their own *imaginaire* and which seems to belong to their own past. Mary Cassatt had known Degas and Gertrude Stein, Picasso. Beginning with Meyer Schapiro and Clement Greenberg, American art historians and critics have opened an intellectual discourse on the history of modern art in modern society which has no equivalent parallel in the Old World. Seventy years after the arrival of the European Graeculi in "uneducated" America, the direction of the intellectual transplantation in art history seems reversed.

Contributors

Mieke Bal is Professor of Theory of Literature at the University of Amsterdam and co-founding director of the Amsterdam School for Cultural Analysis. An eminent cultural critic and theorist, her publications include *Quoting Caravaggio: Contemporary Art, Preposterous History; Narratology: An Introduction to the Theory of Narrative;* and *Reading "Rembrandt": Beyond the Word-Image Opposition.*

Stephen Bann is Professor of History of Art at the University of Bristol. He is the author of *The Clothing of Clio* (1984), *The Inventions of History* (1990), and *Paul Delaroche: History Painted* (1997), works on aspects of the history of historical representation. His *Parallel Lines* (2001), a study of the relations between printmakers, painters, and photographers in nineteenth-century France, was awarded the Gapper Prize by the Society for French Studies.

Horst Bredekamp is Professor of Art History at Humboldt University, Berlin. He is the author of *The Lure of Antiquity and the Cult of the Machine* (1995), *Thomas Hobbes's Visual Strategies* (1999), and *Sankt Peter in Rom und das Prinzip der produktiven Zerstörung: Bau und Abbau von Bramante bis Bernini* (2000).

H. Perry Chapman is Professor of Art History at the University of Delaware and editor-in-chief of *The Art Bulletin.* She is the author of *Rembrandt's Self-Portraits: A Study in Seventeenth-Century Identity* (1990) and co-author/curator of *Jan Steen: Painter and Storyteller* (1996), as well as other studies on aspects of seventeenth-century Dutch art.

Georges Didi-Huberman teaches at the École des Hautes Études en Sciences Sociales in Paris. A distinguished teacher, philosopher, and art historian, he is the author of numerous books on the history and theory of visual culture, including most recently *Devant le temps: Histoire de l'art et anachronisme des images* (2000); *L'Image survivante: Histoire de l'art et temps des fantômes selon Aby Warburg* (2002); and *Ninfa moderna: Essai sur le drapé tombé* (2002).

Eric Fernie has recently retired as director of the Courtauld Institute. He is a fellow of the British Academy and the Society of Antiquaries of London, and the Royal Society of Edinburgh. His books include *The Architecture of the Anglo-Saxons* (1983), *An Architectural History of Norwich Cathedral* (1993), *Art History and Its Methods* (1995), and *The Architecture of Norman England* (2000).

Françoise Forster-Hahn is Professor of the History of Art at the University of California, Riverside. She has published widely on issues of art and culture and the role of institutions and exhibition displays in the construction of national and cultural identity. Most recently she edited the volume *Imagining Modern German Culture: 1889–1910* and is preparing a forthcoming book, *Adolph Menzel (1815–1905): A Career Between National Empire and International Modernity.*

Carlo Ginzburg is Franklin D. Murphy Professor of Italian Renaissance Studies at UCLA. His published works deal mostly with history, art history, and historical methodology, and include *The Cheese and the Worms: The Cosmos of a Sixteenth-Century Miller; The Enigma of Piero; Wooden Eyes: Nine Reflections on Distance;* and *No Island Is an Island: Four Glances at English Literature in a World Perspective.* He received the Aby Warburg Prize in 1992.

Charles W. Haxthausen is the Faison-Pierson-Stoddard Professor of Art History and director of the Graduate Program in the History of Art at Williams College. Formerly the curator of the Busch-Reisinger Museum at Harvard University, he has published widely on twentieth-century German art and criticism, and edited *The Two Art Histories,* the first volume in the series *Clark Studies in the Visual Arts.*

Karen Michels is Privatdozentin at Hamburg University. Her research interests include modern architecture, especially Le Corbusier, and the history of art history. She conducted a research project concerning the emigration of art historians from Nazi Germany and Austria and is the author of *Transplantierte Kunstwissenschaft: Deutschsprachige Kunstgeschichte im amerikanischen Exil.*

Willibald Sauerländer is former director of the Zentralinstitut für Kunstgeschichte, Munich. One of Germany's most distinguished art historians, he taught for many years at the University of Freiburg and has served as visiting professor at New York University, Harvard University, the University of California, and the Collège de

France, Paris. His recent books include *Cathedrals and Sculpture* and *Geschichte der Kunst, Gegenwart der Kritik.*

Alain Schnapp is Professor of Greek Archaeology at the University of Paris (Panthéon-Sorbonne) and is director of the newly founded Institut National d'Histoire de l'Art in Paris. He has excavated in Italy and Greece, and his recent books include *Le chasseur et la cité, chasse et érotique en Grèce ancienne* and *The Discovery of the Past.*

Michael F. Zimmermann is Professor of Modern and Contemporary Art History at the University of Lausanne. Formerly the deputy director of the Zentralinstitut für Kunstgeschichte in Munich, he is currently studying the arts and the media in Italy from industrialization to the avant-garde. His monograph on Georges Seurat has been translated into four languages.

Photography Credits